Electronic Moviemaking fourth edition

Lynne S. Gross

California State University, Fullerton

Larry W. Ward

California State University, Fullerton

Wadsworth
Thomson Learning™

Australia • Canada • Denmark • Japan • Mexico • New Zealand
Philippines • Puerto Rico • Singapore • Spain
United Kingdom • United States

Radio, TV, and Film Editor: Karen Austin
Associate Developmental Editor: Ryan E. Vesely
Editorial Assistant: Dory Schaeffer
Executive Marketing Manager: Stacey Purviance
Marketing Assistant: Ken Baird
Print Buyer: Mary Noel
Permissions Editor: Susan Walters

Production Service: Hal Lockwood, Penmarin Books
Text Designer: Ellen Pettengell
Art Editor: Connie Hathaway
Copy Editor: Jean Mann
Cover Design: Cuttriss & Hambleton
Compositor: Thompson Type
Printer/Binder: World Color, Taunton

For permission to use material from this text, contact us
Web: www.thomsonrights.com
Fax: 1–800–730–2215
Phone: 1–800–730–2214

Library of Congress Cataloging-in-Publication Data
Gross, Lynne S.
 Electronic moviemaking: Lynne S. Gross,
 Larry W. Ward.—4th ed. p. cm.—
 (Wadsworth series in television and film)
 Includes bibliographical references and index.
 ISBN 0-534-55971-9
 1. Video recording. 2. Electronic cameras.
 3. Cinematography. 4. Motion pictures—
 Production and direction. 5. Video recordings—
 Production and direction. I. Ward, Larry Wayne.
 II. Title. III. Series.

 TR850 .G76 1999
 778.5'23—dc21
 99-043750

For more information, contact
Wadsworth/Thomson Learning
10 Davis Drive
Belmont, CA 94002-3098
USA
www.wadsworth.com

International Headquarters
Thomson Learning
290 Harbor Drive, 2nd Floor
Stamford, CT 06902-7477
USA

UK/Europe/Middle East
Thomson Learning
Berkshire House
168-173 High Holborn
London WC1V 7AA
United Kingdom

Asia
Thomson Learning
60 Albert Street #15-01
Albert Complex
Singapore 189969

Canada
Nelson/Thomson Learning
1120 Birchmount Road
Scarborough, Ontario M1K 5G4
Canada

 This book is printed on acid-free, recycled paper.

Preface

Electronic Moviemaking, which emphasizes the combination of film and video, has become more valid as the years progress. The use of electronic equipment in conjunction with traditional film techniques is becoming increasingly widespread, academically and professionally. This edition, like its predecessor, is intended to meet the needs of professionals and academics who are combining film and video and want to emphasize the directorial and storytelling functions of the media.

This fourth edition of *Electronic Moviemaking* follows the same basic preproduction, production, postproduction structure as the first edition. However, we have updated a number of chapters, particularly those that deal with equipment operation. Chapters 4, 8, 10, 11, and 13 have been most heavily updated because of the rapid changes brought about through innovations related to digital technologies. The chapters that deal with approaches to handling moviemaking have changed the least. The aesthetic principles remain fairly constant, regardless of changes in technology.

- Preproduction, which is frequently short-changed, is given special emphasis in this book in two chapters. One deals with developing the original concept, and the other covers the various tasks involved in preproduction and the organizational skills and planning concepts needed to ensure a smooth production.
- The first chapter in the production section gives an overview of each activity likely to take place during a typical production. The rest of the chapters in this section are paired. The first chapter in each pair deals with the technical aspects of the subject and

the second with the aesthetic concepts. Cameras and lenses, lights and filters, and microphones and recorders are all handled in this way.

- The postproduction section also starts with an overview chapter and is then arranged in pairs. We discuss image editing and sound editing in terms of techniques and creative approaches.

Throughout the book we discuss various levels of equipment, from consumer-grade to professional equipment that is still evolving. We do this because the type of equipment available varies greatly from school to school or company to company and because we feel students should know not only about the equipment they are currently using but about the equipment they may be using in the future. Our emphasis is on electronic equipment, but we also give some attention to film equipment, in part because film and video are often used together and in part because numerous techniques discussed in the book have evolved from film.

The book's focus is on what a student needs to know to develop a successful narrative moving picture, but many of these principles are useful for other forms, such as documentaries, educational programs, commercials, and music videos. Our overall emphasis is on the forethought and care that must go into all aspects of production. A book like this cannot avoid the "techno-speak" associated with film and video, so we have included the technical information that we feel anyone engaged in production in this area should know. However, our main emphasis is on the creative process, the kinds of decisions that are made, and the strategies that are developed.

We have included a number of special features that we hope will aid the reader. The glossary defines all the words that appear in the text in boldface print. The selected readings and Web sites at the end of the book and the references cited in the notes should lead those who desire more information to appropriate sources. Many notes also contain additional content for those who want to understand a subject more deeply. The many drawings and photographs should be especially helpful in understanding the concepts discussed.

We appreciate the help of the many professionals and academicians who made suggestions for this revision. In particular, we wish to acknowledge the following reviewers:

Zaki Lisha, De Anza College
William Neff, Montana State University
Phil Miller, Boston University
Michael Zingale, Pasadena City College

We also thank the reviewers of previous editions as well:

Steve Gilliland, West Virginia State College
Margot Starr Kernan, Maryland Institute College of Art
Jay Korinek, Henry Ford Community College
Philip Miller, Boston University
John W. Newhouse, Southwestern College
Kenny Suit, Baylor University
Gordon Webb, Ithaca College

About the Authors

LYNNE GROSS teaches television production and theory courses at California State University, Fullerton. In the past she has taught full-time at Pepperdine University, Loyola Marymount University, and Long Beach City College.

She has worked in the television business as program director for Valley Cable TV and as producer for several hundred television programs, including the series *From Chant to Chance* for public television, *Effective Living* for KABC, and *Surveying the Universe* for KHJ-TV.

Her consulting work includes projects for Children's Broadcasting Corporation, RKO, KCET, CBS, the Olympics, Visa, and the Iowa State Board of Regents. It has also taken her to Malaysia, Swaziland, Estonia, Australia, and Guyana, where she has taught radio and television production.

She is active in many professional organizations, serving as a governor of the Academy of Television Arts and Sciences and president of the Broadcast Education Association. She is the author of ten other books and numerous journal and magazine articles.

LARRY WARD is a professor of communications at California State University, Fullerton, where he heads the TV/Film Sequence. He teaches primarily film and television production and film history and aesthetics.

While at the university, he has produced hundreds of hours of sports and public affairs programming broadcast and cablecast in the Los Angeles–Orange County area.

He was producer-director for *The Science Report,* a series of twenty-minute educational tapes for sixth-grade students, funded by Union Oil and the Placentia School District. Before that he was director-editor for *The Moving Picture Boys in the Great War,* a one-hour documentary film for Post–Newsweek Television Productions, and *Lowell Thomas Remembers I and II,* a series for public broadcasting.

He has published a number of articles and papers and one other book, *The Motion Picture Goes to War.* He has also served as the western regional coordinator for the Motion Picture Academy's Nicholl Fellowships in Screenwriting Contest.

Contents

part one
Preproduction

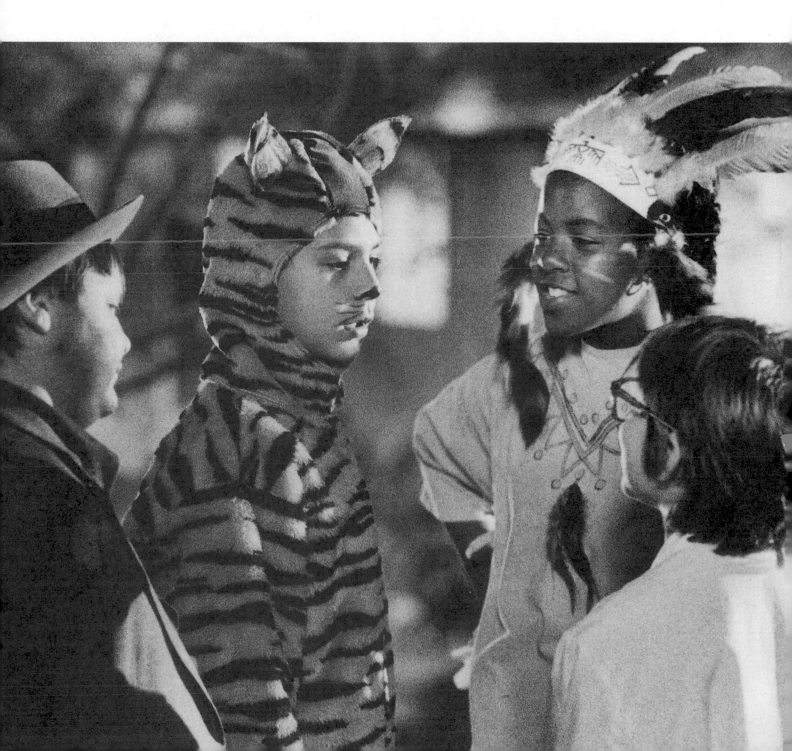

chapter one
Developing the Script

Willam Goldman, a two-time Academy Award winner and the author of screenplays for such films as *Harper, Butch Cassidy and the Sundance Kid, Marathon Man,* and *All the President's Men,* has expressed an obvious but fundamental axiom about moviemaking—"There is no picture without a script."[1]

The script is the crucial element that drives preproduction (planning), production (shooting), and postproduction (editing). Each of these phases is crucial to the phase that follows. Inadequate preproduction almost guarantees poor production, and poor production is seldom "saved" in editing. However, none of these phases is even possible without a script.

The Writer's Role

The idea for a movie may be initiated by the **writer,*** or a **producer** may initiate the idea and find a writer willing to turn the idea into a screenplay. Sometimes scriptwriting begins with the writer verbally presenting the basic story idea or concept to a producer. If the producer buys the idea, the writer may be commissioned to develop it into a completed script. Regardless of who initiates the idea (the writer, the producer, or the director) or where the idea comes from (an original story or an adaptation of a novel or play), someone ultimately must put words on the page and prepare a completed script. That someone is the writer.

The writer's major contribution comes before and during preproduction. As a screenplay evolves from a rough idea to a polished script, it will go through many stages of writing and rewriting. Different writers may be brought in at any stage to turn the story in a new direction,

to solve plot problems, or to punch up the dialogue. Although it may be possible to sell an idea and initiate a project based entirely on a verbal presentation, until a complete screenplay actually exists on paper, proceeding with meaningful preproduction is difficult.

The writer's role during shooting is far more limited and often the source of great frustration.[2] The writer may be called on to rewrite dialogue or to make small changes in some area of the script but often has little say about how the screenplay is modified or rewritten during production by the director, producer, actors, agents, or anyone else with the power to make changes. This frustration has sent some writers into directing as the surest way to bring a script to the screen in the way they originally visualized it on paper.

Many excellent books focus on the art and craft of screenwriting.[3] Typically, such books provide guidance on how to develop a story and plot, create characters, write dialogue, and use the proper screenplay format. This book is not a screenwriting text, and for that reason we assume that the student moviemaker will have a completed script in hand before electronic moviemaking begins. Nevertheless, students must be familiar with certain screenwriting terms and concepts. These are discussed in the next section.

Script Terminology

A **shot** begins when the camera and/or videotape recorder starts recording and ends when it stops. It may be short or long, require a complex camera movement, or be totally static. The **scene** is the basic dramatic building block of the screenplay. A scene is usually defined as a unified action occurring in a single time and place. It may be composed of a single shot but normally is made up of a group of shots. A **sequence** is a somewhat more arbitrary concept. It consists of a group of scenes linked together or unified by some common theme, time, idea, location, or action. A sequence might consist of a character coming of age in a series of related scenes. Elaborate car chase scenes are often sequences. In

*Boldfaced terms are defined in the glossary at the end of the book.

```
                          CONCEPT

                      OLD MOTHER WITCH

     Old Mother Witch is a film adapted from the popular
children's book of the same name by Carol Carrick.  It is a story
about understanding, empathy, and the need to bridge the
generation gap.
     A young boy and his rambunctious friends have a running
quarrel with a cranky old woman in their neighborhood.  She is so
mean that they begin calling her the "Old Mother Witch."  During
a dark and eerie Halloween night a "really" frightening event
occurs.  This teaches the young boy and his friends a dramatic
lesson about appreciating and helping other people.
```

Figure 1.1

A sample concept for Old Mother Witch.

Forrest Gump the cross-country running sequence compresses Forrest's three-year, two-month, fourteen-day run back and forth across America into six minutes of screen time. The series of mob murders during the christening scene near the end of *The Godfather* is an example of a far more complex sequence, one that juxtaposes the rituals of religious ceremony and Michael Corleone's consolidation of power through the ritualistic killings of his gangland rivals.

A screenplay is constructed from scenes and sequences. Like any narrative—a novel, short story, or fairy tale—a screenplay has a beginning, middle, and end. But a motion picture narrative is not really complete on paper. Until the screenplay is brought to life by the sounds and images in the completed picture, it is more of a blueprint, a movie in waiting.

Scripting Stages

A narrative screenplay usually goes through many different stages of writing. Sometimes a particular stage will be skipped or combined with another stage. At other times a stage will be repeated again and again, perhaps with a new writer brought in, either to do a complete rewrite or to make minor changes.

The Concept. The **concept**, also called the *story idea, premise,* or *synopsis,* is a brief written account describing the basic idea for the story.

It presents a thumbnail sketch of the story and is often used to provide a busy producer or story editor with a quick means of evaluating the overall scope of a motion picture. It is short (usually only a paragraph or two), simple, and to the point. Some screenwriters believe that a good concept can be expressed in a single sentence, one line that describes who does what and where this takes place. The argument for beginning the screenwriting process with a brief story idea is that if a short concept can't catch and hold a reader's interest, it hardly makes sense to develop that idea into a full-length 120-page screenplay.

Reducing a story to a few sentences or paragraphs is difficult. Professional screenwriters often see this as an effective way to distill the central ideas and to provide direction for writing the entire screenplay. A well-written concept or premise can offer an overview or unifying thread for the entire production; it is a way to keep the screenplay focused on the basic concept.

Figure 1.1 presents an example of a brief concept for a movie script written by Mark Chodzko, based on a children's book by Carol Carrick. This script was made into a twenty-eight-minute movie distributed by Phoenix Films. We will refer to this script from time to time to illustrate the various steps and stages in electronic moviemaking.[4]

The Scene Outline. The **scene outline** is a list in numerical order of all the scenes in a

Figure 1.2
*Part of the scene outline
for* Old Mother Witch.

SCENE OUTLINE

OLD MOTHER WITCH

1. Introduction of the main characters in the film: David Martinez, age 10, and his friends Scottie, Mary Ellen, and Eric-- the so-called neighborhood "wild bunch." They have a brief but noisy confrontation with their neighborhood rivals, the bullies Eddie Malone and Don MacDonald. This disturbs David's next door neighbor, Mrs. Oliver, an old widow who hates the loud noises and disturbances the children frequently cause. She asks them to keep down the racket.

2. David and his friends complain to David's father about Mrs. Oliver's constant nagging. Then they decide to play football.

3. During a spirited football game the ball is accidentally thrown into Mrs. Oliver's yard, almost breaking her window. She decides to keep the football to punish them.

4. David and his parents discuss the need to empathize with the old woman. She is alone and in poor health. David's parents suggest that he go over and apologize to her.

5. Mrs. Oliver explains her difficulties with the neighborhood children to a friend.

6. David, acting on his parents' suggestion, nervously approaches Mrs. Oliver's house. He rings the doorbell.

7. At first, Mrs. Oliver does not hear the bell. When she finally does she hesitates to answer it.

8. By the time she reaches the door and opens it, David has already left in disgust.

9. It's Halloween night, and groups of kids in costumes are trick or treating in the neighborhood. A newly cut jack-o-lantern glows on David's front porch.

10. David and Scottie meet at David's house to plan their evening's trick or treating and to compare costumes.

11. On the sidewalk outside of David's house, David and Scottie discuss the "old witch," Mrs. Oliver. David draws a picture of an old witch on the sidewalk with chalk and adds an arrow pointing toward Mrs. Oliver's front door.

12. The two boys go to the Bridwell's house. The Bridwell's take Halloween seriously, dressing in scary costumes and trying to frighten the would-be trick or treaters. As they are taking candy from a bowl, the boys are given a good scare by Mrs. Bridwell.

screenplay, with a brief description of what occurs in each scene. A scene outline does not use dialogue or elaborate descriptions. Its purpose is to help the writer expand the basic elements suggested in the concept and develop them into a workable structure. This is done by listing, scene by scene, what happens in each setting. The first page of the scene outline for *Old Mother Witch* is shown in Figure 1.2 and photos illustrating some of the scenes are shown in Figures 1.3 and 1.4.

A scene outline is an excellent tool for testing the plot, the way the story will be presented in the screenplay and eventually in the completed film. This is not necessarily the same thing as the story, the chronological telling of events

from beginning to end.[5] The same story, for example, might be presented with a variety of different plot structures. One plot presentation might focus on a single day in a character's life with the rest of the story fleshed out by dialogue and voice-over remembrances. Plotted in a different way, the story might begin with a character's death and go back to show the events leading up to the moment at which the film began. Some films, such as Quentin Tarantino's *Pulp Fiction,* have a plot presentation that purposely jumbles the order of the story events, forcing the viewer to mentally reconstruct the story chronology.

James Cameron's Academy Award–winning film *Titanic* (1997) is a good example of the differences between story and plot. This film tells the story of Rose and Jack, two lovers who meet on the *Titanic*'s 1912 ill-fated trip. She is about to marry a wealthy man she does not love. He is a struggling artist who won a ticket for the *Titanic* trip in a card game. The story deals with their chance meeting and growing love and with the fact that he dies in the icy waters and she survives to become an old lady.

The order in which these events are presented on the screen is not chronological. The film begins when Rose is old and items from the *Titanic* are being recovered from the floor of the ocean. Rose learns of this from a TV report and contacts the head of the recovery team. She begins to tell him and his associates her story and the movie flashes back to 1917. This pattern of plot presentation is repeated throughout *Titanic,* moving back and forth in time from Rose and the *Titanic* recovery team in the present to Jack and Rose in 1917. The flashbacks move consistently forward in time until the story catches up with Rose at the *Titanic* recovery site. At that point, the story and plot move together to the film's conclusion.

A scene outline can be an invaluable tool for analyzing plot development and for experimenting with the relationships between scenes or between scenes and the screenplay as a whole. It can help the writer see whether a scene is helping to advance the story or whether it is contributing primarily to character development. Professional screenwriters frequently advocate putting each scene on an index card, a

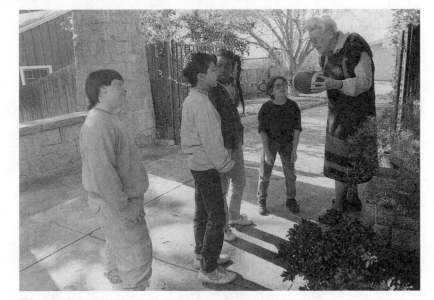

Figure 1.3

The neighborhood kids have a run-in with Mrs. Oliver in Old Mother Witch. *(Photo courtesy of Phoenix Films, Mark Chodzko, and Carol Carrick)*

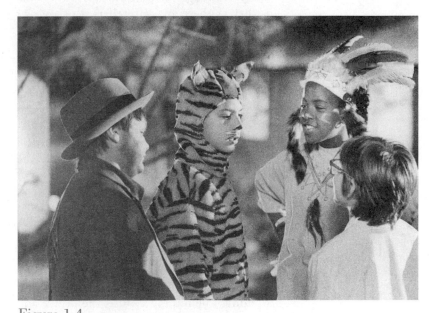

Figure 1.4

Scottie, David, Eric, and Mary Ellen meet on the street on Halloween night in a scene from Old Mother Witch. *(Photo courtesy of Phoenix Films, Mark Chodzko, and Carol Carrick)*

procedure that makes it easy to insert or eliminate scenes or try scenes in a different order.

One of the best-known screenwriting books, Syd Field's *Screenplay,*[6] stresses the importance of having each scene advance the action and move the story forward. Field places special emphasis on what he calls *plot points,* especially

important scenes that occur near the end of the screenplay's opening movement and again just before the motion picture's climax and resolution. Plot points help grab the audience's interest and turn the story in a different direction, driving the story to a more powerful and dramatic conclusion.

Most screenwriting books, Field's included, focus on the type of screenplay written for commercial, feature-length motion pictures. This is a highly conventional (or traditional) means of storytelling—what some scholars have referred to as the "classical Hollywood narrative."[7] This style evolved in Hollywood filmmaking over a period of approximately eighty years and became the dominant mode of motion picture storytelling throughout the world. Although there are as many ways to tell a story as there are storytellers, this style of motion picture does have some common patterns or traditions. Typically, such stories are centered on a single character (the protagonist) who has some need or desire that drives the story forward. The basic conflict in the story springs from some character (the antagonist) who blocks or opposes that need or desire. Because of time constraints (normally 90 to 120 minutes), the plot presents only the events that advance the story to resolution of the basic conflict. Finally, this style of narrative almost always has a conclusion that ties up the loose ends. By the time the final credits roll, the conflict is resolved, all our questions are answered, and we usually have a good idea of what will happen to each character. Many films today have two protagonists (the cop and a buddy, Thelma and Louise, the prince and the princess), but the basic narrative structure of such screenplays is similar to the classic Hollywood model.

The student moviemaker often has difficulty applying many of these narrative principles and patterns to a screenplay that is only twenty to thirty pages long (twenty to thirty minutes' running time). The screenplay must have a beginning, a middle, and an end, but such a short script provides far less time for developing characters, creating an elaborate plot, or providing a complete resolution of the conflict. The budget and the lack of equipment and editing may impose additional constraints. The only answer is to keep things simple. Reduce the number of characters and settings, eliminate as much on-screen **backstory** (the background material needed to set up the narrative) as possible, and write a script that can be produced within the many limitations the student moviemaker typically faces. Keep the script short, simple, and focused.

The Treatment. The **treatment,** one of the most important stages in scriptwriting, is a prose description of the story. It reads like a short story, describing the action in detail (see Figure 1.5). A well-written treatment provides precisely the kind of visual imagery and atmosphere the writer must have to develop a finished screenplay. It gives the first indications of where dialogue will be needed and builds on and amplifies the characters, settings, action, and motivation suggested in the scene outline.

Treatments vary in length. Some writers advocate a full dialogue treatment as the final step before writing the screenplay; such a treatment is much longer than the scene outline. Treatments often are used to sell a project to a network or to raise money. They are excellent for these purposes because they provide a full, readable description of the movie. A treatment developed as a sales tool will be rather short (usually no more than five pages) because that is all a busy executive will take the time to read. A verbal pitch of the story to an executive or potential backer often occurs in conjunction with delivery of the treatment.

The Screenplay. The **screenplay** (sometimes called the **master scene script**) is a translation of the treatment into script form (see Figure 1.6). It is based on general scenes (like a stage play) rather than on specific shots. Using the treatment as a guide, a writer creates a screenplay, which includes a heading for each location or scene (for example, INT. GRAND BALLROOM—LATE EVENING). In some cases scenes are numbered, although this is not a requirement. Beneath the scene heading is descriptive material that provides detailed infor-

TREATMENT

OLD MOTHER WITCH

The film begins on a beautiful autumn day. Walking down the
sidewalk, carrying the Halloween pumpkins that they have just
purchased at the local pumpkin patch, are the members of the
neighborhood "wild bunch." Their unofficial leader is David
Martinez, a bright dark-haired boy of 10. He is accompanied by
his friends Scottie, a pudgy kid who is always eating something;
Mary Ellen, a black girl with long legs who is very athletic; and
Eric, the "brain" of the group. It is Halloween day and they are
in high spirits as they plan the evening's trick or treating and
refine some new one-liners about Scottie's eating habits and
Eric's intelligence. Their kibitzing is abruptly ended by the
arrival of the long-time neighborhood bullies, Eddie Malone and
Don MacDonald. The two groups exchange putdowns on the sidewalk.
Eddie and Don are out of their league in a game of words, so they
turn to their specialty--threatening to get even with the "wild
bunch" in the dark streets on Halloween night. Laughing, they
speed away on their skateboards. This sidewalk confrontation has
caught the attention of Mrs. Oliver, David's 70-year-old
neighbor. Leaning over her garden fence, Mrs. Oliver delivers an
all too familiar lecture about making noise and causing a
disturbance in her quiet neighborhood.
 David's father is washing the family car in the driveway as
David and his friends arrive at David's house. After their
confrontations with Don and Eddie and Mrs. Oliver, the "wild
bunch" is not feeling so wild. Mrs. Oliver, they decide, is
simply a "nag." Mary Ellen suggests they forget their troubles
with a game of touch football.
 The football field is the front yard of David's house. Two
trees and some sweatshirts mark the boundaries. Sides are
chosen. Mary Ellen and David are on one team, and Scottie and
Eric are on the other. These teams are not fairly matched. Mary
Ellen is by far the best quarterback, and David is the best
receiver. It is going to be a mercifully quick slaughter. Mary
Ellen and David decide to strike quickly with a "bomb." David
heads for the end zone as Mary Ellen throws a beautiful spiral
toward him. Unfortunately the ball sails far over David's head,
over the fence beyond the end zone and into Mrs. Oliver's yard.
It hits her house with a loud thud, nearly breaking a window.
Everyone freezes. Suddenly Mrs. Oliver storms out the door and
down the steps. She picks up the football and angrily castigates
the children for nearly breaking her window and for making such
an infernal racket. To teach them a lesson, she tells them she
is going to keep their football for a while. After she goes back
in the house, the former football players agree that she is
indeed an "old witch." Mary Ellen suggests that she might have

1

Figure 1.5
Excerpt from the treatment for Old Mother Witch. *The entire treatment runs seven pages.*

mation about the scene and the characters' action. The dialogue spoken by each character and any appropriate stage directions follow the descriptive material. There are no camera instructions or detailed shot descriptions.

At this stage a screenplay is considered a finished product, the final script commonly shown to producers, directors, studios, and agents. The screenplay contains as many ideas from the treatment as is feasible, rounding out and filling in details of location, action, and characterization as needed. Rewriting or even omitting a few scenes described in the scene outline or the treatment may be necessary, but

Figure 1.6
Excerpt from the screenplay of Old Mother Witch, *written by Mark Chodzko and based on the book by Carol Carrick.*

```
                    MASTER SCENE SCRIPT

                    OLD MOTHER WITCH

SCENE 1

EXT. NEIGHBORHOOD STREET - DAY

It's a beautiful autumn day as 10-year-old DAVID MARTINEZ
and his friends, SCOTTIE, a pudgy little kid who is always
eating something; MARY ELLEN, a black girl with long legs
who is very athletic; and ERIC, the "brain" of the group,
walk down the street carrying pumpkins that each of them has
just picked from the local pumpkin patch.  They are laughing
and having a good time.  Eric tries to balance his on top of
his head.  OPENING TITLES and MUSIC play over the scene.

                         DAVID
                       (beaming)
              Now this is what I call a pumpkin!

David's is perfectly shaped.

                         ERIC
              Hey Scottie!  Your pumpkin kind of
              reminds me of you.  It's a wide body!

Mary Ellen and David laugh.

                         SCOTTIE
              Watch it "slide rule" or you're going
              to be wearing it for a hat!

Everybody laughs as they near Mrs. Oliver's house, which is
next door to David's.  MRS. OLIVER, an old cantankerous
woman in her 70s, is out raking leaves in her garden.  Just
then Mary Ellen notices EDDIE MALONE, age 12, and his friend DON
MACDONALD drive up with Eddie's brother FRANK, age 16.  Frank
just got his driver's license and with it an old junky Fiat
convertible.  Frank thinks it's a great car even though it's
not.  And Eddie and Don think they are pretty cool riding
around with the top down.

                         MARY ELLEN
              Oh no.  Look at the sludge that just
              creeped in.

David groans.

                         DAVID
              Not Eddie and Don.

                                              (CONTINUED)
```

these changes are minimal if the treatment is well developed. The completed screenplay represents the screenwriter's final attempt to visualize the story on the page. Additional changes will be made during production, but in many cases the screenwriter's task ends when the screenplay is finished.

The Shooting Script. Many directors like to convert the screenplay into a **shooting script** that helps them prepare for the day's work. Different directors have different ways of working, but a shooting script basically consists of the settings, characters, dialogue, and action in the screenplay broken into individual shots with a

SHOOTING SCRIPT

OLD MOTHER WITCH

SCENE 1

EXT. NEIGHBORHOOD STREET - DAY

FADE IN:

1. L.S., <u>HIGH ANGLE</u> of the street on a beautiful autumn
day. We see four neighborhood kids: 10-year-old DAVID
MARTINEZ; SCOTTIE, a pudgy little kid who is always
eating something; MARY ELLEN, a black girl with long
legs who is very athletic; and ERIC, the "brain" of the
group. The <u>CAMERA TRACKS</u> with them as they walk down
the sidewalk. They are each carrying pumpkins that
they have just picked at the local pumpkin patch. We
<u>TILT DOWN</u> and <u>MOVE CLOSER</u> as Eric tries to balance a
pumpkin on top of his head. OPENING TITLES and MUSIC
play over the scene.

DISSOLVE TO:

2. TWO SHOT David and Eric:

DAVID
(beaming)
Now this is what I call a pumpkin!

ERIC
Hey Scottie! Your pumpkin kind of
reminds me of you. It's a wide body!

3. C.U. of Mary Ellen laughing at Eric's joke.

4. C.U. of Scottie:

SCOTTIE
Watch it "slide rule" or you're going
to be wearing it for a hat.

5. M.S. as everybody laughs. The <u>CAMERA PANS</u> over to MRS.
OLIVER'S house. Mrs. Oliver, an old cantankerous woman
in her 70s is out raking leaves in her garden beside
the house. The <u>CAMERA MOVES UP CLOSER</u> to register the
look of irritation on Mrs. Oliver's face as she
observes the kids on the sidewalk.

6. M.S. of Mary Ellen who turns abruptly and looks toward
the street at the <u>SOUNDS</u> of an old car <u>SPUTTERING TO A</u>
<u>STOP</u>.

(CONTINUED)

Figure 1.7

The same scene from
Old Mother Witch *in a*
shooting script format.

particular camera angle, movement, or position. (Figure 1.7 shows part of the shooting script for *Old Mother Witch*.) Some shots may be suggested by the dialogue or scene descriptions, but the kind of technical information in a shooting script is considered a decision to be made by the director, not the screenwriter.

In some respects a shooting script is one of the final steps of preproduction. A detailed shooting script can provide an additional level of control and predictability, supplying the director and production crew with the technical information they need to set up each shot of the movie. A shooting script can also save time and

Figure 1.8
Even people who do not know how to draw can use software such as StoryBoard Quick™ that features predrawn characters, props, and locations. Clicking the mouse on the appropriate tool (a) can change perspective, size, screen direction, or other features; (b) six frames and captions from a storyboard created with this software. (Graphics courtesy of Power-Production Software)

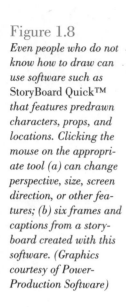

a

Conery's car screeches to a stop in front of the warehouse...

He runs up the dark staircase.

Conery kicks the door open and it's Eva...She's been found!

Eva: "I can't believe you, what are you doing--" Conery slams his hand over her mouth.

The evil Vance's footsteps echo through the building as he advances on our hero.

b

Conery turns to listen as we move in closer on his face...

money by helping to create a realistic schedule (and budget). For example, an especially long and complex shot (one with much complicated camera movement) might take an entire morning to execute—with obvious ramifications for the budget and the shooting schedule.

The shots in the shooting script are numbered consecutively. In addition to the scene headings, descriptive material, and dialogue from the master scene script, the shooting script includes specific instructions about camera angles, positions, and movements. The shooting script also contains information about the transitions between shots or scenes (for example, FADE IN, CUT TO, DISSOLVE TO). Sometimes this information is suggested in the screenplay and is refined further in the final shooting script.

Storyboards. Some directors prefer to develop visual representations known as **storyboards** rather than relying on a shooting script. Other directors supplement the shooting script with storyboards. A storyboard represents the director's initial idea for the composition of each shot. A detailed storyboard can provide valuable guidance for the art director, set designer, or camera crew. The director may hire an artist to draw the storyboard or may use a computer program to develop it. Dedicated computer storyboard programs that link graphics and text make it easy to render high-quality storyboards (see Figure 1.8).[8]

Even if the director has a complete shooting script and a storyboard in hand, it is easy to change a shot (or decide to try a new one) when the director arrives on the set and begins working with the actors and crew on location. Changing something that is only on paper is always easier (and less costly) than changing something that has already been shot. Revisions to the shooting script and/or storyboards may be made throughout production if the script is too long, if the production is taking too much time and running over budget, or if scenes that read well on paper do not play as well during rehearsals. Storyboards and shooting scripts create a kind of safety net for the production. For the beginning moviemaker especially, succumbing to the urge to improvise is far less risky if paperwork provides a basic foundation.

Other Script Forms

Writing a script for a television documentary, a corporate video, a training program, an educational CD-ROM, or any other of the many forms of film, video, or **multimedia** projects involves many of the same steps we have just discussed in the creation and development of a dramatic screenplay. As was the case with theatrical screenwriting, many textbooks detail the development of scripts for news, features, commercials, music videos, multimedia projects, and corporate videos.[9]

Some of these script forms are less likely to require the kind of full-blown development we have been discussing. Many modern documentaries, for example, rely heavily on interviews or actuality shooting, material that is virtually impossible to prescript. As a result, an outline might be the final scripting stage.

Music videos also tend to work more from outlines than fully developed scripts. The outline in Figure 1.9 is one example. The lyrics to the song already exist. They are a given. This outline sets up the basic parameters for the shoot. There will be four different locations, and in two the performer (Brian) will lip-sync the song's lyrics. The third location will feature children who will sing a refrain, and the fourth location will wind up as a nonsync vignette based on specific lyrics from the song. Obviously, this kind of scripting is much looser and more open. It relies on the editor (and director) to select and juxtapose the images and lyrics in postproduction. In reality, the final stage of writing (or rewriting) for most music videos occurs in the editing room.

Other types of script do require full development. Look at the excerpt from the script for *DUII: The Price Is Too High,*[10] shown in Figure 1.10. This movie, used in schools for traffic offenders, is sponsored by departments of motor vehicles around the country. It conveys a strong message about driving under the influence of intoxicants. The script is in standard screenplay form and uses an actor/narrator to set up a variety of dramatic scenes that illustrate the basic message. Documentary and instructional materials give the facts and figures that underscore the anti-intoxicant theme.

Figure 1.9

An example of a music video outline. (Script courtesy of Brian Gross)

MUSIC VIDEO FOR
"I LOOK SO GOOD IN YELLOW'
BRIAN

The video will consist of four different set-ups:
 1. Brian, dressed in a variety of yellow clothes, lip
syncing in a nightclub setting.
 2. A chorus of children dressed in yellow singing the "Oo la
la la la la" refrain.
 3. Brian, dressed in a yellow shirt and lip syncing, walking
a dog dressed in a yellow dog jacket.
 4. The three back-up singers in a department store trying on
ugly colored shirts and finally finding yellow ones they like.

We will build two sets in the studio, one for the nightclub scene
and the other for the children's chorus. The nightclub scene
will have a 1940s look to it and will consist of a sequined
curtain and a floor stand microphone. The audience will not be
shown. An intense spotlight will highlight Brian's yellow
clothing.

The children's chorus (about twenty 8 to 10 year olds) will be on
risers against background flats that are painted with geometric
shapes in primary colors.

The dog walking scene will be shot on an eastern street in the
autumn so that several trees with colorful leaves can be shown in
the background.

The scene with the back-up singers will be shot in the men's
clothing store late at night when the store is closed.

As the track begins, we see Brian in the nightclub scene dressed
in yellow pants and a black shirt. As the first verse
progresses, he adds (in jump cut fashion) additional yellow
clothing--a shirt, shoes, a jacket, and finally a large floppy
hat.

At the first "Oo la la" chorus, we cut to a long shot of the
children singing.

Next, Brian is seen walking the dog. At first the dog is not
seen, but it is obvious from the leash and the way Brian is being
pulled that a dog is present. When the next "Oo la la" section
comes, the dog and its yellow jacket will be revealed. Both the
children and Brian will be heard for this "Oo la la," but the
children will not be seen.

The video returns to the nightclub lip syncing until the words "I
hardly know anyone who wears yellow shirts" at which point the
back-up singers are seen rummaging through shirts on a "sale"
counter in the men's clothing store.

page 1

2.

NARRATOR (cont'd)
And I sure didn't know what a DUII arrest
could do to my life. I want to tell you
what happened to me, but first let me tell
you about some other people who made the
same mistake I did...

DISSOLVE TO:

INT. - CROWDED BAR -NIGHT

Four young women in their early twenties are seated in a booth at
a bar. They are making a toast and laughing uproariously.

NARRATOR (V.O.)
Like Jennifer. It was her birthday. Was
it her fault that everyone from work wanted
to buy her a drink?

GIRL ONE
Happy birthday dear Jennifer...

JENNIFER
(slurring slightly)
Stop it you guys. My poor dumb sister is
waiting with a whole big party she thinks
is going to surprise me and I can't just
not chow up. I gotta go.

Jennifer stands up abrubtly, grabs her purse and car keys off the
table and turns to leave.

JENNIFER
Goodnight.

GIRL ONE
Jennifer are you sure you're able to drive?

JENNIFER
Yeah..this is nothing. I've driven in far
worse shape than this before. Nothing is
going to happen to Jennifer.

Jennifer turns and walks away with her girlfriends saying goodbye
in the background.

EXT. - URBAN STREET - NIGHT

Jennifer drives through an intersection and a police car pulls in
behind her, lights flashing. Jennifer glances up at her rear
view mirror and starts to pull over.

JENNIFER
Damn!

Figure 1.10
Scenes from the educational film DUII: The
Price Is Too High.
*(Script courtesy of AIMS
Media, Inc., Chatsworth, CA)*

Figure 1.11
Excerpt from a script in the split-page format.

```
Women at Work                                          page 8

          VIDEO                             AUDIO        TIME

Roof shingler sequence       SOUND ON FILM.  Starts 0:50
from the film "Other         seconds in with "I remember
Women, Other Work"           my father" and runs 2:55
                             ending with "You are the
                             best darn shingler in this
                             country."                   9:15

HOST                         Psychological ideas have also
                             played a part in the division
                             of labor between men and women.
                             One idea that has existed in
                             the past is that women are
                             frivolous by nature.  This is
                             reflected in the old popular
                             show tune "I Enjoy Being a
                             Girl."                       9:45

Slide 19 - woman in white    RECORD 2 - "I Enjoy Being a
                             Girl."  Start at beginning and
                             go 2:05.  "I'm a girl and by me
                             that's only great.

Slide 20 - woman in black    I am proud that my silhouette is
                             curvy

Slide 21 - woman and         That I walk with a sweet and
    umbrella                 girlish gate
```

The key to this kind of scriptwriting is its focus on a message. The script has a definable objective and a client or sponsor who wants to teach, persuade, or inform the viewer about something. Combining narrative and nonnarrative elements is not uncommon. Charts, graphs, and interviews may be interspersed with dramatic illustrations.

This type of scriptwriting tends to place greater emphasis on research, since the entire project is being developed to meet the specific needs and objectives of the client or sponsor. In

some instances the writer may need to obtain the client's approval at each stage of the writing process. Before writing begins, surveys may be used to gauge the intended audience's knowledge of a subject, or they may be used after the script is completed to test its effectiveness. Once a basic strategy has been devised (and agreed on), scriptwriting proceeds through as many stages as the particular subject requires.

Many nonnarrative scripts employ a **split-page** format (see Figure 1.11). The video information is written down one side of the page, and audio information (often voice-over narration) is placed opposite it. This two-column format is especially useful for scripts in which the audio comments on or clarifies the visuals.

In a short, highly visual form like a commercial, the best script might actually be a storyboard containing the copy (dialogue or voice-over) and a drawing for each shot.

The newer **interactive media**—CD-ROMs, computer games, and virtual reality—often require complex programs that "branch." People are not expected to watch these materials from beginning to end. They skip around viewing the materials they need or want to see. The script material must be written in such a way that it makes sense even though people are making choices, leaving out some of the information. For example, the CD-ROM *Myst* combines elements of a narrative motion picture with a mystery game, allowing the viewer to interact with the story.[11]

Computer Programs for Scriptwriting

Computer scriptwriting programs greatly facilitate the scriptwriting process. As we have already seen, writing script material from concept to outline, treatment, and screenplay is a process of constant revision and rewriting. Computer software makes this task much easier.

Obviously, any of the excellent word-processing programs available for the two most popular computer systems, the Macintosh or the IBM (or IBM-compatible) computer can be used for

Figure 1.12

An example of Movie Magic Screenwriter *software for writing scripts. (Photo courtesy of Screenplay Systems, Inc.)*

scriptwriting. Word-processing programs, such as *Word*, are easy to use for screenwriting. You can use the program to set the correct margins, to check the spelling, and usually to set a style sheet, a sort of template for your screenplay format. Many professionals have made screenwriting with their word processor even easier by using macros (a key or keys programmed to execute a series of time-saving keystrokes—most helpful when centering a character's name or changing the margins for the dialogue).

The main advantage of scriptwriting with a word processor is that you probably already are familiar with a program and will not need to spend time learning a new one. The primary disadvantage of screenwriting with your word processor is that such programs have difficulty conforming to the labyrinth of rules surrounding correct screenplay format, such as the proper placement of *continued* or *more* at the top or bottom of the page. If you drop a scene or a few lines of dialogue, you would need to manually correct *continued* and *more* throughout the script.

Another approach to screenwriting software is to use a dedicated, stand-alone scriptwriting program (such as that shown in Figure 1.12). The main purpose of such a program is to put the text in proper screenplay format with

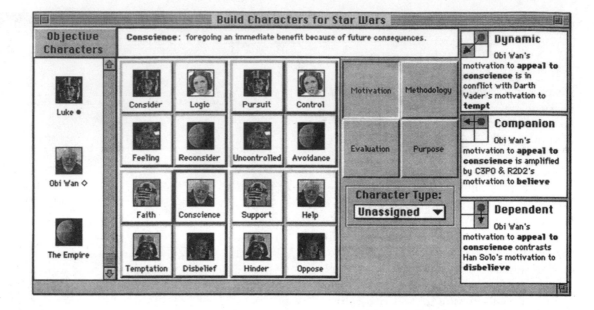

Figure 1.13
A sample of how profiles for Star Wars *characters could be developed using the computer program* Dramatica. *(Photo courtesy of Screenplay Systems, Inc.)*

proper margins, page breaks, and transitions. With such a program you can number scenes and shots, insert *continued* at the top and bottom of the page, and print out individual pages or scenes or an entire screenplay. Some dedicated programs can also be adapted to different scriptwriting formats, such as split-page. The disadvantage of using a dedicated program is that you must learn how to use it. The advantage is that you know you will have a script that conforms to Writers Guild style. What the screenplay looks like on the computer scrreen is what it will look like on the printed page. Typically, the word-processing capability of stand-alone scriptwriting programs is not as powerful or sophisticated as the dedicated word-processing programs. You do see what the script will look like on the screen before it is printed out, but you may not have as many text-writing features (high-quality spell checking, grammar analysis, and so on).[12]

Finally, one of the more interesting developments in screenwriting software is the creation of computer programs to help writers analyze their plots, characters, and story lines. Such programs typically are interactive, prompting the writer to answer questions about story structure, character development, and plot conflicts. Beginning writers may find these programs helpful for generating ideas and exploring story structure and character development (see Figure 1.13).[13]

New screenwriting programs undoubtedly will continue to be developed. A computer does not do the writing for you, but it does make it much easier to rewrite and revise while maintaining the correct screenplay format.[14]

Copyright and Clearances

Writers typically **copyright** their work to protect it. One way to do this is to obtain a copyright registration form from the Registrar of Copyrights at the Library of Congress in Washington, D.C.[15] A copyright can be secured for a full treatment or for a completed screenplay.

Another possibility is to register your script with the Writers Guild of America (WGA). The Writers Guild will accept story ideas, synopses, treatments, outlines, and full scripts from members and nonmembers (for a nominal fee). If you live west of the Mississippi River, you register your material with the Writers Guild of America, West; if you live east of the Mississippi, you register with the Writers Guild of America, East.[16]

Perhaps the simplest method of providing proof of authorship is to mail your script to yourself in a sealed envelope by certified mail. Do not open the envelope. The postmark on the envelope establishes a specific date of creation. This kind of self-copyrighting may be difficult to sustain in court and is probably not the best means of protecting your script. The more completely your idea is developed on paper (a screenplay compared to a scene out-

COPYRIGHT AGREEMENT

I,_____ grant to
 (the copyright holder)

_____ the
 (the producer)

non-exclusive right to produce a motion picture based upon the

work entitled _____

written by _____
and to exhibit, distribute, publicize, and otherwise exploit the
picture in all media, by any title, in perpetuity, and throughout
the world. I hereby grant to the producer any further rights
that the producer may need to carry out the above-made grant,
including all rights necessary to adapt the work for the picture
and to use the name of the author in connection with the picture.
The producer shall have the right to copyright the picture in
his/her/its own name.

I further warrant that I am sole owner of all rights of copyright
and that I have full authority to convey these; that the work is
wholly original and that neither any incident contained in the
work nor any part thereof was taken from or based upon any other
dramatic, literary, or musical material; that the exercise or use
of any rights herein granted will not in any way infringe upon or
violate any rights of any person, corporation, or firm
whatsoever, including without limitation rights of privacy and
publicity, and that no part of the rights herein granted have in
any way been used, limited, or impaired and that they are free
and clear of any and all claims or liens whatsoever, and that
there are no claims or litigation outstanding, pending, or
threatened, which may in any way prejudice the producer's rights
in the work.

I warrant that, except as expressly provided herein, neither the
producer no any of the producer's assigns shall have any
obligation to pay any monies in respect to this work.

Signed_____

Position_____

Date_____

Figure 1.14
Sample copyright agreement form.

line, for example), the easier it is to prove ownership based on specific details within the work. Trying to sustain a court claim to a basic idea can be almost impossible.

If your script uses or adapts copyrighted material (such as a novel, magazine article, or short story), you must obtain a release from the owner of that original material (see Figure 1.14). This release should contain statements that verify the copyright holder's ownership of the material and warrant that the owner has the right to grant use of the material (that it has not been previously sold). Obtaining the right to use copyrighted material often can be quite expensive.

Material can be used without copyright release if it is old enough to be in the **public domain**. Assuming that a work is in the public domain or out of copyright can be dangerous. A work created before 1978 has an original copyright term of twenty-eight years, which can be extended (or renewed) for twenty-eight to forty-seven years. A work created after 1978 can be protected for the author's lifetime plus fifty years. Even if an author has been dead for a century, a particular edition, translation, or version of a work may still be under copyright protection. If you intend to use material in your screenplay that you suspect may be owned by someone else, you should undertake a full-fledged copyright search.

For a fee the Copyright Office at the Library of Congress can conduct a search for the current copyright holder.[17] A good library with access to the *Catalog of Copyright Entries* may be able to provide this information for you as well. To initiate a search you will need to know the title of the work, the name of the author (or authors), the type of work, and any other information you can gather concerning the original copyright date (or registration number), the date of publication, and the name or names of people who might own the copyright.

Notes

1. Quoted in Jason Squire, *The Movie Business Book* (Englewood Cliffs, NJ: Prentice-Hall, 1983), p. 52.
2. For a funny and insightful view of this problem, see William Goldman, *Adventures in the Screen Trade: A Personal View of Hollywood and Screenwriting* (New York: Warner Books, 1983).
3. See, for example, Richard A. Blum, *Television and Screen Writing* (Stoneham, MA: Focal Press, 1995); William Miller, *Screenwriting for Film and Television* (Boston: Allyn and Bacon, 1998); Linda Seeger and Edward Jay Whetmore, *From Script to Screen* (Stoneham, MA: Focal Press, 1994); Hillis R. Cole and Judith H. Haag, *The Complete Guide to Standard Script Formats* (North Hollywood, CA: CMC Publishing, 1993); and Syd Field, *Screenplay: The Foundations of Screenwriting* (New York: Dell, 1982). For a classic text on dramatic structure, see Lajos Egri, *The Art of Dramatic Writing* (New York: Simon & Schuster, 1946). For some excellent advice on how to write a screenplay, check out the Web site www.worldplayer.com. For a more extensive list of books on screenwriting, go to www.screenwriting.com.
4. We would like to express our deep appreciation to filmmaker/screenwriter Mark Chodzko, author Carol Carrick, and Phoenix Films for making this material available to us.
5. David Bordwell and Kristin Thompson, *Film Art: An Introduction* (New York: McGraw-Hill, 1993), pp. 65–68.
6. Field, pp. 7–13 and pp. 110–152.
7. Bordwell and Thompson, pp. 82–84 and pp. 471–474. See also Thomas Schatz, *Hollywood Genres* (New York: Random House, 1981), pp. 4–11 and Chapter 2, "Film Genres and the Genre Film."
8. One example of a traditional storyboard program for computers is a program called *Storyboard Quick* from Power Production Software in Hermosa Beach, CA (www.powerproduction.com). See also F. D. Miller, "IBM Storyboard Live!" *AV Video,* October 1991, pp. 62–69; and Lon Poole, "Mac TV Tools," *MacWorld,* September 1989, pp. 209–216.
9. See, for example, Edgar E. Willis and Camille D'Arienzo, *Writing Scripts for Television, Radio and Film* (New York: Holt, Rinehart & Winston, 1993); Alan Rosenthal, *Writing Docudrama* (Stoneham, MA: Focal Press, 1994); Dwight V. Swain and Joye R. Swain, *Scriptwriting for New AV Technologies* (Stoneham, MA: Focal Press, 1991); and Ray Di Zazzo, *Corporate Scriptwriting* (Stoneham, MA: Focal Press, 1992). For more books of this nature, refer to www.amazon.com.
10. This film is distributed by AIMS Media, 9710 De Soto Ave., Chatsworth, CA 91311-4409. It was written by Renne Leatto, directed by Dan Sandler, and produced by Sandler Films, Inc.
11. David Coller, "Lots of Mouses Will be Stirring," *Los Angeles Times,* 23 November 1995, p. F–1; and Charles Platt, "Interactive Entertainment: Who Writes It? Who Reads It? Who Needs It?" *Wired,* September 1995, pp. 145–150. Also, the computer program Storyvision is a utility for interactive scriptwriting that can be used to structure and branch links in an interactive script.
12. One of the better-known stand-alone scriptwriting programs is *Movie Magic Screenwriter* from Screenplay Systems, 150 East Olive Avenue, Burbank, CA 91502. Others include *Scriptware, The Script Thing, Final Draft,* and *Scriptwriter.* The latter is a stand-alone program that includes a storyboard creation function in addition to screenplay and split-column script formats. It can be purchased from MBC Images in Coopersville, Michigan.
13. Examples of this kind of software are *WritePro,* a writing tutorial to help develop character and conflict; *FirstAid for Writers,* a program that emphasizes

problems writers need to solve; *Plots Unlimited,* a program that helps generate plots, story ideas, and outlines; *Dramatica,* a story creation and analysis tool; and *Idea Fisher,* an idea-association tool. Other software is designed to help organize and/or outline script ideas in an index-card style. Two examples are *Three By Five* and *Writer's Blocks.*

14. The amount of scriptwriting and production-related software is so great that keeping up with it is nearly impossible. One way to maintain some currency might be to subscribe to the *Journal of the Writers Guild of America, West* (7000 West 3rd Street, Los Angeles, CA 90048). Another way to try to stay abreast of this ever-changing area is via the World Wide Web. The site www.screenwriters.com provides links to a wide variety of services including screenwriting chat rooms, legal issues, newsletters, and software. Other good sites are www.hollywoodnetwork.com and www.writerscomputerstore.com. Script City is an excellent source for purchasing scripts of current and classic films. The mail order address is 8033 Sunset Boulevard, Suite 1500, Hollywood, CA 90046. Script City also sells a wide range of screenwriting software and instructional software, books, and videotapes about screenwriting and screenplay marketing.

15. The address is Registrar of Copyrights, Library of Congress, Washington, DC 20559, or download forms from http://LCWeb.loc.gov/copyright/reg.html.

16. In the West, Writers Guild of America, West, 7000 West 3rd Street, Los Angeles, CA 90048. In the East, Writers Guild of America, East, 555 West 57th Street, New York, NY 10019. Or check out the Web site at www.wga.org.

17. The address is Reference and Bibliography Section, Copyright Office, Library of Congress, Washington, DC 20559.

chapter two
The Process of Preproduction

Preproduction is one of the most important stages of moviemaking. Unfortunately, students often overlook it. **Preproduction** is the least expensive part of the production chain; thorough planning during this stage will help to avoid unnecessary costs during the **production** and **postproduction** stages. Mistakes made at this "paper" stage can be more easily corrected than mistakes made during shooting.

Elements of preproduction are interdependent. The inability to find a certain type of location may necessitate changes in the script. The signing of a busy actor for a small part may necessitate changes in the shooting schedule. The amount of money that can be raised for the project can affect every element.

Students usually do not have to handle the financial reality that professionals encounter. Equipment is provided by the school, and the crew probably consists of class members who are not paid and who have to be there to receive class credit. Nevertheless, preproduction planning is as important for student productions as for professional productions. The lack of a prop can ruin a whole day's shooting, as can arriving at a local park and learning you can't shoot because you never asked for a permit. Even fellow students do not like to go on a location shoot where there is no time or place to eat.

Students who aspire to become professionals should learn the intricacies of preproduction. Most professional producers say they wish they had learned more about budgeting in school. Script breakdowns, shooting schedules, budgets, location scouting reports, set and costume designs, catering arrangements, releases, and insurance are all important to a production and should be taken care of before shooting begins. This is true not only for full-blown movies but also for music videos, commercials, corporate tapes, and other forms of productions.

Preproduction Planning

One reason that people (especially students) often skimp on preproduction is that it is boring. Much of it involves poring over paper, making sure that small details will not be forgotten. Although attending to such paperwork may not feel creative, it is what allows for creativity during production. If production necessities are not organized and available, proper shooting cannot occur.

The **producer** plays the major role in preproduction. At the height of the studio system (1930–1945), the producer was the chief financial officer—the person who controlled the budget, managed the writer and director, and organized the entire production. As the studio production system began to unravel in the 1960s, the role of the producer began to change. The modern independent producer is responsible not only for basic preproduction planning but also for developing the idea and, more important, for gathering the financing necessary to produce it. Unless the producer is adept at deal making, project packaging, and other financial negotiations, a movie project may die for lack of money. This means that an independent producer is usually deeply involved in scriptwriting, either by purchasing a script or by working closely with a writer to develop the kind of script that the producer can sell.

Independent producers also tend to work more closely with a director during preproduction than their studio predecessors did. Together, the producer and the director make decisions about the script, the cast, and the crew needed to create a specific motion picture. Not surprisingly, many producers (often called *hyphenate producers*) combine the roles of producer and director or of writer and producer. By controlling the money the independent producer can exert creative control at every level of the production, from scripting and casting to choosing the director, production crew, editor, and composer.

Script Breakdown

Once the script is finished (see Chapter 1), it must be broken down into various elements so that pre-

production and production can progress smoothly and efficiently. Usually, the producer hires a **unit production manager (UPM)**, sometimes also called a **production manager** or a **unit manager**[1] to handle this chore and other phrases of preproduction. The UPM reads through the script, marking the important elements of each scene, such as main characters, extras, props, set, costumes, and special effects. Not all scripts have the same elements. A movie set in the Old West may need livestock but no vehicles, while a 1930s gangster plot might have vehicles but no livestock.

Most unit production managers use computer programs to mark the script. For example, if a screenplay was written using Movie Master scriptwriting software, the UPM can import that script into Movie Magic's breakdown and scheduling software and use that to generate the breakdown. Obviously the computer programs cannot determine what actual materials will be needed. Unit production managers must go through scripts and choose the initial breakdown data. This is usually accomplished by using simple codes for each category. (Figure 2.1 presents an example of a computer-generated breakdown sheet and its codes.) Then they go through the script and, using mouse clicks, indicate what elements belong in which categories. Once these major elements are selected, the computer can generate separate lists, catch errors, and allow changes made in one area to be recorded throughout the script. For example, if a character's name is changed from Maribelle to Mary, the unit production manager can make the change in one place and it will automatically be changed everywhere else.

Students who do not have access to these programs can still break down the script the "old-fashioned way" by writing on a copy of the script. You can develop your own shorthand system for this. Some people circle characters needed for a scene, underline sets, put stars by special effects, and write a list of props in the margin. Others use different colored pens to highlight each category. (Figure 2.2 shows a page of a script marked by hand.)

Although many elements needed for a script breakdown (characters, set) are written in the script, many are not. For example, a scene may take place in a restaurant and mention that the main character is eating quiche. The script will not detail the dishes, utensils, and glasses that will be needed in the scene. The person breaking down the script must recognize these needs and make sure such props are listed.

The information from the breakdown is used to prepare **script breakdown sheets**. Again, these can be computer-generated or handwritten, as shown in Figure 2.3. Script breakdown sheets are among the most important organizational documents generated for production. They list all the pertinent elements needed at each location. Usually, all scenes at one location are shot at one time, even though some scenes may appear at the beginning of the movie and others may appear in the middle or at the end. In other words, the movie is shot out of sequence. Shooting in this manner saves setup and transportation time, both of which can be costly.

The script breakdown sheet is used to ensure that all people and items needed at a particular location will be available and in place. Most breakdown sheets contain the title of the production, the location, whether the scene is interior or exterior, the time of day the scene is supposed to take place, the scene numbers (taken from the script) to be shot at that location, the number of pages of script for each scene (the importance of this is discussed in the section on shooting schedules), and a brief synopsis of each scene.

Sometimes the actors needed are broken down into **principal actors** (the stars and supporting cast), **bit players** (people with only a few lines of dialogue), and **extras** (people needed for atmosphere but who don't have distinguishable lines). On the student level, one column for cast may suffice.

A separate category for props is almost always necessary. Special effects should be indicated if the film contains a large number of them (for example, scenes that are supposed to look like they were shot in the fog). Students often list the equipment and crew members on the breakdown sheet. This is less likely on a professional sheet because a different sheet detailing technical needs is drawn up for each location.

The breakdown sheets are used to generate various lists of what is needed for the production. For example, a list of sets could go to the set designer and/or location scout, a list of costumes

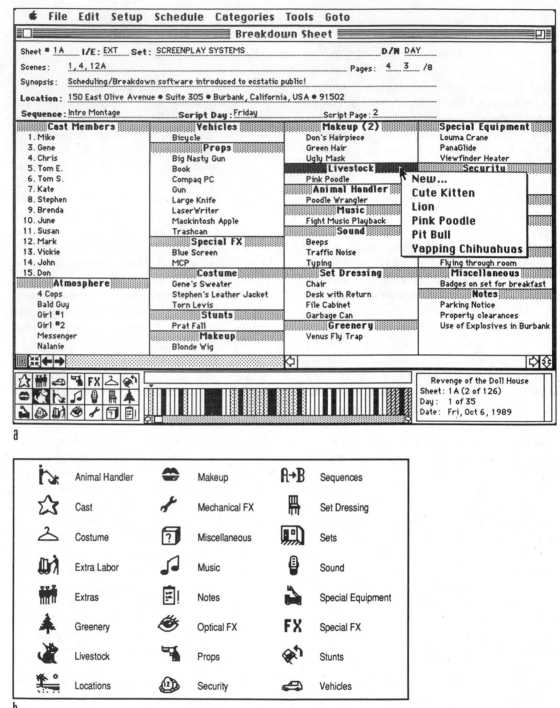

Figure 2.1
Screenplay Systems' Movie Magic Script Breakdown and Scheduling, *a program that uses handy icons to denote frequently used breakdown categories. (a) The icons at the bottom left of the breakdown sheet, and (b) the categories for the various icons. A mouse makes it easy to point and click on different elements needed for the breakdown sheet. (Courtesy of Screenplay Systems)*

(CONTINUED)

SCENE 12

EXT. BRIDWELL'S HOUSE - FRONT PORCH - NIGHT

props
Jack-o-
lanterns
Halloween
decorations
bowl of
candy
skeleton

The Bridwell's house is a big old one like Mrs. Oliver's.
It's lit eerily and there are big jack-o-lanterns on the
porch. The front door is ajar. Spooky organ music plays
within and a madman's laugh can be heard inside. The boys
know the Bridwells play the holidays to the hilt, but they
are still getting a little scared. When David and Scott go
up on the porch they hear a terrible cackle. It's MRS.
BRIDWELL dressed as an ugly witch.

(David as
cat)
(Scott as
tramp)

(Mrs. Bridwell
as witch with
green face)

 MRS. BRIDWELL
 Come in, sonny. Why don't any of you
 boys want my candy?

SFX
organ
music
mad
laugh
scream
thunder

The boys reach for some out of a big bowl when Mrs. Bridwell
lets out a shrieking laugh. The boys stand back afraid.
Then there is a horrible scream from behind them. The boys
whirl around wide-eyed, and a skeleton drops in front of
them. There is a sudden flash of lightning from an
approaching storm, and the boys scream in terror. They back
away from the skeleton, and Mrs. Bridwell's bony fingers
touch their shoulders. They whirl back around toward her.
Her green face is laughing at them. They shriek in terror
and run off the porch. Mrs. Bridwell watches them go,
laughing in her own voice now. She enjoyed that one.

FX
lightning

SCENE 13

EXT. STREET IN FRONT OF BRIDWELL'S HOUSE - NIGHT

Mary Ellen and Eric are coming down the walk toward them.
David and Scottie are desperately trying to regain their
composure. They don't want it to be known that they were
scared. Eric is dressed as a scientist, and Mary Ellen is
an Indian Scout.

(Mary Ellen
as Indian scout)
(Eric as scientist)
(David as cat)
(Scott as tramp)

 ERIC
 Who was screaming?

David and Scottie look at each other and shrug.

 DAVID
 I didn't hear any screams. Did you?

 (CONTINUED)

14.

Figure 2.2
A page from the Old
Mother Witch *script
handmarked for script
breakdown. Note the
marking system: char-
acters circled, locations
underlined, costumes in
parentheses, and props
and effects organized
into separate lists.*

Figure 2.3

A script breakdown sheet for scene 12 of Old Mother Witch.

SCRIPT BREAKDOWN SHEET

Title Old Mother Witch	**Prod. No.** 1
Director Mark Chodzko	**Page No.** 1
Location Bridwell's House	

Script Page Numbers 14

Day	**Night** X	**Season** Fall	**Period** Modern

Scene Numbers and Synopsis

12 - David and Scottie
go trick or treating
at Mrs. Bridwell's
house and are scared
by her elaborate
decorations and noises.

Cast and Costumes

David - cat costume
Scottie - tramp costume
Mrs. Bridwell - witch costume

Bits

None

Props

Jack-o-lanterns
Halloween decorations
Bowl of candy
Skeleton

Extras

None

Miscellaneous

Decide if sound effects will
be done during production or
post
Special lighting needed for
lightning

```
                    CAST LIST

        Character                    Scenes
David                   1, 2, 3, 4, 6, 8, 10, 11, 12, 13, 14,
                        15, 16, 17, 18, 19, 20, 21, 22, 23,
                        24, 25

Scottie                 1, 2, 3, 9, 10, 11, 12, 13, 14, 15, 16,
                        19

Eric                    1, 2, 3, 13, 14, 15, 16, 19

Mary Ellen              1, 2, 3, 13, 14, 15, 16, 19

Eddie                   1, 13, 14, 19, 23

Don                     1, 13, 14, 19

Frank                   1, 13, 14, 19

Mrs. Oliver             1, 3, 5, 7, 8, 17, 19, 24, 25

Dad                     2, 4, 18, 19, 24

Mom                     2, 4, 10, 18, 20, 21, 24

Mrs. Bridwell           12

Policeman               19, 20

Ambulance attendant     19
```

```
                    LOCATION LIST

        Location                     Scenes
Neighborhood street          1, 14

David's back yard            2, 4

David's front yard           3

Inside Mrs. Oliver's house   5, 7

Mrs. Oliver's front porch    6, 8, 17

David's front porch          9

David's living room          10, 18, 20, 24

Outside Mrs. Oliver's house  11, 19, 22, 23, 25

Mrs. Bridwell's front porch  12

Street by Bridwell's house   13

David's street               15, 16

David's bedroom
```

```
                    COSTUMES LIST

        Costume                          Scenes
Cat costume             10, 11, 12, 13, 14, 15, 16, 18, 18,
                        19

Tramp costume           10, 11, 12, 13, 14, 15, 16, 19

Witch costume           12

Scientist costume       13, 14, 15, 16, 19

Indian scout costume    13, 14, 15, 16, 19

Ambulance attendant outfit  19

Pajamas                 21
```

Figure 2.4
*Three different lists
generated from script
breakdown sheets.*

to the costume designer, the props list to the propmaster. A list of scenes in which each actor appears can be used for casting purposes. Figure 2.4 shows samples of three different lists generated from the breakdown sheets.

Computer breakdown programs are particularly valuable for keeping track of the huge number of elements needed for a two-hour professional movie. Student films are usually fairly short, so the value of these computer programs is less obvious. However, students who have access to these programs should learn to use them. Doing so will make you more competitive in the job market.

SHOOTING SCHEDULE

TITLE _Old Mother Witch_

DIRECTOR _Mark Chodzko_

Date	Time	Scene	No. of Pages	Description	Location	Cast	Props, etc.
10/6	3:00 p.m.	7	1/8	Mrs. Oliver hides behind curtain	Inside Mrs. Oliver's house	Mrs. Oliver	Curtain
10/6	4:00 p.m.	5	1	Mrs. Oliver's voice over to Vera	Inside Mrs. Oliver's house	Mrs. Oliver	Photographs Clock Writing paper and pen
10/6	7:00 p.m.	21	1-1/2	David and his mother talk about Mrs. Oliver	David's bedroom	David Mom	Pajamas
10/6	8:30 p.m.	12	1/2	Mrs. Bridwell scares the boys	Bridwell's house	Mrs. Bridwell David Scottie	Jack-o-lanterns Halloween decorations Bowl of candy Skeleton Cat costume Tramp costume Witch costume Special lighting for lightning

Figure 2.5
A sample shooting schedule.

Shooting Schedule

The breakdown serves another major function: developing **shooting schedules** (see Figure 2.5). These specify what is to be accomplished each day of production.

Because all scenes at a particular location are usually shot together, the script breakdown sheet for each location is used to devise the shooting schedule. However, location is not always the main factor determining schedule. The availability of a particular actor or place can be a determinant. If an actor needed in three different locations is available for only two days of the shooting schedule, all other cast and crew might be moved to three locations in two days to accommodate the actor's schedule. Or, if a department store can be used for location only on Wednesday night when inventory is in prog-

ress, the cast and crew might shoot in the park Wednesday afternoon, move to the department store for Wednesday night, and go back to the park on Thursday.

Likewise, scheduling might be determined by an expensive piece of equipment. If a helicopter must be rented to shoot two scenes, these (and only these) will be shot in one day, even though they are in different locations.

Generally, however, shooting schedules are set up according to location. Outdoor shoots are often scheduled before indoor shoots because indoor shoots often require sets that can be built while outdoor shooting is underway. Also, if the weather does not cooperate, the schedule can be rearranged to handle indoor shoots. If all the indoor scenes had already been shot, the only option would be to cancel until the weather cleared.

One of the most difficult aspects of formulating a shooting schedule is determining how much time each scene will take. This must take into account many factors, the most significant of which is the length of the scene. A scene that runs three pages will usually take longer to shoot than one that is half a page. This is why the number of pages for each scene should be listed on the script breakdown sheet. Unit production managers can develop a formula for calculating shooting time for movies that consist primarily of talk (for example, eight pages a day). If this is possible, developing the shooting schedule is fairly easy.

However, many productions contain scenes or circumstances that do not fit into an all-purpose formula. A scene with complicated special effects or stunts can take much longer to shoot than one with straightforward dialogue. Scenes with exotic lighting, large crowds, or elaborate camera movement also take longer than average. Often, scenes shot at the beginning of the production process, when everyone is becoming accustomed to one another, take longer than those shot later, after the crew has developed a working rapport. This is especially true of student productions in which crew members are learning a great deal at the beginning.

In determining the number of pages that can be shot in a day, the UPM must also consider the director's style. Some directors spend a great deal of time on setup so that everything will be perfect for shooting; others retake scenes from many different angles; still others pride themselves on setting up and shooting quickly.

Nevertheless, unit production managers become quite adept at estimating how long each scene will take. Accurate estimates are important for budgeting and for the preparations that must be made for the entire production. Shooting schedules are often modified during production, but they provide the blueprint for how the production can be shot most efficiently.

Some people organizing shooting schedules like to include everything on the script breakdown sheet. But this usually makes for unwieldy schedules. A better schedule is one that includes date and time, scene numbers, location, a brief description, and one or two of the more crucial elements, such as props or cast members needed.

Of course, with computer programs all elements can be stored in the computer and the essential ones printed out as needed.

Stripboards

Many productions use computer-based **stripboards** (see Figure 2.6) rather than printed shooting schedules. These vertical strips list the locations and characters needed for each scene. They are helpful because an entire production can be laid out across the computer screen and changed easily. If, for example, you discover you can't shoot at the airport on Tuesday afternoon as planned, you can remove the Tuesday afternoon strip, place it at some other time, and juggle other strips to readjust the schedule.

The computer program can also be used to print out strips that can be mounted on an old-fashioned stripboard. Some programs bar code the strips so that if they are changed on the board, a light pen attached to the computer can read the changes and resort the electronic data quickly.[2]

In the days before computers UPMs, handmade cardboard strips that they mounted on boards in such a way that the strips could be moved easily. Students who don't have access to stripboard software can easily handmake a stripboard.

Production Schedule

Another important form, the **production schedule** (see Figure 2.7), delineates the length of time allotted for the entire production cycle—preproduction, production, and post-production. Again, the amount of time needed for each phase varies with the complexity of the movie and the amount of time and money available. In student moviemaking preproduction, production, and postproduction time must be allocated to meet the due date specified by the professor. Television projects must be completed by their contracted air dates. Films made to be shown in theaters often need to be finished for certain release times—Christmas or at the beginning of summer when audiences are likely to be biggest. Corporate videos need to be finished to accommodate the schedule of the client.

Figure 2.6

A computer-generated stripboard using the Movie Magic Script Breakdown and Scheduling software. (Courtesy of Screenplay Systems)

🍎 File Edit Setup Schedule Categories Tools Goto

Stripboard

Character	No.	1 Kitchen	124 Kitchen	2 Kitchen	End Of Day 1 – Fri, Oct 6, 1989	19 Screenplay Systems 1,4,12A	End Of Day 2 – Mon, Oct 9, 1989	34 Downtown Burbank	11 Downtown Burbank	End Of Day 3 – Tue, Oct 10, 1989	5 Street	99 Street	103 Street	9 Convention Center	End Of Day 4 – Wed, Oct 11, 1989	8 Office	12 Apartment
Sheet Number:		1	124	2	3 4/8	19	4 3/8	34	11	2 4/8	5	99	103	9	2 5/8	8	12
Page Count:		1 1/8	3/8	2		4 3/8		2	4/8		7/8	1 2/8	3/8	1/8		3/8	4/8
Int/Ext:		INT	INT	INT		EXT		EXT	EXT		EXT	EXT	EXT	INT		EXT	INT
Day/Nite:		DAY	DAY	DAY		DAY		DAY	DAY		DAY	NIGHT	DAY	DAY		DAY	DAY
Mike	1					1		1	1		1	1					
Sera	2															2	
Gene	3					3						3					
Chris	Tom E. 4 5			5		4/5					4	4	4/5	4			
Tom S.	Kate 6 7			7		6/7						6					
Stephen	Brenda 8 9	8		8		8/9		9	9		9			8			
June	Susan 10 11	11		11		10											
Mark	Vickie 12 13		13	12								13					
John	Don 14 15		14/15			14/15							14				
Sam	Lisa 16 17		16/17														
Verne	Pat 18 19												19				

EXT – Downtown Burbank – DAY

Revenge of the Doll House
Sheet: 11 (8 of 127)
Day: 3 of 36
Date: Tue, Oct 10, 1989

The three elements of moviemaking may overlap. Some elements of preproduction, such as set construction, may be in the final stages when production begins. With **nonlinear** editing systems, some scenes can be edited while others are still being shot. These overlaps should be delineated on the production schedule. For this reason, one of the forms commonly used for this schedule is a time line.

A major flaw of student productions is not allowing enough time for postproduction. More often than not this is because production runs longer than anticipated. And the main reason production runs long is that preproduction planning was not thorough enough. At the end of the semester students wind up fighting each other for access to the editing equipment during the wee hours of the morning. The wise student, who thinks everything through thoroughly during the preproduction stage, can finish early and avoid this fray.

The Budget

Within the professional world the budget is the governing force of all movies. Estimations of what the picture will cost must be accurate. Directors who complete a picture on budget or under budget are valued. Those who habitually run over budget are likely to find themselves in unemployment lines.

Financing. The financial arrangements for pictures vary greatly, in part because the business is so risky. For one thing, the money for preproduction, production, postproduction, and distribution must be spent before anyone knows whether the movie will be profitable. Although some movies make huge profits, others never recover their costs. As a result, conventional money-lending organizations such as banks rarely fund individual movies. Rather, the money comes from individual investors and from deals that can be made for advances from distributors, cable and broadcast networks, foreign systems, and companies wishing to sell ancillary products such as T-shirts or toys based on some character in the picture.

Sometimes money can be raised on the merits of an idea or a best-selling book, especially if a few well-known stars are guaranteed. But more

WEEK	1	2	3	4	5	6	7	8	9	10	11	12	13	14	15

Preproduction

Find locations
Design sets
Build sets
Obtain props
Design costumes
Sew costumes
Ready equipment
Buy videotape

Production

David's house exteriors
Mrs. Oliver's house exteriors
Street locations
Mrs. Bridwell's house
Mrs. Oliver's house interiors
David's house interiors

Postproduction

Edit picture and dialogue
Spot effects and music
Compose music
Record effects
Record music
Do sound mix
Do layback
Dub

Figure 2.7
A sample production schedule.

often the money is raised after the script is completed. Even with a completed script in hand, the budget can change. For example, three scenes of the script may take place in Kenya. If the script is budgeted so that the scenes are actually shot in Kenya, a lot of money will be needed to transport cast and crew to Africa. If the total amount needed for the film cannot be raised, the Kenya scenes might be rewritten so that they can use stock footage of Kenya and other shots, such as close-ups, that do not need the specific location.

If preproduction is progressing on the assumption that a wealthy person is ready to contribute the last $200,000 needed for the production and that investor backs out, breakdowns, shooting schedules, and production schedules will change.

Budgeting Procedures. Although the size of the budget can affect the script, the usual procedure is for the budget to be derived from the script. This means someone must go through the script carefully, figuring the cost of all the elements. Script breakdown sheets and shooting schedules are extremely important in this process. Computer programs are also helpful, especially spreadsheets that can calculate how much the overall budget will change under varying circumstances.[3]

Budgets for movies are broken down into **above-the-line** and **below-the-line** expenses. Above-the-line expenses are those related to a specific film and are creative in nature. They include the costs of writing and acquiring the script, the costs associated with the producer and director, and the salaries and fringe benefits for the actors. Below-the-line costs are those that could be associated with any picture and are more likely to be in the crafts area. They include the pay for crew and the money needed for equipment, tape or film stock, sets, props, costumes, makeup, transportation, food, sound effects, music, and editing.

The organization of a budget can vary from movie to movie. Sometimes all the costs associated with one function, such as lighting, are lumped together, including the salaries of the people who plug in the lights, the cost of renting the lights, and the electricity bill. Similarly, costs for sound, sets, and wardrobe would be together. For other budgets, categories such as crew salaries, utilities, transportation, and insurance serve as the organizing thread. The organization is not nearly as important as the accuracy with which the budget is figured.

Figure 2.8

*A budget front sheet (a)
presents an overview of
the entire budget. Each
budget category can be
broken down into
greater detail; (b) shows
some of the typical cost
categories associated
with the producer and
staff; (c) shows the same
for props.*

```
                          BUDGET

      Title_____

      Date Prepared_____

      Account
      Number        Description              Total
       01      Story and Writers         |
       02      Producer and Staff        |
       03      Director and Staff        |
       04      Cast                      |
                       Total Above-the-Line  |
      ████████████████████████████████████████████

       12      Camera                    |
       13      Sound                     |
       14      Script Supervision        |
       17      Electrical                |
       20      Set Construction          |
       21      Set Dressing              |
       22      Props                     |
       23      Wardrobe                  |
       24      Makeup and Hair           |
       30      Special Effects           |
       40      Transportation            |
       41      Location Expenses         |
       45      Stock Footage             |
       50      Licenses                  |
       51      Insurance                 |
       52      Legal Fees                |
       60      Editing                   |
       61      Postproduction Sound      |
       62      Graphics                  |
       63      Music                     |
       70      Dubbing                   |
       75      Publicity                 |
                       Total Below-the-Line  |
      ████████████████████████████████████████████

                  Total Above- and Below-Line  |
                               Overhead  |
                            Contingency  |
                            GRAND TOTALS  |
```

a

Budgets for complicated productions usually contain a front sheet that summarizes the various costs (see Figure 2.8a). Behind it are more detailed breakdowns for each specific area (see Figure 2.8b and c).

The single factor that can have the greatest effect on a budget is the cost of the above-the-line people, particularly the actors and the director. In Figure 2.8a the above-the-line costs—for writer, producer, director, and cast—consist primarily of salaries and fringe benefits. The latter is always a significant expense that cannot be overlooked if indeed people are going to receive medical benefits, retirement contributions, and

BUDGET SPECIFICS

Title_____

Date Prepared_____

Budget Category_____Producer and Staff_____

Account Number____02_____

Account Number	Description	Days, Hours, or Quantity	Rate	Total
02.10	Producer			
02.12	Production Manager			
02.15	Secretary			
02.20	Fringe Benefits			
02.25	Telephone			
02.26	Postage			
02.27	Copy Costs			
02.30	Entertainment			

_____Grand Total

b

BUDGET SPECIFICS

Title_____

Date Prepared_____

Budget Category_____Props_____

Account Number____22_____

Account Number	Description	Days, Hours, or Quantity	Rate	Total
22.10	Propmaster			
22,12	Assistant Propmaster			
22.20	Fringe Benefits			
22 25	Prop Purchase			
22.26	Prop Rental			
22.30	Insurance			
22.32	Pickup and Return			

_____Grand Total

c

Figure 2.8
(Continued)

other fringe benefits. Some production companies hire nonunion freelancers for each picture and do not pay fringe benefits.

The below-the-line part of this budget is usually organized primarily by function—sound, set construction, wardrobe, and so forth. Insurance, legal fees, and licenses are easy to overlook but can add up to substantial numbers.[4]

Overhead includes such items as rent and utilities and is generally figured as a percentage of other costs—usually about 15 percent of the total budget. Movie budgets should usually set aside about 20 percent for contingencies. This not only will take care of overlooked items but also will be needed when the production inevitably falls behind schedule. During the production phase regular reports are made to indicate how much of the budget has been spent.

Budgeting a Student Production. Budgeting for a student movie is quite different from budgeting for a professional movie. Student producers or directors can be less concerned about money. Their classmates work for free, the school may provide equipment and stock, the dorm or campus can be used for locations, and the props can be borrowed from someone's home.

Student productions can accumulate costs if they are period pieces that require costumes, if the director decides to rent special equipment such as a dolly in order to capture certain shots, or if professional actors are hired. Under these circumstances the producer may want to draw up an actual budget and keep track of the expenses.

Even if a production costs very little, students should calculate what it would cost if it were being produced by a professional company that had to rent equipment. This is good practice for future jobs, and it can show how much the college is contributing to the production budget.

Costs vary greatly from one part of the country to another, from one equipment rental house to another, from one postproduction facility to another, and from one circumstance to another, so students should check out current prices in their area. However, for budgeting practice, students can use the following average costs from a large metropolitan area.[5] Obviously no production needs all the equipment

listed, and some directors may feel the need for other equipment such as a monitor or intercom system.

Production Costs

(Production equipment is usually rented out for a minimum of one day, so all costs listed are daily figures.)

	Per day
16mm-film camera	$200
35mm-film camera	$400
Consumer-grade camcorder (such as S-VHS or Hi-8)	$100
Professional-grade camcorder (such as Betacam or DVCPRO)	$375
Camera tripod and head	$55
Camera dolly	$100
Light kit with 4 lights	$60
Microphone and fishpole	$30
Wireless lav mic	$50
Portable audio mixer	$45
Nagra recorder	$125
DAT recorder	$100

Postproduction Costs

(Postproduction facilities are usually rented out by the hour, so all costs listed below are per hour.)

	Per hour
Transfer from film to video	$150
Tape logging or viewing	$25
Cuts-only linear editing	$45
Linear editing with switcher effects	$65
Nonlinear editing	$80
Pre-session digitizing for nonlinear editing	$60
Titles and graphics	$55
Video special effects	$80
Audio recording and/or editing	$55
Digital audio sweetening or enhancement	$80
Dubbing	$25

At most universities, students need to buy their own tape or film. Costs for this vary greatly depending on the format used, but many types of tape are available at electronic discount stores, so you can check the prices fairly easily.

Costs for cast and crew are negotiable if the production is shot with a nonunion crew.

Unionized cast and crew must be paid wages that at least meet union minimums. Of course, people who are well known or successful can demand much more than the minimum rate. Union contracts are complicated, but some general minimum figures that should be helpful in developing budgets follow.

Writers are paid about $35,000 for a feature-length screenplay with a treatment and $22,000 for a screenplay without a treatment. They are paid $4,000 for a TV program of less than 15 minutes; $8,000 for 30 minutes; $15,000 for 60 minutes; and $21,000 for 90 minutes.

Directors' minimums are rather complicated, often pegged to the type and length of the work and sometimes including a guarantee of a certain number of weeks of work. Some minimums are based on days, others on weeks, and still others on total projects. For a very short project, such as a music video, a director's minimum would be about $1,200 a day. A director's fee for a low-budget movie or a 30-minute TV show would be approximately $6,000 a week. Movies with a higher budget would allocate a minimum of $9,000 a week for a director, and a director's fee for a 2-hour TV pilot could run $68,000 for the project.

Producers usually earn about the same or a little more than directors. Feature performers' minimums are $500 per day, and extras should work for about $10 an hour. The minimum hourly fee for a director of photography is about $64 per hour, camera operator $40, sound mixer $33, boom operator $30, script supervisor $21, art director $45, carpenter $24, propmaster $25, costume designer $26, seamstress $23, makeup artist $21, graphic artist $35, picture editor $43, and sound editor $35. The pay for other crew positions is comparable, at about $25 to $30 an hour.[6]

Given all this, the actual budget for a simple ten-minute student production that is set in modern times, uses only two principal actors, utilizes a digital camera and nonlinear editing, rents middle-of-the-road TV equipment, and employs cast and crew willing to work for minimum rates might look something like the one shown in Figure 2.9. In actual practice the college or university bears the costs of the equipment for a student production, and there are no personnel costs above the line or below the line.

Therefore, out-of-pocket costs can be as low as several hundred dollars.

Budgeting usually does not seem important to students because so little actual money is involved. But the professional world places a high value on the ability to read a script, estimate quickly how much it will cost to produce, and determine how to cut costs without cutting content or creativity. For this reason students should take advantage of every opportunity they have to learn how to budget a movie.

Daily Call Sheets

Daily **call sheets** are posted during production to let people know when and where they should report each day (see Figure 2.10). Formal sheets often are not needed for student productions because much of the shooting occurs during one set time, such as a weekend.

However, call sheets are helpful for student productions that require multiple shoots and certainly are necessary for professional shoots. Simple call sheets list all the members of the cast needed for the day and the times they should report for various functions, such as makeup and appearance on the set. More complicated call sheets also specify when caterers are to have meals prepared, when drivers will be needed to move equipment, and when special vehicles or effects must be available. They may also include special instructions for makeup, costumes, or props.

Although call sheets are used during production, they can be at least partially prepared during preproduction. Changes in the shooting schedule can necessitate changes in call sheets, but if the basics have been compiled ahead of time, these alterations can be made fairly quickly, especially if computer programs are used.

Although script breakdown sheets, shooting schedules, stripboards, production schedules, budgets, and call sheets are the primary forms prepared during preproduction, other forms can be generated if needed. For example, work orders list the equipment and supplies needed for each day, and worksheets detail the special working conditions to which the production must adhere because of certain provisions in a star's contract. Most colleges have checkout forms that students must fill out ahead of time to reserve equipment.[7]

Figure 2.9

A sample budget for a ten-minute student movie.

```
             SAMPLE STUDENT BUDGET FOR A 10-MINUTE SHOW

     Above-the-line
          Story and Writers                          $4000
          Producer and Staff                          5000
          Director and Staff                          5000
             (5 days at $1000 a day)
          Cast                                         2400
             2 Principals (2 days each at $400 a
                day) --$1600
             5 Extras (16 hours each at $10 an
                hour) --$800

                            Total Above-the-Line    $16,400

     Below-the-Line
          Camera                                       2070
             Director of photography (16 hours at
                $45 per hour) --$720
             Camera operator (16 hours at $25 per
                hour) --$400
             *Camera rental (2 days at $375 per day)
                --$750
             *Tripod and head rental (2 days at $55
                per day) --$110
             *Light kit rental (1 day at $60 per day)
                --$60
             Videotape (1 reel at $30 each) --$30
          Sound                                        1070
             Mixer (16 hours at $30 per hour) --
                $480
             Boom operator (16 hours at $20 per
                hour) --$320
             *Microphone and fish pole rental (2 days
                at $30 per day) --$60
             *DAT recorder rental (2 days at $100 per
                day) --$200
             Audiotape (1 reel at $10 each) --$10
          Script Supervision                            320
             Script supervisor (16 hours at $20 per
                hour) --$320
          Electrical                                      0
          Set Construction                                0
          Set Dressing                                   30
          Props                                          20
          Wardrobe                                        0
          Makeup and Hair                               10
          Special Effects                                 0
          Transportation (gas money)                    30
          Location Expenses (2 meals)                   75
          Stock Footage                                   0
          Licenses                                       20
          Insurance                                       0
          Legal Fees                                      0

                               1
```

```
Editing                                           1770
    Picture editor (14 hours at $30 per
       hour) --$420
    *Tape logging (8 hours at $25 per hour)
       --$200
    *Nonlinear editing (14 hours at $80 per
       hour) --$1120
    Tape (1 reel at $30 each) --$30
Postproduction Sound                               180
    Sound editor (2 hours at $25 per hour) --
       $50
    *Audio recording and editing (2 hours at
       $55 per hour) --$110
    Tape (2 reels at $10 per reel) --$20
Graphics                                            75
    Graphics operator (1 hour at $20 per
       hour) --$20
    *Titles and graphics (1 hour at $55 per
       hour) --$55
Music                                               50
Dubbing                                              0
Publicity                                            0

                   Total Below-the-Line      $5,720

        Total Above-and Below-Line          $22,120
              *Overhead at 15%               $3,318
            Contingency at 20%               $4,424

                     GRAND TOTALS           $29,862
```

*The costs usually borne by the college or university.

Figure 2.9
(Continued)

Preproduction Responsibilities

Preproduction involves much more than creating schedules. In fact, the schedules are used extensively to accomplish all the chores needed before actual production begins. These chores include hiring behind-the-scenes personnel, casting, finding locations, obtaining permits, designing and building sets, sewing costumes, buying props and other supplies, arranging transportation and catering, obtaining stock footage and music, buying insurance, and checking the equipment.

Hiring Behind-the-Scenes Personnel

By the time a script is approved, several people are usually already involved in the production. The producer, for example, has probably been trying to sell the script. A director may have been hired, and several actors may have been signed in order to sell the script.

If the producer is the only person involved in selling the initial concept, he or she will hire a **director** quickly so that plans for preproduction and production can proceed with the director's participation. The director's primary responsibility is to interpret the script (and to guide the writer in reworking parts that are weak). During preproduction the director will read and reread the script, deciding how best to match the particular character and tone of the screenplay with the appropriate actors, locations, sets, and costumes. This requires the ability to visualize and the ability to communicate that vision to others.

For complicated productions the producer or director will also hire a unit production manager or **assistant director**[8] to handle the details of preproduction. In simpler movies, such as student productions, the same person often serves as producer, unit production manager, and director.

The director usually makes the hiring decisions, although the producer may participate. In the early stages of preproduction the director may hire a **production designer** or **art director**[9] to develop the overall look of the film, a **set designer**

Figure 2.10
A sample daily call sheet

CALL SHEET

Title Old Mother Witch Date October 16

Director Mark Chodzko Production No. 1

Location 1526 Main Street and 1723 Main Street

SET	SCENES	CAST	PAGES
Inside Mrs. Oliver's house	7	Mrs. Oliver	1/8
Inside Mrs. Oliver's house	5	Mrs. Oliver	1
David's bedroom	21	David Mom	1-1/2
Mrs. Bridwell's front porch	12	Mrs. Bridwell David Scottie	1/2

CAST	PART OF	MAKEUP	SET
Grace Ridgley	Mrs. Oliver	2:00	3:00
Tommy Mays	David	6:00	7:00
Cynthia Thomas	Mom	6:00	7:00
Loreen Washington	Mrs. Bridwell	7:00	8:30
Steve McLean	Scottie	7:30	8:30

ATMOSPHERE AND STAND-INS	REPORT TIME
None	

CREW	REPORT TIME
Camera operator	2:00
Boom operator	2:00
Audio/video operator	2:00
Makeup person	2:00
Wardrobe person	6:00
Script supervisor	2:00
Electrician	1:30
Grips	1:30
Prop person	2:00
Caterers	5:00

to begin planning sets, and a **costume designer** to plan wardrobe. When these people have their concepts fairly well in mind, they begin hiring others—carpenters, painters, seamstresses, and so on—to execute the work. Directors also make early hires of people in the areas of special effects or animation because this type of work is time consuming.

Some directors like to hire the **director of photography** (also called the **cinematographer**) early in the preproduction stage so that he or she can help decide colors and other aspects of the overall look.

As the preproduction process proceeds, people will be hired to handle properties, set decoration, makeup, and hairstyling. They will begin making plans and buying supplies for their respective areas and will eventually hire assistants who will work during the production phase. Shortly before production begins, members of the production crew—camera operators, audio operators, a script supervisor—will be hired. For complicated productions the number and types of people hired can seem almost infinite—handlers for animals, teachers for child actors, truck drivers, and so on. For smaller productions a few generalists called **production assistants** can be hired to handle various miscellaneous jobs.

Because of their scaled-down nature, student productions usually do not require extensive crews. However, although people are not actually hired, students' abilities must be matched with the jobs that need to be accomplished.

Casting

Choosing people to act in a narrative movie is important because it is the actors who convey the story. In fact, **casting** is one of the director's most crucial decisions. Casting errors inevitably hurt the final product. Behind-the-scenes people who cannot handle their jobs can be replaced in the middle of a production, albeit with some disruption, but people in front of the camera are essentially irreplaceable.

Some directors feel that casting is 90 percent of directing. As a result, they often write rather elaborate descriptions of the personality traits of the main characters and discuss these traits with the auditioning actors to determine who will fit the role most effectively.

Stilted, unnatural performers detract greatly from a story and sometimes even make dramatic moments inappropriately humorous. Student productions are especially vulnerable to poor acting, some of which cannot be helped because of budget and scheduling limitations. However, in both student and professional movies every effort should be made to cast people who fit the parts and can be counted on to perform well.

In the professional realm casting companies are often hired to screen actors. These companies have close contact with agents and can gather quickly any category needed—pudgy men in their fifties, red-headed teenagers, Abraham Lincoln look-alikes. The UPM supplies the casting company with character breakdowns (prepared from the script breakdown), and the company then sends out a call to agents for actors to fill the various roles. Often these companies will winnow candidates down to four or five for each major role. The director then makes the final selections.

Other directors like to be more involved in casting, to the point of finding their own actors. They watch movies and television shows to check out people who might fit into the movie. They attend community theaters for the same reason. Sometimes they place ads for **open casting** in trade journals. This means anyone can try out for parts. The main difficulty with this is that so many people show up that selection becomes quite time consuming. Open casting often works well for student films, however. An ad in the school newspaper can draw talented people to fill the parts.

Generally, casting involves a short interview with the actors to determine if they appear to be right for the part. Then they read some of the lines with other actors who are trying out or with people who have already been selected for the other parts. Often these short acting scenes are videotaped so they can be reviewed. These videotaped scenes can serve as a **screen test**—a demonstration of how the person will look and sound on video or film. The major roles are cast first, then other people are cast to fit in with the stars.

Student movies usually do not have the luxury or financing to engage in elaborate casting procedures, but every effort should be made to find the best person available for each role. Using your friends and relatives is an accepted but not particularly advisable practice. Generally, directing someone you do not deal with

regularly is easier than directing someone you are close to.

One casting problem that student productions often have to a greater degree than professional productions is reliability—making sure that all people cast will be reliable throughout the entire production period. If cast members are not paid, they may have little incentive to stay with the project as it becomes more difficult and time consuming. The person who is doing casting for a student production should be honest with actors about the amount of time and commitment the production will require. Using people in the production class as actors is the best way to ensure reliability, but often they do not fit the roles or they are more interested in behind-the-scenes jobs.

Preproduction also involves working out contracts for the people cast. Lawyers, agents, and personal managers are usually involved in this for well-known stars. The contract stipulates the salary, the working conditions, the placement of credits, the size of the dressing room, and anything else that needs to be negotiated.

Student producers are wise to have actors sign releases, such as that shown in Figure 2.11, so that they do not come back at a later time, demanding pay or some other type of recognition.

Finding Locations

One of the primary functions of the script breakdown sheet is to detail the various locations needed for shooting. Once these are determined, someone must find or build the appropriate locale. Scouting for the proper location is another province of the director.

There are professional companies that will find locations, and many cities and states that want to encourage filmmaking have offices with photographs of various sites.

The assistant director, unit production manager, or art director often does the initial scouting. But most directors want to see where they will be shooting so that they can anticipate problems and see whether the location fits their conception of the movie. Locations are important to the overall look of a picture. A chase scene can take place just about anywhere, but a director who wants to give scenes a closed-in feeling will want to look for a certain combination of streets and buildings that can be shot at the appropriate angles. Of course, budget must be considered. The ideal street might be in Rome, but cast and crew cannot be transported there economically. A street in Burbank will have to do.

The director (and often the production designer and director of photography) should carefully survey the locales selected to ensure that shooting will go smoothly. The director should note the name of the person in charge of the facility as well as the name of someone to turn to if unexpected problems arise. If the shoot is outdoors or if natural light is going to be used indoors, the director should look at the facility at the same time of day as when the shooting is planned. In this way problems can be noted that might be caused by shadows or the position of the sun. Polaroid pictures with compass directions marked on them are helpful.

Many other important factors must be considered. Where should vehicles be parked? Where can cameras, lights, and mics be placed? How much power is available? Can cables be strung safely? Are there likely to be any interruptions such as a ringing phone? Will any noises such as air conditioning interfere with the audio? Do any large items (telephone poles, billboards) block the camera's view? The best way to cover all the important points while investigating a location is to develop and follow a location survey form such as that shown in Figure 2.12.

Someone must obtain permission, preferably in writing, for shooting at any location. (See Figure 2.13 for a sample location release.) This is true for student productions as well as for professional ones. Releases should be obtained for use of people's homes, stores, or other commercial buildings.

Many cities require movie producers to pay for permits in order to shoot in the city. The money is used to help defray any extra costs the city may incur for directing traffic around the production area or adding security. If permits are required, they should be obtained during preproduction so that production is not delayed.[10]

Designing and Building Sets

Determining what sets to build is closely associated with location scouting. Theoretically, any

PERFORMANCE RELEASE

In consideration of my appearing in the movie

 (title or subject)
and for no subsequent remuneration, I do hereby on behalf of
myself, my heirs, executors, and administrators authorize

 (producer or production company)
to use live or recorded on tape, film, or otherwise my name,
voice, likeness, and performance for television or film
distribution throughout the world and for audiovisual and general
education purposes in perpetuity.

 I further agree on behalf of myself and others as above
stated that my name, likeness, and biography may be used for
promotion purposes and other uses. Further, I agree to
indemnify, defend, and hold the producer (or production company)
harmless for any and all claims, suits, or liabilities arising
from my appearance and the use of any of my materials, name,
likeness, or biography.

Conditions:

Signature_____

Printed Name_____

Street Address_____

City and Zip Code_____

Phone Number_____

Date_____

Figure 2.11
_An example of a perfor-
mance release form._

Figure 2.12

*An example of a form
that covers some of the
primary points to con-
sider when surveying a
location.*

LOCATION SURVEY CHECKLIST

Type of material being shot_____

Time of shooting_____

Potential location of shooting_____

 Principal contact person_____

 Address_____

 Phone number_____

Camera:

 Where can the camera be placed?
 What, if anything, is needed in the way of camera mounting devices or platforms?
 What, if anything, is needed in the way of special lenses?
 Will any objects interfere with the camera shots? If so, how can this situation be corrected?

Lighting:

 What types of lights will be needed?
 Where can the lights be placed?
 What light stands or particular light holders will be needed?
 What, if any, special lighting accessories will be needed?
 How can any problems regarding mixing indoor and outdoor lighting be solved?
 In what ways will the sun's position at different times of day affect the shooting?
 What kinds of problems are shadows likely to cause?

Power:

 Is enough power available or will a generator be needed?
 Where is the circuit breaker box?
 Who can be contacted if a circuit blows?
 Which circuits can be used and how many watts can be run on them?
 How many, if any, extension cords will be needed?
 What power outlets can be used?

Sound:

 Are there background noises that may interfere with audio? If so, how can they be corrected?
 Where can the microphones and cable be placed?
 Are any particular microphone holders or stands needed?
 What types of microphones should be used?
 How much microphone cable will be needed?

General:

 Where is parking available?
 Where is the nearest telephone?
 If passes are needed to enter the premises, how can they be obtained?

LOCATION RELEASE

I hereby grant_____

permission to use the property located at_____

for the purpose of photographing and recording scenes for the

movie entitled_____.

This permission includes, but is not limited to, the right to

bring cast, crew, equipment, props, and temporary sets onto the

premises. I understand that all things brought onto the premises

will be removed at the end of the production period.

Conditions:

Signature_____

Printed Name_____

Title_____

Street Address_____

City and Zip Code_____

Phone Number_____

Date_____

Figure 2.13

A sample permission form for shooting at a location.

movie can be shot totally on location or totally in the studio. During the 1920s, for example, the Germans used the massive studios of UFA (Universum Film A.G.) for all scenes in their films—even those that depicted masses of people in city streets or forests (complete with concrete trees). By doing that they were able to control the lighting, the tonalities that would show on the black-and-white film, the shape of all the architectural structures, and the relationship of all other elements of art design.

Control is a primary reason for building a set and shooting in a studio. You do not need to worry about the position of the sun. You can shoot long shots at 9 a.m. and close-ups at 4 p.m. without worrying that when you intercut them they won't match. You can place trees where you want them and not where they happen to be growing. You do not need to worry about airplanes flying overhead and ruining the audio of your Civil War picture. You don't have to hurry to finish a shot because classes will be changing and a horde of unwanted students will appear in the background.

A studio set can also be more convenient if you can leave the set up and plan to shoot in the same place for a number of days. Under these circumstances you can leave everything in place and do not need to set up and break down every day as you might at a remote location.

Another reason for building a set is that you cannot find what you want in the "real world." A "Star Trek" control room does not actually exist anywhere, so you need to build it.

Cost can be another consideration. For student productions sets are usually more expensive than locations because the material for the sets must be purchased, whereas the locations are usually local and free. On professional features this may not be the case, mainly because the wages of crew and cast are such a large percentage of the budget. The extra time needed on location and the costs that may be associated with transportation and lodging can greatly exceed the cost of a set in a studio.

Sometimes a scene requires a combination of location and set. For example, a TV studio control room might serve as the basis for a futuristic space control lab but be augmented by peripheral flats that show additional complicated instruments.

Someone—usually the director, producer, production designer, and/or unit production manager—must decide which scenes need sets and which need locations. These decisions are usually made tentatively after the script is broken down. The director may look at city photos for available Victorian dining rooms while the art director is planning and determining costs for what it would take to build one. What to do would be decided after they have both completed their research.

Once the decision to build a set has been made, the set designer draws up the plans, keeping in mind the overall feel of the picture decided on by the director and art director and the lighting and shooting requirements that the cinematographer might impose. (See Figure 2.14 for a drawing and photo of a set design.) Computer programs can help with set designing. For example, one program allows a set designer to "build" a set with computer graphics. Then the set designer, director, and others can "walk through" the computerized drawing as though they were looking through a camera. Aspect ratios or lens focal length can be changed with the click of a mouse.[11]

Once the director approves the set design, it can be built. Construction must be started well in advance of the shooting date because building a set can be a long, multistep process. Flats must be built before they can be painted, must be painted before pictures can be hung on them, and must be erected before major pieces of furniture can be placed in front of them. The sturdiness of the set must be considered. A door that is not used can be rather flimsily built, but one that is going to have characters using it must be sturdy and well braced so that it looks real.

Set decorations must also be considered as part of the set design. These are items that add atmosphere, such as flowerpots, ashtrays, pillows, and lamps.

A set can be expensive if everything is bought new. Students rarely need to do this; they can raid the dorm (with permission!) or their own bedrooms. Even professionals usually deal with secondhand or rental stores or find flats and set pieces among those stored at the studio.

Digital technologies are beginning to provide an alternative to traditional set building. In-

a

b

Figure 2.14

Emmy Award–winning production designer Jan Scott did the set drawing (a) for the motion picture Grandview, U.S.A. *The photo (b) shows the set as it was actually constructed. (Courtesy of Jan Scott, production designer)*

creasingly, computers are being used to create the sets, themselves, so that they do not need to be constructed. These "virtual sets" are basically a computer-generated graphic that is placed behind the actors, who, while they are performing, do not have an actual set surrounding them. Computerized sets, or parts of them, can be reused in different films. Elements of a set can be modified and reshaped. New elements can be added, cut, and repositioned. Perspective can be changed and objects can be resized. In a period piece, for example, contemporary buildings intruding on what is basically a 1920s street setting can be erased and replaced with more appropriate buildings that are either generated in the computer or copied from another scene or film. It is possible for the digital skyline and sets designed for *Batman Forever* to be reused in commercials, television shows, and other movies. By the time these sets are digitally repainted, reshaped, repositioned, and composited with other elements in the new film, we will probably not recognize them as Gotham City.

However, whether the set is made of pixels or plywood, a great deal of time, thought, skill, and hard work goes into it. The whole process must be considered carefully because the set can be the major element in creating the atmosphere for the scene.[12]

Planning Costumes, Wardrobe, Makeup, and Hairstyling

The extent to which costumes, wardrobe, makeup, and hairstyling need to be considered during the preproduction phase depends on the nature and scope of the picture.

Many student directors give little thought to these elements. Actors wear their own clothes and handle their own hairstyling and makeup,

if any. The main consideration is making sure actors wear the same clothes and makeup in all scenes that supposedly occur close to each other in time. Actors should also keep the same general hairstyle. One student actor decided to shave his beard about three fourths of the way through a production. Shooting had to be halted for two weeks while he grew his beard back. If a student production is set in a different era, period costumes will be necessary; special makeup will be needed if some characters have an unusual look or are much older than the actors actually portraying them.

Professional productions pay more attention to these elements. Even if a movie is set in modern times, the wardrobe of the stars is usually specially designed so that it flatters the stars and fits the overall mood of the picture. Period pieces require a large staff of people fitting and sewing costumes for many months before production begins. People involved with period hairstyling also can be busy during these weeks, researching the styles of the period and buying and styling wigs. Unusual makeup, such as a hand with six fingers or a burned face, must be considered in advance so that all the necessary supplies are available.

For movies that do not require anything unusual, makeup artists and hairstylists do most of their work during production. They are there to enhance the actors and to make sure face and hair look the same from one day to the next if that is what the shooting schedule requires.[13]

Preparing Props, Effects, and Supplies

A list of essential props can be culled from the script breakdown, but someone, such as the UPM, must make sure all are obtained and fit the director's overall vision of the movie. The person buying or borrowing props can often look for set decorations as well.

Props are usually thought of as items required by the plot (for example, the flowers the hero gives to the heroine to win her heart). **Set decorations** add to the overall feel of the scene but are not integral to the plot (for example, the vase of flowers sitting on the coffee table). The line between the two often becomes blurred. If a scene is shot in a garden in September, but the plot is set in May, someone may need to buy artificial spring flowers.

Special effects can fall into a number of areas: a blood packet that explodes in the mouth of someone who has been socked in the jaw could be considered makeup, a sleeve that rips off could be part of a costume, a chair that breaks in half could be designed into the set, mashed potatoes made to look like ice cream might be considered a prop, and a fog machine might fall in the province of the cinematographer.

It is important that someone makes sure all items needed for special effects are ordered and in place for production. Of course, special effects can also be created on film or tape and then intermingled with the live footage. This work is usually done in a studio and involves the use of models. It must be carefully coordinated with the live shots so that all elements look alike. For example, tiny models of the main characters must wear the same color clothes as the people in the live action scene.

Most supplies that will be needed during production should be purchased during preproduction. This includes all supplies for makeup, hairstyling, special effects, and other elements, as well as such items as masking tape, cleansers, sponges, and a first aid kit. Most important, someone must make sure that the raw stock (tape or film) is purchased or obtained.

Acquiring and Checking Equipment

All equipment should be purchased, rented, or obtained in some other way during the preproduction period. It should then be carefully checked out to make sure it will work properly. Before equipment is taken to a location, it should be connected and operated somewhere close to a maintenance facility so that any problems can be corrected.

Batteries should be checked to make sure they are fully charged. Lenses should be examined for scratches or focus imperfections. Tripods should be lubricated, if necessary, so that they operate smoothly. Lights should focus properly; extra lamps and extension cables should be readily available. The viewfinder should be checked for picture accuracy by framing something with it and making sure the framing is the same when the image is recorded.

Camera tests should be run to make sure calibration is correct. Microphones should be tested for proper pickup. The headsets should work. Connectors and cables should be carefully checked both visually and in operation because they are likely to cause trouble.

All in all, a great deal needs to be done before shooting occurs. The individuals involved in the project must be diligent about accomplishing the chores of preproduction so that production and postproduction have a chance of moving smoothly.

Obtaining Rights

Some movies contain elements that involve rights clearance. For example, if the plot calls for a radio to play or one of the characters to sing "I Want to Hold Your Hand," rights to that Beatles song must be cleared. Clearing music is not easy. The first step is to find out what company published the music and ask that publisher for a synchronization license, which usually costs money. The publisher may also require that you receive permission from the performer, the record company, and/or the composer. Gaining all these permissions can be time consuming.[14]

It is easier to use copyright-cleared music from one of the many stock libraries that exist solely for this purpose. The music is not distinctive, but it often can fill the need.[15] Using music that is so old that it is in the public domain is another solution. Music can also be specially written for the scene, but this often costs more than obtaining the rights. Students can sometimes obtain original music economically by talking to friends in the music department who are eager to experiment with music for movies.

Film or tape footage is another item that often needs clearance. One example would be a news story that is an integral part of the plot. You cannot simply tape Dan Rather off the air and include that in a production. Permission must be sought from CBS. Sometimes, rather than shooting at a location, a movie will incorporate a few shots that establish the location; for example, shots of an airplane taking off will establish the location as an airport. Many movies contain shots of airplanes taking off that could be used, but rights again must be cleared. A number of companies supply copyright-cleared stock footage, including news clips. They charge for the footage, but using them is usually cheaper and more convenient than trying to clear rights.[16]

Photographs, artwork, pictures from books, and sometimes even sound effects must also be cleared through the appropriate contact(s)—publisher, artist, author, photographer, museum, or record company. (Figure 2.15 shows a sample letter requesting permission to use a copyrighted work.) Usually, finding the address of the appropriate contact requires some research. Books such as *Writer's Market* and *Literary Market Place* can assist you in this search. Other books such as *Blu-Book* and *Motion Picture, TV, and Theatre Directory* can lead you to music libraries, stock footage houses, and other sources of copyright-cleared material.[17]

Arranging Transportation, Lodging, and Meals

Someone must attend to the creature comforts for members of the cast and crew. For any shoot that will last more than four or five hours, someone should locate in advance the nearest restaurant and restrooms. At a more complex level are arrangements for air travel, ground transportation, overnight accommodations, and meals in some exotic country. If the travel is to be extensive, perhaps to several different countries, the unit production manager can enlist a travel agent to make the arrangements. However, the plans cannot be handled like a simple tourist travel plan. Such a shoot often involves shipping an extensive amount of expensive equipment, and stars may require extra security. If the movie falls behind schedule during production, many of the transportation arrangements made during preproduction may need to be changed.

Usually, someone goes to the location ahead of time to check on whether equipment can be rented and to try to line up some crew members and extras. This will cut down on transportation costs. This person can also check out local hotels, restaurants, and catering services so that cast and crew can be adequately cared for within the limits of the budget.

If the film is shot locally, lodging is not a problem because everyone can go home at night.

Figure 2.15

A sample letter asking for permission to use a copyrighted work.

```
Date

Name
Licensing Department
Music Publishing Company
Street Address
City, State, and Zip Code

Dear Person's Name:

I am producing a movie entitled Name of Movie for which I would
like to have one of the characters sing the song  "Name of Song"
composed by Name of Composer.  I would like to acquire a non-
exclusive synchronization license for this musical composition.

I would like permission to use this material for broadcast,
cablecast, or other means of exhibition throughout the world as
often as deemed appropriate for this movie and for any future
revisions of this movie.  Your permission granting me the right
to use this material in no way restricts your use for any other
purposes.

For your convenience, a release form is provided below and a copy
of this letter is attached for your files.

Sincerely yours,

Your Name

I (We) grant permission for the use requested in this letter.

Signature_____

Printed Name_____

Title_____

Phone Number_____

Date_____
```

But transportation for people and equipment still is a consideration. A student producer must make sure enough cars are available to transport everyone and everything to the location site. Maps and phone numbers for the location should be provided for everyone.

For shoots that last all day, at least one meal should be provided. One way to handle this is through caterers. In cities that host a great deal of video and film production, companies specialize in catering to casts and crews at location sites. The UPM hires the catering company and makes sure it is kept up-to-date on when and where the cast and crew will be for lunch. Catering has definite advantages, especially if the shooting is occurring at a remote location. People can get back to work

more quickly if the food comes to them than if they have to drive a long distance to a restaurant.

A variation on catering often used by students is sending one of the crew members to the nearest fast-food place to buy lunch for everyone and bring it back to the location.

On the professional level many union regulations govern meal breaks. The production company must follow them strictly or face fines and legal grievances. Requirements vary according to the particular working arrangements for cast and crew, but generally no one can work for more than five hours without at least a thirty-minute meal break. Some contracts stipulate the quality of the food that must be provided—a soft drink and a bag of potato chips won't do. Students are not encumbered with union regulations, but a student producer should still make sure people have time to eat. An empty stomach makes for a grouchy disposition.

Obtaining Insurance

Moviemaking is subject to a great deal of risk. During the preproduction phase the producer or unit production manager should make sure that adequate insurance is purchased to cover any mishaps.

One risk is that the movie will not be completed because the money runs out. To cover this Hollywood has developed a special type of insurance, called a **completion guarantee.** Of course, like any insurance, a completion guarantee costs the production company money in terms of a premium, usually a percentage of the estimated cost of the picture. The company that provides the money for the completion guarantee usually states that if its money is needed to finish the movie, it can take over the production, which usually means firing the director and hiring someone who can finish the job economically.[18]

Liability insurance is a must, especially if the picture is to be shot on location. This insurance covers damage to people's homes or other sites used as locations, as well as harm to people. Someone on the production crew should be assigned to take before and after pictures of a location in case a damage claim is filed by the owner of the location.

Insurance is also needed to cover theft or breakage of equipment, props, set pieces, and the like. This insurance is often quite expensive or else it doesn't cover much. The producer and unit production manager must decide on the breadth and depth of the insurance coverage in relation to its cost.

Vehicle insurance is a must for all cars and trucks that will be moving equipment or people during a production. Many other specialized forms of insurance exist—for example, a particular star or a particular prop can be insured. Insurance can even be taken out against inclement weather, but these special insurance plans are expensive and usually not worth the cost. Nothing is fail-safe.

Notes

1. The titles and duties of the unit production manager role vary from production to production. *Production manager* was, historically, a term used in film production and *unit manager* was a television term. Now that the two are merging, the term *unit production manager* is generally used. To complicate the situation further, the unit production manager often shares duties with the first assistant director. Because the unit production manager usually reports to the producer and the first assistant director reports to the director, their roles are often related to the relationship (and power equation) between the producer and director. Within this chapter, we will assume that the producer is taking the lead role in preproduction and, therefore, will assign most duties to the unit production manager.

2. Preproduction software includes *Movie Magic Breakdown* and *Movie Magic Scheduling,* programs that interface with *Movie Magic Budgeting* and *Movie Magic Screenwriter. Movie Magic* is available from Screenplay Systems, 150 East Olive Ave., Burbank, CA 91502. Quantum Films has budgeting and scheduling software called *Turbo AD,* which has other programs integrated with it: *Script Scan* allows breakdowns to be done within an imported script; *Turbo Report* manages crew and cast lists; *Turbo Budget* and *Cost Tracking* help in budget preparation and analysis and track expenses during the production. These programs are available from Quantum Films Software Division, 8230 Beverly Blvd., Suite 17, Los Angeles, CA 90048. Birns and Sawyer, the equipment rental house, sells many of these software

packages. It is located at 1026 N. Highland Ave., Hollywood, CA 90038. Another company that sells a variety of film/television preproduction software is The Writer's Computer Store at www.hollywoodnetwork.com/writerscomputer.

3. Such programs include *Movie Magic Budgeting* and *Turbo Budget,* both noted above. Programs such as these can usually be linked to libraries containing current union labor rates, overtime, and fringe benefits, such as *Movie Magic Labor Rates.*

4. Sometimes insurance, legal fees, and licenses are considered to be above-the-line rather than below-the-line costs.

5. These rates are based on a number of rate cards, including those of Alan Gordon Enterprises, Ametron, Aries Post, Birns and Sawyer, Four Media Company, and Raleigh Studios—all based in Hollywood and Burbank.

6. These figures were taken from *Paymaster 95-96* (Los Angeles: Entertainment Partners, 1995).

7. For a variety of forms, see Richard Gates, *Production Management for Film and Video* (Stoneham, MA: Focal Press, 1995); Eve Light Honthaner, *The Complete Film Production Handbook* (Los Angeles: Lone Eagle, 1992); Bastian Cleve, *Film Production Management* (Stoneham, MA: Focal Press, 1994); Steve R. Entwright, *Pre-Production Planning for Video, Film, and Multimedia* (Stoneham, MA: Focal Press, 1996); and *Producer's Masterguide* (New York: Producer's Masterguide, 1995).

8. Generally in television production the term used is *associate director,* while in film production the term used is *assistant director.*

9. *Production designer* is a term popularized by the elaborate science fiction films of the 1970s, such as *Star Wars,* that needed a great deal of design coordination. During the studio era an art director developed the overall look of a film, but now that task is often given to a production designer, who then oversees one or more art directors. As a result, many people who used to be art directors have become production designers, a term that has more stature than art director. Some current movies have a production designer and no art director, some have both, and some still have only art directors.

10. See Rober Maier, *Location Scouting and Management Handbook* (Stoneham, MA: Focal Press, 1994).

11. "Making Virtue of Necessity," *Daily Variety,* 26 May 1992, p. 3

12. For more on set design, see Peter Utz, "The Joy of Sets," *AV Video,* May 1995, pp. 90–93; and "Building Virtual Sets for HDTV," *TV Technology,* 15 June 1998, p. 10.

13. For more on costumes, makeup, and hairstyling, see Virginia J-R Kehoe, *The Technique of the Professional Make-Up Artist* (Stoneham, MA: Focal Press, 1995); Janet Literland et al., *Broadway Costumes on a Budget* (Colorado Springs, CO: Meriwether, 1996); Margit Rudiger and Renate Von Samson, *388 Great Hairstyles* (New York: Sterling Publishing, 1998); and Penny Delamar, *The Complete Make-Up Artist: Working in Film, Television, and Theatre* (Evanston, IL: Northwestern University Press, 1995).

14. For more information on copyrights, see John D. Zelezny, *Communications Law* (Belmont, CA: Wadsworth, 1993), pp. 287–323.

15. A list of music libraries can be found in "Production Music Libraries" *Mix,* August 1998, p. 78.

16. A list of stock footage providers can be found in "UnCommon Stock," *AV Video,* March 1995, pp. 159–172. Some companies put out CD-ROMs that index their offering.

17. *Writer's Market* is published by Writer's Digest, 9933 Alliance Rd., Cincinnati, OH 45343. *Literary Marketplace* is published by R. R. Bowker Co., 121 Chanlon Rd., New Providence, NJ 07974. *Blu-Book* is published by The Hollywood Reporter, 5505 Wilshire Boulevard, Los Angeles, CA 90036. *Motion Picture, TV, and Theatre Directory* is published by Motion Picture Enterprises Publications, Inc., Tarrytown, NY 10591.

18. "The Gap: Closed for Business," *Hollywood Reporter,* 29 June 1998, pp. S-1–S-4.

part two
Production

chapter three
The Process of Production

T he production stage of moviemaking involves a large number of people and complicated logistics. In fact, it has been said that in order to create art, a poet needs a paper and a pencil, an artist needs a canvas and paint, a photographer needs a camera and film, and a moviemaker needs a bank and an army.[1]

Production is the most exciting, high-profile part of the movie business. The various elements needed to make the movie—people, equipment, sets, supplies—come together during production. The individuals involved interact in many ways and usually build personal bonds. Production is also the most expensive and most potentially explosive phase of moviemaking—the one during which Murphy's law (*Anything that can go wrong will go wrong*) is likely to be in full swing.

Production Responsibilities

The major tasks connected with the production stage of moviemaking involve directing, acting, organizing and record keeping, lighting and camera operation, sound and picture recording, and supporting the production. The details of these functions and the people who undertake them vary greatly from one situation to another.

For example, a production with a union crew differs from a production with a nonunion crew. In a union situation the people needed and the specific duties each will perform are often spelled out in the union regulations and cannot be controlled by an individual director. An electricians' union can specify that only its members can handle lights. Someone trying to be helpful by moving a light can cause a grievance to be filed. Union regulations help define the tasks that need to be accomplished and keep people from being exploited, however. In a

nonunion situation the assignment of specific tasks is more flexible. Duties can be assigned according to people's particular talents and the needs of the particular movie. However, movies produced with nonunion crews usually have lower budgets, and people can be called on to work long (sometimes unreasonable) hours for scant remuneration.

Student films present yet another variation. Many of the same tasks need to be performed for student films, but students are in a learning situation. As a result, individual students often undertake a variety of tasks in order to gain experience. In some instances they cannot effectively perform the particular jobs they are assigned, but the school environment is for experimentation and learning individual strengths and weaknesses. Sometimes the final product suffers in the name of learning, but students who work hard and produce an acceptable movie can experience the same excitement professionals do.

The nature of the movie also determines what needs to be done and who should do it. Shooting a documentary in a desert for *National Geographic* is quite different from shooting a narrative movie such as *As Good As It Gets*. The documentary crew would be smaller, with people doubling up on jobs.

The merging of film and video techniques has further complicated the delineation of what needs to be done and who should do it. Technologically, film and video require different tasks. Someone must load film into a separate container called a **magazine** for a film shoot, but this job does not exist for a video shoot.

The tasks to be performed during the production are in a constant state of evolution. No hard and fast rules can be made for every movie about what should be done and by whom. We will therefore discuss, in rather broad terms, the various functions that need to be undertaken and describe some of the variations that exist within professional and student productions.

Directing

The tasks to be performed in relation to directing are multifaceted and to some extent defy

definition. They involve developing the overall vision and keeping it alive throughout the production process, getting the strongest performance possible from the actors, making sure that the movie is shot correctly, both technically and aesthetically, and maintaining morale so that people work well toward a common goal.

For the most part these tasks are handled by the **director,** who is the "boss" during production. Directors are part artist, part technician, part psychiatrist, and part judge. They establish the overall creative tone of the motion picture that others follow as they light, frame shots, act, set up props, and attend to the other details of the movie. Directors have the final say regarding all aspects of the picture, so they must be well versed in both the technical and aesthetic principles of moviemaking. They provide the controlling vision that translates the story into images and sound. Before shooting, most directors will have decided what kinds of shots they think they will need and how these shots might be edited in postproduction. Some directors will even develop a complete storyboard or shot list to help them visualize how each shot will fit into the whole.

Directors must also be able to deal well with people. They give specific instructions to actors, in terms of both the emotional content of the script and the physical needs of the shooting environment. They may, for example, tell an actor to be more low-key or to change the expression on his or her face. Actors have more confidence in directors' advice if they sense the directors have done the homework needed in terms of analyzing the characters they are to portray and understanding the actors' methods by having observed some of the actors' past performances.

One of the most important functions of directors is **blocking.** This involves placing the actors in particular spots and telling them where and when to move. Blocking is crucial in terms of making sure the camera can frame the action appropriately. It also must be comfortable for the actors. If the leading lady must contort her body to glance at the leading man, the result may not only be uncomfortable but ludicrous. Some directors make sketches of the action (see Figure 3.1) to help them envision the moves the actors will make.

Directors also deal with the crew. They must be able to communicate their desires effectively so that the various crew members do not waste time setting something up incorrectly.

For some types of productions directors must deal with outsiders. When a commercial is being produced, executives from the ad agency or the advertising company may appear on the set. The client for a corporate video may do likewise. Directors must handle these people (and their ideas) with tact but still maintain control of the creative process. Directors should never allow one of these people to give instructions to cast or crew members.

The atmosphere on a movie set can be emotionally charged. Egos abound, and cast and crew members have their own creative ideas about how the movie should be shot. Directors must be able to handle the conflicts that arise, compromising as needed, cajoling as appropriate, but remaining firmly in control. Directors can certainly take advice from others, but they must be able to reject ideas (preferably in a diplomatic manner) if they will not enhance the final product.

At the beginning of any production there usually is a honeymoon period when everyone is enthusiastic and willing to get along well with everyone else. However, as the work grinds on and perhaps falls a bit behind schedule, people's nerves tend to fray, and morale begins to drop. Directors must solve the interpersonal problems (even though they may be the cause of some of them) and keep the production process on track.

There are as many different styles of directing as there are directors. Some act like generals; others act like buddies. Some interact with all cast and crew members; others interact with only a few and expect them to interact with the rest. Some block all talent and camera angles on paper ahead of time; others improvise on the set. Some rehearse for long periods before shooting; others shoot the first rehearsal. Some give actors specific instructions about how to play a character; others prefer that the actor make character determinations.

Figure 3.1

This blocking sketch is typical of what a director might draw in preparation for a scene that involves four people sitting at a restaurant table, one of whom gets up and leaves. The angles with numbers by them are camera setups. For example, camera setup 2 is a pan shot of the girl as she gets up from the table and goes to the door.

Directors sometimes have one or more **assistant directors** to help them with directorial chores. Exactly which aspects of directing these assistant directors undertake depends on what the director wants them to do.[2]

In some instances assistant directors oversee the lighting of one scene while the director is rehearsing another scene—or vice versa. An assistant director may also direct a **second unit**, a group of production people who are in a separate location, shooting scenes that do not require the principal actors. Some assistant directors are asked to handle all extras so that the director can concentrate on directing the principal actors. Assistant directors often keep people quiet on the set or handle crowd control if the shooting is taking place in a public area. Or the director may ask an assistant director to handle the problems associated with some particularly cantankerous cast or crew member. In general, assistant directors should be flexible and prepared for the unexpected.[3]

Acting

Principal actors (those who have the main speaking parts) usually come to the production

situation trained in their art. They have studied the character and have ideas about how the person should be played. They work with the director and other actors to develop their character. Some people are, of course, much better actors than others. Truly fine actors can leave their real selves behind and "become" the people they are portraying.[4] Although many people aspire to be actors, few can actually do it well.

Acting in a movie is difficult because scenes are shot out of order. Actors have no time to build up to a particular emotion, as they do during a stage play where everything happens in sequence. For example, movie actors may have to react to the death of a loved one days before the recording of the scene in which the loved one dies. They must be able to switch their emotions off and on at the convenience of the schedule. A good director will review with the actors the emotional level of scenes before and after the one being shot. If some of these scenes have already been shot, actors can ask to watch them on videotape so that they can better recall their actions.

Lines are shot out of order even within a single scene. When actors' close-ups are shot, they often deliver their lines out of context. Sometimes the characters they are supposed to be talking to are not even on the set. They must profess mad, passionate love—to a camera.

Bit players and **extras** are also involved in the acting process. Bit players have only a few lines—usually five or fewer. Extras have no speaking lines; mainly they stand in the background and move as they are told. Bit players and extras should remain fairly inconspicuous and not distract attention from the principal actors.

Stand-ins are also part of the acting process. These are people who play the parts of principal actors so that the equipment can be properly set. They stand and move as the actor should so that the crew can adjust lights and plan camera angles. This relieves the actors from tedious and rather unproductive work so that they can memorize lines or prepare emotionally for the upcoming shoot.

Sometimes the actors in movies, particularly student movies, are not professionals. They are friends or relatives of the director or other crew

members, or they are people who were recruited through an ad in a newspaper. Getting a good performance from these people may be difficult. For one thing, they are likely to be unreliable, especially if they are not being paid. If the male lead drops out in the middle of a shoot, all his scenes have to be reshot. The director should somehow determine the commitment level of all nonprofessional actors and, if possible, find some way to pay them.

People who have not been trained in acting are often self-conscious and feel awkward doing something they would never consider doing in real life. The best solution to this problem is to cast people who are, in temperament and style, similar to the characters they are to portray.

People who have been trained to act on the stage can usually overcome self-consciousness, but they do not necessarily make good movie actors. They are so used to projecting their voices and using broad gestures—much needed when the audience is yards away—that they cannot give the intimate type of performance needed for most movies.

Organizing and Record Keeping

Movie production is so complicated that someone must keep records of all details. Scenes shot on Friday have to be shot in such a way that they can be intercut with scenes shot on Tuesday. A shot missed the first week of taping has to be rescheduled for the third week. Someone must log and tally spending so that the production does not run over budget. Almost everyone involved in the production process has some paperwork to do, but the main organizing and record-keeping chores fall to the producer, script supervisor, unit production manager, and assistant director.

Although they are the chief executives of the picture, many movie producers spend little time on the set. Others, especially those on small independent productions, make their presence felt and oversee the director fairly closely. Generally, however, the production phase is the domain of the director. When producers do come on the set, they are usually there to see that money is not being wasted and the movie will be finished on time. Some producers appoint **line produc-**

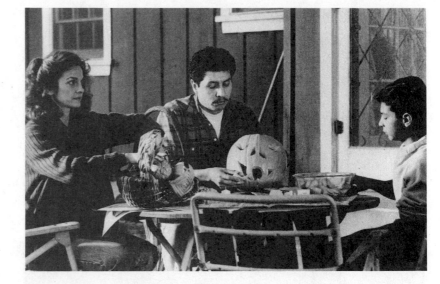

Figure 3.2
Continuity would be an important element in the pumpkin-cutting scene from Old Mother Witch. *Someone should carefully keep track of how much of the pumpkin is cut in each shot, how items are arranged on the table, and where each person's hands are during each shot. (Photo courtesy of Phoenix Films, Mark Chodzko, and Carol Carrick)*

ers to represent them on the set. These people handle organizational details, try to speed up shooting, and keep an eye on the money. Sometimes **executive producers** oversee a number of TV series or movies. Again, they are not active on the set, but they help solve problems and make sure the production is under control.

Script supervisors (sometimes referred to as **script clerks**)[5] deal primarily with continuity. During rehearsals they take Polaroid and/or camcorder shots or make diagrams detailing where the camera, lights, and actors are placed so that everything can be duplicated during the shoot. They also keep continuity notes on such things as where props were located, whether doors were ajar, unusual filters that were used on the camera, where actors' hands were when they were saying certain words, the direction people walked, the amount of food on a plate, and the color of someone's tie (see Figure 3.2).

Script supervisors usually stay close to the director so that they can communicate all the information needed. They also make sure that the director actually shoots all the lines of script dialogue at least once. Script supervisors are extremely important to directors because, if they do their job well, they eliminate the need to bring an entire cast and crew back for a reshoot because shots did not match during editing. Many directors feel that the script supervisor is

Figure 3.3
Script supervisors are important throughout the world. Here a Chinese script supervisor is jotting down notes for a period piece movie being shot outside Xi'an, China.

the most valuable person in the crew; without a competent supervisor the production will flounder (see Figure 3.3).

Script supervisors also prepare an **editor's script.** On this script they note any changes, such as dialogue rewording, that were made during production. They also mark all takes on the script so that the editor will know how much of the scene each take covers. On the page opposite each page of script they list all the shots and give pertinent information about each (see Figure 3.4).

Unit production managers (UPMs)[6] are responsible for seeing that all the elements needed for a particular day's shooting (people, equipment, sets, permits, props, makeup) are available and functioning. Their job begins early in preproduction (see Chapter 2) and continues through production. Their duties are primarily logistical. For example, unit production managers make sure that the smoke machine ordered for day 4 is actually delivered. Or, if the production falls behind schedule, they reschedule the smoke machine for day 5. They constantly check and alter the lists made during preproduction and communicate production needs to the appropriate people. Sometimes UPMs keep ledgers detailing what they spend each day. They also prepare the **daily production report** (see Figure 3.5), a form that goes to the producer listing what has been accomplished each day. It details such points as the number of scenes shot, the number of pages of the script covered, the minutes of footage shot, the time taken for setups, the people who worked and how much time they worked, and the amount of time taken for meals. The form also summarizes what has been accomplished to date and states whether the production is on schedule.

In addition to helping with creative directing functions assistant directors often undertake organizational and record-keeping duties. For example, an assistant director is often the one who prepares and posts the daily **call sheets** (see Figure 2.10), which tell all cast and crew members when they should report to work. (Refer to Chapter 2 for more information on call sheets.)

Assistant directors sometimes keep **logs.** These list all the shots that were taken in the order that they appear on the tape. They give the tape reel number, the location on the tape, a description of the shot, and comments about the shot (see Figure 3.6). The editor uses log sheets to locate shots. If the sound for a movie is shot on one recorder and the picture is shot on another, the assistant director will keep two separate log sheets, one for picture and one for sound. As with many other aspects of moviemaking, generating the log is often made easier

CONTINUED:

① ⑴A ⑴B ⑴C ⑴E ⑴F ⑴G ⑴H

EDDIE
Hey "gang." How's it going?

DAVID
It was going O.K.

Don squints at David. He is not real bright.

DON
What do you mean "was," Martinez?

Everyone just ignores Don as Frank sits snickering.

EDDIE
So, Dave ol' buddy, going out trick or
treating tonight?

DAVID
Maybe.

SCOTTIE
Is this your new car Frank?

FRANK
Yeah. And you just wait until I get
some paint on it. It's gonna look all
right.

SCOTTIE
(deadpans)
Yeah, it's a real pile of beauty.

Frank glares at Scottie as Mrs. Oliver starts to look on.

FRANK
You and that mouth of yours ought to go
on a diet, lard face!

EDDIE
You better keep your head on a swivel
tonight, "Tubs." You never know where
we're going to be.

⑴D

Don snickers like a true follower.

⑴I

(CONTINUED)

Handwritten vertical labels: Master shot · OS to Eddie · Ms Mrs Oliver · CU Eddie · OS to Don · CU Don · OS to David · OS to Scottie · OS to Frank · Two shot- Eddie and Frank

a

Figure 3.4

(a) A page of script and (b) the corresponding notes made by the script supervisor. Note that the script supervisor has listed a few minor dialogue changes and has drawn lines that show how much of the script each shot covered. The sheet of notes lists each shot and all its takes, how long the shot was, whether the shot was completed in its entirety (C for complete) or stopped midway (I for imcomplete), uses NG for takes that are definitely no good, and includes other pertinent comments.

by a computer program. A notebook computer used on the set can be connected to the VCR so that time code numbers automatically transfer to the log.[7]

Assistant directors are not always the people who keep log sheets. In a nonunion shoot the person operating the camera, VCR, or audiotape recorder sometimes handles this chore.

Figure 3.4
(Continued)

1		Master shot				10/11	
1	:44	C	NG	Hair blend with sky			
2	:33	C	NG	camera jerked			
3	:35	C	good				
1A		OS to Eddie				10/11	
1	:20	I	NG	Don moves in front of lens			
2	:36	C	good				
1B		CU Eddie				10/11	
1	:33	C	looks too close to camera				
2	:35	C	OK				
3	:34	C	best				
1C		OS to Don				10/11	
1	:37	C	sun in and out of clouds				
2	:10	I	Don said "Marcus"				
3	:34	C	OK				

1D		CU Don				10/11
1	:15	C	good			
1E		OS to David				10/11
1	:10	I	NG	boom shadow		
2	:33	C				
1F		OS to Scottie				10/11
1	:33	C	good			
1G		OS to Frank				10/11
1	:10	I	NG	car noise		
2	:35	C				
1H		2-shot Eddie + Frank				10/11
1	:26	I	NG	Frank laughed		
2	:27	I	NG	Frank laughed again		
3	:33	C	good			
1I		MS Mrs Oliver				10/11
1	:15	C				

b

The specific jobs that particular crew members undertake are fairly well delineated if the movie is shot under union contracts. However, in a nonunion or student shoot various people might handle different organizational and record-keeping tasks. On one production the director may do the call sheets, a script supervisor will prepare continuity notes and an editor's script, the videotape operator will keep the log, and no one will do a daily production report. For another production the assistant director may prepare the call sheets, the camera opera-

DAILY PRODUCTION REPORT

Title Old Mother Witch Date October 16

Director Mark Chodzko Production No. 1

Script Supervisor Susan Stribling Day 18 of 25

First Call 1:30 p.m. First Shot 3:07 p.m. Meal 5:15 p.m. for some of
 cast. 6:00 for crew

First Shot 7:30 Meal ---- First Shot ----

Wrap 11:38 p.m. Finish 12:42 a.m.

	Scenes	Pages	Minutes	Setups
Total in Script	24	28	20	138
Taken Previously	16	20-5/8	13	92
Taken Today	4	3-1/8	3	24
Total to Date	20	23-6/8	16	116
To Be Taken	4	4-2/8	4	22

Cast Member	Makeup	Report on Set	Dismiss on Set	Meals Out	In
Grace Ridgley	2.00	3:00	5:45	5:45	6:45
Tommy Mays	6:00	7:00	11:38	5:15	6:00
Cynthia Thomas	6:00	7:00	8:37	5:15	6:00
Loreen Washington	7:00	8:30	11:38	----	----
Steve McLean	7:30	8:30	11:38	----	----

Scenes Shot Today 7, 5, 21, 12

Scheduled Finish Date 10/24 Estimated Finish Date 10/23

COMMENTS (Explanation of Delays, Cast and Crew Absences, Etc.)

30-minute delay on Scene 21 because of need to get extra
extension cords.
Grip (Tom Coates) had to leave at 10:30 because of a family
emergency. This made wrap time extra long.

Figure 3.5
An example of how a daily production report might be filled out.

tor will keep the log, the unit production manager will make the daily production report, and no one will prepare a script for the editor.

Lighting and Camera Operation

Historically, the types of jobs related to lighting and camera operation have differed greatly

Figure 3.6

An assistant director's log sheet.

PRODUCTION LOG

Title **Old Mother Witch** Page **5** of **5**

Director **Mark Chodzko** Date **10/22**

Reel	Scene	Take	Counter	Description and Comments
9	23D	1	126	CU bag and note - bad angle
9	23D	2	132	CU bag and note
9	23E	1	140	CU football
9	23F	1	152	CU chocolate chips
9	23F	2	167	CU chocolate chips - better light
9	23F	3	176	CU chocolate chips - best light
9	23G	1	189	MS note
9	23G	2	197	CU note - hand in way
9	23G	3	209	CU note

between film and video. In film, lighting and camera operation have been closely aligned and have been considered primarily artistic functions. A **director of photography (DP)**, or **cinematographer**, has overall responsibility for creating the image. This includes seeing that the set is lit properly and that the pictures are framed and shot properly. Cinematographers like to think of themselves as artists who paint with light. They work closely with the director

because cinematographers establish the look that the director wants the movie to have. Often a director will select the same director of photography for film after film because the two establish such a close relationship that the cinematographer can anticipate the director. This reduces the amount of time the director needs to spend explaining concepts to the DP.[8]

Usually, cinematographers do not touch either the lights or the camera. They decide what types of lights to use, where the lights should be set, how much light should enter the camera, and some details of shot composition, but they do not actually set up lights, change the settings on the camera, or operate the camera. **Grips** carry lighting equipment and electricians position and plug in lights. If the film is complex, it may require a head electrician (also known as a head **gaffer**) who will direct others in setting lights.

A **camera operator** actually sets up and runs the camera. Often the camera operator is aided by one or more **camera assistants.** For a film shoot, these people load film into magazines so that it can be placed on the camera quickly when the old magazine of film is finished. They also measure the distance from the camera to the object to be filmed so that the camera operator can set the focus accurately (see Figure 3.7), and they change the focus setting while the camera is moving so that the picture remains sharp and clear (pulling focus). They hold the slate in front of the camera at the beginning of a take so that pertinent information about the shot is recorded on the film, and they sometimes keep logs.

The lighting and camera operations in video have traditionally been handled very differently, mainly because video's roots are in live studio production. Lighting has not had nearly the importance in video that it has had in film because a three-camera studio setup requires that all angles be lit equally well. With no stopping between shots, one lighting setup has to work for an entire show. Film, on the other hand, from early in its history was a start-and-stop process that allowed for lighting of individual shots.

As a result, the director made the lighting decisions in television. Each program needed

Figure 3.7
The camera assistant is measuring the distance from the camera to the subject so that focus can be set properly. (Photo courtesy of John Fedel)

only one lighting setup, and for most comedy series, game shows, news programs, and talk shows this lighting was the same for subsequent shows. The person in charge of setting the lights was the **lighting director,** who usually oversaw a **lighting crew**—people who climbed the ladders and positioned the lights on the grid. Lighting directors used light meters to help set the lights. Sometimes this aided in creating particular aesthetic effects, but more often the meter ensured the light was falling evenly across the whole set.

Historically, TV camera operators have functioned separately from the lighting crew. They, like their film counterparts, were responsible for running the camera. However, they did not usually have assistants, although for shows that required a great deal of camera movement they had grips to hold and move the cable as the camera moved around the studio or to push dollies or cranes from place to place.

As film and video are merging, the functions that need to be performed are changing. The TV studio functions are similar to what they have always been, although because cameras are smaller and more maneuverable, grips are not needed as often. Movies shot on film still use much the same crew structure that they have always used.

Movies shot on video are edging toward film techniques in that one person makes lighting and camera decisions for video in

much the same way the cinematographer does for film. Some video productions opt for the term **videographer,** although nothing in the term *cinematographer* excludes video. The term *cinematography* literally means "to write in motion." This is appropriate for film and video. The main difference between film and video shoots is that video does not require as many camera assistants. Unlike loading a magazine, loading a videocassette is a simple operation that the camera operator can handle.

Recording the Picture and Sound

Who handles recording varies greatly and according to the equipment that is used. In film, the recording of the picture is inherent in the operation of the camera. This is also the case in video if the equipment used is a **camcorder,** which, as its name implies, is a combination camera and recorder. If the camera and videocassette recorder are separate, someone must operate the VCR. If sound is recorded on the same piece of film or tape as the picture (a process known as **single system**), it is tied closely to camera operation. For video, the VCR that is recording the picture can also record sound. In this case, one person can be responsible for recording both picture and sound, or two people can be involved—one making sure that the picture is recorded and the other listening on headphones to control the audio. If sound is recorded separately from picture (**double system**), either for film or video, someone must operate a separate audiotape recorder.

In any of these configurations someone must make sure the mic is properly positioned. Usually this person is referred to as a **boom operator** because the most common thing he or she does is position and move the mic while it is on some sort of microphone support, often called a **boom.** However, sometimes the boom operator pins mics on people's clothing or places mics on stands.

Someone other than the boom operator must adjust the controls on the sound recorder, be it VCR or audiotape recorder. This person is responsible for making sure the sound is clear and consistent through different setups. In film, this person is called a **sound mixer.**

In TV, people who deal with any aspect of audio are referred to as **audio technicians** (or *audio mixers* or *mixers*), and the people who operate videotape recorders (even if they control sound as well as picture) are referred to as **VCR operators.**

Large-scale productions are likely to have *sound assistants,* who carry and position cables, carry equipment, and sometimes keep logs.

As in other areas, picture and sound recording is evolving, mainly because of the confluence of film and video and the changing nature of sound recording in relation to picture recording.

Supporting the Production

Shooting a movie involves a vast number of tasks in addition to those connected with directing, acting, organizing and record keeping, lighting and camera operation, and sound and picture recording. These include putting on makeup, fitting wardrobes, hairdressing, placing props in their proper positions, executing special effects, painting, hammering, keeping plants and flowers alive and fresh looking, handling animals, teaching child actors, attending to minor injuries, preparing and serving food, driving trucks, and carrying things.

For a big feature movie separate individuals usually handle each chore—a makeup artist applies makeup, a greensperson keeps plants alive, caterers prepare food, grips carry and move things such as set pieces and cables. Other times jobs are combined, and general purpose people, usually called **production assistants** or **utility persons,** perform them on an as-needed basis. These people may also perform other unassigned jobs in the record-keeping or technical areas, such as holding the slate, keeping logs, or plugging in lights.

The people who undertake the many tasks associated with moviemaking become proficient by working on a multitude of movies. They rarely are bored, however, because each movie has its unique challenges.

The Stages of Production

Some aspects of production (such as putting up sets on a soundstage) can actually begin during

preproduction, but production is generally thought of as the time during which the movie is shot. A typical production day includes setting up, rehearsing, shooting, and striking.

Setting Up

Production days usually begin quite early, especially if the day's shooting is to occur outside. Every hour of sunlight must be used to its best advantage. Therefore, it is not unusual for actors and for makeup, hairdressing, and wardrobe people to report to the set at 5 A.M. so that the actors can be in costume and ready to perform by 6:30 or 7. Actors usually practice lines whenever they have time to themselves during setup time.

The early morning hours also are the time for set preparation. If the set is elaborate, truck drivers bring flats, bushes, paintings, and other large items to the location. Grips carry and erect what is needed, painters touch up nail holes, and people dress the set and place props in their correct positions. Even if the set is a natural location, such as a park, there are always minor changes that need to be made to accommodate the script.

Once the set is prepared, or almost prepared, the director of photography and electricians work on the lights. If they are using a generator to supply power, they fire it up. If they are using batteries, they attach them to the lights. If household current is to provide the power, someone should check to see if anything else is operating on the circuits that are to be used for lights so that the lights do not overload and blow out the circuit.

The DP no doubt has thought about the lighting requirements ahead of time and has a sketch—either on paper or in his or her mind—of how the lights should be set. This includes ideas about the overall lighting effect needed for the scene and the types of lights that will be needed.

Light meter in hand, the DP oversees the electricians as they set up and activate the lights according to the plan. The DP cannot fine-tune until the actors arrive on the set but can establish general positions of the lights and use stand-ins to determine more precise lighting re-

quirements. Proper lighting takes a long time, so as much as possible should be done during the setup period.

Once the light positions are fairly firm, the electricians should place sandbags on stands or in other ways secure all lights, tape cords so that actors and crew members do not trip over them, and in general make sure the whole lighting setup is safe. They should not overdo the taping and securing of lights and cords, however, because lights will be moved during and after rehearsal. Safety is important and should not be overlooked in the rush to shoot.[9]

Meanwhile, the camera and sound crews should be making their preparations. They, too, must secure power through the generator, batteries, or house current. The camera should be placed on its **tripod** or other support (see Chapter 4). The camera operator should check all the settings to make sure they are correct. The status report that appears in the viewfinder of many cameras is helpful for checking all these functions.

The operator of the videotape recorder should make certain that all connectors coming into it are secure. He or she should also make sure that the day's supply of tape is readily available but in some safe, relatively cool place. The VCR operator should decide, in conjunction with the director, what type of time code is going to be used throughout the production (see Chapters 4 and 11 for more about time codes).

During the setup time the camera and VCR operators can record leader material on the tape. The ideal leader consists of about one minute of **color bars, time code,** and audio **tone** (see Chapter 10); however, the equipment to generate this often is not available on the production set. Something should be recorded at the beginning of the tape, though, to identify it and to keep the beginning of the tape (which is somewhat subject to stretching and damage) from being used for important production footage. With consumer-grade cameras it is possible to program some identifying graphics with the character generator built into the camera and record them at the beginning of the tape.

The sound crew should select the proper mic(s) for the scene that is to be shot and should

attach the mic to the boom or to whatever type of stand is being used. They should decide the general positioning of the mic.

The person operating audio, like the person operating video, should check to make sure all dials and switches available and related to audio are in the right position (see Chapters 8 and 9). The mic should be firmly connected to the mic input on the recorder, and the whole audio system should be checked to make sure it is operating correctly. It is embarrassing to have the whole cast and crew standing around because the audio operator put the mic battery in backward and did not bother to make sure the mic was actually working.

The director might oversee the whole setup process, or the director may be off planning the blocking for the day's shots or viewing the footage from the day before. In this case, an assistant director or the unit production manager may be in charge of the overall setup.

Rehearsing

A movie requires two types of rehearsals, one that involves the cast and one that involves the cast and the crew. For the former, the director works with the cast to determine blocking and to build the proper emotional feeling.[10] If a scene doesn't work, a writer may be brought to the set to undertake a minor rewrite. Extras may or may not be part of the cast rehearsals, depending on the specific roles they play.

Once the actors are sure of their lines and the blocking has been worked out, the director holds a rehearsal, sometimes referred to as a **technical rehearsal,** mainly for the benefit of the crew. All cast and crew are present, and all sets, props, lights, and equipment are at least tentatively set up. The actors usually do not give their all during this rehearsal. They just run through their moves and lines so that the crew can determine camera angles, fine-tune lights, and position the mic for best pickup. The director makes any decisions that need to be made about the shooting setup. He or she must always be thinking about the final edited movie and ways to underscore the narrative (see Chapter 5).

This technical rehearsal gives all crew members an opportunity to check details in their areas of responsibility. If something is wrong and the changes can be made quickly, the crew makes them during the rehearsal period. If the changes will take a fair amount of experimentation (such as resetting lights to get rid of undesirable shadows), the crew member in charge makes notes and corrects the problem after rehearsal when doing so will not tie up the whole cast and crew.

The cinematographer pays careful attention to how the light falls on the actors and how it reflects into the camera: Are there undesirable shadows? Are there hot spots? (see Chapter 7). The camera operator frames and focuses the shots according to what the director and cinematographer want. The director may look through the camera viewfinder or may use a monitor to make sure the shot is what is actually desired.

The boom operator should position the mic for best pickup. Undesirable background noises that might still be present when recording begins should be noted so that they can be eliminated. If other shots have been taped that will be intercut with what is being rehearsed, the audio operator should think in terms of continuity to make sure the audio signals will match. A check with the script supervisor may help in this regard.

During rehearsal the script supervisor makes notes related to continuity. Some script supervisors bring a consumer camcorder to work and shoot various angles of the set so that the footage can be used later if continuity questions arise.[11]

Prop, set, costume, and makeup people need to make changes if something doesn't work in the overall scheme. In general, the technical rehearsal is the time when the individual elements of the production must be made to work together.

Once the technical rehearsal is complete, people make the more complicated changes noted during the rehearsal, usually with the help of stand-ins. The cinematographer and electricians are likely to have the most work to do because of all the fine-tuning that the lights will require. Once they have finished,

they must once again check to make sure the set is safe.

During the period between the technical rehearsal and the recording, the director must be totally in control because, although many of the changes crew members desire are justified, others are not worth the time it will take to complete them. Spending endless hours after rehearsal in fiddling with equipment is a major contributor to overbudget movies.

Shooting

The exact procedure for shooting can differ from one situation to another according to the personal style of the director and the needs of the movie. Sometimes directors will rehearse one shot at a time and then shoot it. Other times they will rehearse an entire scene and then shoot all the shots in that scene. In other circumstances they may feel it is more logical to rehearse everything that will be done at a particular location before starting to shoot.

Shortly before shooting begins, the TV camera operator should make sure the camera is **white balanced** for the final lighting setup for the shot. Generally, someone (perhaps a production assistant) holds something white near where the action will take place to white balance the camera. The camera operator then fills the screen with the white, focuses, and presses the white-balance control on the camera (see Chapter 4).

Once this is done, the camera operator should frame the shot as it is going to be recorded. Meanwhile, the person in charge of audio should take a level reading by having the actors talk as they will when the recording begins. The sound mixer (or audio technician) then sets the volume controls for optimum pickup (see Chapters 8 and 9).

When all this has been accomplished and all people are in their proper places, the director says, "Stand by." The next command is "roll tape." If the production is being shot on videotape, the person operating the VCR places the machine into record. The tape should run for about ten seconds before any crucial material is recorded. This extra time will be needed later, during the editing process, if linear editing is employed.

If the production is being produced on film, "roll tape" is the command to begin the audiotape recorder. After that recorder is up to speed, the director says, "Roll camera," and the camera operator starts filming.

After tape or film is rolling, the director says, "Slate." At this point someone (a camera assistant, a production assistant) holds a slate in front of the camera. This slate contains information about the shot that is to be recorded: the director's name, the date, the production title, a short description of the shot, and the scene and take number. The **scene number** should correspond to what is on the **screenplay** (see Chapter 1). Most scene numbers have letters after them (*A, B, C*) to indicate particular shots in the scene. For example, when scene 11 of *Old Mother Witch* was being recorded, scene 11 was a master shot showing the whole set; scene 11A was a close-up of David; scene 11B was a close-up of Scottie; scene 11C was the picture of Mrs. Oliver on the sidewalk; and scene 11D was the final action of the two boys. These are the scene numbers that go on the slate before each shot. **Take** numbers indicate how many times that particular shot has been recorded. The first time the shot is recorded, the take number is 1. If people are not satisfied with the shot and it needs to be done over, the take number on the slate changes to 2. If the close-up of Scottie needs to be recorded for the fourth time, the slate should read "scene 11B, take 4."

Slates are made of virtually anything that can be written on. Professional slates are usually made of an erasable material so that they can be changed easily. Some slates are electronic and display the time code of the particular shot (see Figure 3.8). Film slates have a clapper at the top. The clapper is raised and then snapped against the base. Film editors use the frame in which the slate closes to line the picture up with the sound of the clapper to synchronize picture and sound. This is unnecessary for video because video is usually shot single system.

Figure 3.8

A slate with a clapper and an electronic time code. (Photo courtesy of Denecke, Inc.)

The person holding the slate should try to position it so that the camera can use the same focus and focal length for the slate as for the beginning of the shot. (Near the actor's face is often the best place.) Sometimes this is not possible, and the camera operator will have to refocus after recording the slate. The slate holder should also read the information on the slate while holding it in front of the camera. That way, the tape will contain both an audio slate and a video slate, often a help to the editor.

Once the tape rolls and records the slate, the director's next command is "action." The actors should wait a second or two before beginning their movements and dialogue so that the "action" command will not be part of the shot.

While the shot is being recorded, the VCR operator should be watching the tape to make sure it is actually moving and recording. Many VCRs have a video meter that registers in a green area, indicating the tape is receiving a signal. The VCR operator should also watch for signals that the batteries are low or that the tape is coming to the end.

The boom operator should follow the action. If the mic must be moved because the actors move or because a different person begins to talk, it should not be panned too quickly because this will create noise. The person overseeing audio recording (this might be the mixer, the VCR operator, or the camera operator, depending on the equipment configuration) should also wear a headset to make sure the sound is recording properly. Audio can be

double-checked on the volume unit (VU) meter, if one is available.

The camera operator should keep the camera shot properly framed and in focus and should execute any camera moves called for. If the moves involve changing the position of a dolly, a grip will push the dolly (see Chapter 4).

The cinematographer should watch for lighting problems, and the script supervisor should look for potential continuity problems. The director should be constantly thinking about the shot in terms of its overall effectiveness and its relationship to the entire movie.

A second or two after the actors are finished, the director should say "cut." The VCR should continue to roll for about ten seconds so that the end of the shot contains strong sync information. Because of its importance in editing, continuous material is needed both before and after the shot on a linear system. Material will not edit if it does not have enough of a lead to get up to speed, and the edit may fall apart if it does not have strong sync at the end (see Chapter 11). The director decides whether to record the shot again, but any crew member should speak up if something went awry. If the camera operator knows the shot was out of focus, if the script supervisor noticed that a prop was misplaced, if the cinematographer saw a boom shadow, if the audio technician heard a strange noise, they should say so. Of course, an actor totally blowing a line would be obvious to everyone.

If there is any doubt about the quality of the take, it can be played back on a monitor. In fact, someone involved with audio or video should play taped material back from time to time to make sure it is recording well. However, the director should not make a practice of viewing each shot—it's too time consuming.

If the shot is to have another take, whatever problem occurred should be fixed quickly. During this time the person holding the slate can change the take number, the person compiling the log can note the result of the take, and the script supervisor can make continuity notes and work on the editor's script. The director should restart the process as soon as possible—standby, roll tape, slate, action, and cut.

Once a particular shot such as the master shot is finished, the director moves on to the

PROPERTY CHECK OUT RELEASE

I hereby affirm that, on inspection of the property
located at _____,
where_____days of shooting between the dates of _____
and _____have taken place for the movie_____
_____, I have found that the property has
been left in the state that it was originally in before the
shooting for the production began.

Signature_____

Printed Name_____

Title_____

Street Address_____

City and Zip Code_____

Phone Number_____

Date_____

Figure 3.9

An example of a property checkout release.

next shot, perhaps a close-up. The set must be relit, and cast and crew must reposition themselves and rehearse as needed. The director shoots as many different shots of a particular scene as are necessary to provide the editor with options. The director and the sound mixer should be sure to remember at some point to record **room tone** and any other audio effects needed (see Chapter 9).

Once a particular scene is finished, the next scene starts. If the scene is in the same location, it can start rather quickly, although in all probability actors will need to change costumes and the crew will need to set new lighting. If the scene is in a new location, the crew will have to strike the set and move everything.

Striking

The word **strike** refers to the tearing down and cleaning up of everything that was set up and used for rehearsals and shooting. The electricians should turn off the lights, untape and coil the cords, and put all lights, stands, cords, and accessories in cases. Similarly, the camera operator, mixer, and/or grips should make sure cameras, lenses, microphones, and recorders are properly stored in their cases. All used batteries should be recharged overnight.

The VCR operator should rewind tapes and label each tape and the box.[12] Ideally, the labels include the producer's name, director's name, movie title, reel number, date recorded, type of time code, type of audio, and camera and VCR (or camcorder) used for the recording. This information will be of help to the editor and can also be used if there are any problems with the tape.

The set should be taken down, unless it is needed the next day. Props, wardrobe, hair pieces, and makeup should be stored for the night or packed away for transport to the next

location. The people in charge of these items may want to reorganize them so that what they will need early the next morning will be readily available.

Before everyone leaves, the assistant director or whoever is in charge of call sheets should post the call sheets for the following day and several days thereafter. If the production is moving smoothly, these will not be very different from what everyone anticipated, but if the production has fallen behind schedule, major changes in who reports where and when may be necessary.

When you leave a location, it should be in the same condition it was in before shooting started. The unit production manager should have the person in charge of the site sign a property checkout release form (see Figure 3.9) so that no bad feelings (or lawsuits) will arise later. The UPM should also fill out the daily production report so that it can be used for control and for payroll verification.

The director, if not too tired, may view the tapes shot during the day or begin planning the actor and camera blocking for the next day's shots. The cinematographer may start planning the lighting for the next scenes. Or the tasks may be undertaken early the next morning.

Notes

1. This is a paraphrase of a paraphrase that appeared in Steven Kane, "Videocy," *Emmy*, April 1989, p. 12.
2. The Directors Guild has a document that lists duties of First Assistant Directors and Second Assistant Directors. It generally gives supervisory functions to the First Assistant Director and assisting functions to the Second Assistant Director. For example, the First Assistant Director is to direct background action and supervise crowd control, and the Second Assistant Director is to assist in the direction and placement of background action and in the supervision of crowd control.
3. For good advice for directors, see Alan A. Armer, "Part Two: Directing Fiction," *Directing Television and Film* (Belmont, CA: Wadsworth, 1990), pp. 92–240; Mike Crisp, *Directing Single Camera Drama* (Woburn, MA: Focal Press, 1998); Renee

Harmon, *Film Directing* (New York: Lone Eagle Press, 1997); and Ivan Cury, *Directing and Producing for Television* (Woburn, MA: Focal Press, 1998).
4. Information about actors can be found in Paul Newman, "The Players," in Roy Paul Madsen, *Working Cinema: Learning from the Masters* (Belmont, CA: Wadsworth, 1990), pp. 156–181; Tony Barr, Eric Stephen Kline, and Edward Asner, *Acting for the Camera* (New York: Harper-Collins, 1997); and Patrick Tucker, *How to Act for the Camera* (New York: Routledge Press, 1993).
5. The term *script supervisor* is a film term, and *script clerk* is a video term. Historically, most of the people who held these jobs were female, so the term *script girl* has also been used. In early TV, the script clerk's duties were different from the duties of the script supervisor of film. The script clerk was the woman who kept time during early TV live shows, particularly dramas. She would backtime the show so that when a commercial break came, she could tell the director how many minutes were left until the program had to end. The director would then tell the actors how to adjust their lines and actions so that the program finished on time. For many years, the script supervisor and script clerk were the only women on most film and video crews. Although the functions of script supervisor are important, this is still a low-paying position.
6. As with preproduction (see footnote 1, Chapter 2), the duties assigned to unit production managers and assistant directors vary from one production to another. Because the director is more firmly in charge during production, the assistant director is likely to have the more elevated position and undertake chores that are of a more creative nature than those of the unit production manager.
7. Two computer programs that can be used to create logs are *Log Producer* from Image Logic, 6807 Brennan Lane, Chevy Chase, MD 20815, and *The Executive Producer* from Imagine Products, 12220 North Meridian Street, Suite 130, Carmel, IN 46032.
8. See Vilmos Zsigmond, "The Cinematographer," in Madsen, pp. 209–259.
9. The BBC has a policy of not letting anyone on the set until a safety check has been completed.
10. Sometimes the director and actors have been working on this during preproduction. For example, they may have been rehearsing in a big hall

with the set boundaries taped on the floor. This allows them to determine blocking even before the sets are built. In some instances the writer may be with them. Some directors invite the writer for the first run-through so that any lines that do not read well can be corrected early.

11. James Caruso and Marvis Arthur, "Blue Lagoon's 8mm Secret," *Video,* October 1991, p. 33.

12. Sometimes tapes are stored tails out to minimize print-through and wear and tear caused by rewinding.

chapter four
Cameras and Lenses

Electronic moviemaking begins with the portable video camera and recorder. In some ways the process is similar to that for a film camera, and in other ways it is quite different. Both have lenses, viewfinders, and some means of recording what you see through the viewfinder. However, the method of creating the image—electronic versus photochemical—is different. In this chapter we highlight the portable video camera and recorder (or camcorder), camera mounting equipment, and lenses. We also look at the variety of film and video **formats** and, where appropriate, highlight some basic differences between capturing an image on video and capturing it on film.

Formats

Film formats have been standardized for many years, whereas new video formats are introduced regularly. Film formats are determined primarily by the actual width of the film in millimeters, but because it is possible to have two formats of the same width (Super 8 and regular 8mm, for example), film formats are also based on the differences in image area, perforations, and sound tracks. Video formats are based on such factors as tape size, the method used to record the video signal, the kind of processing that signal receives, and the speed at which the tape moves through the recorder.

Film Formats

The original motion picture format, invented by Thomas Edison and George Eastman in 1889, was 35mm, basically the same film format used today for most theatrical motion pictures. Perforations (**sprocket holes**) along the

sides of the film, the area of the film available for the image (the **frame**), and the sound tracks were quickly standardized.

In the 1920s Eastman Kodak introduced a new format, 16mm, intended to encourage amateur filmmaking. This format proved to be too costly for most amateurs, but it became the choice for many educational and training films.

Super 8 was introduced in 1965, preceded by 8mm. Both formats use film that is 8mm wide, but Super 8, by repositioning sprocket holes and making them smaller, allows for a larger image area.[1]

Formats larger than 35mm (primarily 70mm) have also been developed to improve the quality of theatrical films. Because 70mm is so expensive, it is usually reserved for big-budget epic productions that can truly take advantage of the more dynamic large-screen image.[2]

Obviously, the different formats require different cameras because they must be able to hold different sizes of film. Figure 4.1 shows examples of various cameras.

In film, the producer selects a format based on the cost and the ultimate place of exhibition. The larger the format, the better the image and the more expensive the production. Theatrical motion pictures use 70mm and 35mm. The less expensive 16mm format and its sister Super 16 format are used for productions that do not call for the large-screen image, such as music videos and cable TV documentaries. Because of the enormous cost associated with the theatrical film formats, student filmmakers usually work in 16mm and Super 8. Before the advent of small-format video, Super 8 was also the mainstay for recording family gatherings, baby's first steps, and vacation trips. (See Figure 4.2 for a comparison of different film formats.)

Video Formats

Video formats are much more numerous than film formats. The first video format, introduced by Ampex in 1956, used tape that was 2 inches wide. The size and complexity of the videotape recorders ruled out their use in portable configurations.

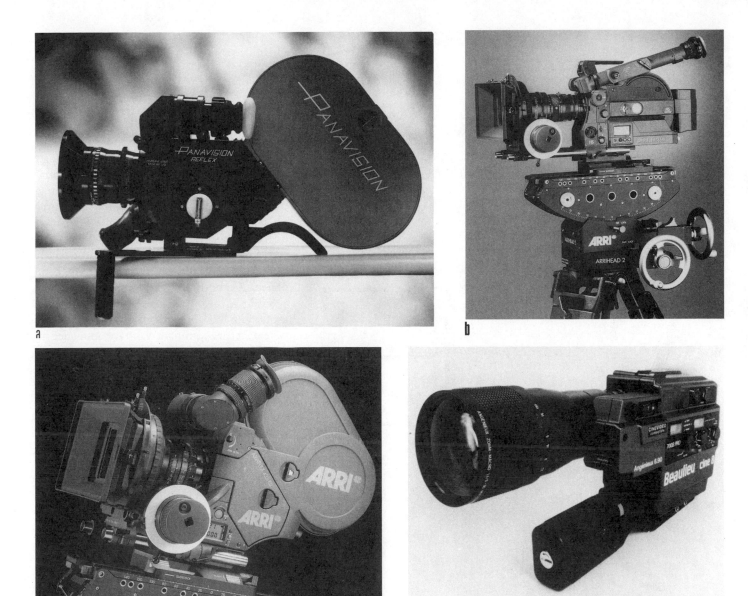

Figure 4.1

Several motion picture cameras. (a) A Panavision 70mm camera; (b) an Arriflex 35mm camera; (c) an Arriflex 16mm camera; (d) a Beaulieu Cinepro Super 8mm camera. (Photo a courtesy of Panavision; photos b and c courtesy of Arriflex Corporation; photo d courtesy of Super 8 Sound)

Beginning in the 1970s manufacturers introduced a number of formats suitable for portable operation. The first significant one was **U-Matic,** introduced in 1971. It consisted of a camera and a separate videocassette recorder that used a ³/4-inch tape. The camera and recorder were linked by a cable. This format almost immediately replaced 16mm motion picture equipment for television news production,

and schools and businesses adopted it for training and production purposes.

In 1975 and 1976 two ¹/2-inch formats intended primarily for the home consumer were introduced—Sony's **Betamax** and JVC's **VHS.** These were not compatible with the U-Matic because of the difference in tape size, but they also were not compatible with each other because the way the tape wrapped

70mm
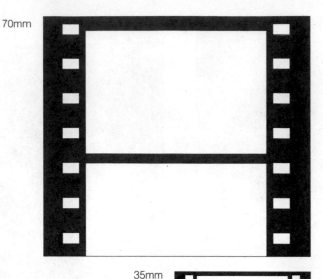

35mm
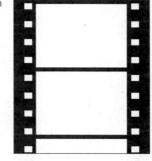

16mm

Super 8

Figure 4.2
A comparison of different film formats.

In the early 1980s several manufacturers introduced high-quality camcorder systems for professional television production; they combined the camera and videotape recorder in a single highly portable unit. Two main formats dominated—Sony's **Betacam** and JVC's and Panasonic's **M-format.** Although they both used 1/2-inch tape, these formats were not compatible with each other or with the consumer-grade 1/2-inch formats. Consumer-grade recorders were **composite,** while the professional ones were **component.** Composite systems record information about brightness (**luminance**) and information about color (**chrominance**) together. Component systems record luminance and chrominance information separately. The component systems are superior because recording the two types of information separately greatly reduces color smearing and improves picture quality. However, they are more expensive than the composite systems.[3]

Shortly after the camcorder configuration was introduced for the professional world, Sony and JVC also developed camcorders for their consumer formats. Betamax was not nearly as successful as the VHS format, which eventually dominated the consumer market. However, in 1981 Sony introduced a new format, **Video-8.** This format used tape that was 8mm (about 1/4-inch) wide and was the smallest, most portable format yet devised.

All major formats in existence in the 1980s—U-Matic, VHS, Betacam, M-format, and Video-8—improved their recording abilities (in large part by developing better tape stocks) and came out with new equipment—**U-Matic SP, Super-VHS** (also called **S-VHS**), **Betacam SP, M-II,** and **Hi-8.** In general, these newer formats are only partially compatible with the older formats from which they were derived. They usually can play the older formats, but material recorded on the newer formats cannot be played back on the older ones. For example, a tape recorded on a VHS recorder can be played back on an S-VHS recorder, but a tape recorded in S-VHS cannot be played back on most VHS recorders.

Format development today is concentrating on **digital** technology. All the formats mentioned previously are based on **analog** technology. Analog recording produced a continuous

around the video recording heads and the speed at which the tape traveled were different. The main consumer use of these formats was to play back entertainment programs rented from the video store or recorded off-air. However, a number of people bought cameras to go with their recorders in order to make home movies.

electrical signal with a shape that is defined by the video wave that it is representing. Digital equipment records the video information as a series of discrete on and off pulses (zeros and ones). The digital technique produces superior picture quality and also allows taped material to be copied without losing quality. This is because the on and off pulses of digital can be repeated without degradation while the shape of the analog signal changes slightly as it is dubbed from one record to another. If you have ever seen a fourth-generation VHS tape, you have seen the degradation process of analog recording.

A number of different digital formats have been developed. The first, **D1**, which was introduced by Sony in 1986, was an expensive component system that used $^3/4$-inch cassette tape. Because of its high cost, it had trouble gaining acceptance and companies introduced competing composite systems—Ampex with $^3/4$-inch **D2** in 1988 and Panasonic with $^1/2$-inch **D3** in 1990. In 1992 Ampex introduced a format it called **DCT** that was component $^3/4$-inch but compressed.

Compression is a digital technique for placing more information in less space. Much of the information in a particular shot does not change over the course of that shot. For example, if two people in a long shot are standing in front of a building having a conversation, the building does not change; only the gestures of the people will change. In the digital domain, the building does not need to be recorded over and over for each frame as it does for analog recording because the discrete on and off pulses remain the same and can be referenced to the first frame. The only information that needs to be recorded is that related to the two people. This means the information about the shot can take less tape space than would be required if the building were recorded over and over. The ability to compress is another way that digital technologies differ from analog.

Once compression became part of the equation, other digitally compressed formats emerged. In 1993 Sony came out with $^1/2$-inch **Digital Betacam/SX,** and in 1995 both Sony and Panasonic came out with component $^1/4$-inch digital formats designed to be used by both the professionals and consumers—**Mini-DV** and **DVCAM** from Sony and **DVCPRO** from Panasonic.[4]

The video format world is complicated because formats become entrenched and do not fade away easily, even when higher-quality formats are developed. (Figure 4.3 shows a variety of equipment and formats.) This, of course, is the case with VHS, a markedly inferior format but one that permeates the consumer market. New formats will continue to proliferate. The latest advances relate to recording on a computer drive or on a disk—perhaps some form of recordable **digital versatile disk (DVD)**.[5]

Aspect Ratio

The basic shape of a film or video frame is referred to as its **aspect ratio.** It is the ratio of the width of the frame to its height. In film, the most popular early aspect ratio of three units of height to every four units of width was eventually adopted by the Academy of Motion Picture Arts and Sciences as the standard for theatrical films. This **Academy ratio,** also expressed by the ratio 1.33:1 (a square would have an aspect ratio of 1:1), remains the aspect ratio for standard 8mm, 16mm, and 35mm film. Although 1.33:1 was basically an arbitrary frame configuration, the fledgling television industry also adopted the mildly rectangular, 4:3 aspect ratio when it standardized its frame shape.

Partly in an effort to lure television viewers back to movie theaters with a larger and more powerful film image, the motion picture industry in the 1950s developed several **widescreen** aspect ratios. One method was to mask off the top and bottom of the typical 35mm film frame, a procedure that created the commonly used widescreen aspect ratios of 1.85:1 in the United States and 1.66:1 in Europe. Another method involved the use of an **anamorphic lens** to squeeze the widescreen image optically into the film frame and then unsqueeze it onto the movie screen with an anamorphic lens on the projector. The anamorphic widescreen process created an extremely elongated rectangular frame with an aspect ratio of 2.35:1 for the popular Panavision process.[6] Figure 4.4 illustrates various film and TV aspect ratios.

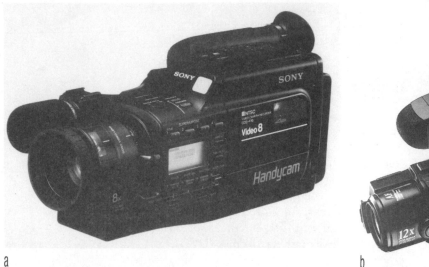

a

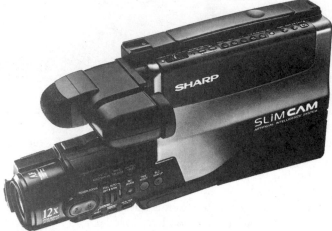

b

c

d

Figure 4.3

A sampling of equipment for different video formats. (a) A Sony 8mm Handycam; (b) a Sharp regular VHS camcorder; (c) a Sony Digital Betacam SP camcorder; (d) a Panasonic DVCPRO camcorder. (Photos a and c courtesy of Sony Electronics, Inc.; photo b courtesy of Sharp and Dorf & Stanton Communications; photo d courtesy of Panasonic Broadcast and Digital Systems Company)

Occasionally, widescreen films are shown on television (or released on videotape or disk) in the "letterbox" format that masks off the top and bottom of the frame and displays the entire widescreen image within television's 1.33:1 aspect ratio. More commonly, this translation of aspect ratios involves some loss (or even reframing) of the original film image, a process frequently referred to as *panning and scanning*.[7]

As of 1999, television has a new aspect ratio of 16:9. This is the ratio for the new sets being sold for reception of the digital **high-definition television (HDTV)** that has been ap-

proved by the Federal Communications Commission. HDTV sets have many advances over the standard TV sets that preceded them, and one of the advantages of HDTV sets is that they can display widescreen movies without letter boxes or panning and scanning. The 16:9 aspect ratio is approximately 1.77:1, so it is close to widescreen motion picture ratios. Video cameras that record HDTV obviously must produce the 16:9 pictures. Most of the digital formats have an option for shooting either 4:3 or 16:9. Because of the cost factor, both the HDTV cameras and the sets are

being phased in over time. In the meantime, people will be able to receive standard 1.33:1 pictures whether they have an older set or a new HDTV set.[8]

Choosing a Film or Tape Stock

Selecting a film or videotape stock begins with the format you choose for your production. A 35mm film camera requires 35mm film, and a $^1/_2$-inch S-VHS VCR requires the right $^1/_2$-inch videotape cassette. But the choice of a film stock has a far greater impact technologically and aesthetically than the choice of videotape. The film stock itself is the actual **imaging device** in a film camera, and the selection of a particular type of film profoundly affects the kind of image it produces.

Motion picture film is composed of a thin layer of light-sensitive silver halide grains suspended in gelatin, the emulsion. The layer of **emulsion** is supported by a flexible, transparent **base** of cellulose acetate. When the lens focuses light onto the emulsion, a photochemical reaction occurs. The areas of the photograph (each frame of the motion picture film is an individual photograph) that receive the most light will appear darkest when the film is developed (chemically processed and stabilized) in the laboratory. For one type of film called **negative** film, the image must be printed on another piece of film to produce a **positive** image with correct photographic tones (that is, black as black and white as white). Another type of film called **reversal** requires additional processing in the laboratory to convert the film (the original film run through the camera) into a positive image. After processing, reversal film can be viewed (or projected) without the need to make a print. Color film stock uses three layers (yellow, cyan, and magenta) of photosensitive dyes to produce all the colors in the visible spectrum.

Most people have bought film for a still camera and have some familiarity with the many choices available. You must decide whether to shoot in black and white or in color. You must

1.33:1 Academy aperture

Figure 4.4
A variety of aspect ratios.

4:3 standard TV ratio

1.66:1 European standard widescreen

16:9 HDTV ratio

1.85:1 American standard widescreen

anamorphic 2:1 squeeze, 2.35:1 when projected

also decide if you want to use the negative or reversal film system to create a positive image (like a slide) or a negative image (the kind used for most professional filmmaking) for making prints. If you want to shoot where there is not much light, you need to buy a **fast film stock** (one more sensitive to light) that has a high **exposure index (EI)** or **ASA.** Or you may want a **slow film stock** (with a lower EI) to produce a sharper, less grainy image. Film stock is also **color balanced** (designed to produce the correct colors in different types of light) for artificial light or for daylight. Finally, even similar film stocks from different manufacturers (like Kodak, AGFA, and Fuji) have different **tonalities**—the range of colors (or black and white) that they reproduce.[9]

In video, almost all these choices are predetermined by the recording format and the quality of the camera. Whether to shoot in black and white or in color is not determined by the selection of videotape because all videotape can record either color or black and white. The quality and sensitivity of the camera determines the ability to produce an image in low light as well as the overall sharpness and quality of the image. Given the same camera and VCR, the choice of one videotape over another has only a minimal effect on image quality and almost none on the cinematographer's artistic control of the image.

Videotape is composed of a polyester base coated along one side with a thin layer of metal oxide. If you have ever purchased a videotape for use at home, you have undoubtedly been exposed to different grades of videotape. The higher grade (and more expensive) videotapes usually (but not always) provide some slight gain in image quality and color rendition, a reduction in **dropouts** (loss of signal due to imperfections in the tape's surface), and some improvement in the videotape's audio recording capability. The cheapest tape may actually clog the recording heads on the VCR or even damage them. The videotape used in component recording systems like the M-II or Betacam SP formats (or S-VHS or Hi-8 formats) has a finer metal particle layer than regular videotape. As a result, it can record a higher-quality picture.[10]

All videotape used in portable video recorders or camcorders is packaged in cassettes. A number of formats use **minicassettes,** which load shorter lengths of regular 3/4-inch, 1/2-inch, or 1/4-inch videotape into smaller cassette housings to increase portability. Usually these smaller cassettes will play in a full-size studio VCR, but the full-size cassettes will not fit into the portable machine.[11]

Videotape can, of course, be recorded over and used many times. However, because videotapes show wear after being used only a few times, most professionals would never consider using "used" tape stock for an important shoot. Although this reuse capability is a definite advantage, especially in terms of cost, it is also possible to erase or record over something that you meant to save. Most cassettes have some temporary means of preventing an accidental rerecording such as small tabs that can be moved to a different position or broken off from the cassette housing to ensure erasure/recording protection. If you change your mind later and want to record on a tape after you have broken off the recording tab, you can place a piece of masking tape over the hole.

The Camera

For our purposes any of the portable camera-recorder systems (DVCAM, Betacam, S-VHS, Video 8, and so on) provide the ideal tool for the beginning student moviemaker. We will emphasize the general principles of the video camera rather than any one format or type of gear. Undoubtedly, some of the points we make will not apply to the camera you have access to, and some of your camera's features will be missing from our discussion. You should always read the instruction manual for your particular camera to make certain you know its capabilities and idiosyncrasies.

Imaging Devices

Whether you are shooting with the finest broadcast-quality studio camera or working with a low-end camcorder from the local discount

store, the main parts of the camera and the principles on which they are based are virtually the same. When the camera is pointed at a scene, the lens gathers the light reflected from that scene and focuses it on an imaging device, a solid-state element known as a **charge-coupled device (CCD)**. The function of the CCD sensor is to transform the incoming light into electrical signals that can be recorded on videotape and/or be seen in the camera's electronic viewfinder.

A CCD sensor is a solid-state device (a chip) that contains an array of *individual* light-sensitive picture elements (called **pixels**). When the image is focused on the sensor, each pixel builds up an electric charge containing color (chrominance) and brightness (luminance) information. This information is stored momentarily in a storage area (similar to the imaging area) in the chip until it is read out to create the video signal.

The more active pixels a CCD sensor contains, the higher the quality of the image it can produce. Given the direct relationship between number of pixels and image quality, the competition among camera manufacturers to produce ever higher pixel counts for their chips is ferocious. Even consumer-grade CCD cameras today tout sensors with more than 400,000 effective pixels.[12]

Video creates the illusion of movement in a very different way than the process used in motion pictures. One second of film is composed of 24 **frames**, actually 24 individual still pictures. When that film is projected, each frame is displayed on the screen for only a fraction of a second. While the projector is pulling the next frame into place, a shutter momentarily blocks the light and then swings out of the way to reveal the next frame.[13]

In the United States the video process creates a series of 30 frames in one second.[14] The video frame does not exist as a single, discrete frame like a motion picture frame. It is a moving dot that lights up phosphors on the TV screen one pixel at a time, line by line. For the video process used from the 1940s up to the present time, there are 525 lines for a frame that are broken down into two **fields**, each composed of half the 525 lines in the frame. The first field contains the 262.5 odd-numbered lines (1, 3, 5, and so on), and the second field contains the 262.5 even-numbered lines (2, 4, 6, and so on). At the end of each field, there is a **vertical blanking interval**, a short period of time between the bottom of one field and the top of the next. The importance of this vertical blanking interval will be discussed later in conjunction with time code. This type of scanning process that involves building two fields to create one frame is known as **interlaced scanning** (see Figure 4.5a). It was developed because the phosphors of early TV sets could not hold a charge for long. If an entire frame had been laid down from top to bottom, the top of the screen would have been dark by the time the moving dot got to the bottom of the frame.

By the time computers were developed, phosphors on screens had improved greatly, so computer screens lay down total frames rather than two fields. This process is known as **progressive scanning** (see Figure 4.5b). When the standards were set for the new digital TV, the parameters related to scanning method and to the number of lines on the TV set were left somewhat open. Therefore, some TV stations are converting to 720 lines and some to 1,080 lines, and some are using progressive scanning while others are using interlaced scanning.[15]

Color Video

In effect, the video signal created by a color camera superimposes the color information (chrominance) on the brightness information (luminance) that would be produced by a black-and-white camera. Color has two basic components: **hue,** the specific tint of the color (for example, yellow, brown, red), and **saturation,** the intensity or purity of the color (for example, a highly saturated deep blue, a lightly saturated pale blue). The luminance information, which presents the full range of variations from the darkest to the lightest part of a scene, also has an effect on the **brightness** of a color, how dim or how bright a particular color appears to be. (See Color Plate 1.)

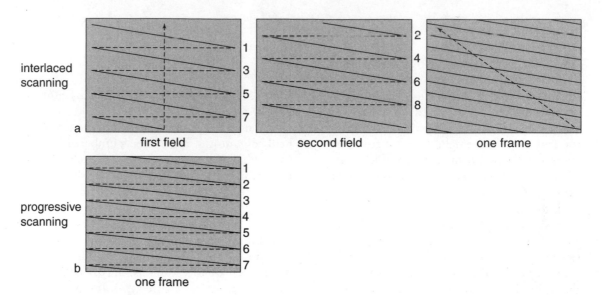

Figure 4.5

The basic scanning patterns. (a) For interlace, the odd field (lines 1, 3, 5, and so on), are scanned moving left to right across each line. At the end of a line the signal goes into a blanking mode and quickly retraces back to the left edge to begin scanning the next line. This continues until all the odd-numbered lines in the first field (half of the picture) are scanned. Then, the signal goes into the vertical blanking mode while it moves back to the top of the picture to begin scanning the even-numbered lines that make up the other half of the picture. The scanning process for each field takes $^{1}/60$ of a second. Combining the two fields, a pattern called interlaced scanning, produces the full video frame in $^{1}/30$ of a second. (b) For progressive, the lines are laid down one after the other to form an entire frame.

A three-chip camera creates a color video signal by separating the light coming through the lens into the three primary colors of light—red, blue, and green—one for each of the three chips. (See Color Plate 2.) The light is divided into the primary colors (in proportion to the amount of each color in a scene) either by a prism block or by a special dichroic mirror system. Eventually the color signals are recombined (see Figure 4.6). If the signal is composite, the color is combined with the luminance information. If it is component, the chrominance and luminance information are kept separate.

Evaluating Camera Performance

One of the most important ways of evaluating a camera's performance is to assess its ability to reproduce fine detail. Most camera manufacturers tout their particular camera's resolving power in terms of **horizontal resolution**—the maximum number of vertical lines per millimeter the camera's CCDs can distinguish (together with the lens, optical system, and electronic circuitry). A camera with 600 lines of horizontal resolution will produce a sharper picture than one with 200 lines.[16]

A camera's **low-light sensitivity**—its ability to produce an acceptable image with minimal illumination—is another way to evaluate camera performance. You will recall from our earlier discussion that a filmmaker can select a faster (more light-sensitive) film stock for shooting in low-light situations. In video, low-light sensitivity basically is built into the camera. Although the lens and the camera's electronic circuitry contribute to a camera's performance in low light, the light sensitivity of the CCD sensors is the primary determinant. Camera manufacturers usually express a camera's low-light sensitivity by listing the minimum number of **footcandles** (such as 200 footcandles) the camera requires to produce an optimal image. An-

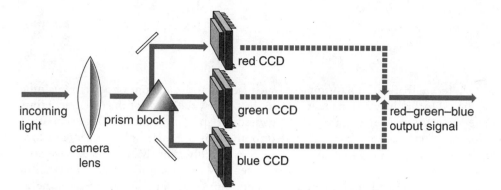

red CCD

incoming light

camera lens

prism block

green CCD

red–green–blue output signal

blue CCD

Figure 4.6

A prism block separates the light coming through the lens into its red, green, and blue components. Those three signals are then sent to the appropriate red, green and blue CCDs. Eventually, the three separate color signals are recombined by the encoder to produce the full-color image.

other measurement, **lux** (roughly ¹/₁₀ of a foot-candle), is also used.

In general, three-chip cameras outperform single-chip cameras. They produce the most horizontal resolution, the best color rendition, and the highest **signal-to-noise ratio**, the ratio of background noise (visual distortion) generated by the camera's imaging system to the strength of the desirable video signal it produces.

Basic Camera Features

All cameras require electrical power to function. Portable cameras are battery (**DC**) powered, often by a rechargeable lithium-ion or nickel cadmium battery pack. Batteries usually insert into the camera, but they may also be carried in an external battery belt or shoulder pack. Most cameras have some type of adapter (or power unit) that allows the camera to use **AC** current from the wall, and many consumer-grade cameras provide car battery adapters that plug into the cigarette lighter for power. There often is a switch on the camera for selecting the type of power (AC or DC) a camera is to receive; another switch turns the power on or off. In some cameras the on/off switch has a **standby** position that allows the camera's circuitry to preheat or warm up without using full power.

Some rechargeable batteries can develop a "memory" problem if they are not handled properly. If a camera is used only for a brief time and then the battery is removed and placed in the recharger, it eventually will not be able to accept a full charge. This can be avoided if the battery is fully drained before being recharged.

The signal strength (brightness of the picture) of many portable cameras can be increased electronically by boosting the **gain**. Although this allows the camera to operate effectively at lower light levels, it creates more video noise (comparable to increasing the grain in a film image). Usually, a two- or three-position switch on the camera boosts the gain in large increments, such as +9 **decibels (dB)** or +18 dB.

Most consumer cameras are equipped with an **automatic gain control** (AGC) option that continuously adjusts the signal gain as the picture changes. In situations that call for a great deal of camera movement and different light levels, problems arise because the AGC will constantly try to compensate for varying levels of brightness and darkness. Being able to turn off the automatic gain control is a valuable asset.

Because they are designed for use by a single operator, camcorders have a triggerlike switch on the handgrip for starting, stopping, or pausing the tape. A camcorder has numerous control panels, each containing a series of buttons, switches, and knobs, usually grouped together according to whether they control functions for recording or playback.

Many consumer camcorders can insert the date and time on a recording, and some models can insert titles into a shot (some have a small keyboard). Another switch may record an index

search pulse to help locate that position during playback. Also, digital technology has made it possible to generate a number of in-camera (and recorder) special effects, such as wipes, still frames, pictures in a picture, strobing, and fades in or out.

A zoom lens is almost standard equipment in camcorders. A strap near the front of the camera or lens provides support for holding the camera by hand and should also place the hand close enough to the lens to allow for focusing or control of the power switch that governs the zooming operation. Such lenses normally have an **automatic iris** (auto iris), which continuously adjusts the iris opening to any lighting condition, and an **automatic focus** (auto focus) to keep the picture sharp and clear. Digital cameras often provide a digital zoom that extends the range of the optical (mechanical) zoom through digital means, usually with some loss of image quality.[17]

Many cameras also contain an electronic shutter switch for different high-speed shutter settings. The shutter reduces exposure in order to sharpen detail and help eliminate blurring in shots with fast action (such as a racing car). Another feature, **image stabilization**, digitally magnifies part of the image and tracks the image if the camera moves or mechanically readjusts the lens elements. Although image quality diminishes somewhat, image stabilization does make a camera movement appear steadier and less jerky.

Because the camera operator must be able to turn on or off many of these automatic functions, often while the camera is running, their layout and accessibility are important features. The electronic **viewfinder,** so standard on camcorders, is really an eyepiece-size monitor that not only allows the camera operator to compose and focus the shot but also enables the operator to monitor a variety of recording and playback functions. Most viewfinders are mounted on the side of the camera, can swivel to different viewing angles, and often contain some means of correcting vision for camera operators who want to shoot without their glasses.

Although cameras vary, electronic viewfinders usually present some sort of visual display of information (a warning light or graphic) about such factors as the amount of power remaining in the battery, the status of the tape (recording, paused, or amount of time left), the exposure (too much or too little light for proper exposure), which **filters** or **shutter speeds** have been selected, and the position or status of a range of camera controls (titling, special effects, standby, and so on).

Another set of controls on the camera is used to adjust the picture for proper color rendition. A filter wheel, or a switch on the less expensive cameras, permits selection of filters appropriate for various lighting conditions, such as sunlight or artificial light. (We deal with the issues of lighting and filtering in much greater detail in Chapter 6.) A closely related function, **white balance,** enables the camera operator to make more subtle adjustments in the camera's ability to record white correctly, even in situations in which the lighting has a different hue—more red at sunset, more blue on an overcast day.

Camcorders now incorporate a wide range of automated functions and controls such as automatic white balancing and automatic black balancing (setting the level of black in the picture). We have already mentioned a number of other automatic functions such as auto focus, auto iris, and auto gain control. Most of these automatic controls can be quite useful, particularly to a camera operator whose eye is glued to the viewfinder and whose attention may be focused on other elements of the production. In many instances, however, the auto-mania so rampant in consumer-grade equipment can mean a loss of creative control—an inability to make the camera do what you want it to do in certain conditions. The solution is simple enough—a switch that allows you to select a manual mode of operation.

Video Recording

A video recording system can be built permanently into the camera (a camcorder), it can be a VCR totally separate from the camera, or it can be a dockable recorder unit (see Figure 4.7). In the latter, the camera and recorder function like a camcorder, but you can detach the VCR unit from the camera and use it in other config-

urations. The main differences among these different systems are convenience and connections. A totally separate recorder must be joined to the camera by means of cable and connectors. These are often the weak link in the recording system because they break or in other ways malfunction. Having a separate VCR is more cumbersome, but it allows one person to operate the camera while another monitors the audio and video signals, reducing the likelihood of error. A dockable VCR can be used with a variety of different cameras or detached from the camera for repair or use in an editing system.

Videotape recorders place a number of signals on videotape, including, of course, the basic picture signal. (See Figure 4.8 for a diagram of typical signals recorded on videotape.) A number of **heads** within the recorder take the scanning information fed from the camera and put it on the tape, one diagonal track at a time.

The recorder also places **control track** information on the tape. This consists of electronic timing impulses that keep the picture stable. The audio information also is placed on the tape. This process is discussed in Chapter 8.

Some recording systems can lay **SMPTE time code** on the tape. This is a numbering system that provides an address number for each frame of video. For example, 1:02:15:10 would mean the tape was at 1 hour, 2 minutes, 15 seconds, and 10 frames. For some video formats, the time code is laid on one of the audio channels. For others it is laid on the vertical blanking interval or on a special section of the tape specifically reserved for time code. Still other camcorders and recorders do not come equipped with the components for recording time code in the field, in part because this would add to the cost. For this reason time code is sometimes added to the tape in postproduction. See Chapter 11 for a further discussion of time code.

Whether they are separate, dockable, or permanently attached to the camera, recorders contain the same basic controls familiar to home audio and videotape recorder users—play, record, pause, fast forward, rewind, and stop. Even in a separate camera-recorder configuration, the cable connecting the two components usually allows the camera operator to control most VCR functions from the camera.

Figure 4.7
(a) A camcorder with the recording system permanently built in; (b) a camera and a separate portable recorder; (c) a dockable camcorder—the back half is removable. (Photos courtesy of Panasonic Broadcast and Digital Systems Company)

Most recorders also have some sort of metering system so that you can evaluate the quality of the signal you are recording. The most professional VCRs have a number of separate meters—one for video and one for each of the

— control track

— video track

— time code address track
— audio channel track 2
— audio channel track 1

Figure 4.8

A typical, but by no means exclusive, positioning of analog signals on a videotape. Each format has its own unique placement of information. In this example, control track is on the top, but often it is at the bottom. Under the video track is a special area for time code. Some formats do not have this time code track; they record time code on one of the audio tracks or they embed it in the vertical blanking interval of the video track. Two or more tracks of audio are common but sometimes they are recorded diagonally like the video track.

audio channels. Others have only one meter, but it can be switched so that it shows either video or audio. Sometimes this same meter indicates the amount of charge in the battery.

VCRs have a variety of inputs and outputs for video and audio. The basic video input is the signal from the camera. In a camcorder the signal goes directly from camera to recorder. The audio inputs are used primarily for microphones and are discussed in detail in Chapter 8.

Audio outputs are used to route audio signals to editing equipment or to headphones or speakers. Video outputs take the signal to a TV screen where it can be displayed.

Video Connectors

Whenever the video signal leaves one piece of equipment and goes to another, it travels through cables and connectors. This is true when the signal goes from the camera to a recorder or when it goes from the recorder to a monitor. Because it is all in one unit, a camcorder can operate without cables or connectors. The connectors you are likely to encounter on a camera, VCR, or monitor are multipin, BNC, S, RCA, RF, and firewire connectors (see Figure 4.9). The **multipin connector** can carry video, audio, and remote control signals all in

one cable. For example, a multipin cable might allow the camera operator to use a button on the camera to place the separate recorder in the record mode. Multipin connectors are not alike; usually a particular multipin can be used with only one specific type of camera and VCR. Multipins that connect a camera and VCR look quite different from those that connect a VCR and monitor.

BNC connectors carry video only. If a camera's video output is connected to a VCR with a BNC connector, the recorder cannot be operated remotely from the camera controls. BNC connectors also are frequently used to route signals between VCRs.

S-connectors also carry video only. They are used with monitors and VCRs to input and output video signals that are separated into luminance (brightness) and chrominance (color). In other words, they are used for transporting component signals.

RCA connectors can carry either video or audio, but not both at the same time, and **RF connectors** can carry both audio and video from a VCR to a regular TV set.

Digital cameras usually include one or more of these analog connections so that the digital signal can be displayed on analog equipment such as monitors. Increasingly, digital cameras also include **firewire** connections. Firewire, which is also known as IEEE 1394, enables a digital signal to be copied from one piece of equipment to go to another. For example, if a camera has a firewire output, its signal can be copied into a computer with a firewire input.[18]

Monitoring the Recording

Viewfinders, monitors, and TV sets all can show the picture recorded by a VCR, but they vary in design, construction, and accessibility. The viewfinder is part of the camera and can be used to play back the videotaped signal. This is easiest with a camcorder or with a system that has a multipin connector between the camera and the VCR. Using a camera viewfinder is a convenient way to make sure you have an acceptable recording. However, it can show you

the picture only after the fact, and it can be viewed by only one person at a time.

Monitors look like home TV sets, but they cannot receive signals off the air. They receive a signal from a VCR through a multipin, BNC, or RCA connection. A cable run from video out (also called *line out*) of the VCR to video in (*line in*) on the monitor will enable the monitor to display the picture. Some monitors have built-in speakers (although many do not), but connecting the video alone will not allow sound to be heard. For a monitor to play video and audio, either use a multipin connector or run a separate cable from audio out on the VCR to audio in on the monitor. Separate, small, battery-powered monitors can be helpful on a shoot because they enable you to evaluate your recording while the taping is in progress. They also allow a variety of crew members (not just the camera operator) to see what is being taped. This advantage may be outweighed by the slowdown in production that results when the producer, director, actors, and crew members are constantly viewing the tape.

Regular home **TV receivers** can be used to display what is shot on videocassette, provided the necessary components and connections are available in both the VCR and the receiver. Unlike monitors, TV receivers are designed to receive broadcast signals that are transmitted via **RF (radio frequency)**; in other words, the signals have been **modulated** so that they will appear on a particular channel—2, 3, 4, 5, 6, and so forth. The video out signal from a VCR has not been processed in this way. It must first go through a modulator that places it on a channel—usually channel 3 or channel 4. Most ¹/₂-inch VCRs intended for home use have built-in modulators, and you can add RF units to many other systems. Home TV sets can be handy for viewing and assessing material shot for student movies.

multipin for a camera

multipin for a monitor

BNC

S-connector

RCA

RF

firewire

Figure 4.9
Some basic video connectors. From top to bottom: a multipin connector for a camera, a multipin connector for a monitor, a BNC connector, an S connector, an RCA connector, an RF connector, and a firewire connector.

Supporting the Camera

Many elaborate pieces of equipment have been designed to support cameras, including stands and clasps for holding a camera on an airplane wing and platforms that mount on the side of a speeding car. But the types of supporting devices most common in electronic filmmaking are the tripod and the human shoulder. Less common, mainly because of their cost and size, are the dolly and the crane.[19]

Figure 4.10
*(a) A Steadicam cam-
era stabilization system.
(Photo courtesy of
Cinema Products
Corporation and Lewis
Communications);
(b) a much smaller
Steadicam JR™ is
made for lightweight
consumer camcorders.
(Photo courtesy of
Cinema Products
Corporation)*

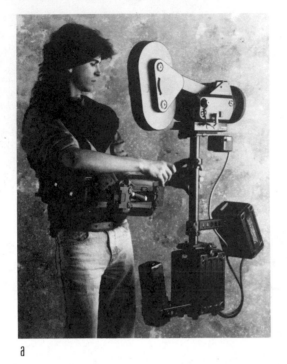

a

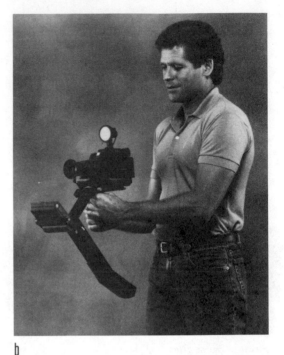

b

Figure 4.10
(a) A Steadicam camera stabilization system. (Photo courtesy of Cinema Products Corporation and Lewis Communications); (b) a much smaller Steadicam JR™ is made for lightweight consumer camcorders. (Photo courtesy of Cinema Products Corporation)

Hand-Held Cameras

Small lightweight cameras can be placed on the shoulder and hand held, even by people who are not especially strong. However, it is difficult to hold them steady for any long period, especially if you must walk or move in any other way. The result is often jerky pictures that are likely to cause motion sickness in anyone who watches them.

As previously mentioned, some cameras are equipped with a stabilized lens, a lens mounted in a housing in such a way that the lens moves counter to the camera's movement. Such housings improve picture stability, but they are expensive and cannot compensate for large movements.

More commonly, **shoulder mounts** are attached to the camera so that it rides comfortably on the shoulder. More elaborate **body braces,** such as a **Steadicam** (see Figure 4.10a), can also help the operator reduce unwanted camera movement. The Steadicam JR, a scaled-down version of the original Steadicam, was designed specifically for lightweight consumer camcorders (see Figure 4.10b).

Tripods

The **tripod** is a three-legged device for supporting a camera. The lengths of its legs are adjustable so that the tripod can be level even if the surface on which it is resting is not (see Figure 4.11a). Most legs will adjust so the camera can rise from 2 to 3 feet off the ground to slightly above eye level. If a camera needs to be lower, you can use a **high hat,** a board attached to very short legs.

Tripod legs have spikes or pads on the bottom so they can rest firmly on the ground or a floor. Sometimes wheels are attached to the legs to make the whole unit mobile.

Mounted on top of the three legs is a tripod **head,** a device with a handle that allows the camera to pivot smoothly (see Figure 4.11b). A screw on the head attaches it to the bottom of the camera. Some heads (usually inexpensive ones) are referred to as **friction heads** and use the resistance created by surfaces touching each other to provide smooth movement. More expensive **fluid heads** have adjustable hydraulic resistance that allows for easy, smooth camera movements. Both types have levers or screws that control the amount of freedom the camera has; heads can be locked down so they do not move at all, or they can provide varying degrees of movement.

Dollies

Professional **dollies** are wheeled carts that come in various sizes, from about the size of a wagon

to the size of a small truck (see Figure 4.12). They are often motorized and have a pole in the middle on which the camera is mounted. Usually, one person drives or pulls the dolly while another operates the camera. They are excellent for moves that involve going forward and backward. Students are usually talented at concocting homemade dollies from wheelchairs, grocery carts, and the like.

Cranes

Cranes are large pieces of equipment, like the phone company's cherry pickers, that can move the camera from very low to very high above the set. Many cranes can also move forward, backward, to the side, and in arcs.

A crane often requires several people to move it from one position to the next. Cranes are very expensive and are not used frequently, so they are usually rented. Many manufacturers also make counterweighted **jib-arms** that can be used to swing the camera out over an area that would be inaccessible to a large crane holding the camera operator and camera. For additional flexibility, many camera jibs can be attached to dollies or tracking bases. (Figure 4.13 shows a jib-arm and a crane.)

Figure 4.11
(a) A lightweight tripod and (b) a fluid head that allows smooth, fluid pans and tilts. (Photos courtesy of Miller Fluid Heads)

Moving the Camera

Mounting equipment also allows the camera to move. A number of terms describe these camera movements, whether they are accomplished by a crane, a dolly, a tripod, or a human body. A movement of only the camera from left to right is called a **pan**. Camera operators can pan left or right by moving the handle attached to the head. A **tilt** involves moving only the camera up or down and again involves using the tripod head's handle. Moving the camera and the supporting device left, right, in or out is called a dolly. For example, a tripod on wheels could be dollied left or right. The head would need to be locked down so that the camera did not move separately from the tripod. An up-and-down movement of the camera and the supporting device is called a **crane** or **boom**, once

Figure 4.12
A camera dolly mounted on tracks. Taken off the tracks, this particular dolly could also be moved on its pneumatic wheels. (Photo courtesy of EPIX, Pty, LTD.)

again because the crane is the best mounting device to use to go from low to high.

These four movements—pan, tilt, dolly, and crane—are the basic movements, although others, such as an **arc**, are used from time to time. Of course, you can make several movements; a

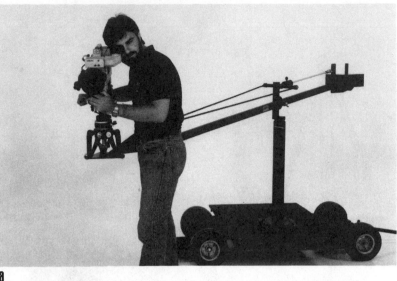

a

b

Figure 4.13

A camera mounted on a jib-arm (a) can provide up-and-down movements similar to those achieved with a larger crane (b). Note that the crane has space for mounting the camera and for the operator. (Photo a courtesy of EPIX, Pty, LTD.; photo b courtesy of Matthews Studio Equipment, Inc.)

camera can dolly in, pan left, and crane up all at the same time.[20]

Lenses

Lenses gather light reflected by a subject and concentrate it on the imaging device. A **lens hood** is often mounted on the front of the lens to keep stray light from hitting the lens surface and causing unwanted glare. A lens hood also may help protect the lens surface during transport.

Lenses consist of curved glass elements that turn the image upside down at the **optical center** of the lens and then focus it at a point where it begins its electronic or photochemical journey to being recorded. In a film camera, this focus point is the film itself; in a CCD video camera, it is the chip. Everything that is filmed or taped passes through the lens, so it is a very important part of moviemaking. High definition television, with its superior picture quality and its 16:9 aspect ratio, has given lens manufacturers a new challenge. They have designed special high-definition lenses that take full advantage of the camera's imaging, but at present these are very expensive. Lenses made for regular standard-definition cameras fit newer cameras but do not deliver an optimal picture. In addition, many digital cameras have built-in circuitry so that they can shoot either 4:3 or 16:9. The lens on the camera must be so designed that it delivers a quality image for both aspect ratios.[21]

Focal Length

Most lenses on TV cameras and camcorders are **zoom lenses** (more properly called **variable focal length lenses**), capable of capturing close-ups, wide shots, and everything in between. Other lenses, called **fixed lenses** (or **prime lenses**), are capable of capturing only one distance. If you frame a close-up with a fixed lens, you cannot keep the camera in the same position and change to a wide shot unless you change to a different lens.

With a zoom lens you can make this change, either while you are taping or between shots. To do so you must move elements within the lens by turning a barrel on the lens. This barrel can be turned by hand but more often is turned remotely by a servo-controlled motor. (Figure 4.14 shows a zoom lens with servo control.) A switch on the camera allows the operator to activate and deactivate the zoom and control its speed. The motor allows for a smoother zoom than can be accomplished by hand.

All lenses, zoom or fixed, have measurements that designate their **focal length.** One fixed lens may be a 25mm lens, whereas another is 50mm. A variable focal length lens may have a range of 10mm to 100mm. The focal length is the distance from the optical center of the lens to the point in the camera where the image is focused. The longer the focal length, the more the shot is magnified. A 50mm lens will show

greater detail, but less of a scene, than a 25mm lens. A zoom lens that is in the 100mm position will have a tighter shot than when it is in the 50mm position.

Zoom lenses often have a designation that specifies the ratio of the closest shot to the widest shot. For example, some lenses are 5:1, whereas others are 10:1. If the widest shot on a 5:1 lens is 20mm, the tightest shot will be 100mm. If the widest shot on a 10:1 lens is 20mm, the tightest shot will be 200mm. The bigger the ratio, the greater the zooming range—and the greater the cost of the lens.

Lenses or zoom lens positions that show shots that appear to be magnified are usually referred to as **telephoto**; those that show views roughly as the eye sees them are **normal**; those with a view wider than the human eye's are called **wide angle**. (These views are depicted in Figure 4.15.) The normal lens creates the most natural perspective. The telephoto not only makes things appear bigger, it also foreshortens them so that they appear to be closer to each other. If the objects are moving, they will appear to move more slowly than they actually are. The opposite is true of a wide-angle lens. It makes things appear smaller, farther apart from each other, and faster than normal if an object is approaching or receding from the camera position.

In effect, a zoom lens can be thought of as a lens having the characteristics of all the prime lenses that it can mimic within the extremes of its zoom range. It is so easy to go from wide angle to telephoto that operators sometimes do not weigh the advantages or disadvantages of a particular focal length setting. For example, an extreme telephoto shot can seem close to the subject and can fill the screen with detail but at the cost of foreshortened depth, difficulty in holding the camera steady, and a touchy focus because of the shallow depth of field. At the other extreme of the zoom range (wide angle) the opposite may be true. For example, although there is depth, the amount of detail needed to understand what is happening may not be discernible.

Zoom lenses often have a **macro** setting that allows the lens to focus on an object very close

Figure 4.14

A zoom lens with servo control mounted on the left. Note the lens hood, which keeps stray light rays from the lens surface. (Photo courtesy of Angenieux Corporation of America)

to the front element of the lens. A button or some other control allows you to select the macro position for the lens in order to create a screen-filling close-up of a small object, such as a coin or fingernail.

Although zoom lenses are standard on most video cameras, they are not always the best lenses to use. They are more expensive, mainly because they have more elements than fixed lenses (see Figure 4.16). They need more light because light dissipates as it goes through these dozen or so elements. They cannot be manufactured to provide an optimum picture at all focal lengths. However, zoom lenses have the obvious advantage of changing magnification easily. They are also likely to deliver more consistent color than prime lenses. Color rendition changes slightly from one lens to another, so if a 25mm lens is removed from a camera and replaced with a 50mm lens, the color recorded may change slightly. Prime lenses, however, need less light than zoom lenses and may produce a somewhat sharper image.

Until recently, the question of whether to use prime lenses or zoom lenses was irrelevant for consumers with camcorders. The camera simply came equipped with a zoom lens that could not be removed or changed. However, a number of equipment manufacturers, including Canon, Hitachi, Matsushita, and Sony, have jointly developed a lens mounting system

Figure 4.15

From the same position a zoom lens can present (a) a wide angle of view, (b) a relatively normal angle of view, and (c) a telephoto view of the scene.

a

b

c

you look in the viewfinder while turning the focus knob, you usually can discern when the picture is in focus. However, a good practice is to look at the focus ring to make sure it reads a distance about the same as the actual distance to your subject. If you are 10 feet from a subject and your focus ring reads 3 feet, something is wrong with the optics. If focus is crucial, you can run a measuring tape from the camera imaging device to the subject and set the focusing ring to correspond to the measurement. For many years this has been a common practice in filmmaking.

The focusing mechanism for a fixed focal length lens is quite simple. It merely moves the lens elements closer to or farther away from the imaging device. When the object to be placed in focus is close to the camera, the elements should be far from the imaging device. If the shot is focusing on a distant object, the elements should be closer to the film or CCD.

To focus a zoom lens properly you should take advantage of the zoom by zooming in all the way (the most magnified or telephoto setting), focusing, then zooming out to frame the shot. This focusing technique allows you to zoom in or out during the shot without losing focus on the subject. This type of focusing sets what is referred to as the zoom lens **front focus** because it changes the glass elements at the front of the lens. Zoom lenses also have a back focus, which should be adjusted only by a qualified camera technician. If the lens is jarred, this back focus can come out of adjustment, causing a fuzzy picture.[22]

that does allow for interchangeable lenses that retain most automatic functions (auto focus, auto iris, zoom control, and so on). In addition, some of Canon's camcorders feature a special adapter that allows the camera to accept a wide array of 35mm lenses from Canon still cameras (see Figure 4.17).

Focus

A lens has a ring for controlling **focus**, with numbers on the ring that give distance in feet (and inches) and meters. When something is in focus, it looks sharp and clear; when it is out of focus, it appears fuzzy and ill defined. When

Aperture

In addition to the focus ring, lenses have a ring that determines how much light is let into the camera. This ring controls the size of the **aperture**—the opening in the lens that allows light to pass. The aperture has an adjustable **diaphragm** or **iris** that opens and closes to let in more or less light. The degree to which the aperture is open is measured in **f-stops,** which are numbers that usually appear on the aperture ring.

F-stops can be confusing, if for no other reason than they are depicted by rather strange

numbers—1.4, 2, 2.8, 4, 5.6, 8, 11, 16, 22. The reason for these seemingly unrelated numbers involves a mathematical formula that calls for multiplying each preceding number by the square root of two. In this relationship each f-stop doubles or halves the amount of light of the f-stop next to it. This relationship adds to the confusion because the larger the f-stop number, the smaller the aperture. In other words, there is an *inverse relationship* between the two. An f-stop of 8 will let in half as much light as an f-stop of 5.6; an f-stop of 11 will let in twice as much light as an f-stop of 16. (Figure 4.18 shows various f-stops and their apertures.)

Some lenses may include a **t-stop** scale. T-stops are more accurate than f-stops and are more likely to be used in film than in video. All lenses lose a certain amount of light within the lens itself, depending on the quality of the lens and its coatings. T-stops denote the actual amount of light *transmitted* (thus the *t* in *t-stop*) through a particular lens.

Lenses are rated according to their lowest f-stop number—the greatest amount of light they can let in. An f/1.4 lens is considered a fairly **fast lens** because it can open up wide enough to let in a good deal of light. An f/4 lens would be a **slow lens** because it can let in much less light.

As with focus, many cameras have an automatic iris that adjusts to the amount of light hitting the image plane and sets the f-stop accordingly with a small motor that opens and closes the iris. Again, this is fine as long as you want average exposure. But if you want the scene to look dark, or if you have a scene with a bright background and a dark foreground, you may need to turn off the automatic iris.

Some situations require sacrificing overall exposure for the sake of correctly exposing the most important element in the frame. One way to make sure that your light reading is correct under these circumstances is to zoom in on that element and look at the automatic iris reading. Then zoom back out to your intended composition, and set the iris manually for the f-stop reading you had when you zoomed in. This is especially helpful if you have a person standing in front of a bright background. The automatic

Figure 4.16

A cutaway of a zoom lens showing the many different elements within. (Photo courtesy of Canon USA Inc.)

Figure 4.17

A Canon LX-100 Hi-8 camcorder that can use many different Canon lenses. (Photo courtesy of Canon USA Inc.)

iris might expose for the bright background when what you want to be able to see is the person's features. If you have zoomed in and set the iris for the person's face, the face will be the element that is properly exposed.

Depth of Field

Depth of field is the distance (the range, really) through which objects will appear in sharp focus in front of and behind the point at which

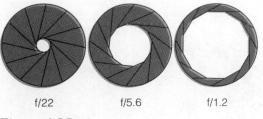

f/22 f/5.6 f/1.2

Figure 4.18
The thin metal blades of the lens iris open or close the aperture to different f-stops. The smaller the opening, the larger the f-stop number (and the less light the lens will allow to enter the camera). Lens speed is based on how much light a particular lens will let in at its maximum aperture. Thus, a lens with a maximum aperture of f/1.2 is faster than a lens with a maximum aperture of f/2.

the camera is actually focused. The depth of field varies according to the aperture, the focal length of the lens, and the distance of the camera from the subject. The longer the focal length of the lens and the wider the aperture, the shallower the depth of field will be. Thus, wide-angle (or short focal length) lenses give a greater depth of field than telephoto (or long focal length) lenses. Generally, the closer the subject is to the camera the less the depth of field will be.

When two characters or objects are lined up at different distances from the camera, it sometimes may be necessary to split the focus to keep both subjects in clear, sharp view. This is not done by focusing on a point midway between the two; rather, it is done by focusing on a point one-third the distance behind the front subject. In other words, focus will be sharp for an area one-third in front and two-thirds behind the point of focus. (Figure 4.19 illustrates the depth of field and the one-third principle.)

Focal length affects depth of field because wide-angle lenses have a greater natural depth of field than telephoto lenses. They are designed to capture large, deep scenes.

The smaller the aperture (and the larger the f-stop number), the greater the depth of field. A lens set at f/22 will create a greater depth of field than one set at f/2.8. This characteristic can be used to highlight certain objects in the frame by having them, and only them, in focus. Most lens manufacturers and many publications such as the *American Cinematographer Manual* publish depth-of-field

charts that give the depth-of-field characteristics for lenses of different focal lengths under various conditions.

Care of Equipment

All equipment and supplies mentioned in this chapter should be handled and stored carefully. They represent an investment on the part of an individual, a school, or a company. Careless handling shortens their life and causes unnecessary operating problems.

One good rule is *never force anything*. If a connector won't slide into its receptacle easily, you probably do not have it lined up correctly. If you force a knob on a tripod, you may strip the threads. If a lens ring is binding or feels excessively loose, you are going to make things worse by forcing it. Driving a lever, switch, or dial against the end of its movement range will damage the equipment.

You should also protect equipment while transporting and storing it. Whenever possible, store and carry cameras and their lenses in sturdy, well-padded cases that hold the equipment securely in place so that it will not bounce around. If possible, store and carry tripods in sturdy cases. Before putting a tripod in the case, be sure that all levers are locked, the legs are bound together, and the handle attached to the head is positioned so that it cannot be damaged. Similarly, monitors and recorders should have their own cases.

Even with cases to protect the equipment, everything should be moved as gently as possible. For cases that have wheels, use an elevator or handicapped ramp if available. If necessary, simply pick up the case and carry it a short distance.

Extreme heat or cold is not good for most equipment, and electronic gear must be protected from moisture. Keep lenses away from areas of high heat because the cement holding the elements in place may melt. Store tape and film in a cool place. Never leave film or tape in a parked car where the temperature can reach high levels.

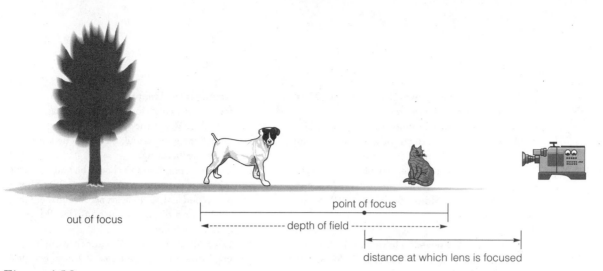

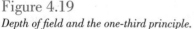

point of focus

out of focus

depth of field

distance at which lens is focused

Figure 4.19
Depth of field and the one-third principle.

Dirt is also an enemy of electronic components. Keep equipment and supplies off the ground, especially if the area has sand or loose dirt. Keep cameras, recorders, monitors, batteries, tape, film, and cables and connectors in cases, boxes, or bags when not in use.[23]

Lenses should be kept spotlessly clean. Although it is possible to clean a lens, doing so too often is not recommended. Anything touching a lens, even a cleaning cloth, can scratch it or wear down its antireflective coating. Fingerprints are especially bad for lenses. They produce a smear on the picture, and the oil from fingers can over time etch the lens. If the lens becomes dirty, remove dust gently with a camel hair brush. Next, place a drop of special lens cleaner on a special nonabrasive lens tissue and rub it lightly over the lens surface in a circular motion.

One of the surest signs of professionalism is the respect with which a person treats equipment.

Notes

1. Lenny Lipton, *The Super 8 Book* (New York: Simon & Schuster, 1975), pp. 9–12.
2. Film formats have never been quite as standard as this discussion suggests. The number of perforations per frame has varied from two to six, and at different times in film history ultra-large-screen film formats have been introduced with film widths of 62mm, 63mm, and 65mm. The Cinerama format, for example, initially required three cameras at a frame rate of 26 frames per second.

In fact, much of the experimentation with large-screen formats involves increasing the frame rate to a speed higher than the customary 24 frames per second (fps) standard. By increasing the filming and projection speed to 48 fps or 60 fps, much higher image quality can be achieved in terms of sharpness and clarity.
3. Robert Rivlin, "Composite-Component: Evolution or Revolution?" *E-ITV,* September 1987, pp. 16–24.
4. Some good general articles that cover the various formats are Claudia Kienzie, "A Wide-Angle View of HD Cameras," *TV Technology,* 10 August 1998, p. 20; "Zooming in on Camcorders," *Consumer Reports,* October 1998, pp. 22–25; "Video Recorders—Year of the Disk," *TV Technology,* 23 March 1998, p. 204; Michael Grotticelli, "Digital Betacam Makes the Film-to-Tape Transition," *Videography,* October 1995, pp. 66, 84–85; "Video Formats for the Past, Present, and Future," *Computer Video,* July/August 1995, pp. 24–32; "Panasonic, Sony Unleash Rival DVCs," *TV Technology,* 22 March 1996, p. 1; and David Brott, "Digital Frontier," *Videomaker,* November 1995, pp. 43–46.
5. In reality there have been and are many more formats than what is discussed here. Formats using 1-inch tape have come and gone several times. In the 1960s there was a 1/2-inch reel-to-reel format developed by Sony and a 1/4-inch reel-to-reel developed by Akai. A number of cartridge-based formats were introduced in the 1970s and 1980s that didn't last long. A 1/2-inch cassette format called ED-Beta was developed by Sony in the late 1980s to appeal to the education market, but this market latched on to other formats and the ED-Beta was discontinued. In

the digital realm, D4 was abandoned but D5 exists and D6 is in development.

6. There are actually far more aspect ratios in film. Between the two extremes, the 1.33:1 Academy ratio and the Cinerama 3:1 ratio, are nine sizes. For a good historical summary of different aspect ratios, see Lenny Lipton, *Independent Filmmaking* (New York: Simon & Schuster, 1983), pp. 182–183.

7. Bruce Elder, "Widescreen Fever: Letterboxed Films Find Passionate Following in the Laserdisc Age," *Video,* September 1991, pp. 53–54. See also "Widescreen Presentation," *LaserNews Special Report,* 1991, pp. 1–4, for an excellent discussion of the problems associated with translating widescreen motion pictures to laser disk.

8. Stuart Jagoda, "CBS Debuts Primetime HD First," *TV Technology,* 14 December 1998, p. 16.

9. Film manufacturers continue to improve the speed and the resolution of their film stocks. See, for example, Tony Harcourt, "The Features and Benefits of T-Grain Emulsion," *In Camera,* Summer 1995, pp. 28–29; "Know Your Vinegar," *Hollywood Reporter,* 14–20 July 1998, pp. S-9; and Frank Beacham, "A Production Standard for the Ages," *TV Technology,* 15 June 1998, p. 37.

10. For an excellent discussion of videotape materials and coatings, see Ron Goldberg, "The Layered Look," *Video,* July 1992, pp. 34–36, 94–96; and Lancelot Braithwaite, "VHS Tape Tests," *Video,* March 1993, pp. 38–43.

11. For example, the VHS format has VHS-C (the C stands for compact). VHS-C tapes are made specifically for camcorders. They can be played in a home-size VHS deck only with the aid of a special adapter. The 3/4-inch U-Matic format has minicassettes that come in 5-, 10-, 15-, 18-, and 20-minute lengths. The consumer-level digital video formats use minicassettes that can record 30 or 60 minutes of digital video.

12. Craig Johnston, "Cameras Come in Many DTV Flavors," *TV Technology,* 4 May 1998, p. 68.

13. Early researchers credited this phenomenon to the so-called persistence of vision, the capacity of the human eye to retain each image (each projected frame) for a fraction of a second. Coupled with the Phi phenomenon, a response observed by Gestalt psychologist Max Wertheimer, the sense of motion on the screen is possible. Scientists, however, are still debating precisely how this process actually works. The illusion of movement created by a series of projected still pictures is the result of complex physiological and psychological factors. If the film projection rate is too slow, 8 frames per second, for example, the image appears to flicker. When the speed is increased to 16 or more frames per second, the viewer no longer perceives the flickering.

14. Some exceptions to this should be noted. In color television the actual frame rates are 29.97 frames per second and 59.94 fields per second. See Chapter 11 for a discussion of non-drop-frame and drop-frame time code.

15. Paige Albiniak, "HDTV: Launched and Counting," *Broadcasting and Cable,* 2 November 1998, p. 6.

16. When you watch an NTSC broadcast television channel at home, you are probably seeing a signal (depending on the strength of the broadcast signal and how finely your receiver is tuned) with somewhere between 200 and 300 lines of horizontal resolution. The highest-quality cameras, recorders, and studio television monitors can produce an image with 600 to 800 lines of horizontal resolution. A regular VHS camcorder produces an image much closer to 200 lines of resolution. In comparison, a S-VHS or Hi-8 camera produces an image with more than 400 lines of horizontal resolution, though you can see the difference only if your television is capable of accepting the S-VHS or Hi-8 signal through a special connector.

17. Three main types of auto-focusing systems are used in camcorders today: range finding, phase detection, and blur reduction. For an excellent discussion of the pros and cons of the various systems, see David Ranada, "Inside Optics: How Camcorders See," *Video,* October 1990, pp. 38–43. One offshoot in auto focusing, "fuzzy logic," was designed to avoid the "hunting" so typical of the earlier auto-focusing systems. When confronted with multiple subjects, many older auto-focusing systems go back and forth, in and out of focus. In contrast, a fuzzy logic system surveys many objects at different distances, chooses a compromise setting, and stops grinding back and forth. See, for example, "Fisher 8mm Fuzzy Logic Camcorder," *Video,* October 1990, p. 25. It is worth testing any auto-focusing system before purchasing a camera. It is also important to be able to override or turn off the auto-focusing system when circumstances require it.

18. "Wrapping Up NAB '98," *Video Systems,* June 1998, p. 50.

19. For articles on camera mounts see "The Pros and Cons of the Tripod," *TV Technology,* February

1993, p. 36; and Michael Wiese, "Zen and the Art of the Steadicam JR," *Videography*, December 1990, pp. 41–43.

20. A remote controlled, consumer-grade camera tracking system has been introduced by Parkervision (8493 Baymeadows Way, Jacksonville, FL 32256). This system allows the operator to execute camera movements entirely by wireless remote control with the camera mounted in special housing.

21. Michael Grotticelli, "New Lenses Key to HDTV Acquisition," *TV Technology*, 8 May 1997, p. 114; and "Choosing the Right Camera and Lens," *Video Multimedia Producer*, November 1998, p. 67

22. This is tied to depth of focus, a concept that is often incorrectly confused with depth of field. Depth of focus refers to the distance between the back of the lens and the target of the camera. If this distance is changed, the depth of focus is changed and the picture will not focus properly. The focus can be adjusted by setting the lens at infinity and zooming in on a distant object. Then adjust the distance between the lens and the target of the tube (the back focus) so that the image is sharp. When you zoom out, the image should stay sharp. If it doesn't, adjust the back focus in the zoomed-out position until the picture is sharp. Now zoom in. The picture should be sharp. Continue to do this until both the zoomed-in position and the zoomed-out position yield a focused picture.

23. Gordon McComb, "How to Triple Your Camcorder's Life," *Video*, December 1994, p. 26.

chapter five
Approaches to Image Making

After deciding what to shoot, the director's concern shifts to how to shoot it. The distinction here is between what is put in front of the camera and how the camera itself is used to record and manipulate the scene being shot. Film scholars have adopted the French theatrical term **mise-en-scène** to describe the director's control of the lighting, sets, locations, props, makeup, costumes, and blocking.[1] This concept is useful in defining more clearly the role of cinematography.

The director can make decisions about the mise-en-scène during preproduction or production (the last-minute blocking of the actors or adjustment of the lights) but before the camera comes into play. In effect, the mise-en-scène is what is visible through the viewfinder before shooting—the way the scene is staged for the camera. Once the director decides on the mise-en-scène, attention moves to how best to capture it with the camera. At this point the director and cinematographer must make a number of choices about composition.

Shot Determination

Interpreting the mise-en-scène involves determining how much of that scene to include within the shot. One of the special powers of the camera is its capacity to force the audience to see what the director wants the audience to see. This situation is quite different from real life or from a stage play, where the observer is freer to choose the point on which to concentrate. At a play, part of the audience may be watching the French maid; the rest may be watching the English butler. When a camera is used to interpret that scene, the viewer can virtually be forced to see a single area of the scene, such as the maid's eyes.

Of course, the director may also use elements of the mise-en-scène to direct the audience's at-

tention, whether in a movie, at a stage play, or even in real life. The lighting, blocking, costumes, makeup, set design, and dialogue are elements that can direct the viewer's eye. But the camera directs the audience's attention in a more obvious and powerful manner.

The Basic Shots

Selecting what is to be seen in the frame is one way the camera can be used to direct attention. This capacity distinguishes a film from a play, where the frame is the entire proscenium arch. In the theater you buy the frame through which you are going to see the play when you pay for your seat. The cheaper the seats the longer your "shot" of the stage. Shots are constantly changing in a motion picture. You see a variety of **long shots (LS)**, **medium shots (MS)**, and **close-ups (CU)**. (Figure 5.1 illustrates these shots.)

Defining these terms is not always easy. A long shot may mean different things to different directors. It may even mean different things in film and television. A long shot in a three-camera television interview show may refer to a shot that includes guests and the host. In a film, a long shot might include a cowboy hero riding his horse through the wide open spaces of Monument Valley.

Generally, a close-up isolates the subject, such as an actor, from the surroundings. A medium shot provides not only a shot of the subject but also of some of the surroundings. A long shot emphasizes the surroundings and the subject's place in relationship to them. To some extent these terms are relative to each other. A shot might be called a long shot in one sequence of shots but a medium shot in another. Perhaps the simplest way to describe different shots is in terms of a spectrum, with an extreme long shot as the widest shot and an extreme close-up as the nearest shot. All other shots are spread somewhere between the two extremes.

Often the language we use to describe various shots is based on the human body. A long shot includes the entire body. A medium shot is from somewhat below the waist to the top of the head. A close-up is from the shoulders up.

Another common way to describe a composition is according to the number of people in

the shot; for example, a two-shot has two people, and a three-shot has three people. Terms such as *head shot, head-and-shoulders shot,* and *full shot* are fairly self-descriptive, but none of these terms is exact. (Figure 5.2 shows some standard shots.) Given that there are many ways to describe a composition and that your medium shot may be somewhat different from what your friend means by a medium shot, the real translation often lies in the camera viewfinder. The director can look through the viewfinder and say, "That's what I want."

Subjective Shots

Another type of composition injects a subjective element into the composition. A shot in which the lens of the camera becomes, in effect, the eye of a character in the film is called a **point-of-view (POV) shot.** We are all familiar with a novel that is narrated by a character such as the hard-boiled detective. Narration from the viewpoint of a character within the story is more difficult in film and video. Nothing within the shot itself tells you that this is what James Bond sees. But a close-up of Bond's eyes (and a slight widening of the pupils) can be followed by a POV shot that approximates the height, angle, and direction of Bond's gaze.

Sustaining this for an entire film, however, greatly reduces a director's storytelling flexibility and can be almost silly. Robert Montgomery's film *The Lady in the Lake* (1946) tried, and not very successfully, to create a visual equivalent of first-person narration (like the hard-boiled detective novel on which it was based) by using POV shots for the entire picture. We see the detective's hands reaching into drawers or his pipe poking into the shot as if the camera were located precisely at eye level and the pipe were in our (his) mouth at the bottom of the frame. The detective in *The Lady in the Lake* is seen only occasionally, in a mirror or window reflection.

Most filmmaking uses POV shots far more sparingly. However, a director who does want to suggest a point of view can heighten the realism of this shot by using a slight movement of the camera to simulate an actor's head or eye movement. Another common subjective cue is placing a mask over the lens to simulate binoculars

a

b

c

Figure 5.1

(a) A long shot, (b) a medium shot, and (c) a close-up shot.

or a keyhole that a character might be looking through.

a

b

c

d

Figure 5.2

Other common shot descriptions: (a) a two shot; (b) a full shot; (c) a head-and-shoulders shot; (d) an extreme close-up, sometimes called a choker close-up. (Photos a, b, and c from Len Richmond's Merchants of Venus, *courtesy of Amazing Movies; Dianna Ippolito, photographer)*

The **over-the-shoulder (OS) shot** (see Figure 5.3) is also executed from a particular position. This shot literally looks over the shoulder of one character toward another character or object. An OS shot is a typical way of shooting two people talking. For example, a man might be seen from over a woman's shoulder. A reverse angle shot would then show the woman from over the

shoulder of the man. Over-the-shoulder shots have a subjective element. We are seeing from approximately the same angle as the character whose shoulder we are looking across.

Lens Selection

Another aspect of composition concerns the choice of **lens** or the setting of the variable focal length zoom lens. This choice can determine how something appears in terms of physical and psychological distance. It can also direct attention by selecting what will and will not be in focus.

Focal Length Characteristics

The **normal lens,** so called because it shows things much as the viewer's eyes see them, might be the least manipulative and most realistic of the various lenses. It introduces the least distortion into the scene.

The **telephoto lens** (or **long lens**) tends to compress the perceived distances between the foreground and background within the shot. The television commercial in which the auto executives demonstrate their faith in the brakes of their company's luxury sedan is actually demonstrating their faith in the power of an extreme telephoto lens. This lens makes the car that is screeching to a halt near their legs seem much closer than it actually is.

In general, the long or telephoto lens may be the most obvious lens in the sense of calling attention to itself. It can draw the viewer into the scene, creating intimacy and involvement. An extreme telephoto lens can so distort perspective relationships that the result is an almost surreal, dreamlike quality. This lens can also give a voyeuristic feeling, almost as if the spectator is eavesdropping on the scene. *Mississippi Burning* was shot largely with a telephoto lens to give a closed-in feeling that evoked racial tension.

On the other hand, an extreme **wide-angle lens** (or **short lens**) calls attention to itself by distorting the image, albeit in the opposite way. It can create a feeling of size and scope by giving a wide horizontal field of view. This characteristic can be used to delineate relationships between characters in a film. Orson Welles's classic film

Figure 5.3
An over-the-shoulder shot.

Citizen Kane is noted for its extensive use of extreme wide-angle lenses to emphasize the physical distance and the psychological distance between its characters.

The object is to choose the focal length that fits the sense of the scene you are shooting. What kind of relationships do you want to emphasize through size, distance, and perspective? Do you want to distort or call attention to the way the *mise-en-scène* is being manipulated? (Figure 5.4 shows the same scene shot through a normal lens, a telephoto lens, and a wide-angle lens. The cars seem closer together with the telephoto lens.)

Depth of Field

By manipulating the **depth of field** the director has yet another way to direct the spectator's attention within the frame. A large depth of field allows the viewer's eyes to roam throughout every plane of action, all of which will be in focus. Some directors, like Orson Welles and Jean Renoir, are noted for using deep focus in their films. This technique can be more realistic because it approximates the way we see. It also allows the viewer to seek out an area of interest in a composition with many layers.

A shallow depth of field (or shallow focus) isolates a subject in one plane and throws all other planes out of focus. (Figure 5.5 shows examples of deep and shallow depths of field.) In the heyday of Hollywood studio production a shallow depth of field was often used to isolate the studio's major star from any visual distractions in the foreground or background. Using a shallow depth of field also makes it possible to

a

b

c

Figure 5.4

*Photo a shows a parking lot shot with a normal lens. The distance
between the cars in photo b, taken with a wide-angle lens, appears
greater than it really is, whereas photo c, taken with a telephoto lens,
makes the cars seem closer together than they actually are.*

shift the point of focus during the shot. This
technique, as it is seen on the screen, is known
as **rack focus**. It is the result of **pulling focus**
(that is, changing focus) during the shot (see
Figure 5.6). For example, a shot might begin
with the star in sharp focus in the foreground,
but as the focus is shifted, the star blurs out of
focus while a character in the background comes
into sharp relief.

Camera Angle

The angle of the shot can also affect composi-
tion. A camera can be placed above or below the
scene, creating a **high-angle shot** or a **low-angle
shot.** The standard (or conventional) meaning
attached to these shots deals with the relative
dominance of different viewing angles. A shot
looking down usually diminishes or weakens the
subject (or character), whereas a shot looking up
tends to accentuate the power or dominance of
the subject. In Orson Welles's *Touch of Evil* the
corrupt and corpulent border police officer,
played by Welles himself, is consistently shot
from extreme low angles, making him gro-
tesquely sinister and powerful at the same time.

These are examples of extreme angles, how-
ever. The normal camera angle in narrative mo-
tion pictures is chest high, not eye height, a
practice that does not match the viewer's every-
day visual experience (unless the viewer is very
short). This angle does match the viewer's expe-
rience of watching motion pictures—a chest-
high camera angle is the norm, the conventional
angle for shooting "larger-than-life" film stars.
Consequently, eye-height angles (as in shoulder-
mounted camera work) look like high angles
even though they are totally realistic in terms of
our normal viewing experience. A **Steadicam**
(see Chapter 4) allows stable, hand-held, mobile
shooting at angles lower than eye height.

The framing of a shot may also be manipulated
by the degree to which the framing is level with
the horizon. A **canted shot**, or **tilted shot**, is so
unusual and disorienting that it can be unsettling
to the viewer. A POV shot that suggests someone
is drunk or drugged frequently uses this composi-
tion, but it is wrong to suggest that a canted frame
always means something is askew or out of kilter.
The meaning of a canted frame, or for that matter

a b

Figure 5.5

(a) A shallow depth of field in "Married . . . with Children" (photo courtesy of Columbia Studios) and (b) a deep or large field in Jean Renoir's classic film Rules of the Game *(photo from Janus Films).*

a

b

Figure 5.6

(a) The man in the foreground is in focus. Pulling focus (b) brings the man in the background into focus and throws the man in the foreground out of focus. (Photo courtesy of Video Producer: A Video Production Lab *by Herbert Zettl and Cooperative Media Group, published by Wadsworth Publishing Company)*

a high angle or low-angle shot, is derived from the context of the film, not from some dictionary of camera aesthetics. (The photos in Figure 5.7 illustrate different camera angles.)

Composing Within the Static Frame

Some shots that the director composes are relatively static because the camera does not move very much. A number of conventions, or so-called rules, have evolved regarding the composition of a shot within a static frame. These involve such elements as balance, depth, relative strength of various planes of the shot, and the space on and off the screen.

Manipulating the Mise-en-Scène

Before the camera rolls, the way the event is staged for the camera has a profound effect on how the composition directs the viewer's eye. The director's storytelling technique is based on a subtle interplay of lighting, blocking, costumes, and setting and the way the camera emphasizes those elements.

In a culture that reads left to right, the left side of the frame is probably more powerful than the right. To counterbalance this tendency it may even be useful at times to place an object (or character) of greater size on the right side of the frame.

Usually, the element that has the greatest mass or that takes up most of the composition will

Figure 5.7

*Different camera an-
gles: (a) a canted shot;
(b) a shot with normal
framing level to the
horizon; (c) a two-shot
from the conventional
chest-high angle in*
Merchants of Venus;
*(d) a high-angle shot;
and (e) a low-angle
shot from Jean Renoir's*
Rules of the Game.
*(Photo c from Len
Richmond's* Merchants
of Venus, *courtesy of
Amazing Movies; Di-
anna Ippolito, photog-
rapher; photos d and e
from Janus Films)*

draw the most attention. However, the placement
of objects or characters within the scene is not the
only way to attract the viewer's attention. The
most brightly lit object (or person) in the compo-
sition also tends to dominate the frame. The col-
ors of costumes, props, or the set itself can create
a visual emphasis. In Robert Altman's *The Player*
the appearance of Cher in a bright red dress at a
formal social gathering, where everyone else is
wearing black or white, absolutely guarantees that
she will be noticed. During the liquidation of the
Warsaw Ghetto in Steven Speilberg's *Schindler's
List,* a young girl in a red coat is the only visible
color in an otherwise black-and-white scene. The
red coat is glimpsed again later in the film as the
camera pans across a pile of discarded clothing,
indicating that the girl is dead.

The different lines of interest established
within the composition have a dramatic effect
on how the viewer sees and interprets the
image. Diagonal lines across the frame are often
more dynamic than horizontal lines (see Figure
5.8). Shooting a group of choir boys in a circle
rather than in a straight line may create a feel-
ing of tranquillity. Shooting an actor framed by
a window or archway says something far differ-
ent visually than shooting the same actor in a
flat, even composition.

The **blocking** of actors is one of the director's
most basic tools for focusing the audience's atten-
tion. An actor closer to the camera is more domi-
nating than one farther away. A performer facing
the camera tends to grab the spectator's attention
more than someone turned three-quarters, in
profile, or away from the camera. A person in
motion tends to attract the viewer's eye more than

a person who is stationary. Similarly, an actor who is standing while the other actors are seated (or vice versa) receives greater emphasis. A performer alone, away from others in the composition, tends to attract more attention, as does an actor on whom all the other actors seem to be focusing their attention. Someone entering the scene usually is more dominating than someone leaving the scene.

Ultimately, the director's dramatic objective for a given scene determines the way the event is staged for the camera. What are you trying to emphasize? What do you want the audience to see? The answer to these questions lies somewhere between the manner in which the viewer's attention is directed by the mise-en-scène and the way in which the camera interprets the mise-en-scène.

Balance

Unbalanced compositions are considered more interesting than **balanced** compositions. When subjects within the frame are balanced so that the relative "weights" on the left and the right or on the top and the bottom are equal, the composition appears stable and solid but also tends to be flat and lacking in depth. Unbalanced compositions are more dynamic and visually active and often can be used to create a sense of instability or tension. One reason for this is that what is in the "heavy" (or weighted) half of the frame tends to draw the items in the "light" half of the frame toward it.

The real objective, of course, is not to create individual shots suitable for framing on the wall but to create a composition that is appropriate for the subject at hand. Sometimes a perfectly stable and relatively flat composition is exactly right. For example, George Cukor used many balanced frames in his film *Adam's Rib* to convey equality between Spencer Tracy and Katharine Hepburn (see Figure 5.9). There is nothing inherently correct or incorrect about a balanced or unbalanced composition. What really matters is how the composition contributes to the overall production.

Rule of Thirds

Closely related to the concept of balanced-unbalanced compositions is the **rule of thirds,** which states that you should try to avoid break-

Figure 5.8

The diagonal lines add to the interest of this shot of Prunella Gee and Michael York. (Photo from Len Richmond's Merchants of Venus, *courtesy of Amazing Movies; Dianna Ippolito, photographer)*

Figure 5.9

A balanced and relatively flat composition from Adam's Rib. *(© 1949 Turner Entertainment Co. All rights reserved)*

ing the frame in half (top and bottom or left and right) because such compositions tend to be overly balanced and flat. Breaking the frame into thirds tends to create less symmetrical and more active compositions. Because the lines of interest are more on the diagonal, the viewer's eyes may be drawn more powerfully across the frame, and a sense of depth may be enhanced by the more angular, less even composition (see Figure 5.10).

Figure 5.10

A shot from "Married . . . with Children" provides a good demonstration of the rule of thirds. A strong diagonal line of interest flows from the kneeling shoe salesman in the lower left third to the woman trying on shoes up to the reaction by coworker Al Bundy in the upper right third. This picture also demonstrates how the sense of depth can be enhanced by having objects in different planes throughout the composition. (Photo courtesy of Columbia Studios)

Creating Depth

A director can accentuate the sense of depth in a static shot in a number of ways. For example, giving a frame a definite foreground, middle ground, and background provides a sense of depth (see Figure 5.11). A shot of a person (foreground) placed in front of a wall (background) does not appear to have much depth, but if a middle ground figure such as a bush, or even a shadow, is added between the person and the wall, the frame will assume more depth. Overlapping foreground objects with middle ground or background objects enhances the sense of depth even more. Variations in size of objects within the frame or in their position within the picture plane can also serve as depth cues, as can color and brightness.

Unbalanced compositions and strong diagonal lines in the composition tend to increase the depth cues and draw the viewer's eyes back into the frame. A director must take care, however, to keep background objects, such as potted plants and telephone poles, from appearing to grow out of a person's head.

Composition is too complex and too subjective for a simple rule book. There is nothing inherently right or wrong about a composition that is flat as opposed to one that emphasizes depth.

On-Screen/Off-Screen Space

Another important element of composition involves the director's use of space outside the frame of the film or television image. The frame limits what we can see of a scene, but a director can choose to open up the frame by having actors leave and reenter the frame or by framing shots that make us more aware of the space outside the frame. We may see only the front half of the dog in the frame, but we are at least subliminally aware that the rest of the dog exists just outside the frame. Conversely, during the heyday of the Hollywood studio system the frame was generally more closed. Actors were usually placed in the center of the frame and seldom left it.

The **off-screen space** in film or video is more "real" than in a stage play. When actors go off-stage (out of the frame imposed by the proscenium arch), we do not expect to follow them. In film or television, the frame is more like the frame around a window. Viewers have the sense that if the camera moved just slightly forward and more to the right they could see through the window and continue to watch the characters who just went out of frame. By having a character simply look off screen, the director to some extent can open up the frame and heighten the use of that off-screen space (see Figure 5.12).[2]

The Edge of the Frame

Regardless of a director's attitude toward on-screen or off-screen space, the frame does pose limits. We generally expect the edges of the frame to remain relatively steady. A shaky camera creates a disconcertingly unsteady frame. Thus, the camera is usually mounted on a tripod to minimize awkward and unwanted camera movement.

The sides of the frame create another kind of limitation, particularly in shots in which a person is the subject. A viewer usually perceives that something is wrong if the framing of a person does not leave enough (or leaves too much) **headroom** between the top of the frame and the top of the person's head. **Noseroom,** sometimes called **look space,** refers to the space to the sides of the frame and the direction a person is looking within the frame. If the person is looking to

the left, placing him or her on the right side of the frame leaves noseroom to the left and focuses attention in the direction the person is looking. If a person looking left is placed on the left side of the frame (with his or her nose virtually touching the left side of the frame), attention focuses on the empty space behind.

These same general principles apply when a person is moving in the frame and the camera is following the action. The convention is to provide **leadroom** in the direction the person is moving. In a chase sequence, however, allowing the people being pursued to bump up against (or move closer to) the side of the frame in the direction they are moving may help create the sense that they are hemmed in and about to be overtaken. The photos in Figure 5.13 illustrate proper and improper use of headroom, noseroom, and leadroom.

The Moving Frame

Most of the concepts we have talked about in this chapter thus far would apply equally well to still photography or painting. The mobility of the camera itself, however, is one of the distinguishing characteristics of film and video. When the camera moves, the framing of the scene moves with it. Within a single shot the framing changes as we move closer to, around, above, or away from the subject. A composition that was unbalanced one second may be balanced the next, or a shot that was high-angle can become straight-on. A medium shot can become a close-up, or the foreground can become the background. A camera moving in toward a character gives that character more impact or emphasis. Moving the camera away tends to diminish or deemphasize the character the farther away the camera moves.

Camera Movements

The major camera movements—pan, truck, tilt, crane, and dolly (see Chapter 4)—can be used not only to follow moving people or objects but also to provide different psychological feelings. In general, when just the camera moves, the feeling projected is one of an on-

Figure 5.11
With Prunella Gee and Michael York in the foreground, the foliage of a bluff in the middle ground, and a harbor in the background, this shot has great depth. (Photo from Len Richmond's Merchants of Venus, *courtesy of Amazing Movies; Dianna Ippolito, photographer)*

Figure 5.12
The frame of this shot is opened up because Beverly D'Angelo is looking off-screen and also holding a cup toward something that is off-screen. (Photo from Len Richmond's Merchants of Venus, *courtesy of Amazing Movies; Dianna Ippolito, photographer)*

looker. When the camera and its mounting support—crane, tripod, human shoulder—move, the feeling projected is one of a participant.

Take, for example, the difference between a **pan** and a **truck**. Both are side-to-side movements, but for the pan only the camera moves left to right, a movement that produces an effect similar to someone moving his or her head

Figure 5.13

Photo a shows a compo sition with too much headroom, while photo b shows a more typical or conventional amount of headroom. Photo c shows inadequate nose- room that makes a character appear to be bumping up against the edge of the frame. Photo d shows a compo- sition with better look space to the right side of the frame. Photo e does not give the man on the bicycle enough lead- room. Photo f is better. (Photos a, b, e, and f courtesy of Video Producer)

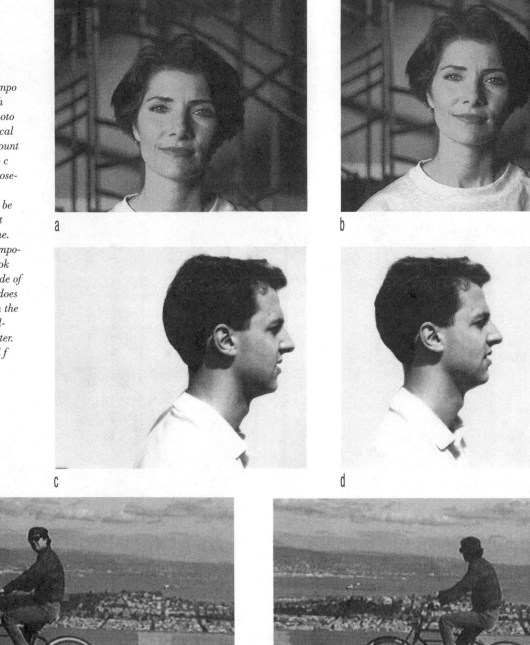

a b

c d

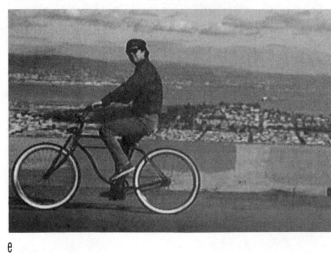

e

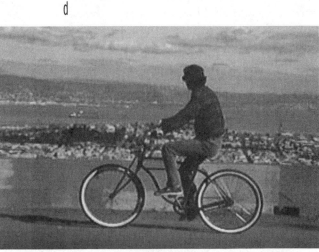

f

from side to side as someone would who was observing the scene. A truck, on the other hand, moves the camera and tripod and pro- duces a feeling of someone walking or running alongside whatever is being photographed, a much more involving type of shot. The move- ment of the background is also very different with a pan and a truck. For the pan, the back- ground moves at an angle; for the truck, it stays parallel. Similar differences in feeling and back- ground occur with a **tilt,** which involves swivel- ing the camera up or down, and a **crane,** which moves the entire camera and supporting mech- anism up or down.

Zooming

In a **zoom** the elements of the lens move, magnifying or reducing objects in a way that the human eye cannot. With a dolly, the camera and the camera support move together into and through the space in the scene, creating a greater sense of what that particular space is like. A zoom in tends to flatten things out and bring everything in the composition closer. With a dolly in, things on screen appear to move out of frame as the movement occurs, forcing the viewer to experience the space at a more visceral level.

Student cinematographers have a tendency to rely too much on the zoom, using it as an excuse not to put the camera in the proper place for the appropriate field of view and depth of field for the lens setting. Rather than placing the camera closer to the scene (or farther away), the novice often relies on the zoom to set up and compose the shot.

Students also have a tendency to use a zoom as a substitute for a dolly. In theatrical feature films zooms are fairly rare. When a zoom is used it is often in a situation in which the artificiality of the zoom lends some particular meaning to the shot. It may also be used in a situation in which a dolly is impossible or too expensive (as across a deep open space like the ocean). Otherwise, professionals rarely use the zoom.

One of the surest signs of a novice camera person is excessive zooming. Constant zooming during shots can create a feeling of uncertainty (if not vertigo); it conveys a subliminal message that the director (or camera person) is trying to find the shot, even while the camera is running. Like any shot, a zoom should have a purpose.

Reframing

The almost infinite number of camera movements presents the director with a huge variety of strategic choices. Camera movement (and the moving frame) constantly shifts on-screen and off-screen space, opening up the frame by providing new and changing information about the space through which the camera is moving. One of the most common camera movements is **reframing,** the slight adjustments made to shift the framing of the shot as characters change positions within the frame. Reframing is common in Hollywood movies: three-shots that become two-shots and subtle shifts of the frame to compensate for the different heights of various characters in the film.

Directors use the subjective feeling created by most camera movements to provide an additional cue that a shot is coming from a particular character's point of view. Hand-held camera movements, as we noted earlier, can also suggest a POV.

A number of action-oriented TV shows, such as *NYPD Blue,* use reframing to a much greater degree than conventional films. Often directors of these shows work their way into a scene through a series of long shots that move about as though someone were turning his or her head quickly to take in the whole area. This is sometimes referred to as a **rock 'n' roll** into a scene. They also use shaky movement that gives the appearance of hand-held shots although the cameras usually are actually mounted on tripods. Some Hollywood practitioners refer to this unstable movement as **Richter,** after the Richter scale that measures earthquakes. The more Richter the director calls for the shakier the camera movement is supposed to be.

Time

Any camera movement also involves a time element. Moving the camera takes time, and a director who chooses to use elaborate camera moves generally tends to emphasize the mise-en-scène (as opposed to editing) to tell the story. Moving back from a close-up to a two-shot usually takes longer than cutting directly from a close-up to a two-shot.

Camera movements can be slow or fast or any speed in between. Many directors have used the rhythmic quality of camera movement as a powerful, expressive tool. Abrupt, quick movements create a different feeling than long, majestic ones. Even a brief look at music videos on MTV provides many examples to illustrate the importance of time in camera movement.

Camera movements are most frequently based on the movement of the characters within the frame. But a director may also use camera movement to create a sense of expectation or suspense unrelated to the characters. A camera movement can also change our focus to some

object or some part of the mise-en-scène that the director wants to emphasize.

In actual practice composing a shot is probably more intuitive than analytical. Through the composition of the image within the frame the director can choose to highlight, modify, shade, reinforce, or even undercut almost any element in the scene. A director making a narrative movie is undoubtedly working with a script, and whether the composition of a shot is good or bad depends more on what the director is trying to accomplish with a shot than on some abstract principle of pictorial composition. In some nonfiction productions, particularly documentary work, it may be perfectly acceptable, even normal, to refocus and reframe in the middle of an unsteady, hand-held shot. The same camera work would usually be considered out of place in a conventional theatrical film, however.[3]

Color and Tonality

Manipulating the filmed image through the choice of film stock or in developing and printing is strikingly different from capturing an image on videotape. A black-and-white **slow film stock** (one less sensitive to light) records a richer range of grays and a sharper image than a **fast film stock** (one more sensitive to light). Faster film stocks also tend to yield grainier images with more contrast, an effect that may be enhanced in the processing and printing of the film. Slow and fast color film stocks have similar differences. In video, the color and tonal qualities do not depend on the choice of the stock.

Film Color

Different color film stocks (and even different stocks from different manufacturers) offer perceptibly different tonal qualities (one stock may emphasize the reds and yellows, another the blues and greens). And the lab can further manipulate all these differences when the film is processed and printed.

Color film is somewhat more expensive to shoot and process than black-and-white, which may be an important factor for student filmmakers. Furthermore, altering the image during processing or printing entails additional expense.

But what filmmakers lose at the bank may be offset to some extent by the many ways they can manipulate the visual quality of the image.

Video Color

There is no such thing as color videotape or black-and-white videotape. In video, the same tape can be used to record both. In most cases it is easier to obtain black-and-white in postproduction than in production because most video cameras do not allow the user to shoot in black-and-white. During its early history the objective in black-and-white (and later color) video was for all pictures to have a similar tonality. Equipment was complicated and the engineers who operated it concentrated on obtaining consistent quality rather than artistic interpretation. As equipment has improved, directors and cinematographers have begun to experiment with the color and tonal qualities of video.

Black-and-White or Color

Despite the technical differences (and differing traditions) of the two media, most of the creative choices confronting the director and the camera operator remain the same. Color is the norm for commercial production in film and video, so the absence of color calls attention to itself. Television advertisers recognize the attention-getting value of a black-and-white commercial. Some commercials extend this idea even further by colorizing the product in postproduction (the pink cherry cola can or ravishing new red hair rinse) to highlight the product in an otherwise black-and-white environment.

More commonly, black-and-white is used to evoke the past. Both film and television began as black-and-white media, with color becoming the standard as the technology evolved. An award-winning episode of the popular television series *Moonlighting* was shot in black-and-white to enhance its parody of the classic black-and-white film *Casablanca*. Woody Allen's comic "documentary" *Zelig* uses black-and-white in much the same way, suggesting not only the past but old movie newsreels as well. In fact, one of the clichés of student moviemaking is the use of black-and-white to cue flashbacks in a color film.

Color Plates

Color Plate 1

The actual properties of the color video image are based on the hue (the specific color), on strength or purity of the color (its saturation), and on the brightness information (luminance), which indicates the amount of light being reflected or given off. In the development of NTSC color video, the chrominance information (hue and saturation) was designed so that it could be added onto an existing black and white signal (the luminance information). This maintained compatibility with existing black and white television receivers that could simply ignore the color information of a program broadcast in color.

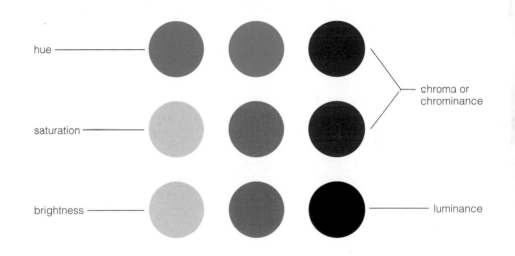

Color Plate 2

Additive color mixing. In video all colors can be produced by mixing together various quantities of the three primary colors (red, green, blue). Where the primary colors overlap, they produce the secondary colors cyan, yellow, and magenta. Magenta, for example, results from mixing red and blue. A mixture of the three primary colors produces white.

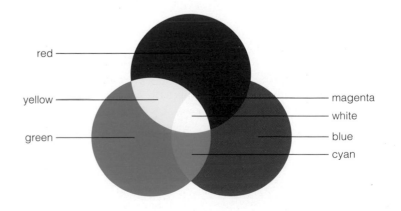

Color Plate 3

This color circle shows the colors of the visible spectrum as they gradually merge into each other. The primary colors (red, green, blue) are on the opposite side of the color circle from their complementary colors (cyan, magenta, yellow).

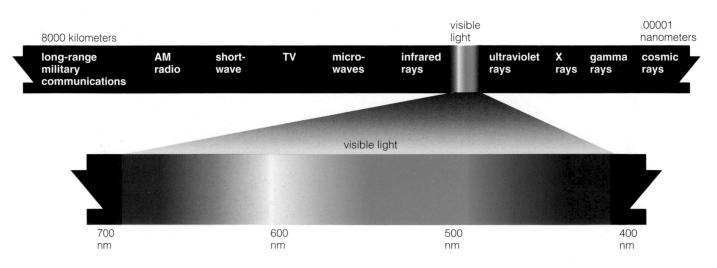

						visible light					.00001 nanometers

8000 kilometers

| long-range military communications | AM radio | short-wave | TV | micro-waves | infrared rays | | ultraviolet rays | X rays | gamma rays | cosmic rays |

visible light

| 700 nm | 600 nm | 500 nm | 400 nm |

Color Plate 4

Electromagnetic spectrum wavelengths. The human eye can see only a small part of the visible spectrum, ranging from the short violet wavelengths to the longer orange and red wavelengths.

Color Plate 6

Color conversion filters. The commonly used orange 85 filter (left) is used to convert 5500-degree-Kelvin daylight to 3200 degrees Kelvin for use with a tungsten-balanced film stock or electronic imaging device. The blue 80A filter (right) is used for shooting daylight-balanced film (5500 degrees Kelvin) under lights that are balanced at 3200 degrees Kelvin.

reflected sunlight	9000°K
hazy sky	8000°K
overcast sky	7000°K
bright sunlight	6000°K
sunlight at noon	
	5000°K
light in the morning and late afternoon	4000°K
quartz light	
household light bulb	3000°K
sunrise and sunset	2000°K
candle flame	1000°K

Color Plate 5

The color temperature of some common light sources.

a

b

Color Plate 7

(a) Shooting in sunlight (5500 degrees Kelvin) with film or with an electronic imaging device balanced for 3200 degrees Kelvin produces a bluish image. (b) With the orange 85 color conversion filter in place, the daylight is converted to a color temperature that more correctly matches the imaging system.

Color Plate 8

Cinematographer Vittorio Storaro utilizes "golden time" throughout Francis Ford Coppola's Tucker: The Man and His Dream. *In this scene the rich, warm lighting underscores a happy family moment in the Tucker front yard. (™ and © Lucasfilm Ltd. [LFL] 1988. All Rights Reserved. Courtesy of Lucasfilm, Ltd.)*

Color Plate 9

Night-for-night lighting in Tucker. *Turning all the lights on in the Tucker car assembly plant provides not only back-lighting for the actors but also motivation for the unseen light source illuminating them from the upper right-hand side of the frame. (™ and © Lucasfilm Ltd. [LFL] 1988. All Rights Reserved. Courtesy of Lucasfilm, Ltd.)*

Color Plate 10

As more and more production and post-production employs digital technologies, computer programs play an increasing role. For example, this display from Cakewalk *shows different windows for music, timing, track building, and editing. (Photo courtesy of Cakewalk Music Software)*

Director Martin Scorcese seemingly inverts this cliché in his black-and-white film *Raging Bull.* The only color material in this film consists of flashbacks to the La Motta family's faded color home movies. As noted earlier, Steven Speilberg's *Schindler's List* is shot in black-and-white, although the film is framed by color sequences at the beginning and end, and it contains two sequences with the red coat painted into what are otherwise black-and-white shots.

Black-and-white may be more appropriate than color for certain subjects. Movies meant to be somber or earthy may convey this mood better if shot in black-and-white. Woody Allen is one modern filmmaker who has shown an interest in using black-and-white for films, including *Stardust Memories* and *Manhattan.* With the evolution of the music video and MTV new interest is emerging in the many ways black-and-white (or black-and-white in combination with color) can be used to enhance the mood or meaning of a particular piece of music. Oliver Stone's *Natural Born Killers* switches between black-and-white and color within the same scene, mimicking the intercutting of color and black-and-white in many music videos.

Color Considerations

Much has been written about the aesthetics of color.[4] But even beyond the theorizing of the artists and scholars about the power of color to evoke specific emotions, most of us accept a number of cultural conventions about color. Whether we are buying fabric at the fabric store or talking to the interior decorator or housepainter, we have a tendency to describe certain colors (reds and yellows) as emotionally warm and other colors (blues or greens) as emotionally cool. One theory holds that warm colors make items appear large, close, heavy, and enduring, whereas cool colors make items appear small, far, light, and temporary.[5]

Certain colors seem to go together, and others seem to clash. Mixing colors opposite each other on the **color circle**, such as green and red, creates color contrast. Working with colors on the same side of the color circle creates color harmony. (See Color Plate 3.) Advertisers go to great lengths to determine what color of packaging encourages us to buy their products.

In moviemaking many decisions about color are made during preproduction. The director, in conjunction with the art director, decides which colors are appropriate for the sets, costumes, props, and even makeup. Color can emphasize or deemphasize any element of the mise-en-scène. The camera can also be used to alter the emotional content of the shot with subtle shifts in color tonality. Think of the warm and homey glow of the typical hamburger chain's television commercials, or the way beer commercials tend to be shot in the orangish light of late afternoon (after work when the world is beautiful). In Robert Altman's western *McCabe and Mrs. Miller* the Golden West comes to life visually on screen. A dreamlike golden tone pervades most of this film, a technique that further heightens the contrast with the cold blue death of McCabe in a snowstorm at the end. Warren Beatty's film *Dick Tracy* uses vibrant primary colors to emphasize the story's comic book origins.

In filmmaking these effects can be produced to some degree in the laboratory as the film is being processed or printed. They can also be enhanced by placing a filter on the lens to warm (orange or reddish) or cool (blue or green) the image. Other types of filters can alter the contrast range of a shot or diffuse and soften the subject being photographed. You can use these same filters with a video camera, and a growing tendency in video seems to be to treat the image in a more photographic manner. See Chapter 6 for a discussion of filters.[6]

The same scene or subject can read in very different ways, depending on shot composition, framing, camera movement, and manipulation of the color and tonality of the image. The power to interpret the mise-en-scène with the camera is basic to the art of moviemaking. Choosing and controlling the type and quality of the shot is one of the most important decisions confronting the moviemaker, student and professional alike.

Shooting to Edit

The camera can move from a medium shot to a close-up (or the actor can move toward the camera and change a medium shot to a close-up), but this change of view is normally created through editing. Material shot during production will

a

b

c

Figure 5.14

In this scene from Merchants of Venus *two policemen confront Nancy Fish, who plays a business owner. Director Len Richmond filmed the master shot (a) of the three people. Because a heated argument transpires between the owner and one of the policemen, he shot the two of them (b). At the end of the scene, the owner becomes ill, so he also filmed her by herself (c). (Photos from Len Richmond's* Merchants of Venus, *courtesy of Amazing Movies; Dianna Ippolito, photographer)*

almost certainly be edited during postproduction. The eventual editing of the shot has a profound effect on the composition, framing, and movement created by the camera. (We discuss the aesthetics of editing in Chapter 12.)

Shot Selection

A **shot** begins the moment the camera begins recording the subject and ends when it stops. It can be long or short, but eventually it will be joined with other shots during editing. In narrative moviemaking the basic building block in the construction of the story is the **scene,** a unified action occurring in a single place and time. A scene is usually composed of a series of shots, though an entire scene can be one continuous shot.

To provide complete coverage of the scene the director usually shoots more shots than will actually be used in the final edited version. At the simplest level the objective is to provide a variety of shots of the physical action and dialogue in the scene (see Figure 5.14). Imagine a simple one-minute scene in which a man and a woman eat breakfast while talking at the kitchen table. To ensure adequate coverage of this scene and to make certain that the needed shots will be available during editing, many directors begin by shooting a **master shot,** a fairly long shot showing both characters at the table as they play out the scene in its entirety. If used in the edited version of the motion picture, this one master scene shot would present all the dialogue and action within a single shot—a one-shot scene. A director using the master scene shooting method would then begin to provide coverage of the scene with shots from a variety of angles and perspectives: close-ups of each actor delivering lines, two-shots, reaction shots of one character listening to the other talk, and **cut-ins** to some essential detail within the scene (for example, a piece of burned toast). Perhaps the last element in providing complete coverage of a scene is to shoot **cutaways,** shots of related details that are not actually part of the scene (such as the kitchen clock on a wall off-screen).

In the editing room these different shots will be cut together to build up the scene—beginning, perhaps, with a master shot of both actors, then cutting to a close-up of the clock, a two-shot of the woman talking, and a CU of the

man listening. It is important that the director select shots that can be edited according to the action, dialogue, and dramatic needs of that particular scene. Directors always select shots with an eye to how they might be edited later.

Shot Duration

The director must also decide how long to shoot each shot. The dialogue or the movement of the actor within the scene often dictates the length or duration of a shot. Moving the camera (because it takes place in time) can also determine shot duration. In addition to the composition, framing, and use of camera movement, the duration of the shot deeply affects how we see and understand it. The viewer can absorb more during a shot of long duration than during one of short duration.

On the purely technical level providing extra time at the beginning and end of a shot for identification and editing purposes is important. In film and video the first few feet are needed to **slate,** or identify, the shot. In filmmaking the first few frames of the shot often contain overexposed frames (or *flashframes*), which are created while the camera is getting up to speed. Having a little more *head* or *tail* on each shot can prove invaluable in the editing room. Providing extra material for a given duration (five or ten seconds) can be just as vital for electronic insert editing, which requires preroll material.

The Long Shot, Medium Shot, Close-Up Pattern

The most conventional way to shoot a scene is to begin with an **establishing shot,** a shot that sets the scene and establishes the location. This often is a long shot (the apartment building), but it could be something like a sign (Mastroianni's Cafe) that tells us where the scene is taking place. Next, we move into the scene from long shots to medium shots and finally to close-ups. If the angle of view does not change sufficiently between the LS, MS, and CU, the shots will appear to jump when they are edited together. The conventional way to avoid this problem is to vary the angle of view at least 30 degrees from the previous shot (the so-called **30-degree rule**). Some critics have argued that the

LS–MS–CU pattern is the most psychologically correct way to construct a scene because it is similar to the way our minds work.[7] When we walk into a dance in a large ballroom (establishing shot), we tend to survey the entire room (the long shot) until we spot a group of friends (the medium shot) and move over and begin talking to them (the close-up). The establishing shot, long shot, medium shot, close-up pattern draws us into the scene. We gather more and more information as the shots move closer and closer.

This pattern can also be reversed. Beginning with a close-up can create questions. Who is this character talking to? Where are we? Moving from close-up to the medium shot and long shot can answer these questions as each shot provides additional information about the scene. Again, there is nothing inherently right or wrong about any pattern, but unless the director selects the shots during the shooting phase of production (shooting to edit), they will not be available when the editing begins.

Shooting for Continuity

Technically, a single shot maintains **continuity,** a sense that the space we see in the shot and the time in the shot are continuous and uninterrupted. In conventional moviemaking continuity most often becomes an issue in the scene. Usually, scenes take place in a single location and in a continuous segment of time. This arrangement would not be a problem if the scene was shot with a single run of the camera. But because most scenes are composed of a variety of shots taken at different times and from different angles, continuity is often difficult to maintain during editing.

On the set of a typical Hollywood film continuity is almost an obsession. Crew members such as the **script supervisor** are constantly checking for continuity errors. Some of the most common gaffes involve costumes or props: the tie that changes color from one shot to the next or the glass that is almost empty in the first shot but full in the next. Even something as simple as changing light values (when shots taken at different times of the day are edited together in what is supposed to be a continuous sequence of time) can violate continuity. This kind of error involves the mise-en-scène, but unless a director is consciously

a

b

c

Figure 5.15

Anywhere within the 180-degree arc established from camera view 1, the two people (A and B) will maintain the same spatial relationship—A on the left and B on the right. Crossing the axis, however (as in camera view 2), will reverse, or flip, A and B to the opposite sides of the screen.

shooting to maintain continuity, the placement of the camera can also create problems.

Perhaps the most common technique for shooting to maintain continuity involves the **axis of action,** or the so-called **180-degree rule.** In any shot, whether it contains two people talking or a single person walking down the sidewalk, the principal axis of the action is identifiable. It is the imaginary line between the two people talking or the **screen direction** established by the walking character or moving object. If the camera is placed on one side of this imaginary line (anywhere within the 180-degree arc on the same side of the line), spatial continuity will be maintained (see Figure 5.15). A shot that crosses the axis would, when edited, flip-flop character A and character B to opposite sides of the screen.

Similarly, crossing the axis of a walking character or moving car would make the person or car appear to reverse screen direction on the cut. As long as the camera is placed on the same side of the action line (again, within the 180 degrees), the character will seem to be moving in the same direction across the screen. A shot taken right on the axis (a neutral position in regard to the line) can be used as a transition between shots that would otherwise appear to cross the axis or reverse screen direction.[8] The photos in Figure 5.16 illustrate screen direction for a moving object.

Maintaining a constant screen direction also extends to the line of action established by a character looking off-screen. Imagine, again, two characters talking. We see character A in a close-up talking to character B, who is off-screen. In the next shot we see a close-up of character B responding to character A, who now is the one off-screen. Unless there is an **eyeline match** between the two shots, character A and character B will not appear to be talking to each other and might even appear to be distracted by something else off-screen (see Figure 5.16).

A radical change in the speed of a character or object (a car, for example) from one shot to the next also can violate continuity. The first few steps people take when they are getting up to walking speed (almost always near the beginning of the shot) are appreciably slower than when they are already at full walking speed. If you cut together two shots of people walking down the street, you want their relative speed (and gait) to match up as you edit from one shot to another. A **match cut—**

Figure 5.16

Once the eyelines have been established in one shot (a), the eyes must maintain those directional lines in subsequent shots in order to match. The woman in photo b (correct eyeline match) appears to be looking in the correct direction for the man established in photo a. If the woman is supposed to be listening to the man, the eyeline match is wrong in photo c because she is looking away from him (and his eyes). The implication of cutting from shot a to shot c is that she is not really listening to him or that she has been distracted by something off-screen in the other direction.

a cut that maintains a continuous sense of space and time from one shot to the next—can be extremely difficult to make unless the director has shot the material with an eye to editing.

The time-tested method of ensuring footage that can be match cut is to **overlap action** during shooting. Imagine two shots that are going to be match cut. A character (from an angle in the hall) comes up to a door and opens it. The next shot shows the character entering the doorway and coming into the room from an angle inside the room. To overlap the action during shooting the director should shoot the entire action (walking up to the door, opening it, and walking into the room) in both shots. By overlapping the action in this manner the director provides the editor with an almost infinite number of cutting places for matching the two shots.

Of course, continuity entails much more than the placement of the camera. It also depends on how the director stages the mise-en-scène for the camera and the way in which the editor puts the material together in postproduction. (We deal with the conventions of the continuity system in much greater detail in Chapter 12.)

Notes

1. See, for example, David Bordwell and Kristin Thompson, *Film Art: An Introduction* (New York: McGraw-Hill, 1993), pp. 145–184; and James Monaco, *How to Read a Film: The Art, Technology, Language, History and Theory of Film and Media* (New York: Oxford University Press, 1981), p. 148.

2. Noel Burch, *Theory of Film Practice,* trans. by Helen R. Lane (New York: Praeger, 1973), pp. 17–31.

3. "Correcting Those Invisible Errors," *TV Technology,* 19 June 1997, p. 42.

4. Monaco, pp. 96–98; R. T. Ryan, *A History of Motion Picture Color Technology* (New York: Focal Press, 1977); Raymond Durgnat and Vincent LoBrutto, "Three Moods Prevail in *Dead Presidents,*" September 1995, pp. 59–66.

5. Herbert Zettl, *Sight-Sound-Motion: Applied Media Aesthetics* (Belmont, CA: Wadsworth, 1990), pp. 66–68.

6. In particular, see Harry Mathias and Richard Patterson, *Electronic Cinematography: Achieving Photographic Control over the Video Image* (Belmont, CA: Wadsworth, 1985).

7. André Bazin, *What Is Cinema?* trans. by Hugh Gray (Berkeley: University of California Press, 1971), pp. 23–40.

8. Frank Beacham, "The Art of Crossing the Line," *TV Technology,* October 1991, pp. 30–31.

chapter six
Lights and Filters

L ight is the key to recording an image on film or videotape. Whether the light record is created photochemically or electromagnetically, the cinematographer's first concern is to determine if there is enough light to record the image. The cinematographer's attention next shifts to how the light can best be shaped to fit the dramatic needs of the shot. Thus, creative control of the image involves not only the means to measure the light accurately but also the means to control it. This chapter deals with the tools needed to accomplish those tasks.

Measuring the Light

To obtain the correct exposure the amount of light reaching the film emulsion or electronic imaging device must be carefully governed. Too much light will result in an overexposed image; too little light will result in an underexposed image. The adjustable diaphragm in the lens is used to obtain the correct exposure setting. To calculate that setting an instrument called a **light meter** is used to measure the amount of light falling on or reflected by the subject.

A needle on a scale or dial can present this information, but many modern light meters produce a digital readout of the light reading. Cameras with built-in metering systems may display this information in the viewfinder. There are several basic types of light meters including incident and reflected meters.

Incident Meters

An **incident light meter** measures the amount of light falling on a particular person or area of a set. Commonly used incident meters, such as the Spectra, have a plastic hemisphere (which looks like half a Ping-Pong ball) over the light-sensitive cell on the meter (see Figure 6.1a). To use an incident meter, hold it next to the subject with the light-collector bulb pointed at the camera position. The intensity of the light reaching the hemisphere creates a light reading that can be measured. Usually, the top half of an incident meter swivels so that the person taking the light reading can read the scale without casting a shadow over the light-sensitive photocell.

An incident meter is generally considered the standard meter for professional cinematography. It is accurate, easy to use, and highly reliable. Because it measures the light hitting a *specific* area, it is not fooled by background light (or darkness). Therefore, it gives an objective light measurement from scene to scene. An incident meter is especially helpful when setting lights to a particular intensity for more than one camera setup.

Reflected Light Meters

A **reflected light meter** measures the amount of light reflected by the subject, providing an overall light reading for the entire scene (see Figure 6.1b). A reflected meter operates differently than an incident meter. You hold it next to the camera and point it at the subject or scene. Reflected light meters typically gather light from a relatively wide angle of view (or *acceptance*), creating a light measurement that is the average of the range of **brightness** levels within the scene. You can adapt many professional-quality incident meters for use as reflected meters.

A **spot meter** (see Figure 6.2) is a reflected light meter with a narrow angle of acceptance, often as little as one degree. Instead of averaging brightness across the entire scene, it provides a reading of a small, individual spot within the composition. A spot meter usually is shaped like a small camera. It has a pistol grip, eyepiece, and viewfinder to enable the operator to target the exact spot (usually designated by a small circle in the viewfinder) being measured. This is particularly useful when you are comparing brightness levels of different parts of the scene. Although they are reflected meters, spot meters can provide the same information as incident meters because they read light for small areas. In this way they combine the best features of incident meters and reflected meters.

a

Figure 6.2
A Minolta spot meter. (Photo courtesy of the Minolta Corporation)

b

Figure 6.1
Photo a shows a Spectra incident meter with an ASA slide. The meters come with a packet of slides keyed to different ASAs. An incident meter is held next to the subject and pointed back toward the camera. Be careful not to skew the reading by blocking part of the light with your body. Photo b shows a reflected light meter held next to the camera and pointed toward the scene.

Automatic Metering Systems

The automatic exposure system built into most modern cameras is really just another type of reflected light meter. It measures the light coming through the lens (usually a zoom lens) and automatically adjusts the iris to the proper setting. Because it is behind the lens, it will compensate for any light lost to filters or to the many elements within the lens itself. Some cameras use a zebra stripe pattern visible within the viewfinder to show areas at the upper limit of the camera's exposure range.[1] Others blink the words *low light* in the viewfinder when there is not enough light for an acceptable image.

Automatic exposure systems are extremely easy to use, which is one reason they are virtually standard on consumer-level cameras. They can be invaluable in situations in which the light cannot really be regulated or when shooting entails rapid, uncontrollable shifts in exposure levels, as in sports or documentaries.

Getting Correct Exposure

Light meters are simply tools. They cannot think nor can they know what you are trying to expose for within a shot. The brightness levels in a particular shot might range from f/2.8 to f/22 (or beyond), and this can pose problems for any type of light meter. In-camera meters, as noted previously, try to solve this problem either by averaging the light readings from the entire scene or by metering a smaller area in the center of the frame, which is called **center-weighted metering.** It is also possible to use a hand-held meter to take readings of different areas within the frame and work out the average

Figure 6.3

A lighting situation such as this easily fools an automatic iris. The iris will close too much because of the large amount of light in the scene's background. A center-weighted light meter offers some correction. Other cameras have backlight compensation systems that increase exposure to make up, at least in part, for strong backlight.

mathematically. What is important is interpreting the light readings to suit your purpose.

Problems with Automatic Metering Systems

Certain lighting situations can easily fool reflected light meters, whether they are hand-held or built into an automatic metering system in the camera. Strong backlighting causes the most common problem. A shot of the face of a person who is standing in shade that is in front of a bright, sunny background can result in a reading that greatly underexposes the face. The meter averages the light for the entire scene, not just the face, and produces a reading that overvalues the bright background. (See Figure 6.3 for an example of underexposure because of backlighting.) The opposite could occur in a shot of the face of a subject standing in bright light against a large dark background.[2]

Using a spot meter or an incident meter is one way to get a correct reading of the area of the frame you are trying to expose. A zoom lens with an in-camera metering system can also be used as a kind of spot meter. By zooming in and filling the frame with the person's face, you can obtain the correct exposure setting. Then you must manually override the automatic exposure system (if that is possible with your camera) or

change the lighting setup (if that is possible). If neither of those options is viable, it is probably time to consider shooting the shot in a different way.

Some cameras have a backlight control button that opens up the iris one f-stop (or more or less) to compensate for strong backlighting. Other cameras have an exposure lock that enables you to lock in a particular f-stop setting, thus overriding the automatic iris system. Another technique for obtaining correct exposure is to **bracket** your shots. Provided you can manually adjust the iris, you simply shoot the scene with several different f-stop settings.

Because different types of light meters have different strengths and weaknesses, it is probably wise to supplement an in-camera reflected meter with a hand-held incident meter. When working outdoors, many cinematographers prefer a reflected light meter. They usually choose an incident meter when working indoors, where the lighting can be totally controlled. You might also consider bringing along your still camera. You are probably quite familiar with its built-in metering system and can use it to back up your light readings on the set, as well as to provide stills of your production.

Footcandles, F-Stops, and EI

Most light meters are calibrated to produce readings in either footcandles or f-stops or in both. A **footcandle** is an international unit of illumination. It represents the amount of light falling on a sphere 1 foot from a light source of 1 candlepower. In effect, a footcandle reading on a light meter is a measurement of light intensity. If the light meter provides an **f-stop** reading, it must have some means of translating the light intensity in the scene to a lens f-stop that is accurate for the particular camera being used.

When metering for film, this usually means that it is necessary to set the **exposure index (EI)**, or **ASA**, of the particular film stock being used. A film stock with an EI of 400, for example, is twice as sensitive to light as a film stock with an EI of 200. Thus, the proper f-stop depends not only on the amount of light available but also on how sensitive a particular film stock is to light. With exactly the same light (that is,

the same footcandle reading) an EI of 100 might require an f-stop of f/8, whereas an EI of 200 would require f/11. Each f-stop change (from f/2.8 to f/4, f/5.6, f/8, and so on) cuts the light that reaches the film in half.

The EI is set either by slipping a slide in front of the photosensitive cell or by turning a dial similar to the type used to set the film speed on a still camera.

Calculating the exposure index for a video camera is more complicated. The light sensitivity of a video camera cannot be boosted by changing the imaging device (as in buying a roll of faster film). Its responsiveness to light is, in effect, built in to that particular imaging system, usually the CCD sensors. Of course, many video cameras can boost the image signal electronically (a 6-dB increase in gain approximately doubles the exposure index). At the normal setting, however, most video cameras have an exposure index that is in the range of 100. With the proper video test equipment, determining the effective EI rating for any video camera is not difficult.[3]

Contrast Range

Contrast refers to the varying levels of brightness and darkness within a particular scene. A high-contrast scene would have extremely bright and dark areas with almost no gradations in between. In comparison, a low-contrast scene would be relatively flat, with the brightest and darkest areas of the scene at roughly the same luminance level. Normal contrast would exhibit a rich, full range of brightness levels between the darkest and brightest parts of the scene.

By taking a light reading of the brightest and darkest areas of the scene, it is possible to calculate the **contrast range,** the ratio of the brightest value to the darkest value. For example, if the brightest area in the scene is eight times brighter than the darkest area of the scene, the **contrast ratio** for that scene would be expressed as 8:1 (a range of light three f-stops wide). A 16:1 contrast ratio would produce a range of light roughly four f-stops wide. Calculating the contrast ratio is relatively simple with a spot meter, but any reflected light meter can be used

for this purpose by moving in closer and measuring the amount of light reflected by different objects across the scene.[4]

All film stocks and electronic imaging devices are limited in the range of brightness they can accurately reproduce. That range or **latitude** is designed into a particular film stock or video imaging system, although the contrast ratio in film is frequently altered during the developing process. Negative film stock has a greater latitude than reversal, and film generally has a greater latitude than electronic imaging systems. A shot exceeding the latitude of a particular imaging device will create areas of brightness or darkness in which all distinguishing details are lost. Thus, measuring the range of brightness within a scene is important not only for obtaining correct exposure but also for creatively manipulating the lighting for a scene.

Using a Monitor to Evaluate Exposure

One of the great advantages in shooting video is the ability to play back the recorded image and sound immediately after it has been recorded. This can be accomplished by rewinding the videotape in the camcorder (or VCR) and playing it through the camera viewfinder or through a portable television receiver, monitor, or combination monitor/receiver. This provides the director and cinematographer with immediate feedback about the overall look of the shot as well as the performance of the actors. In fact, this capability is available with many professional motion picture cameras that can be adapted to record an image on film and videotape simultaneously. This is usually referred to as **video assist.**

Most camera viewfinders display only a small black-and-white image, which reduces their usefulness in evaluating image quality. A portable color television monitor that can operate on batteries (in addition to AC power) is a better tool for judging a recording. Some portable VCRs or camcorders, particularly at the consumer level, have an RF output, which means you can use a regular television receiver for monitoring.

Figure 6.4

A highly portable waveform monitor. (Photo courtesy of Leader Instruments Corporation)

black level setup
(7.5 IRE)

Figure 6.5

The display on the waveform monitor allows the picture to be represented on a luminance scale. The bright areas in the picture register near the top (near 100 IRE). The monitor displays the darkest areas at the bottom, where the black level (7.5 IRE) is normally set. This is often called the pedestal level. If image brightness exceeds 100 IRE or falls below 7.5 IRE on the waveform monitor, the image will be distorted.

Despite the obvious benefits of instant picture review, a monitor can sometimes cause problems when used for image evaluation. It is seldom a satisfactory substitute for a light meter because the actual quality of the image being viewed depends on how accurately the portable monitor is calibrated. With portable gear that is constantly knocked around in transit or television receivers that are adapted for use in the field, image reproduction is seldom trustworthy. A light meter provides a comparable measurement of light values from one lighting setup to the next. Trying to use a monitor for this purpose is haphazard at best. Without the numerical values provided by a light meter, trying to match lighting setups can be total guesswork.

Using a Waveform Monitor to Evaluate Exposure

A **waveform monitor** is a far more accurate way of measuring and evaluating lighting. This piece of equipment is standard in any television studio, and it is also available in portable versions for use in the field. These portable units (see Figure 6.4) can operate on either DC (batteries) or regular AC power.

When a video signal from a camera is looped through a waveform monitor, the monitor's screen presents a graphic representation (see Figure 6.5) of the signal (the waveform). That signal is superimposed on a scale divided into 140 IRE units (IRE refers to the Institute of Radio Engineers). The picture information falls in the area between zero IRE units (the darkest area of the scene) and 100 IRE units (the peak white area of the scene). The blackest areas of the scene are actually set slightly above zero, at 7.5 units. The negative area at the bottom of the scale (between zero and –40 IRE units) displays information about the technical aspects of the signal, such as the vertical blanking interval (see Figures 6.6a and 6.6b).[5]

The waveform monitor provides more information about the brightness and contrast range of a scene than any light meter. The area between 7.5 and 100 IRE units provides information that you can use to adjust the camera's imaging system (20 IRE units equal approximately one f-stop, hence a latitude of approximately five f-stops). Any area of the scene exceeding 100 IRE will be overexposed, and any area of the scene below 7.5 will be too dark to render visible detail. Obviously, this information can be used to set up and adjust lights. The waveform monitor displays the exposure levels for every point in the scene, like a full-frame spot meter. It also shows precisely which areas

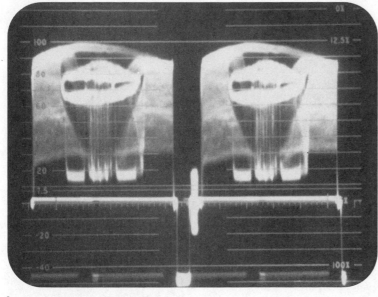

a

b

Figure 6.6

The two fields on the waveform monitor show the waveform (photo a) of the 1-inch metal videotape reel in photo b. Notice how the dark black cutouts in the videotape reel are mirrored in the two rectangular areas just above the 7.5 IRE line on the waveform monitor. The hole in the center of the videotape reel is less distinct on the waveform monitor because it is reflecting some light. It is not as black as the rectangular cutouts beside it. (Photo b courtesy of Maxwell Corporation of America)

of the scene are above or below the contrast range the camera is capable of reproducing.

Some of the more professional video cameras display a crude waveform in the viewfinder, but this does not present the same kind of detailed information as a waveform monitor. Few schools have portable waveform monitors set aside for student use. The waveform monitor is usually mounted in the studio and used primarily by the college's video engineer. But as sophisticated location lighting becomes more commonplace in video, students will need increased access to portable waveform monitors and the training to use them properly.

The Color of Light

Thus far we have been concerned primarily with different ways to monitor and measure light intensity. The color of light in the scene is also an important concern for the cinematographer. Different light sources produce different colors. Being able to measure and compensate for those color variations is as much a part of quality image making as controlling exposure.

The Electromagnetic Spectrum

Our eyes can see only a small portion of radiated energy in the **electromagnetic spectrum.** Electromagnetic energy is measured according to **wavelengths** and ranges from the microscopically small wavelengths of cosmic rays to electrical power waves several miles long. Visible light is only a tiny portion of that spectrum, ranging from the shorter violets to the longer blue, green, yellow, and red wavelengths. The wavelengths just below and above the visible spectrum, X rays and infrared, cannot be seen by the eye but can be recorded on special film. (See Color Plate 4.)

Our eyes see different wavelengths as different colors. White light is composed of all the visible wavelengths. When white light falls on an object like a red flower, it reflects the red wavelengths and absorbs the other wavelengths (primarily the greens and blues). If the color of the light illuminating that flower is changed, our perception of that flower's color will also change. The way we perceive colors is based on both the particular wavelengths (colors) of light illuminating an object and the wavelengths of light that the object absorbs. This fact has important

implications for cinematography. It means that a filter can be used to modify the light by absorbing certain colors and letting other colors pass through.

The Kelvin Scale

What we perceive as the white light of the sun is actually made up of roughly equal parts of red, green, and blue light. The color of sunlight is constantly changing, according to the time of day or the way that light is reflected through clouds or smog in the air. As the sun sets toward the horizon, the longer red wavelengths and denser atmosphere create a redder color. If the noonday sun is reflected through a cover of clouds, the light may seem almost blue.

A **color temperature** scale was developed to provide a precise and accurate measurement of different colors of light. This scale is expressed in degrees **Kelvin** (K). As a theoretical black body source is heated, it will give off light. Imagine a chunk of iron heated over a powerful flame. As the metal begins to heat, it will start glowing red. As it gets even hotter, it will turn orange and then white and finally blue-white. These changes can be measured on the Kelvin scale. The sun at noon, for example, has a color temperature of about 5,500 degrees Kelvin, whereas the color temperature at sunrise could be as low as 1,800 degrees Kelvin. This can be a little confusing because we tend to think of red light as hot and blue light as cold. But in terms of color temperature, the lower the color temperature the redder the light and the higher the color temperature the bluer the light. (See Color Plate 5.)

A special type of light meter, called a *color temperature meter,* registers the specific color of light in degrees Kelvin. It also specifies the type of filters that should be used to obtain a particular color temperature (see Figure 6.7).

Tungsten and Daylight-Balanced Light

Our eyes (and brains) have the ability to compensate for large changes in the color of light and still see seemingly accurate, believable color. Film and video cameras cannot do this, however. Color film stocks and electronic imag-

Figure 6.7
A color temperature meter with digital readout. (Photo courtesy of the Minolta Corporation)

ing devices can only produce correct colors within a relatively limited range on the Kelvin scale. This is accomplished in film and video in a somewhat different manner, but the basic principles are the same.

In film, you can compensate for color changes by purchasing a film stock that is **color balanced** for use in either daylight (5,500 degrees Kelvin) or tungsten light (3,200 degrees Kelvin). When used with lights rated at 3,200 degrees Kelvin, tungsten-balanced film will produce correct colors. If that same stock is used outdoors, color rendition will be skewed by the much bluer 5,500-degree-Kelvin color temperature of the sunlight. Using tungsten-balanced film stock outdoors requires a **color conversion filter** such as a Wratten 85 or 85B filter. These orange filters effectively convert the more bluish sunlight outdoors to the color balance of the tungsten film. Conversely, a daylight-balanced film stock can be used outdoors without a filter. But using that same daylight-balanced stock in the more reddish tungsten light requires a blue filter, such as a Wratten 80 or 80A, to obtain the correct color balance. (See Color Plates 6 and 7.)

Video does not have daylight-balanced pickup tubes or CCD sensors. Video imaging systems are always balanced for tungsten light. Using a video camera outdoors in daylight requires the same type of orange 85 filter used in film, but because it is built into the camera it is not easy to see. Many video cameras have a built-in **filter wheel** that enables the operator to dial in the correct filter for a variety of lighting sources. Such cameras typically have a setting for tungsten lights at 3,200 degrees (actually no filter), a setting for daylight (5,500 degrees), and perhaps an intermediate setting at 4,500 degrees. Some cameras may have only two settings, one for daylight and one for artificial light. These are often represented by graphics of the sun and a lightbulb. Other less expensive cameras may have no filter settings. They have an automatic color correction circuit that makes all color adjustments, and they may not have a manual override.

Small-Scale Color Corrections

The human eye can detect changes in color temperature as small as 100 degrees Kelvin. For this reason, you often must correct for slight variations in color that are much smaller than the broad changes made by color conversion filters such as the orange Wratten 85 filter. Another category of filters, called **light-balancing filters** or **color-compensating filters,** has been designed for this purpose. They are used on the film camera to compensate for subtle shifts in color temperature.

Generally, these filters are paler in color than the heavier color conversion filters used to correct between sunlight and artificial light. Their colors tend to fall at either the blue end or the red end of the color spectrum. Cinematographers often use them to warm up (a yellow to red filter) or cool down (a blue to purple filter) a particular light source.

In video, obtaining this kind of small-scale color correction is much easier. In fact, it is precisely the type of color correction produced by **white balancing.** Once you set large-scale color correction with the filter wheel, white balancing fine-tunes the color, adjusting the camera precisely to the color temperature of any light source.

You do this by pointing the camera at a white surface such as a piece of white paper or a white T-shirt. Zoom the lens in to fill the frame with the white surface, and then press the white-balance button on the camera. A microprocessor in the camera automatically adjusts the imaging device to produce an accurate white in that light. In effect, the automatic white circuit knows what white is (almost equal amounts of red, blue, and green), and white balancing simply adjusts the system to reproduce white at the specific color temperature of the light in a scene. This setting for white will remain in memory until you press the white-balance button again, which you should do with any change of lighting. You could rebalance as often as every shot outdoors, where the color temperature may be constantly shifting because of the movement of the clouds or sun. Some video cameras have an automatic white-balance circuit that operates continuously unless the operator specifically sets an override mode.

You can also use the white-balancing circuit to produce the kind of warming and cooling effects created by light-balancing filters. By white balancing the camera on a colored card rather than a white one, you tint the entire scene. When you do this, you are in effect lying to the white-balancing circuit of your camera. Pressing the white-balance button automatically adjusts the amount of red, green, and blue (the definition of pure white) and produces all the other colors in their natural relationship to white. White balancing on a light blue card, for example, produces a color tint toward the opposite end of the color spectrum (that is, a warmer orange), whereas balancing on an orangish card produces a cooler, more bluish tint. You may need to experiment a little to get the effect you want, but you can check the results immediately with an accurate color monitor.

To obtain comparable control of small color variations in film requires a color temperature meter and a case full of finely graded light-balancing filters. And the color correction still would not be as accurate as the white-balancing process in video cameras.

The Vectorscope

In video, a **vectorscope** is used to monitor the color information in the video signal. It is used primarily to match the color between cameras

in multicamera productions and to analyze and adjust color during postproduction.

The screen of a vectorscope presents a graphic display of the color information in the video signal. It shows the **hue** (the specific tint, such as blue, yellow, or orange) and the **saturation** of that hue (the degree to which the color is mixed with white light). A royal blue, for example, contains less white light than a baby blue. In other words, the royal blue is more saturated (less diluted) than the baby blue. Portable vectorscopes (see Figure 6.8) are used in the field to analyze the color characteristics of various scenes, but a vectorscope is generally less valuable than a waveform monitor as a location production tool.[6]

Figure 6.8
An extremely small battery-powered vectorscope. (Photo courtesy of Leader Instruments Corporation)

Filters for Film and Video

In addition to the filters used to correct color balance and color temperature, there are many other filters that change the image in a variety of ways. Among the most common are **neutral density filters.** They reduce the intensity of the light reaching the imaging system without altering the color of the light in any way. They are designed primarily to bring the light down to a level that the camera can handle. For this reason they are most commonly used for shooting in very bright light. Neutral density filters are calibrated according to their density, the amount of light they block. An ND-3 filter, for example, reduces the amount of light transmitted through it by one f-stop, an ND-6 by two f-stops.

A **graduated neutral density filter** is a special type of neutral density filter that darkens only part of the frame, usually the top. This is helpful on bright sunny days when the sky is too bright to allow correct exposure of the foreground. If you expose for the foreground (probably the most important area of the shot), you will overexpose the sky, hence the graduated neutral density filter. Such filters have a clear area that gradually becomes a neutral density gray. You align the neutral density half of the filter with the sky at the horizon, which allows proper exposure of the sky and clouds without affecting exposure (in the clear part of the filter) at ground level in the foreground.

Neutral density filters reduce all wavelengths of light equally, so they do not change the color temperature of the light transmitted through them. This neutrality means they can be combined with many other types of filters. An 85ND-6 filter combines the orange 85 color correction filter with a neutral density filter that reduces the light transmission by two f-stops. The filter wheels on many video cameras contain this type of combined neutral density–color conversion filter. Cameras that have a setting for clouds and bright sunlight usually have a plain 85 filter for the former and a combined 85–neutral density filter for the latter.

Several types of filters eliminate haze. A **haze filter** is particularly useful for eliminating the bluish cast often seen on overcast days. The **ultraviolet (UV) filter** performs a similar function by blocking out ultraviolet rays. Outdoors, many photographers simply leave a UV filter on their camera at all times. It is clear and has no effect on regular light frequencies. In black-and-white photography a pale yellow **sky filter** usually corrects the overexposure and loss of detail caused by haze.

Polarizing filters may also help eliminate haze and darken a blue sky, but their primary use is to minimize reflections from water or glass. The amount of polarization depends on the angle of light between the camera lens and the surface of the glass or water. Shooting at about a 30-degree angle to the reflective surface and then rotating the filter for maximum absorption of glare usually yields the best results.

Diffusion filters have a rippled surface or an extremely fine, netlike pattern that scatters (diffuses) the light and creates a softer, less detailed image. In the heyday of the Hollywood studio system cinematographers would often put a fine silk mesh over the lens to photograph the movie's female star. This reduced wrinkles and other blemishes and produced the same effect

created by diffusion filters—a softer, more dreamlike, and romantic image. The amount of diffusion a filter provides depends on its grade (how dense it is) as well as the lighting, contrast, and size of the subject in the shot. In general, long shots require less diffusion than close-ups.

Star filters are a special kind of diffusion filter. A grid of parallel lines etched into the filter surface turns any bright point of light in the scene into a bright star pattern.

Fog filters break up the light like diffusion filters but scatter that light from the bright picture areas into the shadow areas. The result is a light fog effect that tends to lower contrast and soften the shot, creating a mysterious, foreboding feeling. **Double-fog filters** also produce a fog effect but without reducing sharpness.

Not surprisingly, **low-contrast filters** reduce contrast and color saturation. They are among the most useful filters for exterior shooting and are frequently credited with creating a film look in video. On a bright sunny day the direct sun casts extremely hard shadows. It also produces a much greater range of brightness levels in the scene. As a result, the camera cannot properly expose the shadows and the highlights. This is where a low-contrast filter is most useful. It uses light from the highlights within the scene, scattering the light to brighten up the shadow areas, usually without reducing sharpness. This can be invaluable in any high-contrast lighting situation and can be particularly helpful in video.

Soft-contrast filters also reduce contrast but preserve a darker shadow area than low-contrast filters. They diminish the highlights without lightening the shadow area. The bottom line for both low-contrast and soft-contrast filters is reducing the contrast range. Whether you do this by brightening the underexposed areas of the shot or darkening the overexposed areas is less important than reducing the contrast range to a level the imaging system can handle.[7]

Using Filters

Filters are normally made out of either gelatin or glass. **Gelatin filters** are the least expensive and come in small sheets that you can cut to the proper size for the lens or filter holder. You can also place large sheets (or rolls) of gelatin filter over windows or fit them into holders on the front of lighting instruments to change the color temperature in mixed lighting situations.

Glass filters may have a gel cemented between two sheets of optical glass, or they may have dyes laminated between two sheets of optical glass. The least expensive glass filters have dyes added directly to the glass during manufacturing.

Mounting Filters

Glass filters normally mount in front of the lens and must be of the proper size and type for a particular piece of equipment. Some glass filters screw directly into threads on the front of the lens and must be sized exactly to the diameter of that particular lens. Others mount on the lens with a special adapter ring and are held in place by a lens hood or matched retaining ring. You can also mount glass filters in a **matte box**, sometimes called a *filter box*. It is an adjustable bellows that attaches to the front of the camera body and extends beyond the lens. Squares of filter glass simply drop into the matte box, an arrangement that offers several advantages. Filters used in a filter box are cheaper because they do not have to be mounted (and threaded) on a specific lens. A matte box makes it easy to stack multiple filters, to drop in a cutout for such effects as binoculars or a keyhole, or to use the same filters with different cameras (because the filter does not have to screw into a particular lens size).

You can mount gelatin filters in a variety of ways. With a matte box you cut the filter to the proper size, place it in a holder, and mount it at the rear of the matte box. It is also possible to attach gelatin filters to the front of the lens with an adapter and retaining ring. Some film cameras, such as the Bolex or CP-16, have a filter slot behind the lens. A gelatin filter is cut to fit into a small metal holder and then inserted in the filter slot behind the lens. In some of the better video cameras a new filter can be added to the filter wheel.

Compensating for Filters

As we have already seen, filters work by absorbing certain wavelengths of light and transmitting others. This means that obtaining proper exposure

usually requires some iris adjustment. A camera with a built-in light-metering system automatically compensates for the amount of light absorbed by a filter. When working with a separate meter, however, you must change the exposure according to the amount of light the filter prevents from reaching the imaging system. The degree of exposure compensation required for different grades of filters is usually expressed as a filter factor, a number based on the amount of light transmitted through the filter.[8]

The filter manufacturer normally supplies exposure compensation tables and an explanation of the filter grading system. In film production, recalculating the EI, taking into account how much exposure is affected by the filter, may be easier. Kodak does this on the film box for its motion picture film stocks. For example, Kodak's Video News Film (7240) has an EI rating of 125 without a filter but an EI of 80 when it is shot with the orange 85 filter required for daylight shooting.

Care of Filters

Because filters sit directly in the light path (either in front of the lens or behind it), they should be treated with the same care as a lens. Gelatin filters are so soft and easily damaged that they should be handled only by their edges and cleaned with a camel hair brush. Fortunately, gelatin filters are inexpensive and if damaged should simply be replaced.

Fingerprints can scratch or smudge glass filters. Carry them in a protective case and keep them immaculately clean. Once damaged, they cannot be repaired. It makes no sense to shoot with a high-quality camera and lens and then degrade the image they create by using a damaged filter.

A plain, clear glass filter is one of the least expensive ways to protect the costly lens on your camera. Mounted in front of the lens, it will shield the irreplaceable lens surface from scratches, water, and dirt. If it is damaged, you simply throw the $10 glass filter away, something you would not do with an expensive zoom lens. Many professional cinematographers use relatively inexpensive daylight or UV filters in the same manner.

Artificial Lighting

The lights used in film or television production come in a seemingly infinite variety of sizes and shapes. They are categorized by the intensity and quality of light they produce and by other characteristics, such as the way they are mounted or how they control the light they emit.

Types of Lamps

Incandescent lights, similar in construction to a typical household lightbulb, are common sources of artificial illumination. They contain a metal tungsten filament sealed to form a vacuum in a glass bulb or lamp. When electric current passes through the metal filament, the filament heats up and produces light. The more resistance the filament has, the brighter (and hotter) the light glows and the more power it consumes. This difference is expressed in **watts,** a measurement of the amount of electric current a particular bulb draws. Thus, a 500-watt incandescent bulb produces more illumination and requires more power than a 100-watt bulb.

The incandescent tungsten lightbulbs used for television and film lighting come in a wide range of wattages. They insert in a lighting instrument with either a flanged base that is pushed down and locked into place or with thin pins that plug directly into the lamp socket. Another common type of tungsten-filament incandescent lamp, called a **photoflood** (see Figure 6.9), has a standard screw base so it can be used with a normal household lighting fixture. The photoflood lamp is one of the least expensive lamps.

The principal drawback of regular tungsten incandescent bulbs is that their color temperature and light output drop as the bulb is used. As the tungsten filament evaporates, it deposits a tungsten coating on the inside of the glass lamp. This can occur after only a few hours of use, and although it may not be immediately visible to the naked eye, the color temperature can easily drop below the standard 3,200-degree Kelvin rating.

Because of this problem much modern professional lighting equipment uses **tungsten-halogen lamps,** also called **quartz-halogen** or **quartz lamps** (see Figure 6.10). These lamps also are incandescent lamps, but the bulb itself is

Figure 6.9
Many photoflood bulbs have a built-in reflector.

Figure 6.10
A quartz-halogen bulb in a highly portable lamp housing. (Photo courtesy of Mole-Richardson, Hollywood, U.S.A.)

made of quartz glass (to withstand the heat), and it is filled with a halogen gas. This creates a sort of restoration cycle. The halogen gas helps to deposit the evaporating tungsten back on the filament as the lamp burns. The result is a lamp that maintains its color temperature and light output far longer than regular tungsten-filament incandescent lamps. Quartz lights are also smaller and more portable than regular incandescent lamps.[9]

Be especially careful to avoid touching the surface of a tungsten-halogen bulb. Oil from the fingers, or any foreign material for that matter, will weaken the quartz envelope and cause it to burn out much more quickly. The bulb might even explode when it gets hot. When changing a quartz bulb, you must use a glove or a piece of cloth or paper to protect it.

Another type of light that is being used increasingly is the **high-speed fluorescent (HSF)** light (see Figure 6.11). Traditionally, fluorescent lights—the kind so common in schools and office buildings—have proved a difficult and unpredictable light source for shooting film or video, mainly because their color rendering in the reds is usually poor. HSF lighting outputs red, greens, and blues in a manner that guarantees 3200K color temperature. HSF lighting also eliminates the flicker problem common with regular fluorescent lights; while office lights oscillate at 60 cycles per second, HSF lighting averages between 25,000 and 40,000 cycles per

second. This makes for a constant pattern that is completely acceptable for film and video recording. The lights are very low energy because they operate through a chemical reaction involving phosphors that are stimulated. As a result, HSF lighting uses 90 percent less energy and generates less heat than tungsten-based lighting and the bulbs last for 10,000 hours, as compared to about 400 hours for tungsten.[10]

Situations that call for daylight-balanced lighting of about 5,500 degrees Kelvin often use special **HMI lights.** (HMI is the abbreviation for *hydrogen medium-arc-length iodide*.) HMI lights (see Figure 6.12) have a restoration cycle similar to that of a quartz light and maintain their color temperature and light output for long periods. They are frequently used as a supplemental light outdoors or to illuminate large areas. They are expensive, however, and require a large and bulky balast unit (high-voltage power supply) to produce consistent lighting.

In some lighting situations HMI lights are impractical or too expensive. In these cases, it may be necessary to convert regular 3,200-degree-Kelvin tungsten-balanced lamps to the color temperature of daylight. This is done by using blue **dichroic filters** that attach to the front of the light housing. Because these filters reduce the light output of the lamp by 30 to 40 percent, additional lighting instruments may be necessary to obtain the same amount of illumination.

Figure 6.11
A lamp that uses high-speed fluorescents. (Photo courtesy of Lowel-Light Manufacturing, Inc.)

Figure 6.12
An HMI light, shown with its ballast, produces daylight-balanced light with less heat and lower power requirements than incandescent lights. (Photo courtesy of Mole-Richardson Company)

Basic Lighting Instruments

Lighting instruments also are typically classified by the quality of the light they produce and how the light can be shaped and controlled by the lighting instrument itself. *Hard* and *soft* are the most common terms for describing light quality. A **hard light** has a narrow angle of illumination and produces sharp, clearly defined shadows, whereas a **soft light** scatters the light to create a much wider angle of gentle, diffused illumination.

Most lamps sit in some type of reflective housing that helps to control and direct the beam of the light. A **parabolic reflector** tends to produce a more concentrated beam of hard light. In contrast, a **softlight reflector** blocks the light directly in front of the lamp and bounces the light back into and off the reflector's surface. The result is soft, diffused light with the degree of softness determined in part by whether the reflector's surface is highly polished or matted.

Lighting equipment manufacturers and rental houses frequently categorize different types of lights according to their primary function. From this perspective lighting instruments are often classified as **key lights, fill lights,** or **scenery** (or **background**) **lights.** Key lights provide the main source of illumination in a typical lighting setup, so they tend to be powerful lights with a beam width that can be focused. Key lights come in a variety of closed-face (usually with a lens) and open-face designs. Fill lights supplement key lights, reducing the shadows and contrast range in relation to the key light. Fill lights usually produce a softer, more diffused light. They are often open faced and are usually more limited in their ability to vary the angle of illumination. Many, in fact, have fixed focus. Scenery lights add depth and control contrast between the subject and the background or set. They are often a form of soft light and provide flat, even lighting over a wide area.

a

b

Figure 6.13
(a) A spotlight in the spot position with the bulb moved toward the back of the lamp housing, and (b) a spotlight in the full flood position with the bulb moved toward the front lens.

Describing lights by their function has definite limitations. A lighting instrument can serve many purposes. A light sold as a key light can easily be used as a fill light. The real issue is not what the light is called but whether the light does what you want it to do in a particular situation. Nevertheless, some understanding of the basic strengths and weaknesses of different types of lighting instruments is important.

Lights are also classified as to whether they are **spotlights** or **floodlights.** The former usually illuminate small, concentrated areas while the latter cast a diffused and even beam of light over a fairly large area. However, many spotlights are variable and can cover either a small or large area. The **Fresnel spotlight** is one of the most widely used lights in professional film and television production. You can vary its beam width by adjusting a control knob or lever on the back of the light that moves the bulb-reflector unit toward or away from the Fresnel lens. In some cases moving the lens itself produces this effect. At the **spot** position the lamp is farthest from the lens. This converges the light rays and produces a narrower, more concentrated beam. At the other end of the adjustment range, the **flood** position, the lamp moves closer to the lens (see Figure 6.13). Flooding creates a wider and somewhat more diffused beam of light that illuminates a broader area.

Common uses of Fresnels are as key lights or to light essential areas of the set, but their controllable beam width means they can be adapted for almost any application (see Figure 6.14). They come in many wattages and with various types of lamps.

Some variable beam spotlights do not have lenses. For the lightweight and highly portable quartz spotlights used for location lighting, an open-face design is commonplace (see Figure 6.15). Although providing less beam control than a Fresnel, this type of instrument does allow the beam width to be varied from spot to flood.

Another type of spotlight has the reflector unit and focusing lens built right into the bulb. The beam width of such **internal reflector spotlights** is fixed, but different bulbs can be purchased with a greater or lesser degree of spotting. This same basic internal reflector lamp design is used in **PAR lights** (PAR stands for

parabolic aluminized reflector). PAR lights are available in clusters of six to twelve bulbs with varying beam widths and a color temperature of either 3,200 degrees Kelvin or 5,500 degrees Kelvin. (Figure 6.16 shows a PAR light bank.) Filmmakers use them to light large areas or to provide daylight-balanced fill light outdoors.

Lens-less, open-face lighting instruments come in many other varieties. Most of these lights are some form of floodlight. One of the oldest types, a **scoop,** contains a single bulb in a bowl-shaped metal reflector (see Figure 6.17). Scoops range in diameter from 10 to 18 inches, and the beam width of some scoops is somewhat adjustable.

Broads are rectangular floodlights that typically use quartz lamps in an open-face housing (see Figure 6.18). They produce a broad beam of relatively diffused light and are often used for fill lighting.

Softlights (see Figure 6.19) create a more diffused and even light than broads. The light they provide is virtually shadowless because the

Figure 6.14
A Fresnel spotlight with barndoors attached. (Photo courtesy of Lowel-Light Manufacturing, Inc.)

Figure 6.15
An open-face quartz spotlight with barndoors. (Photo courtesy of Sachtler Corporation of America)

ing an extremely soft light that is often used for fill or contrast reduction.

Many lighting equipment manufacturers sell portable lighting kits for location use. Such kits usually contain three or four small lighting instruments with stands, extension cords, and other accessories in a carrying case (see Figure 6.20). Location kits typically use quartz lamps ranging from 500 to 1,000 watts, and most portable instruments are open faced (broads or softlights). Small Fresnel spotlights are also available.

If time and space are a problem, a light can be mounted on a camera. This is used primarily for electronic news gathering or documentary work and only then in situations in which the flat, straight-on lighting a **camera light** (see Figure 6.21) provides is absolutely necessary. This type of light is usually battery powered and can be mounted directly atop the camera or held with a pistol grip. For maximum efficiency battery-powered lights typically use low-wattage tungsten-halogen lamps. Battery-powered lights begin to lose color temperature as the battery drains.[11]

Mounting Equipment

In the studio lights usually hang from a grid of pipes on the ceiling. Elsewhere, the most common mounting device is a **light stand.** Stands are made of metal, have tripod bases, and vary in size from the light alloy stands found in portable lighting kits to heavy-duty C-stands equipped with casters. They can be telescoped to a height of 6 to 8 feet (see Figure 6.22).

Telescoping **boom arms** (see Figure 6.23) and **extendable lighting poles** often hold lighter, more portable instruments. **Space-clamps** (see Figure 6.24) hold lights on shelves and similar structures. **Wall plates** or **base plates** are sometimes used to attach lights to flat surfaces.

Alligator clamps (also called **gaffer grips**) are spring-loaded clamps that can be used to secure a lightweight instrument almost anywhere. They are frequently found in portable lighting kits, as are **universal clamps,** small metal clamps that attach to a porcelain socket for holding photofloods. One of the most widely used light-securing devices, a **C-clamp,** attaches lighting instruments to a lighting grid or lighting pole. The screw in the C-clamp locks the clamp se-

bulbs are either recessed at the bottom of the instruments, usually in the larger softlights, or hidden behind a shield at the front of the housing in the smaller, more portable units. The light from the lamp never reaches the subject directly. Instead, it bounces off the reflective surface at the back of the instrument, produc-

Figure 6.16
A nine-lamp MicroBrute PAR light is small enough to be transported easily. (Photo courtesy of Great American Market)

Figure 6.18
A quartz lamp broad on a lightweight stand. (Photo courtesy of Mole-Richardson, Hollywood, U.S.A.)

Figure 6.17
A scoop. (Photo courtesy of Strand Lighting)

curely to the support. Figure 6.25 shows a variety of clamps and mounts.

Controlling the Light

If lighting is going to be used expressively, it must do more than simply provide enough illu-

mination to ensure proper exposure. It must in some way be controlled so that it falls in the proper places, assumes the desired shapes, and creates the proper intensity of illumination. A number of lighting aids have been developed to control and direct the light.

Barndoors, for example, block off the beam of light, preventing unwanted shadows and keeping direct light out of the camera lens. They are thin metal sheets on a frame that attaches to the front of the lamp housing. They are available for most lighting instruments in either a two-leaf or four-leaf design (see Figures 6.14 and 6.15). **Snoots** serve a similar purpose. They are metal funnels of different diameters that attach to the front of the light and restrict the beam to a circle pattern.

Other light-directing accessories, such as **flags, dots,** and **fingers,** are made with heat-resistant

Figure 6.19
A softlight with the lamps recessed along the bottom. (Photo courtesy of Strand Lighting)

Figure 6.21
A camera light mounts on a shoe on the top of the camera. (Photo courtesy of Lowel-Light Manufacturing, Inc.)

Figure 6.20
A portable location lighting kit with lights case, stands, barndoors, and other accessories. (Photo courtesy of Mole-Richardson, Hollywood, U.S.A.)

opaque cloth or thin metal sheets. Filmmakers put them on stands and place them between the light and the subject to create shadow areas or to keep light from reaching certain surfaces (see Figure 6.26).

One of the most valuable light-directing accessories is a **reflector** (see Figure 6.27). It bounces light (for fill) back into the scene from a bright light source like the sun or a powerful key light. Reflectors are mounted on stands or held by grips during production. Any movement of a reflector, however, whether caused by a person holding it or the wind, will create a

moving light pattern and may make the light unusable.

Some portable lighting kits use an **umbrella reflector** (see Figure 6.28) to create an extremely soft light source. The umbrella attaches to the light stand, and the light is turned into it. The beam bounces off the umbrella's reflective interior surface, producing a highly diffused pool of light.

A piece of white cardboard, a sheet of white Styrofoam, a space blanket, or even crumpled aluminum foil taped with **gaffer tape** to a cardboard backing can provide a homemade reflector. Professional reflectors typically have a different surface on each side of a sturdy base: a hard, highly reflective side that redirects the light without scattering it and a more matted

Figure 6.22

(a) A lightweight telescoping light stand, and (b) a somewhat heavier light stand. (Photos courtesy of Mole-Richardson, Hollywood, U.S.A.)

Figure 6.23

A softlight on a boom arm. (Photo courtesy of Lowel-Light Manufacturing, Inc.)

side that redirects and softens the light bounced from it.

Placing a light-diffusing material in front of the light source changes the quality of the light a lamp emits. Common light-diffusing materials such as fiberglass, silk, frosted glass, Dacron, and heat-resistant plastics can alter light quality according to the diffusion characteristics of the material employed.

Diffusion materials can be mounted in a filter holder or filter slot in many lighting instruments (see Figure 6.29). They can also be placed on a stand between the subject and the light source. Because they are used with intensely hot lights, the stronger, more heat-resistant materials are preferred. Large diffusers can be suspended on frames over the entire set for location shooting.

A **scrim** is an accessory for reducing light intensity without changing the color balance of the light transmitted through it. Scrims are made of translucent black fabric or stainless steel mesh similar to a common household window screen. They mount in a holder on the lamp, or they can be placed on a stand between the light and the subject. Outdoors, large scrims such as a **butterfly scrim** (Figure 6.30a) suspended on a large frame reduce the intensity of sunlight in an area as large as 20 square feet. Scrims are available in varying thicknesses. Single scrims (Figure 6.30b) cut the light by one half-stop,

Figure 6.24

An HSF mounted with a space-clamp. (Photo courtesy of Lowel-Light Manufacturing, Inc.)

and double scrims (Figure 6.30c) cut the light by a full stop. Half-scrims cover only half of the instrument's opening.

Dimmer boards control the intensity of the light, but they are somewhat bulky and therefore are rarely used for remotes. Dimmers use varying resistance to change the amount of voltage

Figure 6.25
A variety of clamps and mounts. (Photo courtesy of Lowel-Light Manufacturing, Inc.)

Figure 6.26
A portable light with flags attached to flexible shafts. (Photo courtesy of Lowel-Light Manufacturing, Inc.)

Figure 6.27
Several reflector variations. (Photo courtesy of Lowel-Light Manufacturing, Inc.)

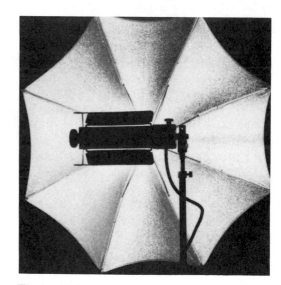

Figure 6.28
A lightweight umbrella reflector. (Photo courtesy of Lowel-Light Manufacturing, Inc.)

reaching the lamp. However, reducing the voltage changes the color temperature, so dimmers can adversely affect color rendition.

Neutral density gelatins also reduce light. Neutral density filters for cameras are more common than neutral density gelatins, but these gelatins are sometimes hung over windows to reduce the relative intensity of sunlight in interior scenes.

One of the most obvious ways to change light intensity requires no special equipment or supplies. It involves simply moving the light closer

to or farther away from the subject being illuminated. As the light is positioned farther away, the intensity of the light decreases. The falloff is not proportional to the distance, however. According to the **inverse square rule**, the intensity of the light decreases by the *square* of the distance from the subject. In other words, moving a simple light source (such as a candle) from 10 feet to 20 feet from the subject will reduce light intensity on the subject by roughly *four times*. (Figure 6.31 illustrates the inverse square rule.) Most lighting instruments, of course, have some

a

b

Figure 6.29
Photo a shows an accessory holder for different filters; photo b shows a lightweight frame for holding various gels. (Photo a courtesy of Mole-Richardson, Hollywood, U.S.A.; photo b courtesy of Lowel-Light Manufacturing, Inc.)

means of directing or focusing the light rays, which alters this formula. In actual practice this axiom simply means that close-ups of actors require less light than medium or long shots, for which the lights must be placed farther away to remain out of the frame.

Electric Power Requirements

Artificial lights require electricity to function. The three basic sources used to power lighting equipment in film and television production are batteries, gas-powered generators, and household current. Battery-powered lights have lim-

ited uses. They provide a small amount of illumination and can operate for only a short time before the batteries must be recharged. In contrast, generators can provide large amounts of electricity. They are used primarily by professional production companies that need to illuminate large areas (and power many lighting instruments) with a power source that can be transported to virtually any location. For the majority of productions, however, the most common power source is the current supplied to a house or building by the utility company.

Portable lighting instruments are usually designed to operate with the 120-**volt** current available from wall outlets in almost every building or home. Lamps of different sizes draw greater or lesser amounts of power. Exceeding the power limits that a household electrical system can provide will cause an overload, resulting in tripped breakers, and sometimes burned connectors or cables.

Power circuits in most buildings or houses have breakers that handle either 15 or 20 **amps** per electrical circuit. If the lights plugged into a circuit exceed that limit, the circuit breaker will cut off the current. To determine the amperage rating for a circuit you must find the breaker box or boxes and read the breaker limit, either the 15 amps usually found only in older buildings or the more common 20 amps listed on the breaker switch handle. All electrical outlets and lighting fixtures at the location are routed through these breakers, and each power circuit has its own breaker switch. If you blow a circuit, the switch will flip to the middle, neither off nor on. You will need to unplug the lights that blew it and reset the circuit breaker by flipping the switch off, then on. The circuit is working if the breaker stays in the on position.

Obviously, it is vital to know which wall outlets are controlled by each breaker switch so you don't overheat a circuit. If that information is not written in the breaker box, you will need to compile your own map of the circuits. To do this, plug a light into each wall outlet in a particular room and switch the breakers off and on to determine which outlets are on which circuit. An inexpensive night-light is ideal for this purpose. A single circuit may have wall outlets in several rooms, such as a hallway, bedroom, and bathroom.

a

b

c

Figure 6.30

A butterfly scrim (photo a) can diffuse light over a much larger area than a single or a double scrim. Made from stainless steel, a single scrim (b) and a double scrim (c) fit into a variety of accessory holders. (Photo a courtesy of Matthews Studio Equipment, Inc.; photos b and c courtesy of Mole-Richardson, Hollywood, U.S.A.)

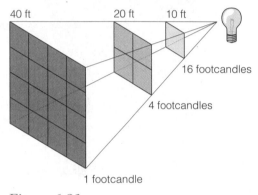

40 ft　　20 ft　　10 ft

16 footcandles

4 footcandles

1 footcandle

Figure 6.31

The inverse square rule. The intensity of the light varies according to the square of the distance from a simple light source.

Once you have mapped a circuit, you will need to do some simple mathematics because circuit breakers (and most generators and batteries) are rated in amps, but appliances and bulbs are labeled in **watts.** Fortunately, a relatively simple formula converts watts and amps: *amps times volts equals watts.* The power voltage in the United States is about 120 volts. But to make the calculation even easier to do in your head, do the calculations using 100 volts instead of 120. This provides a margin of safety to keep from blowing circuits and also makes the multiplication simpler because you can multiply the number of amps given on the breaker box by 100. This tells you how many watts you can safely plug into the circuit. For example, if the circuit can carry 20 amps, you can plug in 2,000 watts' worth of lights (2,000 watts = 100 volts × 20 amps).

This would mean you could plug in four 500-watt lamps, two 1,000-watt lamps, or any other combination of lamps adding up to 2,000 watts. Of course, you can use this much only if nothing else is plugged into the circuit. If a refrigerator or other power-consuming equipment is operating, you must deduct the number of watts each uses.

If the circuit in a room you are lighting cannot provide enough power for all your lighting instruments, you will have to route power to your lights from a different circuit. Extension cables used for this purpose should be of a heavy enough gauge to handle the wattage they are expected to carry. Common household ex-

tension cords are too lightweight and can be dangerous. Long extension cable runs can also reduce the voltage supplied to the lamps and may affect color rendition. A 1-volt drop in power supplied to an incandescent lamp lowers the color temperature by 10 degrees Kelvin.

As noted earlier, renting a generator is the common solution to limited location power. Generators are not cheap, but some rental houses provide student discounts, and in many cases a rented generator may be the only way to assure reliable power. Another option might be to negotiate with a neighbor to buy power from them. Finally, another option available from most lighting rental houses is a range plug. This plug is different from the standard two- or three-pronged Edison plugs. It plugs into the 240-volt outlet used for electric stoves and clothes dryers and breaks it down into two 120-volt legs. The lighting manufacturer, Mole-Richardson, calls this conversion plug a "range to Edison box," but there is really no standard term for this device. In a house with limited circuits it can be invaluable.

Professional film and television crews typically hire a licensed electrician to help deal with electrical problems. An electrician can bypass the breaker box and route the power into a separate distribution box that has its own breakers. This enables power cables to be run directly to the distribution box and be routed where they are needed without the constant risk of tripping circuit breakers. Bypassing the circuit breaker box, however, should be done only by a qualified electrician.

Figure 6.32
Taping down extension cords can prevent injuries and reduce the chances of lights being pulled over.

Figure 6.33
A sandbag can be used to secure top-heavy light stands. (Photo courtesy of Matthews Studio Equipment, Inc.)

Lighting Safety

Setting up and operating lighting equipment, especially on location, requires planning and care. Lights must be securely mounted, and barndoors or filter holders should be locked in place or taped to any supporting structure for additional stability. Electrical cords and extension cables should be taped down with gaffer tape or paper tape or be covered with rubber matting to keep people from tripping and pulling the lights down (see Figure 6.32). Power cables coming from the light should be secured to one of the legs of the light stand.

A fully extended tripod-base light stand is inherently unstable, and you should secure the legs with sandbags to keep them from tipping over (see Figure 6.33). Some heavy-duty light stands have antisway bars to increase their stability or come with rings at the base for securing power cords. Pointing one leg of the light stand in the direction the lighting instrument is facing helps to distribute the weight more evenly and improve the stand's steadiness.

Because lighting instruments get very hot, never place them near flammable materials such as curtains or upholstered furniture. An overloaded circuit or inadequate extension cable can also cause a fire. The placement of gels, filters, or diffusing materials on the lighting instrument also requires careful attention. It is imperative to attach these light-shaping materials in such a way that the heat can escape from the bulb and surrounding area. Even if a light has only been on for a short period, it is usually too hot to touch. If it is not possible to let the light cool down, use insulated electrician's gloves to adjust barndoors or to change scrims or filters. Turn lights off as soon as production is completed so they have time to cool before being packed away. Be careful when removing tape from floors or walls; it is easy to damage wallpaper or painted surfaces as the tape is peeled away.

Most of these safety precautions are just common sense. In the heat of production, however, with time running short and pressure building, cutting corners is a real temptation. That is when accidents occur. To protect the crew and cast from injury you must always handle electrical power and lighting instruments in a careful, systematic, and professional manner.

In addition to well-maintained lighting instruments and the proper filtration materials and securing devices, a number of items should be part of your location lighting kit. These include a fire extinguisher, insulated gloves for each crew member handling lights, burn ointment, rubber matting, gaffer tape, and spare bulbs. Finally, the quality and safety of location lighting are directly related to the amount of advance planning. Scouting a location for power requirements *before* the shoot tells you what to bring.

Notes

1. Several camera models use the zebra pattern. Its stripes are visible in the viewfinder over the areas of the picture that are near the 100 IRE unit level, the uppermost limit of brightness. It is adjustable in cameras such as the Betacam. The zebra stripes could be set to a level, for example, of 65 to 70 IRE, the approximate level for Caucasian skin tone and a level that is not so close to the camera's clip levels.

2. Overexposure in video can be especially troublesome. For an excellent discussion of this issue, see Harry Mathias and Richard Patterson, *Electronic Cinematography: Achieving Photographic Control over the Video Image* (Belmont, CA: Wadsworth, 1985), pp. 99–109, 164–173, 180. They recommend exposing for extreme highlights and then moving down to the required fill levels.

3. Mathias and Patterson, pp. 171–172. The authors describe a simple procedure for establishing an ASA rating for any video camera. This requires a chip chart and waveform monitor in addition to the light meter and camera you will be using. After lighting the chip chart evenly, open the camera's iris to the point at which the white chip on the chart is at 100 IRE units on the waveform monitor. After checking to see which f-stop that requires on the camera, change the ASA slide or dial on the light meter until you reach the same f-stop reading as the one on the camera. You then can use that ASA slide or setting as the ASA for your camera.

 Color negative film stock has a contrast ratio of approximately 128:1. This means it can record more discernable brightness levels (or shades of gray) than a typical video camera. In other words, a scene shot on film will produce a greater range of brightness levels than the same scene shot with the same lighting with a video camera. Details that would be discernable in the shadow area of the film version may not even be visible in the video version of the same scene. This reduced contrast range is one of the primary differences between film and video. Electronic imaging advances continue to narrow this gap.

4. Remember that the range of f-stops is a result not only of the variance of light falling on the scene but also of the varying reflections of different surfaces within the scene. A single light source can result in different ranges, depending on the nature of the subject. For example:

Contrast Ratio	Range in F-Stops
1:1	0
2:1	1
4:1	2
8:1	3
16:1	4

5. For explanations of the waveform monitor, see Eileen Turri, "Scoping Out Your Video," *Videography,* November 1991, pp. 29–34; and Peter Utz, "Bars and Stripes Forever," *AV Video,* November 1995, pp. 77–87.

6. Rosco Laboratories, one of the biggest manufacturers of filters for film and television, has developed complete vectorscope readings for every Roscolux filter, including phase angles, chroma amplitudes, and waveform monitor luminance values. Thus, various colors will plot at different places on the vectorscope, according to their phase angle and chroma amplitude. Information about this may be obtained from Rosco Laboratories, 36 Bush Ave., Port Chester, NY 10573; (914) 937–1300.

7. For a good discussion of filters, see Chuck Gloman, "What's So Swell About Gels?" *TV Technology,* 29 June 1998, p. 48; and Stuart Singer, "Polarizing Filters," *International Photographer,* May 1997, pp. 26–27. In addition, Tiffen Manufacturing Corp., one of the biggest filter manufacturers, has produced a videotape entitled "Which Filter Should I Use?" that demonstrates a variety of specialty filters. For information about the tape, write to Tiffen Manufacturing, 90 Oser Ave., Hauppauge, NY 11788; (800) 645–2522.

8. The filter factor is the inverse of the fraction of the light transmitted (for example, $1/4$ is two f-stops). You can divide filter factors into ASA and make all subsequent exposure calculations based on the new or recalculated ASA. With a filter factor of 4, for example, the ASA might be 320 without the filter but 80 (320/4) with the filter.

9. See "Cameras, Action . . . Lights!" *TV Technology,* 23 March 1998, p. 178.

10. See Steve Michelson, "HSF Lighting Takes to the Field," *TV Technology,* 23 March 1998, p. 226. For a full technical discussion of this type of lighting, see Paul D. Costa, *VIDESSENCE: Sustained RGB Light and Camera Theory* (Burlingame, CA: Videssence Press, 1992).

11. For more on types of lights, see Ronald J. Compesi and Ronald E. Sherriffs, *Video Field Production and Editing* (Boston: Allyn and Bacon, 1994), pp. 155–177; and Thomas D. Burrows, Lynne S. Gross, and Donald N. Wood, *Video Production: Disciplines and Techniques* (New York: McGraw-Hill, 1998), pp. 87–115.

chapter seven
Lighting Approaches

The opening section of Carrol Ballard's *The Black Stallion* (1979) tells the story of a young boy shipwrecked on a deserted island with a beautiful untamed black stallion as his sole companion. The first fifty minutes of the film, from the shipwreck to the rescue of the boy and horse from the island, contain no more than five to six minutes of dialogue. Instead of words, *The Black Stallion* tells its story primarily through an incredible series of images photographed by Caleb Deschanel, director of cinematography. One breathtaking shot follows another: shimmering seas, moonlit cliffs, glowing sunsets, and dark, foreboding rain clouds. The first fifty minutes of *The Black Stallion* are a virtual textbook in image making, an advertisement for Kodak.

For great cinematographers like Caleb Deschanel, Conrad Hall, Vilmos Zsigmond, and Gordon Willis, lighting is more than simply obtaining adequate exposure. It is a way to direct the viewer's eye in the frame, to establish the character, the mood, and the dramatic quality of the image. Lighting can establish the time of day, bring out or mute certain colors, or create a feeling of safety or danger. Light can be used to emphasize or deemphasize depth. Layered in planes from the front to the rear of the frame, light can also help define the space in three dimensions.

Lighting Styles

The lighting in most modern dramatic motion pictures tends to be more or less realistic; it looks like the natural light we experience in everyday life (see Figure 7.1a). The key to this style of lighting is that the light must *appear* to be coming from some real light source in the movie, such as a streetlight, a ceiling fixture, a table lamp, or the sun. This kind of lighting is often called **source lighting** because it mimics or augments the direction of the light and the light source in the scene.

The opposite lighting approach, one that could be called *expressionistic* (or *stylized*), is more concerned with creating a particular mood or feeling in the shot than in seeming realistic (see Figure 7.1b). Such distinctions are not always clear-cut. To produce an image requires light, even in places where light is unlikely. It may be totally unrealistic to have a spotlight illuminating the slimy monster in a dark sewer, but realistic lighting is not the primary objective in such movies. Even motion pictures that make every effort to employ realistic lighting can slip into movie lighting conventions that totally defy our experience with light in real life: the pitch-black alley behind the bar that is *always* lit by a convenient full moon or the light streaming from beneath the dashboard in the front seat of the otherwise dark automobile.

There are many different approaches to lighting. Numerous books and magazines discuss the aesthetics of lighting,[1] but ultimately the style of lighting employed tends to defy any simple formula or rule book. A lighting setup must take into account not only the technical limitations of the camera, lens, and recording medium but also the dramatic needs of the scene being shot.

Basic Three-Point Lighting

Every imaging system (whether electronic or photochemical) requires a sufficient amount of light, called the **baselight level,** to ensure proper exposure. Base illumination typically is diffused, overall lighting coming from no discernible direction. The minimum baselight level for many video cameras is in the range of 100 footcandles, but this level does little to emphasize the subject or define the space. It simply means that the camera has enough light to operate.

Three-point lighting is perhaps the most traditional approach to lighting. It creates a balanced, sculpted image, one that emphasizes

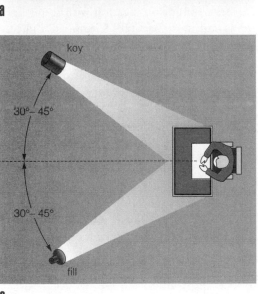

Figure 7.1

In an episode of the TV series Werewolf, *actor Chuck Connors is seen (a) in a lighting setup that is basically realistic and (b) in a lighting setup that is more expressionistic. (Photos courtesy of Columbia Studios)*

Figure 7.2

(a) The basic angles for the key and fill lights in relation to the camera subject and (b) the vertical angle above the camera subject for the key and back lights.

three-dimensionality in the otherwise flat, two-dimensional film or video frame. In the studio, of course, it is possible to control the light totally, but the same basic principles apply to location lighting.

The primary light source in three-point lighting is called the **key light**. The key light simulates the main source of illumination for a scene—the sun (or streetlight) outdoors, a lamp or lighting fixture indoors. It typically is placed 30 to 45 degrees from the camera-to-subject axis

and is elevated at an angle of 30 to 45 degrees above the camera-to-subject axis (see Figure 7.2). The key light is often a focusable lighting instrument like a Fresnel and is adjusted somewhere in the middle of the flood-to-spotlight range. It creates some shadows, giving shape to the subject. As the dominant lighting source, it is the light most responsible for setting the basic f-stop used to shoot the scene.

The **fill light** is placed on the opposite side of the camera from the key light, from near the

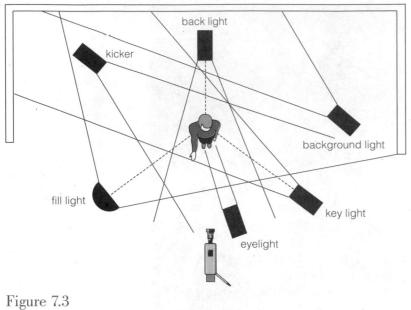

Figure 7.3

A complete lighting setup with key light, fill light, back light, kicker light, background light, and eyelight in their typical positions.

camera to as much as 45 degrees away, and usually at camera height. It fills in, at least to some degree, the shadows created by the key light. For that reason it is never more intense than the key light and almost always employs a softer, more diffused light source. Too much fill light can create a flat, low-contrast image.

The third basic light in a three-point lighting setup is called the **back light.** It is placed above and behind the subject at enough of an angle to keep the light from coming directly into the camera lens. The back light helps to outline the subject (particularly in the head and shoulder area because the light is coming from above and behind) and separate it from the background.

Additional lights, sometimes referred to as **separation lights,** often amplify or enhance the modeling provided by traditional three-point lighting (see Figure 7.3). An **eyelight** is a small, focusable light placed near the camera (at eye level) to add a sparkle to a person's eyes. A **background light** illuminates the background, not the back of the subject like a back light. It helps to separate the performers from the background or set. A **kicker light** is similar to a back light in function. It is usually placed low, behind the subject, often directly opposite the key light. It too helps to separate, or "kick," the subject out from the background. The intensity needed for a back light or kicker light can vary greatly. A brunette requires more light, a blonde less, and a bald person even less. A properly lit scene may

not even require separation lighting, and some lighting directors avoid kickers and back lights in order to achieve greater realism.

Film Versus Video Lighting

Television lighting originated in the studio. Early video cameras required a high baselight level just to produce an image. Thus, the typical multicamera studio production tended to pour a great deal of light over the entire action area, producing the relatively flat, even lighting still seen in many game shows and situation comedies. In contrast, the much greater sensitivity of film stock made it far easier for filmmakers to shoot on location with lower light levels and more natural (or realistic) lighting techniques. **Film-style lighting** grew out of the single-camera shooting method for film: the lighting setup is changed as the camera position is changed for virtually every new shot. This is a slow and tedious process, of course, but what film-style lighting loses in time it makes up for in control.

As technological improvements in video equipment began to narrow the differences between film and video, applying film-style lighting techniques to video production became increasingly possible. Differences in lighting for film and video remain, of course, but now the same basic lighting principles can apply to both media.

The most important difference between lighting for film and lighting for video, as noted in Chapter 6, stems from film's greater **latitude** or **contrast range.** Color negative film stock can accurately reproduce a range of brightness levels (from the darkest to brightest points in the scene) of more than seven f-stops. Most video cameras can record a more limited range of approximately five f-stops. A shot exceeding the contrast range of the imaging system loses visible details in the dark or bright areas that are below or above the camera's range.

Altering the electronic imaging system so that it records more detail in the light or dark areas is possible but does not change the contrast range. If the imaging system is adjusted toward the bright end of the range, it will lose

detail in the shadow areas. If it is shifted toward the dark area, it will lose information at the bright end of the scale. Film's greater contrast range gives it an advantage over video. This may partially explain why so much material produced solely for television (as opposed to theatrical distribution) is still shot on film. Even when a production is shot on film and copied (and postproduced) to videotape for display on television, the film tends to act like a filter, compressing the contrast range and making the transition into bright or dark areas less abrupt than if the same material had been shot on video originally. Furthermore, the film image is less affected by strong highlights because each successive film frame presents an entirely new recording area, unaffected by the previous frame. In a video camera, each frame is scanned from the imaging device.[2]

This difference does not mean that video must be lit in an entirely different way from film. It does mean that video lighting must involve some type of contrast reduction in order to stay within the five f-stop range.

In film, one of the most common methods of reducing contrast is a procedure called **flashing**. This involves exposing the motion picture film to a low but precisely controlled level of light *before* it is exposed in the camera (that is, *preflashing*) or *after* it has been shot (that is, *post-flashing*). Whether it is done before or after shooting, flashing must be done *before* the film is developed. Flashing reduces contrast and increases visible detail in the shadow areas. It can also be used to mute colors or to create a softer image without losing image sharpness or resolution.

A video camera can achieve much the same effect. Although the tradition in video has been to set a camera up strictly according to factory specifications, a video engineer can readjust the imaging system to produce changes in color balance, tinting, and contrast shifting, similar to the way film stock can be manipulated in the laboratory. As the differences between film and video continue to blur, such creative manipulation of the electronic image will undoubtedly increase in production and postproduction.

Some video cameras do not accurately reproduce detail in the shadow areas. Furthermore, large dark areas in a video frame can show a great deal of **noise.** The answer to this problem may be to use fill lighting to bring up the light level in those dark areas.

It is important to keep the light in the scene within the brightness range of five f-stops and, if possible, to make sure that the entire range is filled by including both a **black reference** (some black object within the shot) and a **white reference** (such as a white handkerchief). Video cameras have difficulty when the lighting for a scene is low contrast—at relatively the same brightness level at either end (dark or bright) of the contrast range. Using a white and a black reference helps to fill in or extend the video signal over the full range the camera is capable of reproducing. In a scene that is darkly lit overall, a white reference helps to restore the full contrast range. This can be provided by a practical light within the scene, such as a table lamp, or by any strong back light or side light that can create enough highlights to provide a white reference. In a scene in which the overall lighting is bright with no shadow areas, a black reference helps to produce the full video range.[3]

It is easy to see why a portable **waveform monitor** can be such a valuable tool for video lighting. It displays the brightness levels across the entire scene and provides an extremely accurate guide for setting up or adjusting the lighting for the brightness range the electronic imaging system is capable of recording.

Producing the same lighting effect can be more time consuming in video than in film because of the need to manipulate contrast range. This is offset to some extent by the ability to instantly review lighting results on a monitor. And, as is the case in most student productions, as long as you are not paying the crew for the extra time it takes to light, the low cost of videotape encourages experimentation—shooting until you get exactly the lighting effect you desire.

Preparing to Light

Lighting, like any other element of the production, requires advance planning. The lighting director needs to understand the exact nature of the scene being shot. What kind of mood is

the director trying to create? What kind of lighting instruments does that require? Are any special lighting accessories needed? At what time of day is the scene supposed to be taking place (and will the scene actually be shot at that time)?

If you are not going to be shooting in a studio, careful and systematic location scouting is imperative. You will need to survey each location to determine how much light it will require and how lights can be mounted at each location. How many crew members will you need to set up the lights or handle the reflectors? Seeing the site at the time of day you are actually planning to shoot is important. The position of the sun (and the prevailing lighting conditions) changes dramatically from early morning to late afternoon. Will it be possible to use reflectors? It is a good idea to take a camcorder along to log each location.

Once you have some idea of how many lights you are going to need and how they will be mounted, you should survey the location for electricity. How much power will you need and how much is actually available there? This is the time to find the breaker box and map out the power circuits. How many wall outlets do you have and where are they located? If you need to run power from additional circuits, how long do your extension cables need to be? Do you have a contact person so you can gain access to the breaker box? Do you need to hire a qualified electrician? If the power at the location is inadequate, you will need to rent a generator or perhaps negotiate with people nearby to buy power from them.

You also need to consider how you will transport your lighting equipment. Lights and lighting accessories are large and bulky. They are also fragile. What kind of vehicle do you need to transport the equipment? What kind of access do you have for the vehicle when you reach the location? Ultimately, you will need to develop a checklist so that you don't forget anything. Here are some of the major items:

1. Lighting instruments and spare lamps (number, type, and size)
2. Mounting equipment (number, type, and size)
3. Lighting accessories (barndoors, flags, filters, diffusers, reflectors)
4. Power cables and mats, sandbags, and gaffer tape
5. Generator (if needed)
6. Safety equipment (fire extinguisher, gloves, and such)
7. Transportation
8. A weather report

Outdoor Lighting

Shooting outdoors usually means that you will have enough light to meet the baselight requirements of almost any film stock or electronic imaging system. The sun itself can be a powerful key light, not only defining the time of day (based on the color temperature and angle of the shadows) but also dictating the direction of the light in the scene. Shooting with the light (in the direction the light rays are falling) is the simplest and most common technique for outdoor shooting. Keeping the sun at your back usually eliminates the problems associated with lens flare and backlighting. The photos in Figure 7.4 illustrate shooting with the light and against it.

Light in the early morning or late afternoon casts longer, more clearly defined shadows, creating a greater sense of relief or modeling and a more dramatic image. A shot of a high mountain lake looks quite different in the flat light of midday than early or late in the day. The time of day also affects the color tones in the image. The late afternoon sun casts a particularly warm golden light. Many cinematographers prize the look of this "golden time" and set up their shooting schedule to take full advantage of the atmosphere it establishes for a scene. (See Color Plate 8.) For similar reasons they have used the dramatic red glow of a sunset as the backdrop for scenes in countless motion pictures.

The quality of the outdoor light we actually experience ranges from very harsh and direct to soft and diffused. In fact, natural light is usually a mixture of different light qualities. The sun can be both a source of hard direct light and a source of fill as the sun's light is reflected from clouds, buildings, and the ground to form a softer, more

a

b

Figure 7.4
(a) Shooting against (into) the light can create many problems with exposure, flare, and unwanted reflections. Shooting with the light (b) usually eliminates these problems and is almost always easier.

Figure 7.5
Using reflectors is an efficient way to provide fill lighting in many outdoor situations.

diffused general skylight. In most cases, however, reflected skylight does not provide enough fill for outdoor shooting. Without adequate fill light a sunlit image can easily exceed the latitude or contrast range of a camera's imaging system. As a result, outdoor lighting usually involves some kind of contrast reduction, a way to reduce the enormous range between bright sunlight and the dark shadows of the shade.

Contrast Reduction

Throwing additional fill light into the scene, as we have already discussed, is one way to reduce contrast outdoors. This is why professional film and television companies so commonly use artificial lighting outdoors, even on a bright sunny day. This situation necessitates the use of daylight-balanced light sources such as **HMI lights,** or tungsten-balanced lights converted (with a **dichroic filter**) to daylight color temperature.

An even easier and cheaper method of providing daylight-balanced fill light is using **reflectors** (see Figure 7.5). Reflectors can bounce direct sunlight back into the scene for fill lighting. If the sun is the primary light source in a scene, the reflector will have to be placed in the standard fill light position (on the opposite side of the camera from the "key" light) in order to reflect the sunlight into the scene. Reflectors are usually mounted on stands (or hand-held) above eye level to simulate skylight. If they are too low, or if they create a too clearly defined light pattern, the reflected light they cast can look artificial and unnatural.

Another way to reduce contrast is to suspend a large **scrim** or light-diffusing medium over the entire set area. This can virtually eliminate shadows, creating the kind of soft, dreamy, highly diffused lighting commonly seen in many television commercials. Virtually the same thing can be accomplished by simply shooting the shot in a shaded area or shooting on an overcast day.

Sometimes you can put a filter on the camera to control outdoor lighting conditions. A **neutral density filter** reduces the overall light level in an excessively bright outdoor scene.

This can be helpful when you want to reduce the **depth of field** by forcing the camera to shoot at a wider **f-stop** (see Chapter 4). **Haze filters** and **UV filters** reduce the bluish cast on overcast or hazy days. **Polarizing filters** minimize unwanted reflections from water or glass. **Fog filters** can create a fog effect, and **low-contrast** or **soft-contrast filters** reduce the contrast range. Filters generally cause some loss in image quality, but in many situations they may be the only workable way to deal with existing lighting conditions.[4]

Maintaining Continuity in Changing Light

When the sun is the primary light source, there is always the potential for lighting-induced continuity errors. Movies are usually shot out of sequence, and long delays between camera setups are commonplace. Shots that supposedly occur sequentially in time may have been shot at different times during production, even days or weeks apart. If those shots are to flow together seamlessly in the final motion picture, the lighting within the scene must be consistent from shot to shot.

This means that the light quality must be the same for each shot in the scene. If the first shot takes place in direct sunlight, it will look strange if the light in the next shot is suddenly the more diffused light caused by a passing cloud. Similarly, the direction of the light must be consistent. The angle of the sun creates appreciably different shadows at different times of day. A shot taken at noon when the sun is almost directly overhead contains few shadows. If that shot is followed immediately by a shot that clearly displays the long shadows of late afternoon, the continuity violation is obvious.

Even the natural changes in the sun's **color temperature** throughout the day can be the source of continuity errors. The color temperature of sunlight at 4 P.M. is visibly different from the color temperature at 6 P.M. The automatic **white-balancing** circuit in a video camera, or **color-compensating filters** on a film camera, can correct for these small shifts in color temperature. However, you cannot eliminate gross changes in the shadows or in the overall quality of the light.

The only way to avoid such lighting-induced continuity problems is to organize your shooting schedule carefully when working in natural light. Trying to shoot a long complicated scene late in the day when the light is changing rapidly will almost certainly lead to problems. Group similarly lit scenes together in your shooting schedule, and try to avoid shooting different sections of the same scene at different times of day. Shooting part of a scene before lunch and then finishing the rest of the scene after a long break can easily create incompatible lighting conditions.

Shooting at Night

Night scenes abound in feature films. Shooting at night, what filmmakers call **night-for-night,** produces the most convincing results. One of the biggest battles in night lighting is finding a convincing (well-motivated) source—a store window, streetlight, or bright moon—that could provide a believable source for the illumination of the scene. Artificial lights are then used to simulate the light that would be coming from that source. (See Color Plate 9.) Night lighting is easier if the actors avoid wearing dark clothing that makes them blend into the background.

Dusk-for-night shooting is just what it sounds like—shooting at dusk. The sky at twilight provides a natural blue fill. Artificial lights provide the key. The biggest problem with dusk-for-night shooting is that twilight is so short. The rapidly changing lighting conditions require constant monitoring and readjustment of lights.

Another method, called **day-for-night,** is a well-known film technique for shooting "supposed" night scenes during the day. This involves increasing the contrast and darkening the sky usually by using a deep blue filter for color filming. Or some cinematographers use film that is balanced for artificial (3,200 degree) light and shoot without an 85 orange filter, thus enabling the film to "see" the daylight as blue. The scene is then underexposed by 1.5 to 2.5 f-stops. The

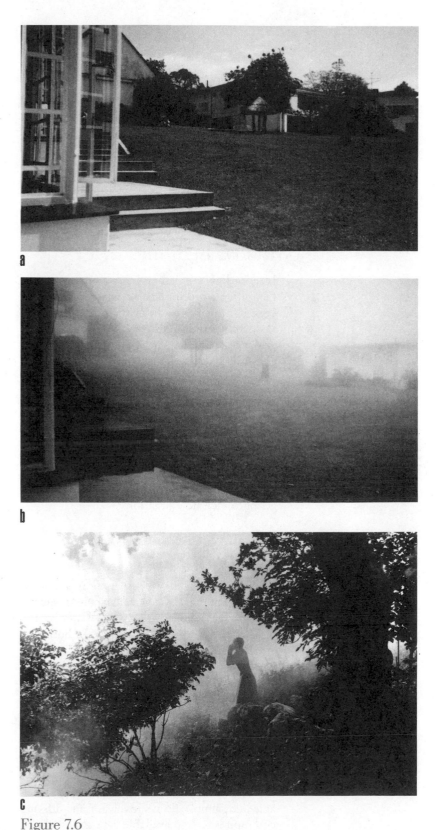

film laboratory can also enhance the day-for-night effect during printing. With the proper tinting and some trial and error many of these night effects may be possible in video as well.

Shooting night-for-night on video generally is more difficult than shooting on film because of video's limited contrast range. What makes a shot read as night is having large dark areas in the background and a fairly large contrast between the light and dark areas. Video cameras have difficulty recording this, although even consumer-level cameras have continued to improve in this area. The best solution may be a subtle boosting of the fill light in the shadow areas, enough to reduce the contrast range but not enough to eliminate the sense of darkness in the background areas. A scene shot in color can also be made to look more like night if a light blue gel is used on the lighting instrument. This is because moonlight is conventionally enhanced by a bluish cast.

Adapting to Weather Conditions

When shooting outdoors, natural weather conditions can change the quality of the light dramatically. A funeral scene shot on a dark overcast day reads differently than the same scene shot in bright cheery sunlight. The highly diffused light of an overcast day often improves a color image. The low-contrast lighting can mute certain colors, making them more subtle and pastel. Shooting just after a rain has stopped can pick up a myriad of reflections and moving water patterns. Snow, fog, and mist each create a distinct mood-provoking atmosphere (see Figure 7.6). Even extremes in temperature can alter the quality of the light. On a cold day the steam curls from virtually every heat source. In the desert the hot air rising from a highway can imbue a shot with a sense of unbearable heat as the light is distorted through the shimmering haze.

Obviously, you cannot control the weather or the temperature, but you can use naturally occurring conditions when the opportunity arises. Professional filmmakers, of course, can "make" weather to some extent with fog and rain machines. Wetting down the streets to create water

Figure 7.6

The same scene from virtually the same angle reads in very different ways on a bright sunny day (a) and in fog (b). Director Carl Dreyer exploits the diffused light of a fog-shrouded forest (c) in Day of Wrath *(1943).*

reflections and glitzy highlights is a time-honored movie tradition. But even without such resources the lighting in different weather conditions can provide the perfect atmosphere for a special scene. With a weather report, a little patience, and some luck, there is nothing to stop you from using natural weather conditions to your advantage.

Indoor Lighting

Interior lighting demands a certain amount of flexibility, a willingness to make things work even in difficult conditions, especially on location. In a studio equipped with an overhead grid, a full complement of lighting instruments, and other accessory equipment, lighting is much easier to set up and control. A friend's living room, a neighborhood restaurant, or a lecture hall at school may be the perfect setting for your movie but a nightmare to light in terms of mounting the lighting instruments or obtaining adequate power. Good location scouting can alleviate some of these problems, but successful indoor lighting still requires an ability to adapt to each new situation.[5]

Shooting in Available Light and Low Light

In some cases it may be possible to shoot indoors relying totally on available light, such as the light provided by an overhead fixture or sunlight coming through a window. In both film and video, shooting in available light is a more viable option than ever before. Each new generation of lenses seems to be faster, and new film stocks and electronic imaging systems require less light to record an image. Still, even with these improvements shooting in available light may not produce a satisfactory image. It may be difficult, if not impossible, to control adequately the intensity of available light, its color temperature, or its direction. Thus, shooting with available light almost always involves trade-offs and compromises. And available light almost always means low light levels in interior locations.

In general, low-light shooting is somewhat easier in film than in video. Some film cameras have **variable shutters** that can be adjusted to allow more (or less) light to reach the film. Incidentally, these are not the same as the variable shutters that are on many video cameras. The electronic high-speed shutters on video cameras *increase* the shutter speed, making it possible to record extremely fast action without the blurring that would occur at the camera's normal shutter speed. This is the reverse of allowing more light to reach the film with a variable shutter. In effect, raising the shutter speed on such video cameras will make it more difficult to shoot in low-light situations.

If the available light is inadequate for a particular film stock and lens combination, the most common solution is to switch to a faster, more light-sensitive film stock. Professional filmmakers, in fact, often use two types of film when shooting a movie: a slower, more fine-grained stock for outdoor shooting (where light levels are seldom a problem), and a faster tungsten-balanced stock for shooting interiors or low-light situations. Film manufacturers have continued to improve film speed, producing stocks that not only are more light sensitive but are finer grained as well.[6]

In a situation in which the light levels are still too low for the film stock, the film can be shot *as if* it actually had a higher **EI**. This requires a special laboratory procedure called **pushed processing,** or **forced development.** Pushed processing entails increasing the developing time (or temperature of the developing chemicals) as the film is processed. It can raise the effective EI of film stock by as much as one or two f-stops. There is a trade-off, however. Pushed processing tends to increase grain and contrast in the image. Negative film can be pushed more than reversal film, but pushed processing usually results in reduced image quality. Much the same thing occurs when you boost the **gain** of the video signal electronically.

Bounce Lighting

One of the most common problems in location lighting is hiding lights (particularly the back light) from the camera's view. The low ceilings in most locations make it impossible to suspend the lights above the scene, the usual procedure

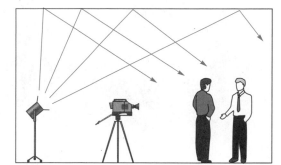

Figure 7.7
As long as the ceiling and walls are light (preferably white), light can be bounced back into the scene to produce relatively soft, even illumination.

in a studio with an overhead lighting grid. One way to provide back light or additional fill in a cramped interior location is to bounce light into the scene. **Bounce light** is light reflected into the scene from the ceiling or wall. Aim a lighting instrument at the ceiling and adjust it to the proper angle so that the reflected light falls where you want it (see Figure 7.7). This tends to create a diffused, even kind of lighting and can be a valuable way to establish an overall baselight level for an interior location.

Obviously, bounce lighting will not work if the ceiling is too high or too dark to reflect the light. It works best if the ceiling is a white or light-colored material such as the acoustic ceilings found in many homes. If the ceiling is dark, some white material such as a bedsheet can be attached to it and the light can be bounced from that. Bounced light will pick up the color of the surface from which it is reflected. This kind of subtle color shifting is difficult to compensate for in film, but white balancing in that light should adjust the color balance correctly for a video camera.

If bouncing light is not workable in a particular location, one solution might be to amplify the light in the **practical lights** on the set, the table lamps or lighting fixtures that already appear in the scene. This entails replacing the bulbs in those lamps or lighting fixtures with 3,200-degree Kelvin bulbs. You sometimes can achieve a similar effect by placing a very small lighting instrument, such as a Nooklite (see Figure 7.8), in a corner of the set where it can be blocked from view by a piece of furniture.

Figure 7.8
A tiny Nooklite can be hidden easily behind objects within the set. This kind of instrument can be invaluable for lighting hard-to-reach areas. (Photo courtesy of Great American Market)

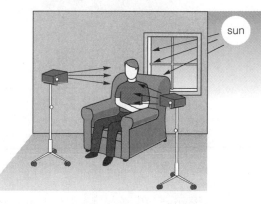

Figure 7.9
A typical mixed-lighting situation. The sunlight's color temperature (5,500 degrees Kelvin) is different from the tungsten-balanced (3,200 degrees Kelvin) instruments providing the main light for the man's face.

Mixed Lighting

When the lighting for a scene contains both daylight and artificial light, maintaining the proper color balance is extremely difficult. **Mixed lighting** is common when shooting location interiors. Imagine a scene with a person sitting in an easy chair in a living room (see Figure 7.9). Some light in this scene is streaming through a large window behind the person. The sunlight has a color temperature of 5,500 degrees Kelvin or even higher,[7] but the key and fill lights illuminating the character's face are

provided by lights rated at 3,200 degrees Kelvin. Trying to color balance for such mixed-lighting conditions can cause problems for any cinematographer.

If you shoot this scene on daylight-balanced film stock, the person's face will be red. With tungsten-balanced film stock the face would be correct, but the sunlit background would be very blue. There are several ways to solve this problem. One is to place sheets of orange Wratten 85 **color conversion filter** (the same filter used to shoot tungsten-balanced film in daylight) over

Figure 7.10

Three solutions for a typical mixed-lighting situation. Gel the windows with orange 85 filter gels (a). This will match the more bluish sunlight to the much redder 3,200-degree Kelvin light indoors. By using a daylight-balanced (5,500 degree) HMI light indoors (b), the color temperature will match the sunlight streaming through the window. A 3,200-degree Kelvin light could also be converted to a temperature of 5,500 degrees Kelvin with a dichroic blue filter placed on the lamp (c). The disadvantage of this approach is that the dichroic filter greatly reduces the amount of light from the 3,200-degree instrument.

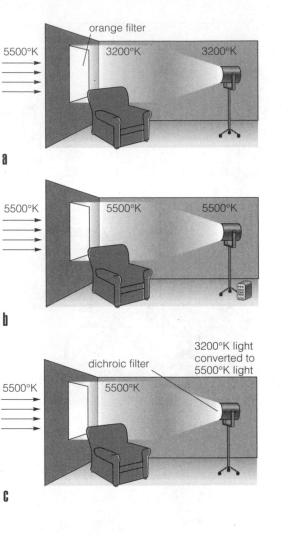

the window. Another is to match the color temperature of daylight by using daylight-balanced 5,500-degree lighting instruments, such as HMIs. A third method is to convert 3,200-degree lights to 5,500 degrees by placing dichroic blue filters over them. Any of these methods will make all the light roughly the same color temperature. (Figure 7.10 illustrates these solutions for mixed-lighting situations.)

The mixed lighting in this scene creates the same problems for a video camera, and the solutions are basically the same: using orange filter sheets to convert the daylight to tungsten-balanced light, using daylight-balanced lighting instruments to match the color temperature of the daylight, or covering 3200-degree lamps with dichroic blue filters. These last two approaches require an orange 85 filter on the camera. Either way, you will need to white balance the camera once the lighting has been established.

In some cases the simplest solution for mixed lighting may be to block out one of the sources.

Closing a heavy curtain over the window might eliminate (or reduce) the sunlight enough to allow the tungsten lights to dominate the lighting of the scene. Depending on what is being shot, it may be acceptable to let the light coming through a window in the background go blue. Certainly this seems to be more common than it once was in film and video.

In general, subtle shifts in color temperature are much easier to correct in video than in film. The white-balancing circuit in a video camera can instantly and accurately fine-tune the color temperature in most lighting situations. This same kind of color correction in film requires a color temperature meter and a case of finely graded light-balancing filters. Even then it can be difficult to obtain faithful color reproduction.

Fluorescent Lighting

The high-speed fluorescent (HSF) lights discussed in Chapter 6 are just as effective as any other 3,200-degree Kelvin lights and are used in many indoor lighting situations (see Figure 7.11).[8] However, the types of fluorescent lights commonplace in offices, schools, and commercial buildings may cause color-balancing problems. This is because these lights break up the spectrum, usually emitting only a few wavelengths, primarily the greens and blues and very little in the way of reds. Similar problems occur with other "noncontinuous" light sources such as the mercury vapor or sodium lamps commonly used in streetlights or in large commercial applications.

Although white balancing a video camera under fluorescent lights can sometimes produce satisfactory results, especially if the lights are warm-white, there are many different types of fluorescent bulbs, each with slightly different color characteristics. The easiest solution is to turn off the office-style fluorescent lights and light the scene entirely with tungsten or HSF lighting instruments.

Shooting in fluorescent light is uncertain in film as well. The broken color spectrum presented by fluorescent lights will fool some color temperature meters. Most cinematographers use tungsten-balanced film to shoot under fluores-

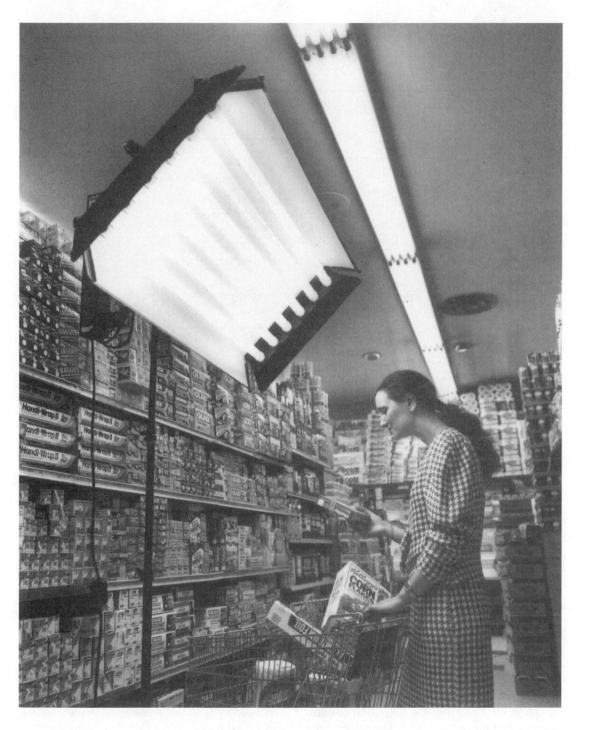

Figure 7.11
A high-speed fluorescent light array being used for a shoot in a super-market. (Photo courtesy of Lowel-Light Manu-facturing, Inc.)

cent lights, but depending on the bulb type, daylight film might be more appropriate. If the fluorescent lights cannot be turned off, special fluorescent filters made by several manufacturers will provide at least some degree of color correction. As long as the color is not too far off, the film laboratory can usually color-correct enough to produce proper skin tones. Perhaps the only way to be sure of your results is to ex-periment, to shoot a test roll with the film stock and filters you think will yield the best image in that specific type of fluorescent light.

Lighting for Movement

Lighting a scene in which a character (or the camera) moves is much more difficult than

Figure 7.12

A lighting plot with a key explaining the type, power, and function of each instrument. In this example, the lights are hung from a grid.

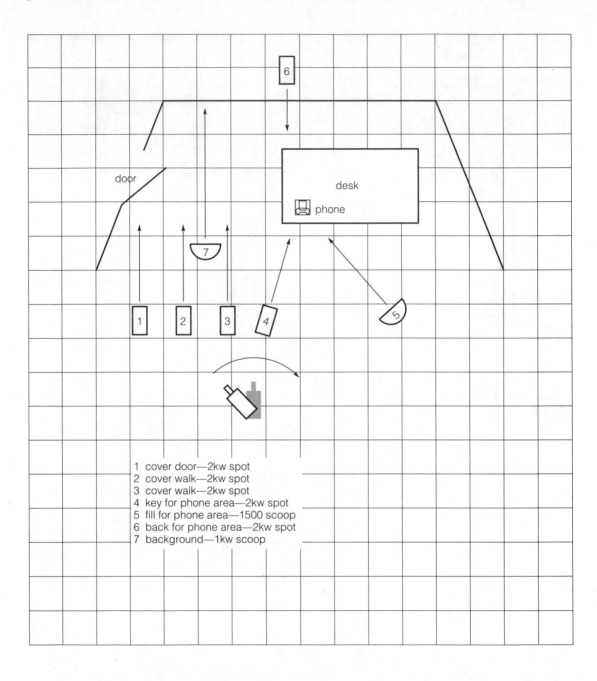

1 cover door—2kw spot
2 cover walk—2kw spot
3 cover walk—2kw spot
4 key for phone area—2kw spot
5 fill for phone area—1500 scoop
6 back for phone area—2kw spot
7 background—1kw scoop

lighting a single fixed area. Most directors draw up a blocking diagram for shots that contain complicated movement. The cinematographer needs to look at the blocking diagram or at least consult with the director to see precisely where the movement occurs and to see if any particular areas within that movement require special emphasis. For example, a woman walking from the door to a desk needs to be lit as she walks but may need more balanced, three-point lighting when she picks up a phone from the desk at the end of the movement.

Drawing up a **lighting plot** on graph paper is a good way to begin planning. A lighting plot is a diagram of the set that also shows the camera position, the location of lights, their size and type, and the direction they will be pointing (see Figure 7.12). Using one means the lights can be set up and placed in position even before the actors arrive on the set. The lights cannot be focused or finely adjusted, however, until the director actually blocks out the scene with the actors. Their positions are marked on the floor with chalk or tape before the final stages

of the lighting can begin. This is one reason why stand-ins are used in movie production. Lighting a spot where the actor will stand is not the same thing as lighting a 6-foot actor or his stand-in.

Perhaps the easiest method of lighting for movement is simply illuminating the entire area with soft, diffused lighting. This avoids some of the problems associated with uneven lighting in a large area: actors walking in and out of hot spots or disappearing into darkness between pools of light. Using diffusers or bounce lighting over the entire shot area can provide an even, overall baselight level.

For a shot in which a character moves toward or away from a light, you can place a half-scrim on the lighting instrument to even out the lighting. The half-scrim should mask the bottom of the light with the open (unscrimmed) half at the top (see Figure 7.13). If the light is angled correctly, the half-scrim will reduce light intensity near the light but will allow full illumination farther away, evenly balancing the light intensity between the two positions. This allows the character to walk closer to the light without the illumination becoming excessive.

Another common technique for lighting movement is to use standard three-point lighting for the areas that require it and to add fill lighting in the gaps between those areas. In this situation an **incident light meter** is especially helpful for checking light levels across the entire scene area, particularly in the gaps between lighting triangles. A similar technique involves *overlapping* the areas of key, fill, and back lights. This way, the same light performs different functions in different parts of the set. The key light can be the primary light source when the actors are in one area, but when they move over into another area, that light might provide fill.

In any lighting setup special care must be taken to avoid unwanted shadows. Multiple shadows or the shadow of the sound boom draws the viewer's attention to the lights. These problems intensify if the shot contains movement. The shadow of a moving sound boom (as it follows the actors) is too obvious to ignore.

You can reduce or eliminate such shadows in several ways. Shadows tend to be much more

Figure 7.13

A half-scrim is invaluable when the subject must move closer to the lighting instrument (with a subsequent increase in illumination as the subject moves nearer the light). By reducing the light emitted from the bottom half of the instrument with a half-scrim, the light intensity can be balanced more evenly between the two positions.

conspicuous against a light-colored background than against a dark background or dark floor. Adjusting the lights to a different angle can eliminate shadows or at least shift them out of frame so they are not visible in the shot. Placing the actors farther from the wall will also make their shadows less visible. Sometimes a **flag** or **barndoor** can block the light that is causing a boom shadow. If that is not possible, moving the boom to a different position or miking the sound without a boom might work. Finally, altering the quality of the light in the scene may be the easiest way to reduce shadows. If the lighting is hard, the shadows are more intense. Simply diffusing the light to produce a directionless, overall illumination will diminish or eliminate most shadows.

The director's rehearsals with the actors provide a final opportunity to recheck the lighting to see whether movement in the shot introduces shadows that were overlooked as the lighting setup was being completed. The time to catch hot spots, dark areas, or moving shadows is before shooting begins.

Variations in Lighting

The mood created by lighting is established to a great degree by the **lighting ratio**—the ratio of the key light plus the fill light to the fill light

a

b

Figure 7.14

The same scene with low-key lighting (a) and with much brighter high-key lighting (b). (Photos courtesy of Claudia Sternberg)

alone. If, for example, the key light and the fill light together have an intensity of 300 **footcandles,** and the fill light alone equals 100 footcandles, the lighting ratio is 3 to 1 (3:1). You add fill light to the key light because the fill light actually provides some illumination to the key side of the subject.

Do not confuse the lighting ratio with the contrast ratio or brightness range. Those terms refer to the range between the brightest point and the darkest point in the frame. The lighting ratio is concerned only with the *ratio* of the key and fill to the fill alone. This ratio is often

expressed as the f-stop difference between the key and fill. A 2:1 lighting ratio has one f-stop difference between key and fill and the fill alone; a 4:1 ratio has a two f-stop difference; an 8:1 ratio has a three f-stop difference.

The commonly recommended lighting ratio for color film is 3:1, though film will still show some shadow detail with a lighting ratio as high as 8:1 or 10:1. In video the traditional advice is to maintain a lighting ratio of 2:1 or 3:1. However, with the continuing improvement in video cameras, producing a quality image with lighting ratios as high as 6:1 or 8:1 is possible.[9]

The lighting ratio between the key light and the other lights on the set, such as the back light, the kicker light, or the background light, is far more subjective. It depends in part on how much light the subject or background will reflect and on the particular mood you are trying to create.

Lighting is often described as *high key* or *low key.* These terms can be extremely confusing. **High-key lighting** is generally bright, even illumination. The key-to-fill ratio is low, resulting in a low-contrast image. It might be easier to understand high-key lighting if we used the term high-fill, because the fill light intensity is actually high in relationship to the key. Conversely, **low-key lighting** uses a low amount of fill light in relationship to the key. That is, the ratio of key to fill is high in low-key lighting, as much as 8:1 or higher.[10]

Historically, the tendency has been to use high-key lighting for lighter subjects, such as comedies, musicals, and romances. High-key lighting is bright, happy, and relatively flat. Low-key lighting is much darker, more brooding, and harsh. Dramas (some might say melodramas), horror films, and thrillers—the kinds of movies in which something, good or evil, is always emerging from the shadows— traditionally use low-key lighting. (Figure 7.14 illustrates high-key and low-key lighting.)

Other factors help to determine the emotional impact of the lighting. The direction of the light (front, side, or back), the angle of the light (above, below, or eye level), and the quality of the light (hard or soft) can affect the image as profoundly as the lighting ratio.

Figure 7.15

(a) In this scene from Len Richmond's Merchants of Venus, *the bright lights from within the shop turn Michael York into a silhouette. Before he arrived in front of this shop, he was walking down the street in a long tracking shot where his face was lit by a camera light.*

(b) In Carl Dreyer's Day of Wrath, *the lighting consistently casts shadows across the face of the young woman, Anne, who is accused of witchcraft. The brooding, low-key lighting in this film underscores its deep sense of mystery and ambiguity.*

(c) See next page. This is an example of lighting a scene in a way that is believable but not realistic. This is actually only a shell of a car with lights from under a mostly nonexistent dashboard—a place where lights would not be in real life. To enhance the effect of a car being driven down a street at night, director Len Richmond had crew members whiz by with white and red lights to give the effect of passing headlights and taillights.

(d) This flattering photo of Beverly D'Angelo was created from natural light and reflectors—but no artificial lights. Beverly wore special makeup with little particles in it that reflect light and give her face a glowing look.

(e) This is a typical low-key shot from Ingmar Bergman's The Seventh Seal. *The ratio of key light to fill light is fairly high.*

(Photos a, c, and d from Len Richmond's Merchants of Venus *courtesy of Amazing Movies; Dianna Ippolito, photographer of c and d. Photos b and e from Janus Films)*

For example, lighting from the front tends to reduce shadows and flatten the image. If frontal lighting is soft and diffused, it will also smooth out the texture of the surface it illuminates. Lighting from the side creates sharper shadows, particularly with a hard light source. Side lighting throws the subject into relief and can highlight texture with small shadows. Backlighting can be used to emphasize depth. Shooting directly into the light silhouettes the subject, accentuating its outline while minimizing specific details. This can make the image more abstract. Lights angled sharply from above or below create more distinct, dramatic shadows than lights closer to eye level. The shape, the color, and the sense of depth can change dramatically, according to whether the illumination is hard and direct or soft and diffused. The number of variables in lighting makes the combinations almost infinite. The photos in Figure 7.15 show various lighting strategies.

c

d

e

Figure 7.15
(continued)

Technological advancements make possible at least one generalization about lighting: The tendency today is to use fewer lights. Faster lenses and more sensitive imaging systems in both film and video make it possible to use less lighting, to place lights farther away, and to have more shadow areas within the shot. This not only makes the set or location more comfortable for the actors but also makes changing lighting setups much faster.

One of the best things about the video revolution is the widespread availability of VCRs and video rental stores. The opportunity to rent and watch a wide variety of films means you can study lighting as never before. Lighting defines the tone and style as much as any element in a movie. In the hands of talented directors, production designers, and cinematographers, the approaches to lighting are almost infinite.

Notes

1. See, for example, almost any issue of *American Cinematographer* or *Lighting Dimensions*. Some books that deal with lighting include Tom Le-Tourneau, *Placing Shadows: The Art of Video Lighting* (Woburn, MA: Focal Press, 1998); Brian Fitt and Joe Thornley, *Lighting Technology* (Woburn, MA: Focal Press, 1997); Ross Lowell, *Matters of Light and Depth* (Philadelphia: Broad Street Books, 1992); Blain Brown, *Motion Picture and Video Lighting* (Woburn, MA: Focal Press, 1996); and Dave Viera, *Lighting for Film and Electronic Cinematography* (Belmont, CA: Wadsworth, 1993).

2. Anton Wilson, *Cinema Workshop* (Hollywood: American Society of Cinematographers, 1983), pp. 243–245.

3. Harry Mathias and Richard Patterson, *Electronic Cinematography: Achieving Photographic Control over the Video Image* (Belmont, CA: Wadsworth, 1985), pp. 6–12.

4. John Premack, "Taking the Sun at Face Value," *TV Technology,* October 1995, pp. 39–45.

5. James Caruso and Mavis Arthur, "Interior Lighting Techniques," *Video Pro,* March 1995, pp. 34–37; and Chuck Gloman, "Soften the Lighting Blow," *TV Technology,* 7 September 1998, p. 76.

6. See, for example, Kodak's line of EXR films. Kodak's EXR 5296 is a tungsten-balanced 35mm color negative film that uses the "T-grain" emulsion technology to produce an extremely sharp, fine-grained stock while also improving the film speed to 500 ASA.

7. Depending on atmospheric conditions and the time of day, the color temperature of blue skylight can range from 7,000 to 30,000 degrees on the Kelvin scale.

8. Steve Michelson, "HSF Lighting Takes to the Field," *TV Technology,* 23 March 1998, p. 226.

9. Mathias and Patterson, pp. 178–179.

10. Sonny Sonnenfeld, "The Basics of TV Studio Lighting," *Videography,* August 1991, pp. 57–59.

chapter eight
Microphones and Recorders

Sound is an essential element of movies and should be given much thought and care. If you need proof, watch your TV set with the sound off for a while and see how well you understand what is happening. Then turn the sound up, cover your eyes, and listen without seeing the picture. You probably will be able to understand what is happening much better without the picture than without the sound.

Nevertheless, student (and professional) moviemakers often become so absorbed in setting up proper picture composition that they forget to leave time for proper microphone positioning. They hastily place a microphone in front of the talent and then fret over the poor sound quality during postproduction—when it is too late.

Much of what is needed for good sound is the same for film and video. Recording equipment differs, but microphones, cables, and connectors are identical. Most significant, the basic principles of sound are the same for virtually all media.

The Nature of Sound

Sound has a number of characteristics that are important to understand in order to select the right audio equipment and record properly. These include pitch, loudness, timbre, duration, and velocity.[1]

Pitch and Frequency

Sound waves travel in well-defined cycles. The number of times per second that the wave travels from the beginning of one cycle to the beginning of the next is its **frequency**, which is measured in **hertz (Hz)**. For example, a sound wave that goes from the beginning of one cycle to the beginning of the next at 200 times per second is said to have a frequency of 200 Hz. (Figure 8.1 shows high and low frequencies.)

The sound made by the differing frequencies is the **pitch**. Bass sounds have lower frequencies and lower pitch than treble sounds. For example, a bass violin has a frequency of about 100 Hz, whereas a triangle has a frequency of about 13,000 Hz. Men's voices have a lower frequency (hence lower pitch) than women's voices. People with exceptionally good hearing can hear about 20 Hz to 20,000 Hz.

Each microphone and tape recorder has its own **frequency response**—the range of frequencies that it will pick up. The frequency response needed depends on the type of sound being recorded. For example, the range of frequencies used by the human voice is from about 200 Hz for a deep male bass to 3,000 Hz for a high female voice. For recording speech, a mic and recorder with a somewhat limited frequency response will probably be adequate. On the other hand, for recording music, you would want a wider frequency response, perhaps as broad as 20 Hz to 20,000 Hz.

Microphones and recorders may not pick up all frequencies equally well. As a result, equipment manufacturers usually represent the ability to pick up various frequencies with a graph called a **frequency curve** (see Figure 8.2). Some mics and recorders do not pick up the very high and very low frequencies as well as they pick up midrange frequencies; therefore, the frequency curve will be higher in the middle. Sometimes this is because the equipment is inexpensive and not well constructed, but other times this is entirely intentional. For example, some mics have a **speech bump**; they *intentionally* pick up human speech frequencies better than they pick up other frequencies. Other mics have a switch with two positions, one for speech and one for music. When the mic is in the speech position, it records a narrower band of frequencies than when it is in the music position. Microphones and recorders that pick up all frequencies equally well are said to be **flat** because they have a flat curve.

You can manipulate frequency characteristics in other ways. For example, some mics boost the bass frequencies as a person moves closer to the mic. This is called **proximity effect** and is usually undesirable because it gives the voice a fuzzy sound. However, it can make some male voices sound more mellow.

There is no universally correct frequency response or frequency curve. The choice depends on the use intended. Sometimes a very limited frequency response, perhaps 1,000 Hz to 2,000 Hz, is desirable to create a tinny sound similar to an answering machine.

Obviously, all the equipment within a complete recording system should have a similar frequency response. A symphony orchestra recorded with high-quality wide-frequency response mics should not be fed into a $50 cassette tape recorder with narrow frequency response.

Loudness and Amplitude

In addition to having a frequency, a sound wave has a height or **amplitude**. Amplitude is related to loudness. As the amplitude increases, the sound will appear to become louder. Loudness is measured in **decibels (dB)**. A whisper is about 20 dB, conversation is about 55 dB, and a rock concert can get well above 100 dB. The **threshold of pain** starts at about 120 dB.

The range of quietness to loudness is called **dynamic range**. Different pieces of equipment have different dynamic ranges. If something is recorded louder than the system can handle, the result is **distortion**. For example, if a system has a 60-dB range and you plan to record at 20 to 100 dBs, some of the sound will not record well. The loud notes will become a muddy jumble, and the frequencies will not come out of the equipment with the same clarity with which they went in. For recording speech, mics and recorders with a limited dynamic range will be quite adequate. But for recording a rock band or symphonic music, every piece of equipment in the system should have a large dynamic range in the neighborhood of 90 dB, or the recording will be distorted.

Another element related to loudness is the **signal-to-noise ratio (S/N)**. Most electronic

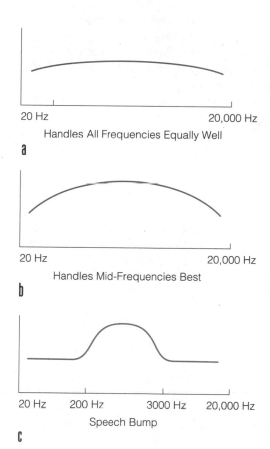

Low Frequency

High Frequency

Handles All Frequencies Equally Well

a

Handles Mid-Frequencies Best

b

Speech Bump

c

Figure 8.1

A low-frequency sound has fewer cycles per second than a high-frequency sound.

Figure 8.2

These drawings show three common frequency curves for microphones and other electronic equipment. The curve in drawing a is often referred to as a flat curve because the equipment it represents reproduces all frequencies with about the same accuracy. The curve in drawing b represents equipment that produces middle frequencies better than it produces high or low frequencies. Drawing c represents a mic that best reproduces frequencies in the human speech range.

equipment has inherent **noise** built into it; it comes from the various electronic components, such as those used for amplification. One of the specifications provided for equipment is its signal-to-noise ratio, usually something like 55:1. This means that for every 55 dB of signal recorded 1 dB of noise is present. A ratio of 55:1 is considered good, whereas one as low as 20:1 is considered poor. Generally, the more expensive equipment has the higher signal-to-noise ratio.

Timbre

Timbre deals with such characteristics as mellowness, fullness, sharpness, and resonance. It is what distinguishes a violin from a clarinet when both are playing the same pitch at the same loudness. It is also what distinguishes each person's voice.

Harmonics and **overtones** contribute to the production of timbre. A sound has one particular pitch, called a **fundamental,** but it has other pitches that are exact multiples of the fundamental frequency (harmonics) and pitches that may or may not be exact multiples of the frequency (overtones). The way the fundamental combines with its harmonics and overtones is part of what creates timbre.

The room in which something is recorded can also affect timbre. All other things being equal, a voice will sound more hollow in a large room than in a small room.

Timbre can also vary for different mics. Although two mics may have the same frequency response and dynamic range, one brand may sound more mellow, whereas the other sounds sharper. Choosing the right mic to enhance a given timbre is mostly a matter of trial and error and experience.

Duration

Another characteristic of sound is **duration,** the length of time that a particular sound lasts. Duration has four parts: attack, decay, sustain, and release. **Attack** is the amount of time it takes a sound to get from silence up to full volume; **decay** is the time it takes sound to go from full volume to a sustained level; **sustain** is the amount of time sound holds its volume; and **release** is the amount of time it takes sound to go from sustained volume to silence. These four together add up to duration.

Clipped speech that occurs in certain dialects is largely the result of duration differences between that dialect and what we consider standard American speech. Much of the difference between the sound of a violin when it is plucked and when it is bowed is due to changes in duration. A note played in staccato on the piano has a shorter duration than one played while pushing the sustain pedal.

Velocity

Velocity refers to the speed of sound. This speed is 750 miles per hour, but it is relatively slow. It is certainly much slower than the speed of light, as anyone who has experienced thunder and lightning can attest.

This relatively slow speed can cause **phase** problems. If two microphones pick up the same sound at slightly different times, they can create a signal that is out of phase; one of the mics is receiving the sound when the wave is going up, and the other is receiving the sound when the wave is going down. The result is that some or all of the sound is canceled, and little or nothing is heard.

One way to avoid the phase problem is to follow the **three-to-one rule.** No two microphones should be closer together than three times the distance between them and the subject. In other words, if one mic is 6 inches from a person, the second mic must be at least 18 inches from the first mic. In this way the mics will pick up very little of each other's sound. Another way to avoid phase problems is to place the mics head to head so that they receive the sound at exactly the same time.[2] Figure 8.3 illustrates the three-to-one rule and head-to-head mic placement.

Phase problems can also occur when only one mic is used. If that mic is placed in the middle of a room that has perfectly parallel walls, the sound will bounce in such a way that some sound waves cancel each other out. This can be avoided by placing the mic so that it is at an angle to the walls and is not equidistant from the walls. One way to do this is to place the mic on a diagonal of the room, slightly off center. Figure 8.4 shows correct and incorrect placement of a single mic to avoid phase problems.

Microphones

In addition to differing in frequency response, dynamic range, and timbre-producing qualities, microphones have particular characteristics that relate to their directionality, construction, impedance, and positioning.[3]

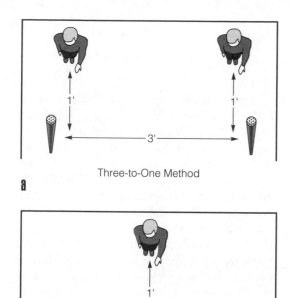

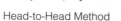

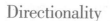

Figure 8.3

The two main methods of preventing multiple microphone interference. The three-to-one method (a) shows how to place the mics so that they are at least three times as far apart from each other as they are from the subject. The head-to-head method (b) shows the placement of mics facing each other.

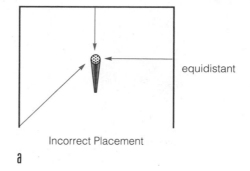

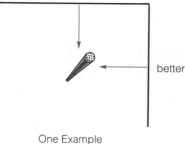

Figure 8.4

This placement of the microphone (a) is likely to cause phase problems because the mic is parallel to the walls and the same distance from all of them. Position b would be preferable because the mic is at an angle and slightly closer to one wall than to the other.

Directionality

Directionality in a microphone involves its **pickup pattern**. The main pickup patterns likely to be used in moviemaking are **cardioid** (picking up mainly from one side in a heart-shaped pattern) and **omnidirectional** (picking up from all sides).

If only one or two people are speaking and background noise is not desirable, a cardioid mic is appropriate. These mics are the work-horses in film because their pattern picks up sound from the front, where the talent is located, and not from the rear, where the camera and other equipment are operating.

Omnidirectional mics are best for picking up a large number of people and are excellent for gathering background noise. Because of their broad pickup pattern they do not pick up distant sounds well. Usually, an omnidirectional mic must be closer to talent than a car-

dioid mic in order to achieve the same volume as the cardioid.

Sometimes sound for a movie must be picked up from a great distance in order to keep the mic out of the picture. In these circumstances, more extreme cardioid mics, referred to as **supercardioid, hypercardioid,** and **ultra-cardioid,** are used. Their patterns are longer and narrower than those of the regular cardioid. (Figure 8.5 shows various pickup patterns.)

Stereo recording requires at least two microphones or specially designed stereo mics that have several different pickup elements within them. One approach to stereo recording is called **M-S (midside) miking.** This uses **bidirectional** (picking up from two sides) and supercardioid microphones (see Figure 8.6a). The bidirectional mic picks up sound to the left and the right, and the supercardioid mic picks up sound to the front. The output of both mics is fed through a complicated circuit that makes use of their phase differences to produce left and right channels. You could set up two separate

Figure 8.5

The most common pickup patterns.

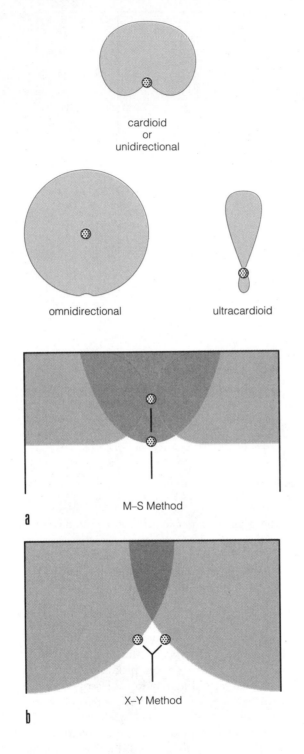

cardioid
or
unidirectional

omnidirectional ultracardioid

M–S Method

a

X–Y Method

b

Figure 8.6

Two methods used for stereo recording. The M-S method (a) uses a bidirectional and a supercardioid mic. The X-Y method (b) uses two cardioid mics.

Another method of stereo recording is called **X-Y miking.** Two cardioid mics are placed next to each other. One angles to the left at a 45-degree angle, and the other angles to the right at 45 degrees (see Figure 8.6b). This way, both mics pick up sound from the center, and sounds for each side are picked up primarily by one mic or the other. When the recording is played back through stereo speakers, it yields left and right channels—one reproducing what was picked up by the right mic and the other reproducing what the left mic picked up. Once again, you can use either two mics or one mic with stereo elements. Figure 8.7a shows how to set up two mics on one stand to record left and right channels, and Figure 8.7b shows a single mic that can record stereo.

M-S is used more frequently than X-Y, in part because it is more compatible with monaural. In other words, a program recorded with M-S stereo will sound better through a monaural speaker than one recorded with X-Y pickup. Also, M-S recording reproduces the sound coming from the center with more sharpness than does the X-Y technique, and it can be manipulated more easily in postproduction.[4]

Quadraphonic and **surround sound** can also be recorded using a variety of pickup patterns. Quadraphonic mics can record four channels of sound, or four different mics can be placed in the scene to pick up the sound. Surround sound, which can encompass up to 360 degrees, is usually recorded with a number of cardioid and/or supercardioid mics, each pointed at a different spot around the circumference of the circle.

Most microphones have a set pickup pattern, often written on the mic or the box it comes in because it is not easy to discern the mic's pickup pattern simply by looking at it. Some microphones have interchangeable elements so that the mic can be changed from one form to another: for example, from cardioid to omnidirectional. In other instances, mics have a switch to change directionality, perhaps from cardioid to supercardioid. A more complicated variation is the **zoom mic.** It can be changed gradually from cardioid to ultracardioid so that sounds at different distances can be heard clearly.

microphones, but it is more common to use one mic with both the bidirectional and supercardioid elements in it. Sometimes a switch on such a mic will disengage the bidirectional element so that the mic can be used to record monaural sound.

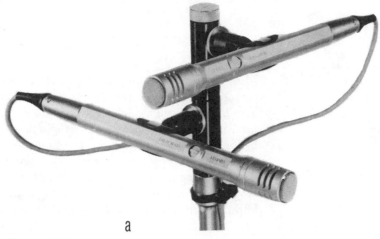

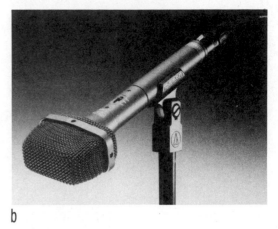

b

Figure 8.7

Microphones for stereo recording. Photo a shows how two cardioid mics might be set up on one stand to record both left and right channels. Photo b is Audio-Technica's OnePoint™ X/Y Stereo microphone. This single microphone contains the elements necessary for X-Y miking. (Photo a courtesy of Shure Brothers, Inc.; photo b courtesy of Audio-Technica)

Construction

The two main types of microphones used for electronic moviemaking, based on their construction, are dynamic and condenser.

A **dynamic mic** uses a diaphragm, magnet, and coils of wire wrapped around a magnet (see Figure 8.8a) to generate sound signals. The diaphragm moves in response to the pressure of sound and creates a disturbance in the magnetic field that induces a small electrical current in the coils of wire.

A **condenser mic** (Figure 8.8b) has an electronic component called a **capacitor** that responds to sound. A diaphragm moving in response to sound waves changes the capacitance in a backplate, which then creates a small electrical charge. Because charging the backplate requires a power supply, many condenser mics have batteries or some other external power source. Other mics, called **electret condenser mics,** have permanently charged backplates.

Dynamic mics and condenser mics are fairly rugged and have wide frequency responses. However, the dynamic mic is slightly more rugged because its sound element is more sturdy than that in a condenser mic. The condenser mic, on the other hand, has slightly better frequency response. Dynamic microphones do not work well with some individuals because the mics have a tendency to exaggerate plosives

Internal Construction of a Dynamic Mic

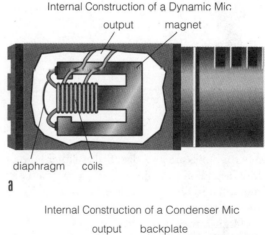

a

Internal Construction of a Condenser Mic

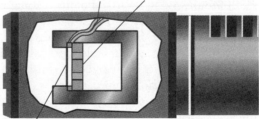

b

Figure 8.8

The construction of the two most common types of microphones, the dynamic mic (a) and the condenser mic (b).

and sibilance. In other words, *p*'s will pop and *s*'s will hiss.[5]

Figure 8.9
A fishpole in its collapsed (unextended) position. (Photo courtesy of Beyer Dynamics)

Impedance

Microphones are also classified as either high or low **impedance**. Impedance is a characteristic, measured in **ohms,** that refers to the opposition to the flow of alternating current (AC).

High-impedance mics can go as high as 10,000 ohms. One thousand ohms is usually considered the upper end of low-impedance mics, but most low-impedance mics are in the 150- to 350-ohm range. Professionals usually use low-impedance mics because they perform better. For one thing, low-impedance mics can be hooked up with long lengths of cable without the sound degrading, whereas high-impedance mics lose sound quality after several feet of cable. This is because the signal encounters less opposition if the impedance is low. Low-impedance mics are also less likely to pick up electrical noises, such as static from vacuum cleaners or fluorescent lights. Low-impedance mics should generally be plugged into low-impedance tape recorders, and high-impedance mics should be connected to high-impedance tape recorders.

Mixing low and high impedance yields distorted sound or degrades frequency response. Some low-impedance mics can be plugged into high-impedance equipment with only a slight degradation, but plugging high-impedance mics into low-impedance equipment can cause severe distortion. Specially made converters can correct an impedance mismatch by changing high-impedance mics to low and vice versa.[6]

Positioning

You can use many devices to position mics. The most common in moviemaking is the **boom,** a long pole with the mic on the end of it. It positions the mic above the actors and is moved as each person speaks. Sometimes these booms are elaborate devices with wheels, gears, and hydraulic lifts. Sometimes they consist of a simple pole (called a **fishpole**) held by the mic operator (see Figure 8.9). Often they have a **shock mount** on the end to isolate the mic from vibrations. One advantage of a boom is that it can follow moving talent.

Stands can also hold mics, but because these stands will show in the picture, they are appropriate only when a mic would naturally be present—a singer in front of a **floor stand** or a radio commentator sitting by a **table stand**. Sometimes people simply hold microphones. This is common for news and documentaries, but for dramas such an obvious show of the mic must be motivated.

You can also hide microphones on the set in props such as flower vases and figurines. You must hide mics carefully, in part so they won't show and in part so their pickup is adequate. **Hidden mics** are not desirable if people in the scene move a great deal because their voices will fade in and out as they move close to and away from the mics.

Mics can also be built into cameras or tape recorders, but **camera mics** are not advisable for moviemaking because they are usually too far from the actors to pick up their sound well. What they do pick up well is the noise of the equipment, which is definitely undesirable in a narrative movie. Mics mounted on cameras can prove satisfactory for news and documentary

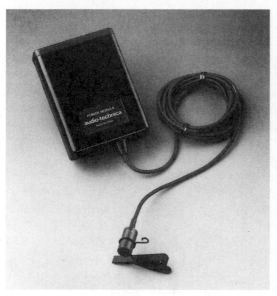

Figure 8.10

A lavaliere microphone (bottom at left) is often attached to a tie, while its power supply is worn on a belt (right). (Photo courtesy of Audio-Technica)

work, however. For example, a mic mounted on a camera is often best for an uncontrolled situation in which people are not willing or able to take the time to talk into a properly set-up microphone.

Very small microphones called **lavalieres** (see Figure 8.10) attach to clothing. Although lavs show in the picture, they usually will not be noticed because they are so small. They can be made to look like a tie clasp on a man or jewelry on a woman. However, often they require a cable, which limits the actor's movement. Also, although you can hide the cable under clothes, it is likely to show in a long shot that includes the set. The sound from a lav may be inadequate when clothes rustle and when people turn their heads to one side or the other.

Some microphones—be they lavaliere or stand mics—do not have cables. They are called **wireless mics** and operate on FM frequencies. The mic has a small antenna attached to it or to a transmitter pack that can be hidden in a pocket (see Figure 8.11). This pack sends the audio signal to a receiver that can be located a considerable distance from the mic and attached to recording equipment such as an audio recorder or VCR. Because the mics do not have cables, the actors can move about freely and quickly, and cables do not need to be hidden on the set.[7]

Another way to pick up distant sound for a movie is to use a **shotgun mic** (see Figure 8.12). This mic has a very long but narrow pickup pattern, usually super-, hyper-, or ultra-cardioid. It can pick up from a distance but must be pointed carefully and repointed if the sound source moves because of its narrow pickup. Unfortunately, this narrow area can include sounds reflected from an object, such as a building. Shotgun mics have been known to pick up the noise of a trash truck not in the immediate area; the sound had bounced off a building in the background that was in the microphone's path. A shotgun mic also tends to pick up some sounds to its rear, so its rear portion should be pointed toward something that is silent.

Shotgun mics are almost always covered with a **windscreen,** a metal or foam cover that cuts down on small noises such as wind (see Figure 8.13). Other mics often have built-in or added-on windscreens, especially if the recording is being made outdoors.

Cables and Connectors

Most microphones (wireless excluded) use cables and connectors to carry the electrical impulses from the mic to other equipment. These are actually the elements most likely to prove troublesome during recording sessions. Connectors that are not soldered properly and cables that contain broken wires are common causes of audio failure.

Figure 8.11
This photo shows a wireless microphone with its transmitter pack (right) and its receiver. (Photo courtesy of Audio-Technica)

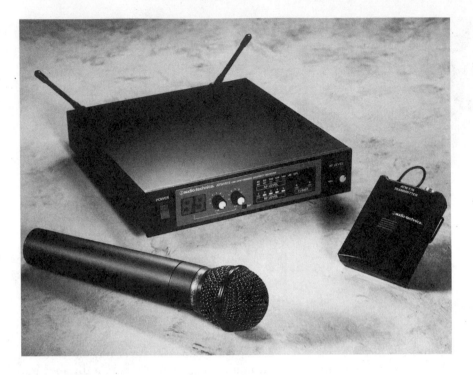

Figure 8.12
A microphone case, a windscreen, a shotgun mic, and a shock mount. (Photo courtesy of Shure Brothers, Inc.)

Figure 8.13
A heavy-duty windscreen for a shot-gun mic. (Photo courtesy of Light Wave Systems)

Balanced and Unbalanced Cables

Cables consist of wires protected by a shielding, usually made of plastic. These cables are referred to as **balanced** or **unbalanced**. A balanced cable has three wires—one for the positive, one for the negative, and one for ground. Unbalanced cable has two wires, one for the positive and one that acts as both the negative and the ground.

Balanced cables are better because a separate ground wire means they are less susceptible to extraneous interference. Unbalanced lines are usually used for consumer-grade equipment because they are cheaper, but professional equipment uses balanced lines. Always take care to avoid placing audio cables (balanced or unbalanced) parallel to power cables because this can induce hum.

Connector Types

A variety of connectors attach mics to recorders. A **phone plug** is a long, slender connector with a sleeve and tip, and the **miniphone plug** is a smaller version of the phone plug. The **RCA plug** (also called the **phono plug**) has a short prong and outer covering. The **XLR connector** has three prongs and an outer covering. It also has a guide pin and lock so that it remains firmly in place. All of these connectors have male plugs and female

jacks (see Figure 8.14). Usually, the male connector is at the end of the mic cable and plugs into the female connector built into the recorder.

Phone and miniphone connectors can be either **monaural** (**mono**) or **stereo** (see Figure 8.15). Monaural versions have one ring, and stereo versions have two. RCA and XLR connectors are always monaural. If you want stereo, you need two connectors, one to the left channel and one to the right channel.

The XLR is the professional standard because its three prongs accommodate the three wires of a balanced line. Its locking mechanism also makes it more reliable.

Other connectors are available, but they are not common. Sometimes manufacturers make unusual connectors, hoping that people will buy only their brand of equipment. This policy usually backfires, especially in the professional world where different situations call for different mics.

Adapters are available to convert the more common connectors from one form to another (see Figure 8.16). For example, an adapter fitted on the end of an RCA plug can change it to a miniphone. This adapter consists of a female RCA jack and a male miniphone plug. Most production facilities have a variety of these adapters on hand because the connectors needed usually change as microphones and recorders are changed.

In general, professional high-quality equipment uses low-impedance mics, balanced lines, and XLR connectors. When cost is a factor, the combination is likely to be high-impedance mics, unbalanced lines, and miniphone connectors.[8]

Recorders

Sound travels from a microphone through cable and connectors to recording equipment. In recent years many new types of recording equipment have become available, mainly because of the advent of digital recording.

Sound for movies used to be recorded only in analog fashion, either on the same videotape used for recording the picture or on a separate reel-to-reel audiotape. Analog recording, like its

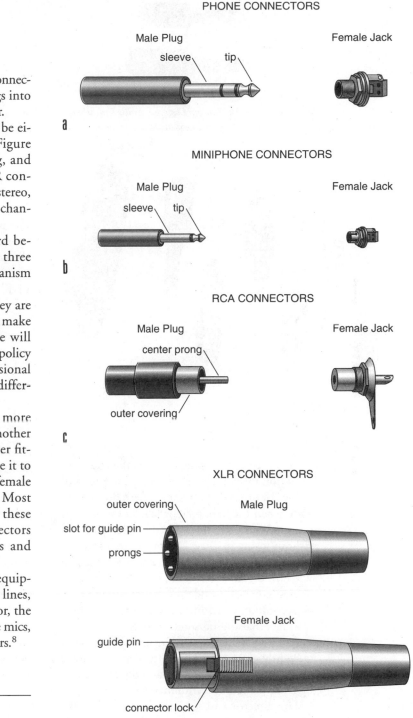

Figure 8.14
Commonly used audio connectors.

video counterpart, produces a continuously variable electrical signal with a shape defined by the sound wave it represents. Each time the analog signal is rerecorded or processed, it is subject to degradation because the signal changes shape

Figure 8.15
The connector at the bottom is stereo, as distinguished by its two rings. The connector at the top is mono.

Figure 8.16
An array of adapters.

slightly. Digital recording converts the audio information into an electrical signal composed of a series of on and off pulses. These do not degrade when they are rerecorded, so sound kept in digital form can be dubbed numerous times without losing quality. Digital audio also has a clearer, sharper quality than analog sound. The switch to digital is not total, however, and some movies (especially student movies) still use analog recording. In addition, some sound technicians feel that digital sound is overly sharp and prefer to continue to work in analog because of its slightly more mellow quality. For this reason, we will discuss both analog and digital recording equipment and techniques.

The director and sound recordist must take into account the concept of single system versus double system. Then they can select the exact equipment they want to use for the recording. The sound technician must have a thorough understanding of how the equipment actually records the sound in order to ensure that the type of recording will be compatible with the equipment used for editing. The person recording the audio should also be very familiar with the features of the particular piece of sound recording equipment in order to maximize the sound quality and to operate the equipment efficiently during the production process.

Double System and Single System Sound Recording

Double system sound records the picture on one piece of equipment and the sound on another. **Single system** sound records both within the same piece of equipment.

Double system sound recording has its roots in film production, which has traditionally recorded sound on an audiotape recorder, totally separate from the film. One reason film has traditionally used double system recording has to do with editing—film was physically cut when edited. This meant the sound for each frame had to be adjacent to it if the cut were to be made properly. But placing the sound at the same point as its accompanying picture was impossible because taking a picture is an intermittent process. The film stops in the camera momentarily to be exposed. If sound were recorded intermittently, it would be unacceptable. As a result, if sound was recorded in a film camera (and sometimes it was back when news was recorded using film), the sound recording equipment was usually placed ahead of the picture by about one second. In this way the film was running at a more uniform pace by the time the sound was recorded. However, this made for difficult physical editing. If the editor made the edit at the appropriate point for the picture, some of the sound needed was lost. If the editor made the edit to accommodate the sound, too much picture showed. The solution was to record sound and picture separately and then match them at a later time.

Single system sound became the norm in early video production because from the very beginning videotape recorders were made to capture both sound and image. The audio and video heads of a VCR cannot be at the same place either, but because video editing involves electronic manipulation rather than physical cutting, the sound and picture can be kept together. Most material shot on film today is

not physically cut. It is transferred to video and edited electronically. However, the trend in recording sound, whether with a film camera or a video camera, is to record double system. This seeming contradiction comes because double system recording allows for greater control than single system recording. A person operating a camcorder is preoccupied with framing a proper picture and usually cannot, or does not, pay proper attention to what is being recorded aurally. If the sound is recorded on a separate piece of equipment, one crew member can give the sound full attention—even to the extent of closing his or her eyes while the recording is taking place in order to concentrate totally on listening for sound problems or imperfections. In addition, separate audio recorders often yield higher-quality sound than the sound track on a VCR.

Of course, when the dialogue and picture are recorded separately, they will need to be put in sync at some time in the future. With single system film or video this is no problem because the two ride together. When double system was first used in film, a cable connected the film camera to the audiotape recorder and sent a pulse to the tape recorder as each frame passed through the film camera. In effect, this created electronic sprocket holes on the audiotape. If the camera ran slightly less than 24 frames per second, a record of that was on the audiotape and could be corrected later. Another method of maintaining film-sound sync was to equip both the camera and tape recorder with a special crystal sync control unit that governed the speed of both units so accurately that sync problems did not occur. Both these methods required the use of a slate with a clapper on the top (see Figure 3.8). The closing of the clapper was filmed and the sound of the clapper closing was recorded on tape. In editing, the two were matched and from there on the sound would be in sync with the picture for that particular shot.

Video equipment did not incorporate these cable or crystal methods and at first utilized only single system recording. When time code was made available, it became possible to record the time code frame numbers on videotape and

Figure 8.17

A four-channel Nagra-D digital audio recorder. (Photo courtesy of Nagra Kudelski S.A./Switzerland)

on audiotape simultaneously. A little later, magnetic strips were added to film stocks and time code numbers could also be recorded next to the frames of film. In other words, a signal that will translate to 2 minutes, 5 seconds, and 15 frames (00:02:05:15) can be recorded on the audiotape at exactly the same time it is recorded on the videotape or film. During editing the time code numbers are lined up and the material is kept in sync. Time code is the primary method used today for keeping double system material in sync, regardless whether the picture is recorded on film or video.[9]

Types of Recorders

For many years sound for film was recorded on a separate reel-to-reel analog tape recorder. The brand name that became synonymous with film audio recording was Nagra. This company's recorder was sturdy and contained the features most needed for recording good film dialogue. Nagra now manufactures a digital recorder (see Figure 8.17) that uses reel-to-reel tape and operates very much like the analog Nagra. It is the choice of many professional film crew members.[10]

Figure 8.18
A professional DAT recorder. (Photo courtesy of Panasonic)

Figure 8.19
A MiniDisc with a microphone and headphones.

Another recorder that is now often used to record film sound is the **DAT** (**digital audio tape**) recorder. This is much smaller than the Nagra and uses cassette tape (see Figure 8.18). It is not as rugged as a Nagra, but it is more portable and less expensive. Some of the least expensive DAT machines are not capable of recording time code, but they hold sync fairly well without time code. Professionals do not use the DATs without time code, but sometimes students can use these less expensive DAT recorders and use the clapper and slate, in the same way that it has been used traditionally in film production, to establish the beginning of picture and sound recording. If the shot is not too long, the sync will usually hold through the editing process.[11]

Anytime you are using a tape recorder (whether reel-to-reel or cassette), you should buy high-quality tape. Tapes are plastic bases coated with metal oxide; on cheaper tapes some of the oxide often falls off creating **dropouts,** a loss of signal because there was no oxide to record it or because the oxide dropped off after the recording was made. Cheaper tapes are often thin so are more likely to stretch, causing unneeded sync problems. The thinness also makes them more susceptible to **print-through,** the transfer during storage of sound from one layer of tape to the layer above or below it. In addition, they sometimes have a built-in **hiss,** noise at the high frequencies that can detract from the clarity of the recording. It is best to use new tapes, but if you are planning to use tapes that have already been recorded on, erase them with a **degausser** before using them. A degausser is a separate piece of electromagnetic equipment that lines up all the metal oxide particles so that the tape appears to be blank. Although the tape recorder itself erases the tape right before it is recorded, a safer procedure is to degauss an entire tape before you use it. In this way there will not be stray sounds on a tape if you stop it and then start in a slightly different place.

Although the Nagra and the DAT are the main recorders used to tape double system movie sound, there are other recording devices available that do not use tape. One is the **MiniDisc,** a Sony product that uses a disk that resembles a computer floppy disk (see Figure 8.19). It doesn't handle time code, so synching can be a problem. It does allow you to undertake some editing of the audio within the MiniDisc itself. You can also record sound so that it can be placed directly onto a computer hard drive. This will probably become more common in the fu-

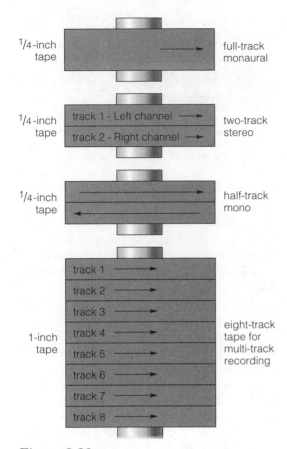

Figure 8.20
Examples of linear recording.

the formats record sound several ways at the same time. Some editing systems do not recognize all the recording methods in existence and may not be able to play back the sound properly. Anyone recording audio should make a careful log of what method(s) was used so that the production sound can be matched with an editing system that will work.

On many recorders, sound can be recorded on different tracks, that is, different places on the tape or disk. This capability can give you additional control when you are recording. For example, you can record two people at opposite ends of a room by recording one person's mic on one track and the other person's mic on another track. This method permits you to adjust each person's volume separately,[13] or the two tracks can be used for the left and right channels of stereo.

Sound can also be recorded a number of different ways, most commonly linear, AFM, and/or PCM. When sound is laid down horizontally along a tape, this is referred to as **linear audio.** If a stand-alone audiotape recorder is full-track linear, the whole audiotape records that one sequence of monaural sounds. If the recorder is half-track monaural, the top of the tape records one signal and then the tape is flipped and the bottom (now the top) records more signal. If the recorder is stereo, two signals record at the same time going in the same direction. Multitrack configurations simply add to the number of separate signals that can be recorded (see Figure 8.20). The positioning of a linear audio signal on videotape varies from format to format, to the point of confusion. For example, one format may have two linear tracks at the bottom of the tape while another has one linear track at the top of the tape and one near the bottom. Most linear recording is analog, but digital can record in a linear fashion also.

Some audiotape recorders and some formats of videotape recorders do not record any linear tracks. Instead, they record using **AFM (audio frequency modulation,** also referred to as **hi-fi)** and/or PCM. These sound methods are recorded diagonally, just as video signals are. Generally they give better sound quality (wider frequency range, larger dynamic range, higher signal-to-noise ratio) than linear recording.

ture as devices that can plug into the computers used for nonlinear editing become larger and can hold greater quantities of sound.[12]

Single system sound can be recorded on any format of camcorder—Hi-8, S-VHS, M-II, DVCAM, and so on (see Chapter 4). If video is used to shoot the movie, there is certainly no harm in recording audio on the camcorder and also recording it on a separate recording device. By recording both single system and double system, you are increasing your flexibility and covering your bases in case something goes wrong with one of the recordings.

Recording Methods

One thing that can go wrong is that you can record beautiful sound but record it in such a way that it is not possible to edit it. Camcorder formats and audio recorders have different ways of placing sound on the recording medium (videotape, audiotape, disk). In fact, some of

AFM Audio Recording

— video track

— hi-fi audio
 track

Figure 8.21
*How AFM records. The audio cannot be separated from
the video.*

PCM Audio Recording

— video track

DATA area
(time code, etc.)

— PCM audio
 track

Figure 8.22
*How PCM records. The audio can be separated from
the video.*

AFM rides with the video signal (see Figure 8.21), so it cannot be played back separately. It also cannot be erased or recorded over without the video also being erased or recorded over. During editing it cannot be separated from the video, so it is not a particularly good method to use for moviemaking.

PCM is separate from the video; it has its own "real estate" on the tape (see Figure 8.22). Because it yields superior quality, is by nature digital, and can be separated from the video for editing, it is a popular method of recording for moviemaking. Some video formats record sound a number of different ways, perhaps two tracks of linear, one track of AFM, and two tracks of PCM. Usually you can select which methods you want to use, but sometimes the sound automatically records on all available tracks; this is often a function of the particular model of camcorder you have.[14]

MiniDiscs record information digitally in the bits and bites common to computers. Usually the sound can be built into separate files so that any particular piece of sound is easy to find. MiniDiscs have the advantage of your being able to listen to material instantly without having to rewind a tape; they easily cue to the beginning of a certain section of audio.

As a sound technician, you need to know how your particular machine is recording so you can pinpoint its advantages and record sound in such a way that it will be easy to work with, given the postproduction requirements.

Features of Sound Recorders

The video recorders and the audio recorders used for moviemaking have the same function controls as most recorders—play, record, stop, pause, fast forward, rewind. Some tape recorders allow you to hear the sound as it is rewinding or

fast forwarding so that you can cue it easily. Audio and video recorders usually have two types of inputs—mic and line. **Mic inputs** are for microphones, and **line inputs** are for other equipment, such as tape recorders and CD players. The difference between mic and line inputs is the amount of **amplification** that the signal is given. Tape recorders and similar equipment usually have some means of amplifying the audio signal. Microphones do not, so they need the extra amplification provided by the tape recorder. Therefore, you should always make sure the mic is plugged into a mic input, not into a line input. If you make a mistake, the sound will not record at a level high enough to be useful.

High-quality tape recorders have a **VU (volume unit) meter,** a device that shows how loudly the sound is being recorded. Sometimes this is an actual scale that has a red area at one end where the needle indicating the **volume** level should not linger. In other cases, the VU meter is a bar of flashing diodes that change color from green to red when the signal is too high. In either case, **peaking in the red** (also called **overmodulation**) for any length of time is undesirable because the recording will be distorted. On the other hand, sound that regularly rides at the low end of the meter (**riding in the mud**) will not be loud enough. See Figure 8.23 for examples. Ideally, audio should ride between 20 and 100 percent on the VU meter.

To help keep levels consistent throughout recording, some tape recorders are equipped with a **tone generator.** This sends out a constant 1-kilohertz sound that can be used to set the various volume controls. The controls should be set so that the tone registers at 100 percent on all the VU meters that are part of the audio system. That way, the operator can judge the relative

Figure 8.23
The needle on the left VU meter is riding in the mud. The needle on the right VU meter is peaking in the red.

loudness of different signals. For example, if a recorder has two channels, 1 and 2, and the volume controls for both are set at 100 percent, the operator can be sure that sound on both channels that registers at 60 percent will be the same volume. It is a good idea to record a minute of 100 percent tone at the beginning of a tape so that when it is played back, the playback recorder's controls can be configured properly. That way, the sound being played back will be at the same volume as when it was recorded.

Another feature often found on higher-end recorders is **equalization.** This function enables you to cut out or emphasize certain frequencies, such as treble or bass. Sometimes unwanted noises in the high frequencies, such as whining from the equipment, can be filtered out through equalization so that they are not recorded. Of course, anything else at that frequency range will be filtered out too. You definitely should not use equalization to get rid of frequencies in the voice area when you are recording dialogue.

Some recorders have **automatic gain controls (AGCs).** When this control is on, the gain is automatically adjusted so that the recording is neither too soft nor too loud. If the control is not on, an operator must adjust the volume control manually to change the degree of loudness. The counter on a tape recorder can be valuable for finding your place. Most counters display the minutes and seconds into the recording and can be reset to zero so that new counting can begin whenever you want. Some have an option that allows you to see the time remaining on a tape or disk.

A connection for earphones, a headset, or a speaker is also necessary. The only way you can really tell whether you are recording the sound properly is by listening to it as it is being recorded and/or afterward.[15]

Some recorders, especially camcorders, have very little in the way of audio recording features. Not only do they not have features such as a tone generator or equalization, but they don't even have a meter or a jack for a headset, making it extremely difficult to know whether the sound is being recorded. Before using (or preferably before purchasing) a video system for moviemaking, consider carefully the audio features available. Many users (and salespeople) become so enamored with the video features of a recording system that they forget about audio and end up with something that is unacceptable and difficult to edit.[16]

Care of Audio Equipment

Although most audio equipment is manufactured to hold up under fairly rugged recording conditions, it should be treated as gently as possible. Microphones should always be carried in their cases, most of which are foam lined. Carrying mics in their cases also helps prevent the loss of accessories such as clips and batteries. You should never blow into a microphone to test it; such puffs of air can damage the sound element.

Always telescope mic stands, such as a fishpole, down to their smallest size for carrying. If they have cases, use them for carrying and storing.

Never pull cables out of their sockets by tugging on the wire; remove the connector gently with your hand. Some connectors require that you push a lever to release them. Always do so; don't just yank. Be sure to coil the cable properly. One way, called the *over-under method,* involves making repeated circles with the cable (see Figure 8.24). Another way is to lay the cable on the floor in a figure *8* and then double the

a b c d

Figure 8.24

To coil cable using the over-under method, make a natural loop for the first coil (a). Then twist the cable for the second loop (b) and place it next to the first loop (c). The third coild is a natural loop (d), the fourth is a twisted loop, and so on until the cable is neatly coiled.

top half of the 8 over the bottom half. Then put tape or specially made cable holders over the wire so that it stays in place. Treat cable gently because the small wires inside the cable break easily. The breaks are difficult to find and difficult to repair. Also, cable that is not coiled becomes snarled, and the next time you try to use it you will find yourself spending precious time untangling it.

Handle recorders carefully so that their internal electronics do not become damaged. Clean video heads and audio heads frequently with special head cleaners.

Notes

1. For several other approaches to the nature of sound, see Stanley R. Alten, *Audio in Media* (Belmont, CA: Wadsworth, 1990); Michael Talbot-Smith, *The Audio Engineer's Reference Book* (Woburn, MA: Focal Press, 1998); Ken C. Pohlman, *Principles of Digital Audio* (New York: McGraw-Hill, 1995); and Herbert Zettl, *Sight-Sound-Motion: Applied Media Aesthetics* (Belmont, CA: Wadsworth, 1990).

2. Another method for minimizing phase problems is referred to as the 8 and 8 method. The mics should be placed either closer together than 8 inches or farther apart than 8 feet.

3. A good way to study microphone characteristics is to look over the specifications provided by manufacturers. These are readily available on the World Wide Web. The sites for four of the major microphone manufacturers are: www.sennheiser.com; www.electrovoice.com; www.shure.com; and www.audiotechnica.com. Books that discuss micro-

phone characteristics include Michael Gayford, *Microphone Engineering Handbook* (Stoneham, MA: Focal Press, 1994); and Alex Nisbett, *The Use of Microphones* (London: Butterworth-Heinemann, 1994).

4. "Stereo Sound Yields High-Impact Video," *TV Technology,* February 1992, p. 33; and Bruce Bartlett, *Stereo Microphone Techniques* (Stoneham, MA: Focal Press, 1991).

5. Dick Reizner and Rick Lehtinen, "Of Mics and Men: Getting Great Audio in the Field," *AV Video,* March 1994, pp. 98–105.

6. Cecil Smith, "Questions from the Seminar Floor," *AV Video,* September 1990, pp. 125–127.

7. "Wired, Wireless Mic Options Abound," *TV Technology,* 23 March 1998, p. 220.

8. David Carroll, "Wiring, Patching, and Interconnecting," *Mix,* February 1998, pp. 109–118.

9. Timothy Liebe, "Double-System Sound, A Shooting Secret You Can Share," *Video,* February 1995, p. 24.

10. "Audio Technologies for Film," *Mix,* January 1993, pp. 141–144.

11. John Watkinson, *R-DAT* (Stoneham, MA: Focal Press, 1991).

12. Ken C. Pohlmann, "Mini Disc Technology," *Mix,* November 1992, pp. 20–25.

13. The best way to record two people is to route the sound through a portable mixer with XLR inputs and outputs and then route it to a camcorder XLR input. The mixer allows for greater control and flexibility of the sound.

14. You should always read the manual for any recording system thoroughly. Not only will it instruct you in the basic operation of the equipment, but it will tell you the recording methods and give technical information you may need to pass on to others.

15. John Borwick, *Loudspeaker and Headphone Handbook* (Stoneham, MA: Focal Press, 1995).

16. For more about the recording process, see Francis Rumsey and Tim McCormick, *Sound the Recording* (Woburn, MA: Focal Press, 1997); Blair K. Benson and Jerry C. Whitaker, *Television and Audio Handbook* (New York: McGraw-Hill, 1990); Bruce Mamer, *Film Production Technique* (Belmont, CA: Wadsworth, 1996); and John Watkinson, *The Art of Sound Reproduction* (Woburn, MA: Focal Press, 1998).

chapter nine
Approaches to Sound Recording

Sound recording is much more important in video than it used to be, partly because of listeners' increased sophistication and partly because of TV set improvements. For many years television sound came from a monaural speaker that was often no larger than three inches in diameter and incapable of reproducing quality sound.

But through the years listeners became enamored with high fidelity and stereo sound on records, cassette tapes, and radio. TV set manufacturers recognized this and began manufacturing sets with higher-quality sound systems. They correctly believed that a generation raised on quality radio sound would be willing to pay a little more for quality TV sound. Better speakers led to better recording techniques, which led to even better speakers.

Most TV sets manufactured today can receive several sound channels, which means the user can listen to stereo and/or a secondary audio program, such as a foreign language translation. This means that video production companies must take greater care with recording because TV speakers pick up even minor sound discrepancies. Listeners could barely perceive such problems as a change in background noise with the older small receivers, but now they can hear such aberrations.

Sound must be recorded properly during the production process so that it can be mixed and rerecorded during postproduction. In early television, technicians often just placed a mic close enough to pick up sound. Now, as in many other facets of electronic moviemaking, they are adopting more sophisticated techniques, most of which come from film.

Elements of Microphone Pickup

Central to all sound recording is the microphone. How it picks up the sound determines the quality and utility of the sound. Some elements of microphone placement are common to all recording, be it dialogue, narration, music, sound effects, or background noises. These elements include the need for presence, perspective, balance, and continuity.

Presence

Sound **presence** refers to the reality of the sound. It must appear to be coming from the picture. This means that it must have the quality that people expect when they are in a location similar to that shown on the screen. For example, sound in a gymnasium will be very different from sound in a living room with thick carpets and heavy drapes. Therefore, sound recorded to accompany a gymnasium scene should have the echo characteristics people expect of that environment.

One of the main elements of sound presence is how *live* or *dead* the room sounds. A gymnasium is quite live (bouncy), and a living room with carpets and drapes is dead (absorbing). One reason is the size; all else being equal, large rooms are more live than small rooms. But an even more important difference involves the surfaces in the room. Hard surfaces such as wood and concrete create live sound, and soft surfaces such as carpets and drapes deaden sound. Hard surfaces tend to bounce the sound from side to side, whereas soft surfaces absorb it. In other words, live sound has a great deal of **echo** and **reverberation,** and dead sound does not.

Echo and reverberation have slightly different technical definitions, but they create the same kind of effect. With echo the sound bounces once, and with reverberation it bounces a number of times. Sound that does not bounce is usually referred to as **direct sound,** which is generally dead. (Figure 9.1 depicts echo, reverberation, and direct sound.)

Neither live locations nor dead locations are wrong. The amount of deadness or liveness depends on the type of presence you are trying to create. But sound with a high degree of echo or reverberation often sounds muddled. In particular, the high frequencies tend to blend into each other and become indistinguishable. For that reason sound technicians often try to deaden a room so that the sound can be under-

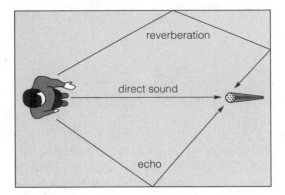

Figure 9.1
Direct sound goes to the source without bouncing off any surfaces, echo bounces off one surface, and reverberation bounces off two or more surfaces.

stood. The easiest way to do this is to hang blankets slightly in front of the walls, place carpet on the floor, put drapes over windows, and/or place cloths over hard tables. Moving the mic closer to the subject also makes for deader sound, whereas moving the mic farther away has the opposite effect. Removing carpets, drapes, and other cloth can enliven the sound.[1]

Of course, most of this must be done in relation to the picture. Closed drapes that show in the picture probably are not a problem because the drapes will also make the presence of the sound match that of the picture. But blankets hung in front of walls would look strange.

Sometimes sound technicians need to make compromises in the perception of the deadness or liveness of the scene so that the sound can be adequately understood. In general, though, the audience will perceive a setting with many hard surfaces as producing live presence and a setting with soft surfaces as dead.

Perspective

Sound **perspective** is related to distance. The voice of a person in the distance should sound different than the voice of that person when shown in a close-up. In this way the viewers will feel closer to or farther from the person, reinforcing what they see on the screen. Similarly, the sound of a bell ringing in the distance should be different from the sound of a bell ringing in the foreground.

The easiest way to achieve proper perspective is to move a boom mic farther from the person or object for a long shot than for a tight shot. This usually needs to be done anyway to

produce a proper picture because a mic close to the talent will show up in a long shot.

Achieving proper perspective is more difficult, if not impossible, with a lavaliere (lav) or table mic. The lav mic is attached to the person and moves as he or she does. A person wearing a wireless lav mic is never going to sound farther away. A table mic must look like it is in front of the person, so it too is essentially unmovable.

Mics hidden in the scenery can provide perspective if the picture relates to where the mic is placed. In these cases, the person moves away from the mic rather than the mic moving away from the person. However, if the camera follows a person with a close-up as that person is moving away from the hidden mic, the perspective will be wrong. The camera should show a medium or long shot as the person is walking away from the mic.

The need for proper perspective is one of the main reasons filmmakers have traditionally used boom mics. They are by far the best for creating the proper perspective.

Balance

Balance refers to the relative volume of sounds. Important sounds should be louder than unimportant sounds. The human ear can listen to sounds selectively, but the microphone cannot. You can be talking to a friend in a noisy area, yet you hear your friend over the other noises because you concentrate on doing so. If you record your friend on a microphone, you will not be able to pick out his or her voice nearly as well as you can in person. Try placing a microphone in the middle of a table when several people are having several conversations. When you play back the tape, it will be a garble. Yet, if you are at the table, you can hear one particular conversation.

The need for balance is one reason microphones have been designed with directionality. A cardioid mic can act a little more like the selective ear than can an omnidirectional mic.

The best way to achieve proper balance is to record every important element **flat** and then adjust relative volumes in postproduction. You try to make the volume of every scene, every person, and every sound effect more or less the same.

This assumes, however, that you have access to sophisticated sound postproduction facilities that can mix various sounds and alter them in a variety of ways. If this is not the case, you will want to take sound balance into account during the recording process. You may, for example, want to have one person appear to have a booming voice, or you may want the sound of a waterfall to partially drown out a conversation. In those cases, you would record sound that is not totally flat.

Continuity

Continuity of sound refers to a sameness from shot to shot. It is as necessary as visual continuity. The script supervisor, who keeps track of continuity of visual elements, should also keep track of continuity of aural elements. If a water spigot is dripping during the man's close-ups, it should also be dripping during the woman's close-ups if you are going to intercut the two shots.

Elements that affect presence and perspective should also maintain continuity. If drapes were hanging over windows for long shots, they should also be there for close-ups, even though they won't be seen in the picture. Removing them will make the room sound more live and create a discrepancy in tone between the long shots and the close-ups.

The script supervisor also should note how far a mic was from a person if shooting is going to stop for the day and the same scene is going to be continued the next day. Knowing this distance is also advantageous when different angles of the same scene are being shot. If the mic is 3 feet from the man during his close-ups and 5 feet from the woman during her close-ups, the shots may not intercut well.

Using the same microphone for the same person throughout a production also helps to maintain continuity because the sound will be similar. If you are using different mics, they should match as much as possible in terms of frequency response, dynamic range, and timbre characteristics.

Keeping track of sound continuity can distinguish a professional production from an amateur one. It is fairly easy to do but is often neglected.

Eliminating Unwanted Noises

When shooting a movie, the recording equipment often will pick up noises that have no relation to the scene being recorded. One is the sound of the equipment itself. This is more of a problem with film than video because film cameras usually have motors. Placing various devices, such as soft foamy cases called **barneys** and hard cases called **blimps,** over film cameras muffles motor noise. Most of the noise created by video cameras comes from electronic circuits or from the equipment being moved around the set. For this reason microphones should be positioned as close to talent and as far away from equipment as possible. This is easy when equipment and talent are naturally far apart, but when they are close, you will have to compromise. One possibility is to move the camera farther from the talent and use a longer lens.

Another disturbing noise is wind. You may not hear the wind with your ears, but it often blows against the microphone sound element, making a low-frequency huffing sound. Placing a **windscreen** on the mic will help to eliminate wind noise.

The recording system may also pick up the hum of fluorescent lights. The best solution for this may be to turn off all fluorescent lights.

Recording equipment with mechanisms for **equalization** can sometimes be used to eliminate unwanted sounds at certain frequencies. This is often better done in postproduction, when you have more time and control. Most equalizers have one position that cuts out high frequencies and another that eliminates low frequencies. If you are trying to tape birds chirping and the low hum of a motor clutters the audio, you can use the equalizer to cut out the low frequencies.

Conversely, the bird chirpings can be cut out when recording the rumble of a train. The problem arises when the sounds you want to record are at about the same frequencies as the sounds you do not want to record. In these cases, and in many others, equalization is not the answer.

A better solution may be to increase the directionality of the mics so that only the desired

sounds are picked up. However, highly directional mics, such as the ultracardioid, can pose problems because they lose the signal if the subject moves slightly. In general, the more directional the mic is, the harder it is to control the small area it picks up.

Often the best time to solve sound problems caused by the surroundings is during preproduction. If someone checks out the area before recording begins, people can make plans to remove the offending sounds or choose a different location.

During production you can assign someone to keep pedestrians and, if possible, automobiles away from the production area. This minimizes the likelihood of unwanted sounds on the set.

Both the sound engineer and the continuity person should listen carefully for distracting sounds during shooting. If the sound will hurt the overall effect of the movie, you can retape.[2]

The principles of presence, perspective, balance, continuity, and unwanted noise apply to almost all field recording. Certain specific approaches apply to particular types of recording such as dialogue, voice-overs, sound effects, ambient sounds, and music.

Miking Dialogue

Dialogue is the most important sound element to record properly during production. You can create most other sounds during postproduction if necessary, but rerecording synchronous dialogue after the fact is a difficult, time-consuming, and sometimes impossible task.

Selecting the Mic

The first step in miking is to select the proper microphone according to the directionality, construction, impedance, and positioning characteristics discussed in Chapter 8. The **cardioid mic** is the most commonly used for moviemaking, but an **omnidirectional mic** will pick up broader sound such as that of a crowd scene, and a **supercardioid mic** will pick up narrow sound. Using a supercardioid mic is tricky because it picks up sounds close to the rear of the mic as well as sounds that are distant from the

front of the mic. It should not be positioned where loud noises, such as honking horns, are right behind it. Also this type of mic telescopes the sound to the front of it in much the same way that a telephoto lens compresses distance. As a result, background noises may rise to an undesirable level.

You can use either a **condenser mic** or a **dynamic mic;** the condenser gives slightly better fidelity and the dynamic mic scores slightly higher on ruggedness. You should try to use low **impedance,** unless, of course, the recording equipment is high impedance. The **fishpole** is the device most used for mic positioning, mainly because it can handle changes in perspective well.[3] However, stand mics might fit naturally into the scene, and **hidden** or **lavaliere mics** solve the problem of the boom showing. **Wireless mics** are appropriate if a person is going to move a great deal, and **shotgun mics** are useful when sound must be picked up from afar. On-camera mics usually do not pick up dialogue very well, but sometimes they are all that is available.

For optimum pickup of voice frequencies, select a mic with a **speech bump.** To emphasize a particular male voice, choose a mic that creates a **proximity effect.** Check out the difference in timbre created by various brands of mics.

Sometimes you may want to use two different microphones to record the same sound. For example, using a boom and a lav, record the boom in channel 1 and the lav in channel 2. Then decide later which sound you want to use. Although miking this way allows for postproduction flexibility, it usually slows production because of the extra time required to set and operate the two mics.[4]

Setting Up the Mics

Ideally, a boom should be positioned above a person's head, pointed toward the mouth (see Figure 9.2). It should be *rotated* as the person moves so that it always points at the mouth. The best distance for a cardioid is 1 to 4 feet in front of the mouth and 1 to 3 feet above it; an omni should be slightly closer. However, the boom or fishpole should not show in the picture nor should its shadow.

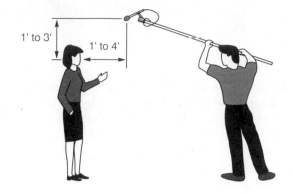

1' to 3' 1' to 4'

Figure 9.2
*Proper placement of a
mic on a fishpole.*

Accomplishing all this is often difficult and requires compromises. The cinematographer may have to change the lighting slightly to get rid of the boom shadow, or the audio person may have to move the mic slightly away from its optimal position. If the mic position must be changed, the audio operator should experiment by placing the mic in various sites and then selecting the one that sounds best (see Figures 9.3 and 9.4). Sometimes this position may be rather unorthodox, such as close to the floor pointing up. Some boom operators place a strip of white tape on the tip of the mic windscreen so the camera operator can readily see the mic if it dips into the shot.[5]

Position hidden mics with care. They should not be in, on, or near something that will be moved during shooting. A lav should be attached 8 to 10 inches from the mouth but not where it is likely to pick up the sound of rustling clothes. You also need to be careful in positioning shotgun mics and monitor them constantly so that they pick up the dialogue. If the talent moves, the mics also must move.

For recording in a room, it is best to place the mic so that it is not equidistant from any two walls. Also, it should be at an angle to the walls rather than perpendicular. This lessens the chances of **phase** problems. If a person has a sibilant voice, place the mic slightly to the side of the mouth. This helps get rid of the high frequencies.

Special Dialogue Situations

Miking two or more people requires adherence to many of the principles already discussed and a few others. When using only one microphone, you'll have to move it often so that it picks up the person talking. The boom is a favorite of moviemakers because it is easy to move. Difficulties arise with one mic, however,

if the various people speak at different volumes. If one person has a booming voice and another is soft-spoken, an equitable balance is hard to achieve. You could ask the two people to try to speak at more similar levels or move the person with the stronger voice farther from the mic than the person with the weaker voice. Another solution might be to record two takes of the scene, one recording the first person and the other recording the second person. With two takes, you'll need to pay attention to continuity so that the shots will edit together well.

Using two mics means each person's level can be set separately. This works best if the mics are attached to a portable mixer that can be used to set the separate volumes (see Figure 9.5), although it can also be done through two different audio tracks on the VCR. Recording one voice at a higher level than the other will compensate for any differences in volume. However, the mics need careful placement so that they do not cause a phase problem and cancel each other out. Some types of miking depend more on multiple mics than other types. When using wireless lav mics, there must be one for each person. One lav cannot pick up several people equally unless they are very close together. There will also need to be several hidden mics if any cast members are going to move. These mics cannot be moved during shooting, and their pickup radius is limited.

Under some circumstances proper dialogue pickup is impossible. If a scene must be shot in a noisy factory or on a busy airstrip, the sound will not be intelligible to the audience. In these cases the actors record their dialogue in a soundproof studio during postproduction, and it is mixed with ambient sounds (such as that of the factory or the airport) at a low level. However, this dialogue must be synched to the characters' lips. Therefore, you'll have to record a cue track of dialogue during production so that the talent can hear what they have said and then rerecord it (see Chapter 13). In these situations selecting and positioning mics does not require a great deal of care. The sound must simply be clear enough to be used as a reference during rerecording.

Achieving high-quality dialogue sound requires time and patience because well over half

the information conveyed in most movies is through the spoken words.[6]

Miking Voice-Overs

Voice-overs (VO) are easier to record than dialogue because they do not involve synched sound. Usually, they serve such purposes as explaining complicated processes, indicating what a person is thinking, or representing someone's conscience. The person doing the talking is off camera, so all the problems related to keeping the mic out of the picture are absent.

A cardioid mic usually handles voice-overs. The best positioning devices are the table stand, floor stand, or boom. When putting a stand on an ordinary table, you might want to put a cloth over the table so that the mic and stand will not vibrate. People can also hold mics to record voice-overs, provided they do not need their hands for holding a script.

In fact, the positioning of the script is one of the primary concerns in regard to voice-overs. Actors must handle the script carefully so that it does not interfere with sound pickup. For example, they must never hold a script in such a way that it covers all or part of the microphone. Pages should not be stapled together because they may make a shuffling noise that is picked up by the mic when they are turned; rather, the actors should have loose script pages that they can carefully lift off and place to the side. The person reading should not have to turn his or her head away from the mic in order to see the script. The distance between the mic and the person's mouth should be constant, unless, of course, the voice-over is to sound as though it is fading off into the distance. Each page of the script should end with a complete sentence so that the actors do not have to turn pages in mid thought. Also, putting the script pages in plastic sheaths cuts down on rustle.[7]

Miking Sound Effects

Moviemakers add many **sound effects** during postproduction but record some during production, especially the **hard effects**—those that

Figure 9.3

Keeping the boom out of this shot may require holding it farther away. Note the miniature Nagra audio recorder on the boom operator's belt. (Photo courtesy of Ryder Sound Services)

Figure 9.4

In this shot five people are talking, so the movement of the boom becomes important.

need to be in sync with the picture. The sound of a cowbell needs to coincide with the shaking of the bell; a door slam needs to sound as the door actually slams. These are noises best recorded during production; in fact, it is almost impossible not to record them while the dialogue is being recorded.

Figure 9.5
A portable mixer being used during a shoot.

Hard effects that are an integral part of the dialogue should be recorded as realistically as possible because they cannot easily be removed from the track. In other words, if the cowbell is shown in close-up at the front of the scene, it should sound close. If the mic is far from the cowbell, taping talent at the rear of the scene, the bell's perspective will be incorrect. Sometimes this means recording the effect with a separate mic.

In other instances, sound effects are not actually recorded—someone verbally indicates that the effect is needed. For example, if a phone is to ring, one of the crew members might say "ring, ring" at the point in the script where the phone rings. This tells the people who add sound effects in postproduction that they need a ringing phone at that point.

Sound effects that need not be synchronous can be recorded separately from the picture. Several crew members might go to a waterfall to record its sound, which will be mixed with the dialogue or narration during postproduction.

Either omnidirectional or cardioid mics are good for recording sound effects because they pick up in a broad pattern. Just about any positioning device will do for asynchronous sounds because there's no problem with the mic appearing in the picture.[8]

Miking Ambient Sounds

Ambient sounds are asynchronous noises that are mixed in during postproduction to give a scene authenticity. Sometimes they are called **wild sounds** because they can be recorded separately from the picture. One type of ambient sound is **room tone.** This is simply a recording of the general ambiance of the place where the dialogue is being recorded. When taping room tone, everyone should be quiet, but all the overall sounds of the room should be just as they have been during the production. In other words, if an air conditioner was running when the dialogue was taped, it should be running when the room tone is taped. All the equipment and set pieces used during production should be in place so that reverberation does not change.

During postproduction room tone smooths cuts from one shot to another (see Chapter 13). In the hectic pace of production people often forget to record room tone. However, it is a very simple process that should be done for all productions, professional or student. A sudden absence of room tone on the audio track calls attention to itself.

Another type of ambient sound is **atmosphere sound.** This adds a certain feeling to a scene. For example, the sound of a bubbling brook enhances the bucolic feeling of a serene country scene. The hustling, bustling mood of a street scene, which is actually shot in a studio, needs traffic noises. Factory sounds might be taped during a busy time because the factory was not operating when the scene was shot. As with room tone, these atmosphere sounds are mixed into the sound track during postproduction.

A third type of ambient sound is **walla walla.** This is the recording of people's voices so that the actual words they are saying cannot be understood. In fact, the term gets its name because sometimes the people talking say "walla walla" over and over at different speeds and with different emphasis. Walla walla might be needed if only a few characters are in a bar scene shot in the studio, but the illusion is that the bar is filled with people. Or many people appear in the bar scene, but they only pretend to talk while the principals are saying their lines. A crew would go to an actual bar and tape the general noises, which would then be mixed into the sound track or actors could be hired to "walla walla." All kinds of scenes—people walking through a museum, people at a party—need walla walla.

The distinctions among these various types of ambient sound are often muddy. Factory noise could be room tone, atmosphere sound, or even walla walla if factory workers are talking to each other. Sometimes ambient sounds and sound effects are one and the same. A dog barking could be considered a sound effect or an atmosphere sound. The definition is not important; what is important is recording the sounds so that they are available for later use.

Mic placement is not overly crucial for ambient sounds because you are trying to pick up general noises. This is one situation in which an on-camera mic may suffice. The most convenient way to record ambient sounds, however, is with whichever mic you use for dialogue. Usually only a few minutes of ambient sound are needed, so it can be recorded at any time, as long as cast and crew are quiet.

Miking Music

Postproduction is the usual time for adding mood music to a movie (see Chapters 13 and 14). However, music inherent to the plot, such as a rock group's performance, usually needs to be recorded during production.

If the music can be taken from a prerecorded CD, it must at least be lip-synced during production. This requires some sort of playback setup so that the group or individual can hear the music. Playback can be something simple, such as a portable CD player on the set, or it can be something more elaborate, such as a public address system. Somehow, picture and sound must be in sync. For this reason moviemakers usually rerecord the CD on the audio track of the videotape or on a separate audio recorder (reel-to-reel, cassette, computer workstation) while the actors are lip-syncing. Time code can aid in making sure sync will be maintained through the entire postproduction process.

There are several methods for recording music during production. You can record the whole musical group on one track or tape individual instruments and mix them later. When recording the whole musical sound at once, you must take great care in placing the mics so that

the recorded sound achieves the best balance possible. A mic placed above the string section of the orchestra, for example, will produce a recording in which the strings dominate the brass and percussion.

Individually miking a large group such as an orchestra is usually not practical. This technique is used more for small groups or individuals. You can mix the recordings from various mics as the recording session is taking place, or you can record each mic on a separate track and mix them later.

If sounds are mixed live, each mic feeds into a different input of an **audio mixer**. Technicians raise and lower the volume of each mic so the instruments are recorded at an appropriate level. Then they feed the mixed music to a single track (or two tracks if the sound is to be stereo) of an audio recorder. The disadvantage of this method is that the mixing must be done in real time. If one of the technicians makes a mistake, it cannot be corrected. However, for something simple, such as a singer accompanied by a guitar, this type of recording works quite well. The singer could be recorded with a mic placed about 6 inches from his or her mouth, and the guitar could be recorded with a mic placed by its sound hole. You can decide on the appropriate mix of guitar to voice, and then record the whole song at those volume levels through a mixer and into an audiotape recorder.

If the music is going to be mixed later, each mic must feed to a different track on a **multitrack recorder** or computer program designed to record music. The sounds may go through an audio mixer to be recorded, but there is no need to adjust their levels because each sound is going on a *separate* track and can be isolated later. The audio technicians can send each track back through the mixer, adjust the volume of each track, and send it to one track of another audio recorder. This can be done in a fairly leisurely manner. The technicians can listen to the music, practice different levels, and can also add reverberation or in other ways improve the sound. They can correct mistakes because the original recording can be played over again either from the multitrack or from the computer drive.

Another method of recording multitrack is to record different instruments at different times, each on a separate track of the tape or computer program. This is the usual method when one musician wants to play several instruments. He or she might first play the guitar melody of the song. Then, while listening to what has just been recorded, the musician could sing the words to the accompaniment of the guitar. The guitar would be *playing back* from one track, and the singing would be *recording* on another track. After that, the musician might listen to guitar and singing and add drums on another track. All three tracks are played back through an audio mixer and recorded on a single track of another recorder. In the process, the sound operator can change the volumes of the guitar, voice, and drums so that they blend with each other properly.

The method of recording used usually depends on the complexity of the music and the size of the budget.[9]

Recording Techniques

You should always carefully monitor the sound you are recording—dialogue, voice-over, sound effects, ambient sounds, or music—to ensure the best quality possible. If at all possible, monitoring should involve looking at a meter and listening through headphones. Headphones are not always reliable because they often have volume controls. With the headset volume cranked up all the way, you may think you are recording properly when in fact you are **riding in the mud.** The meter often shows what is going into the recorder but not what is coming out. The headset gives you the result and assures that you have, indeed, recorded. **Overmodulation** is the problem that occurs most often during recording. Sound recorded at too high a level causes distortion.

One of the best ways to prevent overmodulation and other field audio problems is to use a tone generator to set the reference level at 100 percent. Not all portable mixers or tape recorders have **tone generators,** but if one is available, you should definitely use it to set the reference level at 100 percent. This way, you know that all other

inputs that register near the 100 percent level will be recorded properly.[10]

Most recorders have an **automatic gain control (AGC).** This circuitry prevents the signal from being recorded at too low or too high a level. If the sound is low, the AGC automatically boosts it; if it is high, it lowers it. However, AGC is not always appropriate. For one thing, most AGCs do not handle silence well. If there is a pause between lines of dialogue, the AGC will boost the gain, increasing the ambient noise. This can be quite disturbing if silence was really what was wanted. AGCs also try to compensate for changes in perspective. A distant sound should sound lower than a close sound, but AGC will try to boost the distant sound. This means that you may often want to put the sound gain on manual rather than on automatic so that you are the one making the decisions about the relative volume levels. This approach is similar to that of overriding automatic focus and automatic iris on the camera.

Sometimes you'll be recording sound directly into the recorder on one or more tracks of the audiotape or videotape. Other times you will send it through a portable mixer where various sounds are mixed and sent to one track of the recorder. Neither method is right or wrong; the determining factor is the production situation. Obviously, a mixer is not needed to simply record one person's voice-over with one mic. However, to record a musical group and dialogue working at once, you will probably need more inputs than the recorder can handle. Taking along a mixer adds to the bulk of what you carry to the field and usually adds to the setup time.[11]

If there is access to elaborate postproduction facilities, it is best to record sounds separately so that the postproduction people have the ultimate number of options. If postproduction facilities are limited, you are better off mixing as much as possible in the field. In other words, the equipment used often makes the decision for you. Some tape recorders can record only one track, whereas others have multiple tracks. Some of the newer camcorders allow for recording on **hi-fi, PCM,** and/or **linear tracks.** If you record on the hi-fi track, remember that you

cannot separate the audio from the video. You also need to consider the equipment on which the movie will be played back. You do not want to record on PCM if the playback machine is not capable of playing that track.

Whenever you are recording sound of any sort, you should listen to at least part of it in the field to make sure it is acceptable. Recording it over is fairly easy during production. Fixing it later ranges from difficult to impossible.

Notes

1. David R. Schwind, "Room Acoustics," *Mix,* August 1997, pp. 58–70.
2. Doug Schwartz, "Audio Mechanics Use Sonic Solutions to Solve the Mystery of the Misdirected Mike," *Computer Video,* January/February 1995, p. 32.
3. Fred Ginsberg, "About Selecting Microphones for Fishpole and Boom Application," *Digest of the University Film and Video Association,* January 1989, n.p.
4. Nick Batzdorf, "A Guide to Micing and Mixing in the Field," *AV Video,* May 1991, p. 48.
5. Fred Ginsberg, "Tips on Your Boom Pole," *Equipment Emporium,* 1994, pp. 2–3.
6. "Experimenting with Mic Techniques," *TV Technology,* 24 April 1997, p. 39.
7. Mike Sohol, "Create the Narrative that Shouts Quality," *Computer Video,* July/August 1995, pp. 39–41.
8. "Sound Effects Recording," *Mix,* April 1997, pp. 22–24.
9. Rick Clark, "Acoustic Ensemble Recording," *Mix,* July 1998, pp. 30–39.
10. Rick Shaw, "Sound Check: 20 Questions," *AV Video,* September 1990, p. 54.
11. Chris Michie, "Small-Format Consoles," *Mix,* July 1998, pp. 66–70.

part three
Postproduction

chapter ten
The Process of Postproduction

Commenting on the impact of digital technologies in postproduction way back in 1992, director James Cameron said: "From the standpoint of the filmmaker, we're going to reach a point in a few years where we're going to think of post-production in a different way. We're going to think in terms of image capture, which is the photography, and we're going to think in terms of the manipulation of the image—not just editing, but changing the components of what we've shot and recombining them in different ways, almost like an image mix in the same way that we mix sound."[1] Cameron's way of thinking is becoming more common as the digital revolution brings postproduction into new areas, making it more difficult to define a particular activity as something that takes place solely in preproduction, production, or postproduction.

Take, for example, the act of *building* sets. This has traditionally been a preproduction activity. Today it might take place during post-production. Sets can be created digitally in a computer and added to a scene *after* the actors have been filmed. The ability to seamlessly integrate different layers of the image makes it possible to think of sets in an entirely new manner.[2] In a similar manner, editing has tradition-ally been considered an activity that takes place after shooting, but this too is changing. **On-set editing** using the images obtained via the **video assist** system and a portable nonlinear editing system was used by filmmakers on films such as *Cutthroat Island, The Flintstones,* and *Forrest Gump.* Footage was placed into the editing sys-tem as it was being shot and then immediately assembled into a rough cut on the set. This process could be likened to a sort of digital **script supervisor**, a high-tech way of helping directors see quickly if they had shot enough

coverage of a scene. If not, the on-the-set rough cut let the directors know exactly what they needed to shoot to make the scene work.[3]

The digital revolution of postproduction is proceeding at a rapid rate. The techniques and terminology growing out of these technologies are moving so quickly that some of what has been written in this book will be out of date be-fore it is printed. The equipment used for elec-tronic moviemaking and the methods for combining film, video, and digital imagery are changing daily. These changes are evident in professional production and in the academic world that is preparing students to enter pro-fessional production and postproduction. In a time of rapid technological change, in a period when film, video, audio, graphics, multimedia, photography, and other production forms are merging, blending, and intertwining in a vari-ety of new ways, the only certainty is change. Learning to adapt may be the most important lesson for students to grasp.

One way to learn about adapting is to survey the various forms of editing—past, present, and future. For many years, all movie editing took place on actual film. Celluloid was cut and glued as the images were placed together in proper se-quence. During the six or seven decades that film editing held sway, a large number of tech-niques and terms were developed that are still prevalent today. Once video editing was in-vented, some material intended only for the television screen was shot on film, transferred to video, and then edited on videotape. The origi-nal video editing process, called **linear** editing, involved rerecording. The material shot during the production phase was copied in a linear fash-ion, shot by shot in the sequence desired, from an original tape onto another tape that could then be shown to a TV audience. In the late 1980s a new form of video editing, referred to as **nonlinear** editing, was developed. For non-linear editing the footage does not need to be laid down shot by shot. Because of the advances of digital computer technology, shots can be arranged and rearranged in any fashion before they are committed to a final product.

Pure film editing is rare today, but many of the terms and processes it encompassed are still

in use. Linear editing was not used to edit theatrical films, but it was (and is) a method used for product designed to be shown on television, such as documentaries and news stories. Nonlinear editing is now the dominant form used for postproduction, be it theatrical or television material. It is also used for material that is going to be distributed through CD-ROMs, the Internet, and other multimedia methods.

In this chapter we will overview film and video editing. We will cover film editing in some detail, introducing the terminology and techniques used that were adopted later by both forms of video editing. The overview of video editing will be briefer because we will cover both nonlinear and linear editing in detail in the next chapter. We will conclude the chapter with a discussion of the various postproduction tasks and the people needed to accomplish them.

Film Editing

The need for editing was apparent, even in the early days of the moving image. The first films were short vignettes shot continuously, but filmmakers soon felt the need to show different scenes. At first they did this by turning the camera off after one shot, then repositioning and turning it back on for the next shot. The film was processed and then projected with all the scenes in the same order in which they had been shot. This was a very crude form of production, however. Real editing began when they turned the camera off and on several times in one reel, processed the film, and then cut the shots apart and glued material back together in a shorter form or different order.

Workprints

For traditional film editing, after the film was exposed in the camera, it was taken or sent to the laboratory for processing. At this point most filmmakers ordered a print of the original camera footage, called a **workprint**, to be used for editing purposes. It was possible, of course, to cut the processed film that came out of the cam-

era, but **negative** film (the professional standard) required a print if you wanted to view it. Cutting the camera original avoided the extra cost of a workprint and was a common practice in schools, where students typically worked with Super 8mm or 16mm **reversal** film that produced a **positive** image after processing. Choosing to edit without a workprint meant that prints would not be made of the finished film because you did not have a negative from which to make prints and because it was almost impossible to view, mark, and edit film without scratching it.

Normally a workprint was used for the intrinsically damaging editing process, and the original negative was stored in a clean, cool place, usually at the laboratory. If damage occurred to the workprint during editing, it was always possible to go back to the original material and make another editing copy. That way the original film that came out of the camera remained in pristine condition, untouched until all the editing decisions were made on the workprint.

Film Editing Equipment

A **film splicer** was used to physically cut and join together two pieces of film. One type of splicer, called a **cement splicer** (or **hot splicer** if it has a heating element to speed the drying process), joined shots with a special type of glue. The other basic type of splicer, called a **tape splicer,** joined shots together with a piece of clear mylar tape. Figure 10.1 shows a cement splicer and two different types of tape splicers.

In addition to the splicer, a typical film editing bench contained a film **viewer**, a piece of equipment that allowed the editor to scan back and forth across the material to be edited, and two **rewinds** that held the reel of feed material and the take-up reel. Scissors, grease pencils (for marking the film), extra reels, and masking tape were also common on any editing bench. See Figure 10.2 for a simple film editing setup.

Film dialogue required some special equipment. Because this dialogue was usually recorded on a separate ¼-inch reel-to-reel audio recorder, it had to be transferred (copied) to sprocketed magnetic audiotape called **magnetic film stock** (mag stock) so that it could be lined up with the

Figure 10.1

Three types of film splicers. From left to right, a Rivas tape splicer, which uses sprocketed splicing tape; a cement splicer (hot splicer), which uses liquid cement and has a heated element to speed up the drying time for splices; and a guillotine tape splicer, which punches out (or clears) the splicing tape from the sprocket holes when the handle is pressed down.

Figure 10.2

A typical editing bench for editing Super 8 sound film. This bench contains a set of rewinds, a sync block, a picture viewer, a sound reader plugged into an amplifier, and a small tape splicer (lower right-hand corner). (Photo courtesy of Super 8 Sound)

film during the editing process. This magnetic stock was the same width (16mm or 35mm) as the film and had the same number of **sprocket holes,** so it could move through the editing equipment exactly as the film did. In order to keep the dialogue synchronous with the picture, the tape had to be recorded on a machine capable of recording a sync signal that was derived either from the camera or from a highly accurate **crystal** control unit built into the camera and recorder. This sync signal functioned like electronic sprocket holes. The tape was transferred to magnetic film stock with a special **resolving unit** that read the sync signal and adjusted the new recording so that it, too, would be in sync with the picture.

The sprocketed magnetic film stock was cut and spliced together just like the picture. A device called a **sync block** was used to lock the separate reels of sound and the picture in a consistent relationship during editing (see Figure 10.3). A sync block could have multiple **gangs,** which gave it the ability to hold in sync two, four, or six rolls of film and/or magnetic stock at once. A magnetic sound **head** and amplifier could be attached to any of the gangs so that the sound could be monitored.

Electrically powered editing machines combined feed and take-up reels, a viewer, and sound heads into a single unit. In a vertical configuration they were called **upright** editing machines (see Figure 10.4a). Laid out horizon-

Figure 10.3

A four-gang synchronizer (or sync block) with a sound head. The magnetic film stock is in the first gang, and the workprint is in the second gang. A small footage counter is located on the bottom left side of the sync block.

a

b

Figure 10.4

(a) An upright editing machine with two sound heads and one picture head (note the viewing screen on the right side); (b) a flatbed editing machine, also with two sound heads and one picture head. (Photo b courtesy of W. Steenbeck and Co.)

tally, they were called **flatbed** editing machines (see Figure 10.4b). Such editing machines produced a bright, stable picture, and more important for sound work, they ran at a constant speed, something that is difficult to achieve when hand-cranking film through a viewer and sync block.

Film Editing Stages

In a film with lip-sync dialogue the sound is so intrinsically related to the image that editing de-cisions could not be made until the editor synced up the workprint and principal dialogue track. This process, called *syncing up dailies* (because this job was performed each day as new footage and sound came back from the lab) was often done by an assistant editor. It involved marking the **slate clap** on the sound track and then finding the corresponding frame of the picture in which the slate just closes. Once the picture and sound track were locked into the sync block or editing machine at those marks, the image and sound for that shot were in sync. Syncing up

Figure 10.5
A film bin that holds the various shots before they are edited.

dailies was not really editing. It was simply getting sync-sound material into a form from which intelligent editing decisions could be made.[4]

The first real stage in film editing was **logging** all the footage (sound and silent). Logging involves writing down each shot, what it contains, where it is located, and any other pertinent notes about the shot that will be useful during the editing process. After this tedious task was completed, the editor began to break down the workprint, cutting apart all the shots on the reel. Each shot was numbered with a grease pencil and then hung up in a **film bin** (see Figure 10.5) or placed on a plastic core along with its sound track if it had sound.

Using the logging sheets and script as a reference, the editor then began to map out a plan for assembling the material, making preliminary decisions about which shots to use in what order.

The next step was to put together a loose assemblage, in order, of all the footage (picture and sound if there was dialogue) to be used in a particular scene or sequence. This was sometimes called a **string-out** and was usually done with a tape splicer so that it was easy to take the edits apart by peeling off the tape. At this stage the entire shot, including material on the head or tail that was obviously not going to be in the final film, was left intact. Shots that were not going to be used, called **outtakes,** were labeled and stored away so that they could be used later if the editor or director changed his/her mind.

The next editing stage, called a **rough cut**, consisted of trimming the shots (and dialogue) together more closely. The string-out simply placed shots loosely in the proper order, one shot after another. This enabled the editor to pull the two shots that were going to be cut together through the viewer, carefully weighing different in-points and out-points as potential cutting places. Once a decision had been made, the cutting point was marked with a grease pencil. Then the shots were taken out of the viewer, cut, and joined together with the tape splicer. A close-up might be added or a few frames taken out to soften an edit, but a rough cut was considered rough because it was like the first draft of a paper. Many changes were still likely to occur, and most editors saved every trim, no matter how small, aware that it might be needed later. As the editing proceeded, each successive cut refined the previous cut, moving closer and closer to a polished **final cut.**

Once the director approved the final cut, the picture and dialogue were "locked." In other words, they were not changed. The people involved with adding sound effects and music used this locked cut as the basis for their decisions. They created their sound materials and mixed them together with the dialogue. This process is described more thoroughly in Chapter 13.

The final cut of the workprint was also used as a guide for **conforming** or matching the camera original material. The key to this process was the **edge numbers** along the side of the film. These numbers were a uniform number of frames apart (twenty for 16mm and sixteen for 35mm) and were called *latent* edge numbers because they were exposed on the stock during the manufacture and did not appear until the film was processed. Once editing decisions were finalized with the workprint, the edge numbers enabled a negative cutter to find the same place on the uncut negative that had been stored away. Thus, the negative cutter could duplicate the editing decisions made on the workprint to the exact frame.[5]

Negative cutting is still done today, especially for films that are going to be shown in a movie theater. Because the negative is so easily damaged (any mark on the original negative will show forever in the prints made from it), it is conformed

Figure 10.6

A-B rolls alternate successive shots in a checkerboard pattern from one roll to the next, filling the space between the shots with opaque black leader. When the A roll is printed, the section of black leader between shots 1 and 3 will leave an unexposed portion of film. The print is exposed a second time when the B roll passes through the printer. Shot 2 on the B roll is then printed into the unexposed area created by the black leader on the A roll.

in a **clean room,** a spotlessly clean editing room with air filtered to remove the dust. Negative cutters wear gloves to keep the oil from their fingers from leaving marks on the film. They use cement splicers, which hold the pieces of film together firmly. Before prints are made, most laboratories use an ultrasonic process to remove any dirt or dust that the negative may have picked during the cutting process.

The Role of the Laboratory in Film Postproduction

The motion picture laboratory still has a very important role in the postproduction process because much material, although it is edited using electronic equipment, is shot and distributed on film. The lab processes film and is also responsible for producing the final **composite release print,** a single strip of film that holds both the picture and the sound tracks. This is the print that runs through the projector in a movie theater.

If the final product is going to be a film, as opposed to a videotape, then the negative must be conformed and sent to the lab for printing. With it is the final mixdown of the sound—dialogue, music, sound effects, and so on.

In the original days of film editing, the sound was on magnetic stock. The negative and magnetic stock went through a number of stages in order to make the release print. The key to this process was (and is) the film printer. Film laboratories use two basic types: **contact printers** and **optical printers.** A contact printer is used to run the negative and the new, unexposed print stock past a light source. The light passes through the negative and exposes the emulsion on the print, which is then processed and developed into a positive. Contact printers are very fast, efficient, and relatively inexpensive to operate.

An optical printer projects the negative onto the print stock. The two pieces of film do not come in contact with each other; the process is more akin to using a camera to take a picture of the image that a projector is showing. For this reason, the image size can be manipulated. For example, something that takes up a full frame on the negative can be projected so that it takes up only the right-hand corner on the print

stock. Optical printing has traditionally been used to transfer 16mm film to 35mm, to place credits over film footage, to execute dissolves, and to build a variety of effects such as **wipes** and **freeze-frames.** Optical printers run more slowly and require more care and therefore are more expensive for printmaking than contact printers.

To understand fully the laboratory's past role (and to some extent, present role) in film postproduction, we need to go back to the end of the film editing phase—to the point at which the negative cutter was conforming the original footage to the workprint. At that stage the negative cutter was actually preparing the negative for printing. Decisions about shot fades and other shot transitions, superimpositions, and title placement had already been made by the editor and were marked on the workprint.

If the negative was in the 16mm format, the negative cutter would prepare **A-B rolls** (see Figure 10.6). This required the creation of two different printing rolls—the A roll and the B roll. The A roll contained the first shot, and the B roll contained the second. This pattern of alternating shots continued throughout the A-B rolls. When the A roll was completed, it contained half the shots in the film, with each shot separated by a length of black leader exactly the length of each shot on the B roll.

When the A roll was run through the printer, the first shot was printed on the print stock, but when the printer light hit the black leader (which is so opaque that the printer light cannot pass through it), it left a section of the print stock unexposed. After the A roll was

printed, the partially exposed print stock was wound back to the beginning, and the B roll was then printed into the unexposed spaces left when the A roll passed through the printer. Having multiple printing rolls not only hid the splices but also allowed the editor to set up a number of printing effects.

All printers can be cued to open up or shut off their light source at a point specified by the editor, creating a **fade-in** or **fade out.** A **dissolve,** however, is created by fading one shot out while another shot fades in. At one point in the middle of a dissolve the two shots are actually **superimposed.** If two shots were to appear in the print at the same time, multiple printing rolls were required. Thus, A-B rolls were needed to place a title over the opening shot of a film or to create other overlapping transitions, such as wipes and dissolves.

This same multiple printing technique was (and sometimes still is) the basis for numerous special effects. Many of the motion picture space epics or other effects-oriented films such as *Raiders of the Lost Ark* or *Indiana Jones and the Temple of Doom,* relied on an optical printer to build up elaborate "process" shots. Individual elements of the shot were created layer by layer using multiple passes of the printer to create the **composite shot.** Many of these effects employed **blue-screen photography** to create a **traveling matte.** In this process an actor or object (such as a spaceship) was photographed against a blue background.[6] The moving outline of the actor was matted out of the desired background in laboratory printing. Then, after additional lab work, the image of the actor was printed back into the moving (hence the term *traveling*) blank area created in the background footage, a technique that enabled Superman to fly through Metropolis with the background and foreground elements married invisibly together. With each pass of the film through the optical printer, different areas of the image were matted out (leaving unexposed holes), while other areas were filled in with new elements of the composition. A special effects shot of this kind might require A, B, C, and D (or more) printing rolls, with each roll containing one layer (or element) of the final printed composite image.

After the printing rolls were prepared by the negative cutter and given to the laboratory, they were turned over to a **timer,** a person who evaluated each scene for correct exposure and color balance. For example, if a scene in the original footage was underexposed, the timer could increase exposure by instructing the computer that controlled the printer to open up the printing light to a higher intensity. Similarly, the timer could help control color shifts by varying the amount of red, blue, or green light used in the printing process. The timer could not correct huge errors in color or exposure, but a carefully timed print would appear much more even and balanced than an untimed print.

The first print obtained from the timed A-B rolls was called the **answer print.** The director and timer usually viewed it in a screening room at the lab, discussing and evaluating the timer's decisions on exposure, color balance, or effects timing. Frequently, filmmakers went through several answer prints before a satisfactory print is finally obtained.

Finally, the film was (and still is today) ready for its final printing. If a large number of **release prints** are going to be made, which is normal for theatrical films appearing simultaneously in hundreds of theaters across the country, several additional generations of printing are required. This is done to protect the original footage from wear and tear in the printer.[7]

The flowchart in Figure 10.7 illustrates this traditional film editing process. It shows the progression of the film image from camera original to release print. Many of these same steps occur in movie editing that incorporates electronic techniques, and certainly many of the terms have been carried over to linear and nonlinear video editing.

Video Editing

When video editing first began, it too started with physical cutting and splicing of the tape. But this mode was abandoned largely because it was impractical. The human eye cannot see individual frames of video on tape, and the equipment designed to enable a human to see the end

of one frame and the beginning of another was tedious and unreliable. What developed instead was an electronic process dependent on re-recording desired material from one tape to another, a process that became known as linear editing. After the development of digital computers, nonlinear editing came to the fore, bringing with it the increased flexibility that the computer has brought to many other activities.

Today a great deal of television programming is shot on celluloid and then edited and distributed electronically. Similarly, most movies destined for theatrical release are shot on film and then transferred to video so they can be edited electronically. However, once the editing decisions are made, the final editing is completed on film, through the process of conforming and then printing the film at a laboratory. Regardless how the editing is done, the concept is the same: material filmed or taped is rearranged to convey the essence of the idea—to create a syntax.

Linear and Nonlinear Editing

Originally, all video editing consisted of rerecording shots one after another from the beginning of the program to the end in a linear fashion. This involves at least two tape recorders—one containing the source material from which the final program material will be selected and the other containing the tape onto which the selected material will be recorded (see Figure 10.8). If after the editing of an entire production was finished, it was decided that the second edit should be two seconds shorter, there was no easy way to fix the problem. Editors could either edit everything all over again from the second edit on, or they could rerecord the first two edits to another tape, shortening the second edit and then dubbing (editing) the rest of the material onto that same tape. The problem with this process is that the overall product suffers from **generation loss** because signal information is lost or contaminated when material is dubbed from one analog tape to another. Linear editing is often compared to writing a term paper with a typewriter. If you finish the entire paper and decide you want to remove a paragraph on page 2, you must retype the entire paper from page 2 on.

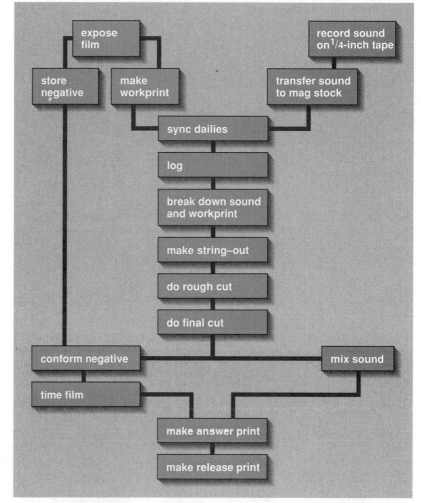

Figure 10.7

A flowchart illustrating the progression of the film image from camera original to release print.

In the late 1980s the first nonlinear editing systems began to appear. These are computer-based editing systems that use either regular home personal computers (Mac or IBM-compatible) or larger, faster computers of a more proprietary nature. The image (whether generated on film or video) is **digitized** (converted into digital information) and stored on large hard drives or some other digital storage medium in the editing system's computer (see Figure 10.9). With the image converted to digital form, it can be stored, recalled, manipulated, and played back instantaneously and in any order. Nonlinear editing is like typing a term paper with a computer word-processing program. If you decide to move a paragraph from page 2 to page 15, a few keystrokes will accomplish the task. Likewise, in nonlinear editing, scenes can be trimmed and moved quickly and easily in a totally **nondestructive editing** process. In other words, if you decide to

Figure 10.8

A linear editing system with two tape recorders, a monitor for each, and a controller to mark the edit points. (Photo courtesy of the Winsted Corporation)

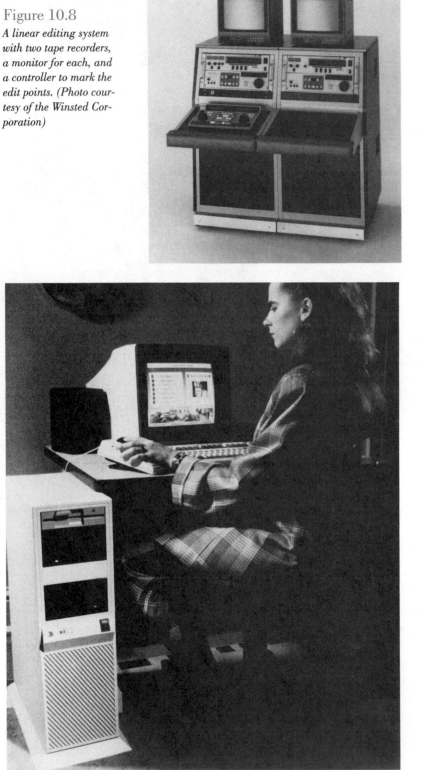

Figure 10.9

A nonlinear editing system. (Photo courtesy of Editing Machines Corporation)

trim off five seconds of a shot, that five seconds is not gone—it is still stored on the computer and you can easily retrieve it in entirety or in part. Another advantage of nonlinear editing is that it is **random access.** You can access any particular shot quickly because the material is stored on disk; there is no need to wait for a tape to rewind. Nonlinear editing has taken the main advantages of film and tape editing and combined them.[8]

Off-line and On-line Editing

The idea of using a film workprint to protect the original film was also incorporated into linear video editing with the concept of **off-line** and **on-line** editing. These two terms have changed meaning over the years and continue to evolve as new procedures and equipment surface. Originally, copies (workprints) were made of the master tapes and these copies were used for editing. The masters themselves were filed away in a vault. The off-line editing occurred on an inexpensive linear video editing system that could only cut from one shot to another; it could not do dissolves or wipes or any special sound or video effects. Once all the major decisions were made using the workprints on the off-line system, then the master tapes were removed from the vault and taken to a more expensive on-line system that could be used to execute dissolves and other effects, improve sound, create graphics, correct color, and in other ways produce a final polished product. The workprints took abuse. They were usually shuttled back and forth many times as the editor made decisions regarding where to make the edit points. Once these decisions had been made, the master tapes could be edited with very little shuttling and wear and tear. Time code numbers on the workprints matched time code numbers on the masters in the same way that film workprint edge numbers matched those on the negative. The off-line system was usually tied to a computer that kept track of the time code numbers and printed out (or stored on disk) an **edited decision list** (EDL) that could be read by the on-line system, enabling the on-line process to proceed quickly.

Initially, universities did not have fancy on-line systems so students used their masters to edit

on cuts-only systems, a process similar in concept to that of cutting camera-original reversal film. However, some students using video to make movies made VHS copies of their tapes that had time code numbers showing somewhere in the picture area. They played these **window dubs** on their home video systems so they could make decisions related to editing—they wrote down the time code numbers where shots should start and stop. They then used their original tapes on a cuts-only system to make the final product. In a way, these home VHS recorders were off-line editing systems and the on-line systems were cuts-only systems that would have been considered off-line in the professional world.

When nonlinear editing systems entered the scene, the concept once again shifted. Nonlinear systems are capable of executing dissolves, wipes, audio mixes, graphics, color shifting, and a large variety of other functions. Theoretically, off-line and on-line can be done on the same machine. However, uncompressed, high-quality video takes up an enormous amount of space on a hard drive. Compressed video of lesser quality takes up less space. So sometimes an editor places video on a nonlinear system in a very compressed form (VHS quality or worse). Decisions are made using this low-quality picture—in essence, off-line editing occurs. Then all the footage can be taken off the computer and only that which is needed for the end product is put back on the computer, this time at an image quality that is similar to one of the top digital formats. Using reference time code numbers created with the lower-quality video, the high-quality material is assembled into the final product in a manner similar to on-line editing. Although only one system is involved, it is used some of the time for off-line editing and some of the time for on-line.

The concept of off-line and on-line is useful in other ways. Even when video is compressed, a computer cannot hold a great deal of it. A feature-length movie might need to be edited in bits and pieces on a nonlinear system used as off-line and then taken to an on-line system where it can be assembled into a whole. Of course, if the final product is going to be shown on film in a theater, the nonlinear system is strictly off-line—used to make the decisions that will later help in conforming the negative film at least until some form of high-definition theatrical distribution arrives.

The terms off-line and on-line are used frequently and are useful in talking about editing. However, the terms are relative in relation to equipment—my on-line system may be your off-line system.[9]

Postproduction Responsibilities

Postproduction does not require as many people as production. Many of the functions of this stage can be handled by a single person working alone. Even when large numbers of people (such as an orchestra) are brought together, they interact for only a short time.

This does not mean, however, that postproduction is less hectic than production. Sometimes the time allowed for postproduction is insufficient, especially if production fell behind schedule and the movie has a set airdate or theatrical release date.

A typical two-hour TV movie of the week has a twelve-week schedule—four weeks for production and eight weeks for postproduction. Of those eight weeks, the first three weeks are devoted to editing the picture and dialogue (see Chapter 11). In the subsequent three-week period the postproduction team composes the music and decides where to place it, rerecords and replaces poorly recorded location dialogue, and records and edits **sound effects** and **ambient sounds**; this is also the period for building graphics, credits, and special video effects. The seventh week is devoted to music recording and the final sound mix and to incorporating graphics. During the last week the movie is prepared for distribution (see Chapter 13). Schedules are somewhat in a state of flux because, with nonlinear editing, you can start editing some scenes while others are still in production. This means schedules can be compressed because postproduction can be started before production is completed. However, at present few movies are actually being handled this way. Most directors like to concentrate on production before thinking about postproduction.

Figure 10.10

A flying spot scanner used to transfer film to video. (Photo courtesy of Rank Cintel)

Student projects have a different schedule—they must be based on the availability of equipment, the length of the semester or quarter, and the number of student projects that must all be edited at the same time. Rarely do students leave enough time for postproduction, making for a hectic end-of-semester crunch.

General Overseeing

Different aspects of postproduction take place both serially and simultaneously. For example, a scene must be edited before a composer can create the music to play under it, but one person can be selecting sound effects while another person is building credits. Someone must oversee the whole process so that all the individual parts add up to a unified whole. Television series often have a **postproduction supervisor** who makes sure everything is completed on schedule. This person often juggles several individual programs at one time. The program scheduled to air the first week of November might be in sound mix while the program scheduled to air the last week of October is dubbed for air. The programs must move through the system in almost assembly-line fashion.[10]

Theatrical films are more one-shot in nature, but someone still needs to make sure they are being completed on time. The **director** has the responsibility for seeing that the movie is edited properly. Some directors handle this responsi-bility by becoming involved in most details of postproduction. They decide all the edit points, indicate where the music goes, determine the type of sound effects that should be added, create the list for the credits, and generally make all the technical and creative decisions. In fact, some directors have nonlinear editing systems on their home computers and actually undertake some of the editing, at least in rough form, from their homes. Other directors convey general ideas to the people involved with picture and sound editing but delegate the specifics, such as which take to use, where to bring in sound effects, what font to use for titles, and whether to add **reverberation** to dialogue. Regardless of how involved or uninvolved directors are, they always view the edited versions of the picture and the dialogue and make suggestions, a process known as the **director's cut**.

The **producer** also oversees the entire postproduction process. The degree of involvement depends to a great degree on the person, the structure established during preproduction and production, and the number of problems associated with the project. If the movie is coming in over budget, the producer will need to be very involved. But if the project is progressing well, financially and artistically, and the producer trusts the director, he or she will rarely appear. Usually, but not always, there is a **producer's cut** of the picture and dialogue.

For commercials or corporate videos the client usually has a definite say in the editing. Because these people are paying for the production, their opinions count.

Transferring Film to Video

As previously mentioned, many narrative productions today are shot on film and edited electronically. When this is the case, the film is first processed and cleaned, and then a **telecine operator** transfers it to some electronic storage medium, commonly videotape or some sort of external drive that can be put into a computer. The operator transfers with a **telecine**, which often uses a **flying spot scanner** or a **linear CCD array**. These devices can transfer the original film negative without damaging it (see Figure 10.10). They do not pull the film down one

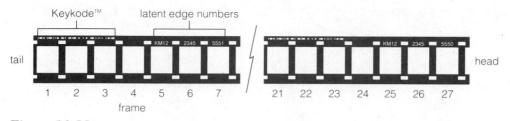

Figure 10.11

A diagram of 16mm film with latent edge numbers and Kodak's machine-readable Keykode™ numbers.

frame at a time as regular film projectors do. Rather, they electronically scan each frame as it flows from a feed reel to a take-up reel. When a negative is transferred, the polarity of the picture is reversed so that the image recorded on tape is a positive. Now that digital technologies play a greater role in editing, telecines can convert the film into digital information during transfer.[11]

If the movie is going to be conformed so that it can be distributed on film, then there must be some method by which the negative cutter can relate the editing decisions to the edge numbers that are on the original negative film. Eastman Kodak has developed **Keykode** to facilitate this process. It is a bar code system similar to that used at grocery store checkout stands that is available on all Kodak film stocks (see Figure 10.11). When the film is transferred to videotape for editing, special equipment reads the bar codes and, through a computer program (see Figure 10.12), relates them to the **time code** that rides with the video signal. After electronic editing decisions are made, the time code numbers can be translated to the edge numbers so that the original negative film can be conformed properly.[12]

One of the problems inherent in transferring film to video involves film speed. American TV operates at 30 frames per second, and most film is shot at 24 frames per second. To compensate for this difference a **three-two pulldown** method has been devised. Generally, the odd-numbered frames of the film are placed on two fields of the TV signal while the even-numbered film frames occupy three TV fields (see Figure 10.13). Over the course of 24 frames, 6 extra film frames are added to equal the 30-frames-per-second rate of video.

Once the film has been transferred to an electronic storage device, it can be edited with any of the various video editing systems discussed in the next chapter. At this point there really is no difference between editing something shot on film and something recorded on tape. At the end of the electronic editing process the "film" can be displayed electronically or the Keykode numbers can be used to conform the film negative. In the latter example, the only time the film itself is actually cut is when the negative is edited to create the celluloid release prints that are shown in motion picture theaters.

Organizing Footage

It behooves you to do as much work on your movie as you possibly can before entering the editing bay. In the real world, time is money, and you pay the same amount for editing time whether you are agonizing over what angle shot to use or whether you are executing a page-flip wipe consisting of four different images. It is much better to agonize using a $300 videotape recorder than a $30,000 editing system.

If the production people kept an accurate **log** and slated well, you should have little trouble finding the shots you want to consider. If not, you will need to log the footage prior to editing. You might want to make a VHS time code **window dub,** a copy of the original tape with time code superimposed on it. You can use this window dub copy to log your footage and/or to make your initial editing decisions—your "off-line" editing.

As you look at your tape, you might want to make a list of the shots you think you might want to use. If you are using nonlinear editing, it is best to make a list of the shots in the order they appear on your tape in order to minimize the amount of time it will take to transfer the footage to the computer. You will be able to fast forward through your tape to each time code indication and place each shot in the computer. Your nonlinear editing software will probably ask you to give each shot a name, so you might

Figure 10.12

A list generated by Slingshot software. It translates the Keykode into frame numbers that the negative cutter can use to assemble the film footage. (List courtesy of TrakkerTech)

```
Title: "Scene 33 Harold Darling"
Cut List for Harold Darling.ppj
Generated by FilmLogic™ on Sun, Nov.8, 1998 at 7:23:34 PM
with database file "Harold Darling.db" and these parameters:
The film standard is 16mm20.
The starting footage is 0000+00 or 00:00:00:00.
Do not start with 8 seconds of leader.
Include a cut list.
Do not include a dupe list.
Include an optical list.
Include a pull list.
Include a scene list.
Show feet & frames.
Show scene & take.
Show camera roll.
Do not save a program file.
Open the list in a text editor.
Transitions are opticals.
Fail on duplicates.
The transition handles are 1 frame(s).
Include the entire project.

The cut list in construction order:

Shot  Footage   Length    Keycode    In Frame  Out Frame  Roll  Scene  Take
001   0000+00   0001+23   Optical 1
002   0001+23   0002+04   KQ710745   9338&06   9342&09    7     33     3
003   0003+27   0001+25   KQ710745   9629&15   9632&19    8     33D    2
004   0005+12   0004+36   KQ710745   8994&04   9003&19    7     33A    4
005   0010+08   0001+38   KQ710745   9644&19   9648&16    8     33D    2
006   0012+06   0002+29   KQ710745   9360&17   9366&05    7     33     3
007   0014+35   0002+01   KQ710745   9653&03   9657&03    8     33D    2
008   0016+36   0002+10   KQ710745   9368&01   9372&10    7     33     3
009   0019+06   0000+22   KQ710745   9558&03   9559&04    8     33C    2
```

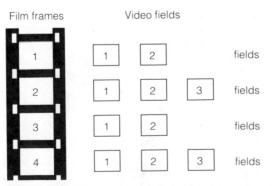

Film frames Video fields

Figure 10.13

The three-two pulldown method, which compensates for the speed difference between film (24 frames per second) and video (30 frames per second). Film frames are alternately scanned with two fields (one video frame) and then three fields (in effect, 1½ frames) so that 24 film frames equal 30 frames (60 fields) of video.

think of names ahead of time. Because your nonlinear system is random access, it can find any shot quickly. But, because of the space limits on your hard drive, you will want to minimize the amount of footage you place in the computer so that you can have room to edit your entire piece. You may want to jot down some comments that will help you when you start editing. Anything that you can write on paper before you start working with the equipment will be beneficial.

If you are using linear editing, you will want to list shots in the order you will use them for the final edited piece. That way you will be able to build the shots one after the other as required for linear editing. If you are making the list for linear editing, you will want to include the reel

TYPICAL LIST FOR NONLINEAR EDITING

Reel	Scene	Take	Approx. Time Code	Name	Comments
1	2	1	1:00:00-9:00:00	Kids	
1	2A	1	11:30:00-16:00:00	Dave-Ed	Search for best sound start place
1	2B	3	19:15:00-19:45:00	David	use as reaction shot
1	2C	1	19:30:00-20:30:00	Eddie	
2	1	2	2:00:00-3:30:00	Neighborhood	put credits over and music under
3	2D	2	2:00:00-4:00:00	Mrs. O-1	see if it works
3	2F	1	6:00:00-8:00:00	Mrs. O-2	use this if 2D doesn't work

a

Figure 10.14
A comparison of lists you might make for nonlinear editing (a) and linear editing (b).

number (if you have more than one tape), the scene and take number, and the in and out points in terms of time code. It is also good to include a description of the shot and, of course, any comments that will help you edit efficiently. Figure 10.14 compares the type of list you might want to make for nonlinear editing with the type applicable for linear editing.

Figure 10.14
(continued)

			TYPICAL LIST FOR LINEAR EDITING			
Reel	Scene	Take	In-Point	Out-Point	Description	Comments
2	1	2	00:02:15:12	00:03:05:17	neighborhood	put credits over do silent - add music later
1	2	1	00:07:10:04	00:08:15:28	establishing shot of children	
1	2A	1	00:11:52:20	00:15:19:17	MS of David and Eddie	begin picture before sound
1	2B	3	99:19:29:12	00:19:33:00	CU of David	use as react shot
3	2D	2	00:02:22:14	00:03:15:04	LS of children and Mrs. Oliver	use shot 2F if this doesn't work
1	2C	1	00:14:33:00	00:20:02:15	CU of Eddie	

b

In the professional world, this organization of footage is often completed by an **assistant editor.** This person also usually places (digitizes) the footage into the computer. Assistant editor is an excellent entry-level position, so it behooves you to learn this craft well.

Picture and Dialogue Editing

The picture and dialogue editor (usually referred to simply as the **editor**) is the main person charged with putting together the material shot during production. This person is part technician and part artist. Editors must know how to operate the equipment and they must be firmly versed in the aesthetics of editing. (See Chapter 12.)

The director can overrule any editing decision. Ideally, the director and the editor are of the same mind about the film; otherwise, the editing will be slowed by arguments and misunderstandings. But if there is conflict, the director prevails.

An editor might work alone, perhaps with the director looking over his or her shoulder, or there might be **assistant editors** who, as mentioned above, organize footage and digitize tapes into the system. If the nonlinear system is being used to generate an edit decision list that will be taken to an on-line system, the assistant editor will make sure this list is consistent and understandable. The assistant editor is often the one who gets the final edited product out of the computer onto some other medium, most likely videotape.

More than one editor may work on a particular movie, especially if it has a tight deadline. Different people edit different parts of the movie so that it can be finished more quickly. One person may be called the editor and the others called assistant editors, but they do essentially the same job. The editor will be responsible for making sure the editing style is consistent among all of them. In other configurations, one person does the initial editing on the less expensive off-line editing system, and another completes the final edit on a more expensive on-line editing system.[13]

Produced as group projects, student productions sometimes run into difficulty because only one person is needed for editing. It is easy to find significant jobs for ten students during production and preproduction. They do individual jobs but see and learn from what their classmates do. Editing, however, requires only one or two people. Ten people in an editing suite, all expressing their opinions, can lead to bedlam. Yet if the extra students are kept from the editing suite, they do not learn the ins and outs of editing. One solution, if there is sufficient equipment, is to make several copies of the production footage, break the large group of ten into several subgroups, and allow each subgroup to edit its own version of the project. This gives more people editing experience and can demonstrate that there are many ways to edit a production; in all likelihood, the groups' end products will be quite different.

Sound Building

With old-fashioned film editing, sound work did not start until the picture and dialogue were locked. That is often the case with nonlinear editing simply because it is easier to add sound once you are sure of the picture and dialogue. If a composer writes music for a three-minute scene, and that scene is later cut to two minutes, the composer's work is essentially useless. However, because it is so easy to make changes with nonlinear editing, the "locked" picture and dialogue is sometimes a "**rubber lock.**" In other words, it is more tentative or flexible than it used to be and more subject to change.

Also, because sound is so easy to manipulate within nonlinear systems, the picture and dialogue editor may include rudimentary sound effects and generic music with the picture and dialogue edit, just to give an idea of how the sound will all fit together. These effects may at a later time be replaced with something more authentic, or they may not. The time sequencing of picture and dialogue editing in relation to other sound is shifting as new generations of hardware and software alter what is possible.

In any case, putting together the elements of the final sound track usually involves a number of people. Because some of these tasks are completed independently, most of them can be done by one person, even the person responsible for the picture editing.

Decisions need to be made about what music, sound effects, and ambient sounds are needed and where they must be placed in relationship to the picture. Sound technicians gather and record and edit sound effects and ambient sounds, rerecord and replace poorly recorded dialogue, add synchronous background sounds such as footsteps

and rustling clothes, and mix music. They also do the final mix, during which all sounds are joined together. The people who build sound are called **sound editors,** and the people who mix it are called **sound mixers.**

In large studios or postproduction houses people are specialists. For example, one person will engineer dialogue replacement sessions day after day for however many movies or TV series are being postproduced at that facility, while another gathers, records, and edits sound effects for the same group of films. In smaller facilities or for shorter movies (such as student productions), people have multiple duties.[14]

Incorporating Graphics

Theatrical film titles and credits are usually placed on the movie at the lab through the use of an optical printer. The titles are usually designed by an artist and then filmed. At the lab they are placed over the opening and closing scenes of the movie.

If a project is only going to be shown on television, it can take advantage of the **character generator** capabilities built into most nonlinear editing systems. These allow for fancy titles that can be manipulated in a variety of ways. When these character generators are used, it is the editor who executes the graphics. If the director wants something specialized or stylized for the credits, he or she may hire a graphic artist to undertake the design.

Incorporating Elaborate Special Effects

The nonlinear editing systems can also be used for limited special effects, including some of the effects that used to be undertaken with blue-screen photography and optical printers. However, the dramatic special effects seen in *Titanic, Independence Day,* and many other modern movies need specialized computers that can hold large quantities of video information. Often the effects for these movies are farmed out to a number of boutique effects houses well before the rest of postproduction begins. People at these facilities work long and hard to execute the needed effects, which are then incorporated into the film during postproduction.

For example, these specialized facilities are used for **digital compositing,** the combining of different elements that were shot separately. This technique is what enabled the computer-generated dinosaurs in *Jurassic Park* to be combined seamlessly with live-action footage, complete with digital shadows and texture enhancement. It is also how Tom Hanks was able to meet with President Lyndon Johnson in *Forrest Gump.* In *Batman Returns* a Gotham intersection is flooded with penguins. These penguins were created digitally, as were the bats that floated over another scene. In the film *In the Line of Fire,* an actor's head is composited on George Bush's body in footage of an actual campaign rally, and a real Secret Service agent is replaced by actor Clint Eastwood.

Another technique that is possible because of computer technology is **morphing.** This process, in which one object gradually changes into another, was used to great advantage in *Terminator 2: Judgment Day.* Throughout the film the Terminator constantly changes shapes, morphing from a patch of linoleum floor into a prison guard, growing a sword out of his arm, turning from a policeman into a housewife.

Morphing uses the computer's ability to make subtle changes from frame to frame. For example, a computer can be programmed to change a square into a circle over a period of two seconds. Frame 1 would be a perfect square; in frame 3 the corners of the square might be slightly rounded; by frame 10, the square's sides would start to bulge; by frame 31, the corners would be totally rounded; by frame 45, the edges would be more round than square; and by frame 60, the figure would be a circle. Similarly, one man's face could change into that of another man. Among other things, the eyes might gradually change from blue to hazel to brown. An automobile with the right kind of gasoline might morph into a charging tiger (see Figure 10.15).

Specialized computer systems are often used for major restoration of old films such as *Snow White* and *Ben Hur.* Once an image is in the computer, a technician can remove scratches, dust, and glare and can correct color and dupli-

Figure 10.15

*Three frames from a gasoline commercial that used computer morphing technology.
(Photos of car transformation to tiger, compliments of Exxon Company, U.S.A. ©
Exxon Corporation 1991)*

cate material that was damaged by frame deterioration. This same process is used to repair contemporary footage that was damaged in the camera or that needs some touch-up. One frequent use is the removal of wires such as those used to make basketball players "fly" in *Flubber*. In the movie *Coneheads* the prosthetic heads worn by the actors were color-corrected to match the actors' skin tone. This was possible because the digital domain allows for the correction of just part of the image without affecting all of it. In *So I Married an Ax Murderer* the director darkened the clouds and digitally painted out the sun to make a scene have a proper mood. In *Wrestling Ernest Hemingway* a sequence where Shirley MacLaine and Richard Harris are looking at each other out of windows was salvaged by digitally matching the natural lighting conditions that had changed over several days of shooting. It is also possible to add a shot. A digitally created snowstorm was added to a scene in *Cobb* when the lack of a heavy snowfall could have caused a delay in the shooting. In *My Father, the Hero*, a young girl's skimpy thong-bikini was digitally enlarged to provide more coverage and help the producers avoid an R rating.

More and more computers are being used to create animated films, replacing earlier methods of drawing each cell of the movie separately. Now films such as *The Lion King* and *Ants* rely on digital technology to create backgrounds that can be repeated throughout the frames for an entire scene and characters that move in a lifelike manner. All of these examples illustrate the power of digital systems to manipulate the image by seamlessly integrating layers of image elements.[15] Director James Cameron was right on when he said, "We're going to think in terms of the manipulation of the image—not just

editing, but changing the components of what we've shot and recombining them in different ways, almost like an image mix in the same way that we mix sound."

Preparing the Movie for Distribution

If the movie is to be shown on television, the distribution preparation is fairly easy. Even though the movie was originally shot on film, there is no need to actually edit the original film. The edited tape (the output of the nonlinear editing system or the tape produced by the on-line system) can simply be placed on a VCR (probably one of the digital formats) and broadcast or cablecast. Usually several dubs of the tape are made so that there are protection copies.

For a theatrical film, a cut done on a nonlinear editing system functions only as a workprint, a means of generating a list of editing decisions that are ultimately converted back to film via Keykode and edge numbers. The negative is conformed and prints are made, just as they always have been.

However, the films that use digital effects need to undergo an extra step. These effects, which are created electronically in the computer, must somehow be transferred to film. This is done through one of a number of high-quality digital film systems. The key to this new technology was developing a film scanner that could digitize film at full resolution, software that could manipulate that material, and a recorder that could copy that information back to film at full film quality (see Figure 10.16). For example, operating at only a quarter of its resolution capability, Kodak's *Cineon* film scanner (see Figure 10.17) and recorder can digitize and record

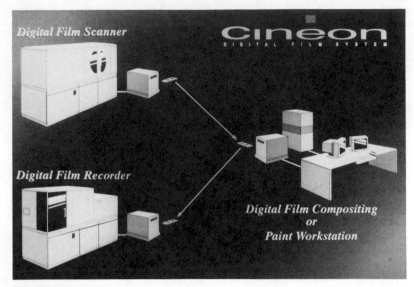

Figure 10.16

This Cineon Digital Film System *developed by Kodak includes a scanner that uses CCDs to digitize each film frame into approximately 3,000 lines of 4,000 pixels each, a high-resolution video workstation with which digital special effects can be manipulated, and a film recorder that uses red, blue, and green laser beams to place the images created in the workstation back onto film. (Photo courtesy of Eastman Kodak Company)*

Figure 10.17

The Cineon Digital Film Scanner. (Photo courtesy of Eastman Kodak Company)

material that exceeds the standards for broadcast television. At half resolution the image quality exceeds the standards for **high-definition television.** At full resolution the system equals film resolution. In other words, a system of this kind enables filmmakers to take advantage of all the various image enhancements and visual effects available in the digital domain and then record them back to film with no loss of image quality. These effects can then be incorporated in the release print prepared by the lab.[16]

Notes

1. Quoted in *Cineon: The Sea of Truth* (Rochester, New York: Eastman Kodak Company, 1992), videotape.
2. "Welcome to the Digital Backlot," *Daily Variety,* 22 March 1996, p. A14.
3. Debra Kaufman, "*Cutthroat Island:* A New Adventure in On-Set Editing," *American Cinematographer,* September 1995, pp. 24–28.
4. At the professional level, editors usually sent the synced dailies back to the lab. A coding machine printed a sequential series of numbers on the edge of both the picture and the sound, making it easier for the editor to maintain or reestablish sync throughout the editing process.
5. Sometimes the same numbers are put on the sound and the picture to keep them in sync after the slate is removed.
6. Other colors in the spectrum, green in particular, can also be used to create a *blue-screen* effect. In television the process is far easier to execute. It is called chroma key or Ultimatte (based on the name of a manufacturer).
7. For more on film editing, see Bruce Mamer, *Film Production Technique: Creating the Accomplished Image* (Belmont, CA: Wadsworth, 1995); Jerry Bloedow, *Filmmaking Foundations* (Boston: Focal Press, 1991); Norman Hollyn, *The Film Editing Room Handbook* (Los Angeles: Lone Eagle, 1990); John Burder, *The Technique of Editing 16mm Films* (Stoneham, MA: Focal Press, 1988); and Thomas A. Ohanian and Michael E. Phillips, *Digital Filmmaking: The Changing Art and Craft of Making Motion Pictures* (Woburn, MA: Focal Press, 1996).
8. Gorham Kindrem and Robert B. Musburger, *Introduction to Media Production: From Analog to Digital* (Woburn, MA: Focal Press, 1997).
9. Gary H. Anderson, *Video Editing and Post Production: A Professional Guide* (Woburn, MA: Focal Press, 1998).
10. Interview with Kathy O'Connell, postproduction supervisor for *Law and Order,* 14 January 1999.
11. Frequently one of these systems is used to scan and digitize the film directly to removable hard drives that can then be used immediately in a nonlinear, random-access digital editing system.

12. Don Ver Ploeg, "New Tools from Kodak Aid Postproduction," *In Camera,* Summer 1995, p. 12; "Keykode Number Emmy Earned Through a Collaborative Effect," *Eastman Images,* Fall 1994, p. 7; and "Keykode Establishing Film-Video Link in Post," *Post,* October 1991, pp. 34–36.

13. Steven E. Browne, *Nonlinear Editing Basics* (Woburn, MA: Focal Press, 1998).

14. Ken Hahn, "The Audio Mixer's Effect on Post," *TV Technology,* March 1991, p. 47; and Jeremy Hoenack, "Improving the Sound Track," *American Cinemeditor,* Summer 1991, p. 32.

15. Ron Magid, "Bit Factory," *Hollywood Reporter,* 1 March 1999, p. C-3; D.R. Martin and Susan Wichmann, "The Digital Toolbox," *The Big Frame,* Fall 1994, p. 29; "Morph Mania," *Videography,"* December 1991, pp. 103–106; Bob Fisher, "Digital Snowstorm Makes Hollywood Dream Come True," *On Production and Post-Production,* October 1993, pp. 41–43; and Christine Bunish, "Wire Removal Usage Grows," *On Production and Post-Production,* November 1994, pp. 50–55.

16. "Cineon's International Success Is No Illusion," *In Camera,* Autumn 1995, p. 17.

chapter eleven
Picture and Dialogue Editing

T̲he most basic step of postproduction involves putting the picture and dialogue in proper order. However, the kind of equipment available determines how you do this. As we have already discussed, technical advances in electronic editing are ongoing. Editing systems are available in every conceivable configuration and price range, and new editing systems seem to appear almost monthly. Not only is the equipment constantly evolving, but the terms and concepts used to describe picture and dialogue editing techniques become obsolete or shift in meaning as new equipment, new formats, and new ways of editing are introduced.

Any editing system, however, from the most simple to the most advanced, can help you learn the vital role editing plays in effective storytelling. Today virtually everything, from feature films to wedding videos, from dramatic television series to commercials, is edited with a computer-based **nonlinear** editing system. It is still possible, of course, to physically edit film (splicing individual shots together) or to edit video by copying from one tape to another (linear editing). But editing film or videotape with a nonlinear editing system has become the standard way to edit picture and dialogue.

Nonlinear Editing

The common denominator in all nonlinear systems is a computer and editing software. The possible permutations of computer hardware and software are enormous.

On one hand, every nonlinear editing system is different, each employing its own unique mixture of hardware for capturing, copying, converting, manipulating, and storing film or video material in the ones and zeros of the **digital** domain. Software differs too but primarily in the terminology different manufacturers use to describe what are essentially similar functions or processes. For example, the image resolution available on one brand of editing system might be described by a proprietary ranking such as AVR 27 (a lower number would indicate lower quality, a higher number better quality). Another manufacturer might describe its highest image resolution in terms of kilobytes (kB) per frame (300 kB per frame is high quality; 10 kB per frame is a space-saving, low-quality draft mode). Yet another might describe the number of horizontal and vertical **pixels** in its video frames (e.g., 720 by 480). The cost of nonlinear editing systems ranges from several hundred dollars for the simplest software-only, consumer-oriented system to over six figures for the type of nonlinear editing system used to edit feature films and network television shows. Generally, the faster the system is, the more storage it has, and the higher the quality of image it can maintain throughout the editing process, the more you will pay for it.

On the other hand, most nonlinear editing manufacturers have gone down a surprisingly similar path in their software development. At times the editing software from one manufacturer might seem like the word-processing program WordPerfect while its competitor's might be something like Microsoft Word. There are different keystrokes and mouse clicks to do essentially the same kind of things. On the whole there are more similarities than differences. Individual shots are stored in a **folder, bin,** or **library** and dragged, clicked, or keystroked from that organizing repository to the place the editor chooses on the **timeline.** Thus, if you know the equivalent of WordPerfect, you are already at least part of the way to learning the equivalent of Word. You're going to have to learn some new keystrokes, menus, and mouse clicks, but the general principles are roughly the same.

To provide an overview, we will discuss a totally imaginary nonlinear editing system called Vanilla. This generalized editing system is not the very top-of-the-line, but its educational

Figure 11.1
The Avid Media Composer™, a Macintosh-based, nonlinear, random-access editing system. (Photo courtesy of Avid Technology, Inc.)

pricing policy has made it popular at colleges and universities.

Hardware

Digital video editing demands both a fast computer processor and lots of storage. Initially the Apple Macintosh was the dominant editing platform, but increasingly manufacturers are providing editing systems for both the Mac and Windows platforms (see Figure 11.1). Nonlinear editing forces large amounts of video and audio data in and out and within the computer. The speed and efficiency with which this can be done is what tends to set various systems apart. All of this can add up to an expensive list of computer hardware.

Let's assume our Vanilla is running a 400-Mhz (megahertz) processor chip. We could have two processors (or four) if we really need to soup up the Vanilla's performance for some extra high-speed work in graphics, but because of budget limitations, we will go with one processor. We also have two speedy video display cards, each with an extra 8 megabytes of **RAM (random-access memory)** to improve their performance and to help drive two 19-inch monitors. Two monitors are helpful when trying to view the many windows and graphical displays used in nonlinear editing. In addition, we have a high-

quality NTSC video monitor to help us see what the material will look like as video.

The computer itself is loaded with 256 megabytes of system RAM and a number of hard drives. One is a very fast 9-gigabyte ultrawide **SCSI-2 (small computer system interface)** hard drive for the system; this is the drive where the programs and operating system are stored. Another 9-gigabyte internal SCSI-2 drive is for the audio and yet another 9-gigabyte internal SCSI-2 hard drive is for graphics and some effects (such as transitions or freeze frames). We also have a 36-gigabyte external disk array set up in a **RAID (redundant array of independent disks)** configuration for our video storage. This array employs two very fast 16-gigabyte fast ultrawide SCSI-2 hard drives with the data split between them as if they were a single hard drive, enabling a very high rate of sustained input and output. All of these drives are **AV-certified,** meaning that they are capable of moving the massive amounts of digital video and audio information required for nonlinear editing at a high continuous rate for relatively long periods of time.

The keystone of our Vanilla is its **video capture card** (also known as the **digitizing board**). The performance of this component defines our particular model in terms of the best image quality it can produce, whether S-VHS, Hi-8, Betacam SP, or Digital Betacam. The closer to

real time our board can turn the analog audio/ video material coming from the attached video deck into digital data, the better it is. Like many electronic components, our Vanilla can never perform better than its weakest link, be that the hard drive, digitizing board, or computer speed.

In addition to a mouse, keyboard, floppy drive, and CD-ROM, we have purchased the jog/shuttle dial option to provide a more tactile means of scanning our footage or controlling our edit decks. One of those video decks we use for **I/O (input/output)** into our system is Hi-8; the other is a DVCAM digital deck. Both are machine controllable. The Vanilla comes equipped with a junction box (an I/O patch bay) that provides a number of different video and audio inputs and outputs (**firewire, S-connector, XLR, RCA**). The sound quality of our Vanilla is outstanding. We can input and output stereo sound the quality of a CD or a DAT. The final component in our Vanilla system is a pair of high-quality computer speakers. If all else fails, we can listen to CDs![1]

Software

The software of our Vanilla nonlinear editing system is very powerful, especially compared to the linear editing systems that preceded it. The software provides an area where footage is stored, often referred to as a bin, an area that contains little monitors so that the footage can be viewed, and a timeline that, in addition to allowing us to edit picture and dialogue, enables us to mix and play back eight separate audio tracks complete with equalization and effects. Through menus, we can access a large number of audio and video transitions and special digital effects. We can apply filters that will flip a shot on its horizontal axis to preserve continuity or mimic the haze of a crowded city. Even the built-in character generator in our system offers a variety of sophisticated titling options, including motion path controls for graphics and titles, and a title track for keying our titles over video. We can view all of this on windows incorporated within the computer monitor or on TV monitor screens (see Figure 11.2).

Our software also provides a variety of tools for organizing, logging, and undertaking data-

base management. It enables us to give our particular project a name so that its files do not get mixed up with files of other projects that may be on the computer, and it allows us to direct our material to the appropriate bin. Each video, audio, or graphic element or titling sequence is identified and cataloged in various modes. The software allows for logging information to be added as each clip is being put into the computer.

Clip databases are viewed in windows. Spreadsheet-style clip lists contain such basic data as the clip title, reel name and number, a free-form shot description, image/sound quality information, and **time code** in and out points. We can also capture a selectable and sizable head and/or tail frame, sometimes called a **picon** (picture icon), to identify each clip. The various databases can be searched, sorted, grouped, and organized in any number of ways.

Before we can begin editing, we need to set a number of parameters related to the software. It is imperative that we develop logical filing and naming conventions for all the elements in our project right from the beginning. We need a clear, logical system to define our video/audio storage bins, and we need to tell the system the locations on our drives where we plan to store various materials. It is important to note that some nonlinear editing systems require the audio to be stored on separate drives from the video. As part of the software organization process, we need to arrange our **desktop** so that everything that is important to our editing project is easily accessible.

Undoubtedly we will need to establish a number of preferences in the software. For example, we need to set up the quality of the audio and video *before* we begin. We need to decide if we are going to make our editing decisions at low resolution to save disk space and then do the editing at the higher resolution for our master.

This kind of decision making demands an understanding of the specific requirements and peculiarities of our nonlinear system. Read the instruction manual carefully and don't be afraid to make liberal use of the information contained in the Help menu. How do you set the time for the pre-roll your tape deck requires? What quality do you require for your audio? You might even have to tell the system whether you are going to make your edits on the first

Figure 11.2

This is the main screen of our Vanilla system. Note the menu bar at the top, the bin where the clips are stored, the monitor where we can view material, and the timeline where we will undertake editing.

field or the second field of the video frame and know what that means.[2]

The possible configurations of nonlinear editing systems are seemingly endless. Still, at a very basic level, nonlinear editing involves a number of common steps that include digitizing and importing, editing, adding graphics and effects, and outputting.

Digitizing and Importing

The sound and images recorded during production must be loaded into the computer for editing. If the material was shot on an **analog** videotape (or film transferred to analog videotape), it must undergo an analog to digital conversion. This is done with a digital capture card or cards (and accompanying software) and is what enables the digitized audio and video to be stored on the computer's hard drives for editing.[3]

Compression hardware (and software) is vital to preserving space on the hard drive, and it is also an important variable in overall image quality. There are many different **codecs** (codec is an abbreviation for compression/decompression) available for the compression process. The one you choose depends on what you need to compress (still images, moving video, audio, and so on) and the final destination of the material (Internet, videotape, and so on). Our Vanilla system used M-JPEG.[4] We can choose the degree of compression we want. A high compression ratio (e.g., 100:1) will give us a lower quality picture than a low ratio such as 2:1. Although we can choose to vary some parameters, a high

compression ratio will generally mean we have to work with an image of poor resolution. The advantage of a high compression ratio is that you can get more footage on your hard drive because it uses less room.[5]

Compression leaves out some of the frame information. For example, one form of compression called **spatial compression** looks for repetition among pixels.[6] It says, "All pixels in this sky area are light blue." And then it does not record information about each pixel. To some degree, the picture loses sharpness and definition because, in reality, some of the pixels are slightly different shades of light blue than others. With some compression, called **lossless**, all information from the original clip is preserved so that when the material is decompressed, it is back to its original quality. You are limited as to how much you can compress, however. With **lossy** compression, some of the quality does not come back. For example, if the sky actually contained eighty shades of light blue, the lossy system might only restore sixty-five of those shades.

If the movie is shot digitally, it can enter the computer through a firewire connection, but it usually still needs to go through a codec so that it meets the parameters of the particular nonlinear editing system.[7]

If you did the kind of organizing discussed in Chapter 10, importing the footage will be much easier. It takes time to bring audio or video material into a nonlinear system and each shot or sound element consumes a large chunk of precious drive space. It is efficient and costly to digitize footage you know that you are unlikely to use. A good **paper cut**—a list of the shots you might want, rough time code in and out points, places where graphics or titles might be needed—will save you time and frustration later. You should not, however, digitize only the exact frames you think you will need. Give yourself at least several seconds before and after the material you think you are going to use so that you will have options concerning where you actually start and stop your edit.

Before you begin digitizing, adjust your incoming footage so that it will be consistent. The best way to do this is to use the digital **waveform monitor**, **vectorscope**, and **VU meter** pro-

vided with the digitizing part of the software. These are not actual pieces of equipment but rather representations that appear on the computer screen. The waveform monitor allows you to adjust the brightness of the various clips you are importing so they are not too bright or dark. The vectorscope allows you to make color modifications (see Chapter 6), and the VU meter can help to ensure that all audio is brought in at the same relative volume (see Chapter 8).

Once we start the importing process, our Vanilla system allows us to preview each shot in an on-screen window. We can mark inpoints and outpoints, and either digitize a shot immediately or create a list of inpoints and outpoints for each shot so that we can import all the shots later. These points are given in terms of time code and are referred to as a **batch list.** In a shared environment, a batch list is an excellent way to protect your work. This small text file listing the time code numbers where each shot begins and ends can easily be stored on a floppy disk. Once saved, it can be used to redigitize material at a different resolution or to replace data that has inadvertently been erased or damaged. As we digitize the material, we give each shot a name and send it to a bin so that we can access it for editing.

One aspect of time code that you need to be careful of is the difference between **drop-frame time code** and **non-drop-frame time code.** Because of various technical difficulties when color video was developed in the late 1950s, the frame rate was slowed fractionally by one-tenth of 1 percent in order to produce color that was compatible with black and white receivers. This causes problems when using time code. The actual frame rate for material recorded and played back in color is 29.97 frames, or 59.94 fields, per second. This is 0.003 frames per second slower than the 30-frame black and white system. When time code is used to time a tape, this results in a discrepancy between the time code numbers and the actual running time. The actual clock time and the time code display do not agree. A one-hour program measured by the time code frame count actually runs 3.6 seconds (or 108 video frames) longer than an hour. To correct for this accumulating timing error, the TV industry developed drop-frame time code, a

Figure 11.3

A timeline as it might look during the editing process.

system that corrects the time code frame counter by systematically dropping (actually not counting) just enough frames to match the clock time and the time code address numbers. Thus, the old type of continuous time code (without any kind of counting adjustment) is called non-drop-frame time code. Most nonlinear editing systems can accommodate both types of time code. You must select the proper time code setting on your system so that it matches the footage you are importing or you will have exasperating timing problems as you edit.

Editing

After the material has been digitized, we can begin the editing process. In our Vanilla system, we can drag clips from the bin onto a timeline (see Figure 11.3). A representation of each frame shows up on the timeline and the clip, if it is 30 seconds long, occupies 30 seconds of timeline space. We can expand or contract the timeline so we see more or less of our program on the screen at one time.

Our timeline has two video tracks. We only need one if we are planning to do simple cuts from one shot to another. We simply drag the clips to the first video track of the timeline and shorten them to the length we want. In order to view a clip, we click on it and it shows on a source monitor window. This monitor window has the same controls as a videotape recorder—fast forward, rewind, pause, stop, and so on. We can actually edit a number of ways on our Vanilla system. We can shorten or lengthen shots by dragging the ends; we can bring the two shots together in a trim window and **trim** frames from

either end of either shot; or we can engage a tool in the shape of a razor blade and, using the mouse, place this tool where we want to begin and where we want to end (the inpoint and outpoint of the edit). As we shave each clip, we want all the other clips to move up so that they butt up against each other on the timeline. This is called a **ripple**—all clips ripple when one is lengthened or shortened. Our program allows us to choose whether we want to ripple or not. If we are planning to insert new material where we take out material, we would not want to ripple.

If we want to restore some of the frames we have cut off, we can do so easily because they are not gone from the computer; we can extend the clip and bring them back. Nonlinear editing is often referred to as **nondestructive** because frames that have been discarded have not been destroyed. If we want to **trim** a few more frames from an edit we have already finished, we simply put the razor blade tool back into action. If we want to interchange the second and fifth clips, we simply click and drag them into their new positions. We can copy a frame over and over to create a still image or we can copy a sequence and use it over and over throughout the movie. We can delete individual frames to create fast motion or repeat frames to give a slow-motion effect. We can **fade** our title in or out by adjusting its **opacity**, the extent to which the footage is opaque (not transparent). For this the software provides **handles** and **rubber bands.** We click on the handle and then stretch the rubber band down to where we want to begin or end the fade (see Figure 11.4).

If we don't like the last three edits we undertook, we can click on "**undo**" three times and

Figure 11.4

On our Vanilla system, when we expand (engage the "E" button) on the graphics track, we get an extra track for opacity that we can use to fade in and out. If we were to expand Audio 1 and Audio 2, we would get similar tracks for handles and rubber bands so that we could fade out the stereo music as the picture fades.

Figure 11.5

Some of the transitions available on our Vanilla system.

be back where we were before completing those edits. Of course, we want to save our work often because computers do hang up. Anytime we want, we can play our work on one of the monitors to see if we are satisfied with what we are doing.

If we want dissolves, wipes, or other transitions, we need to use two video tracks so that the video clips can overlap each other. Often these tracks are called video A and video B; we are doing an **A-B roll** in the same manner as with film editing. A separate area on the timeline lets us indicate what transitions we are using. We have a variety of transitions that we can access by clicking on the menu called transitions. And we can vary parameters of the transitions, such as the speed with which they occur (see Figure 11.5). Once we choose one (perhaps

a page turn), we can preview it to make sure it fits our needs. Previewing transitions on our Vanilla system can take a while because they must be **rendered**—built so that they can play back in real time. If we want a rough, but quick, approximation of the transition, we can **scrub** by dragging the mouse over the part of the timeline with the transition. This will demonstrate the transition but in a rather jerky fashion.

If our clip has dialogue, the sound will be automatically positioned on the first audio track in sync with the picture. Dialogue that is in stereo will use two tracks. If we want, we can unlock picture and sound and move the sound so that it is no longer in sync. We can also add many other sound elements (see Chapter 13).

Anytime we want, we can lock parts of our timeline so they do not get accidentally changed as we are working on other parts of the movie. We can also hide tracks we are not using so they don't get in our way. These are but a sampling of the functions of our Vanilla system. Its 300+-page operators' manual explains many other features.[8]

Adding Graphics and Effects

With nonlinear editing, you can add graphics and effects after you have finished placing the shots in order, or you can add these elements as you go along. Traditionally, these elements were added to a movie after the principal photography and dialogue were edited because it wasn't possible to bring in these elements while undertaking workprint-based film editing. Many edi-

tors still follow that pattern even though non-linear technology offers options. Graphics include the lettering used for opening and closing credits and still images such as charts or logos. Effects include various ways that the picture is altered through such software applications as filters and motion control.

Our Vanilla, like most systems, has a built-in **character generator** that can be used to create titles and other text materials. We can use a pull-down menu to access a special screen on which we can build titles. We can choose to place them over the video or over one of many possible background colors. We can also choose the **font** we want for the letters, as well as the size and color of the letters. In fact, we can shade either background colors or letters, perhaps having a light blue top change gradually into a dark blue bottom. We can add black or colored shadows around the letters so they are easy to read, regardless of the background. We can underline, bold-face, italicize, and change the spacing between lines and between letters. What's more, once we have done all these things, we can change them easily—in much the same way that one can change italics to underlining in a word processing program. The undo feature works just as it does for the rest of nonlinear editing. If we want to, we can save the parameters from one title and use them for other titles. For example, we could design a background that includes a rainbow of colors that gradually merge into each other and we could specify that the lettering be white Arial font outlined with black. Each title we make will then automatically employ that background and that particular style of lettering.

Our Vanilla system also allows us to build some graphics. It has built-in forms for us to use—triangles, squares, rectangles—that we can alter (round the edges, make larger or smaller, duplicate on various parts of the screen) in order to build logos and charts. We can also capture one frame of video and manipulate it to form a graphic. For example, we could take a frame from our footage that has a red car in the middle, isolate the car and make it smaller, and then place the small image at the corner of each closing credit. Or we can sample the color of red and match that color for the lettering of each graphic.

Once we have built the titles and graphics, we can bring them into the timeline just as we would bring in any video or audio segment. We can determine how the titles and graphics will appear in the finished product. We can select to have them roll up the screen, crawl across the bottom of the screen, dissolve in and out, zoom in, flash off and on, rotate off, or any other of a wide variety of effects. We can even set a motion path by using **keyframes.** These are the timing points of the titles (or other graphics) that we choose to place at a certain place or time. For example, we might want the title to start low in the middle of the frame and then move to the middle by way of the right-hand side. We would set keyframes at the bottom, right-hand side, and middle, and the computer would fill in the rest, giving the graphic a swirling pattern as it moved into place. We can preview all these effects in conjunction with the video and change them as needed, perhaps slowing down the movement from the bottom to the right side and speeding up the movement from the right side to the center (see Figure 11.6). If we want a title or graphic to appear over footage, we need to be able to **key** it. For keying, whatever is in the background when the graphic is created must disappear so the video footage can show through. Usually special colors are part of the background and these colors can be keyed out. This is the principle behind the **blue-screening** done with film; the blue drops out and another background is put in its place. Our Vanilla system uses what is called an **Alpha Matte.** It is a special white (or black) that can be keyed out when placed over video. It works because the key function finds the pixels in the image that match the Alpha Matte and makes them transparent. As with the video frames themselves, we can vary the opacity of the graphics so they fade in and out. When we key graphics, we place them on a separate video track so they can be mixed with the other video.

Our Vanilla system also includes **filters** to change the look of the graphics or the video footage. One filter blurs the image (or part of it) while another creates a ghost effect. Other filters distort the image in a variety of ways. If the camera operator forgot to place an orange

Figure 11.6

An example of what can be created using graphics software. (Photo courtesy of Chyron)

85 filter on the camera when shooting outdoors, we can use the nonlinear software to add that filter effect. An editor can use filters to do the job once undertaken by the film **timer,** that of correcting color differences within various scenes of a movie. However, a timer working in a film lab must apply the timing settings to an entire frame; with nonlinear software an editor can color correct a small portion of a frame because the information is in digital form and each pixel can be manipulated separately. It is possible to use several filters at the same time and to spread a filter effect over one clip, multiple clips, or a portion of a clip.

There are many other special effects that our Vanilla software cannot undertake because they would be over our budget or beyond the technical limits of our system. However, they can be accomplished through special programs and then, in some cases, imported into our Vanilla nonlinear editing system. For example, a filter program from Cinelook can make video images look like various film stock images so that material shot on video can be mixed into a movie that was mainly shot on film (see Figure 11.7).

If we want three-dimensional graphics, we can build them with a separate program. With the 3-D software we build a wire frame the size and shape of the graphic we want—perhaps a box wrapped in Christmas paper. We select the color and texture we want for the wrapping paper, add some stars, and then turn the box around so that we can see all six sides. This takes a great deal of rendering time, but once it is complete, we can bring it in to Vanilla. In a similar way, we can import graphics that were created from photographs or drawings that were scanned into the separate graphics software program.[9]

Outputting

When your work is in a nonlinear editing system, it is not really there as an actual movie. The timeline is merely a list of editing decisions that you can keep changing until you are satisfied with your work (or run out of time). Although you can watch the whole thing on the computer monitor, you cannot show it in any other form until you **print to tape** (or CD-ROM or the Internet).

Getting the material out of your computer is somewhat the reverse of getting it in. You must again run it through a codec, this time decompressing it. You must make sure you have all the settings right so that both picture and sound are at the quality you desire. Do you want VHS quality, D-1 quality, Betacam quality? Do you want stereo sound? Do you want interlaced scanning or do you want progressive scanning for HDTV? Do you want to export just one project or several projects all at once?

Before you actually export your movie, you should build a **leader** to go at the beginning of it. A leader provides technical and identifying information and also prevents the placing of program material at the head of the tape where it is most likely to be subject to damage. The standard leader for the beginning of a program consists of **color bars, tone,** a **slate,** and a **countdown.** As part of a premade leader, our Vanilla system has color bars and tone, so we simply need to select the amount of time we want these to run (one minute is usually a good length). Color bars and tone are important when someone is playing the tape back on some other system. An engineer can use the vectorscope and bars to make appropriate adjustments in color so that the colors recorded are the colors that are played back. He or she also makes sure the tone

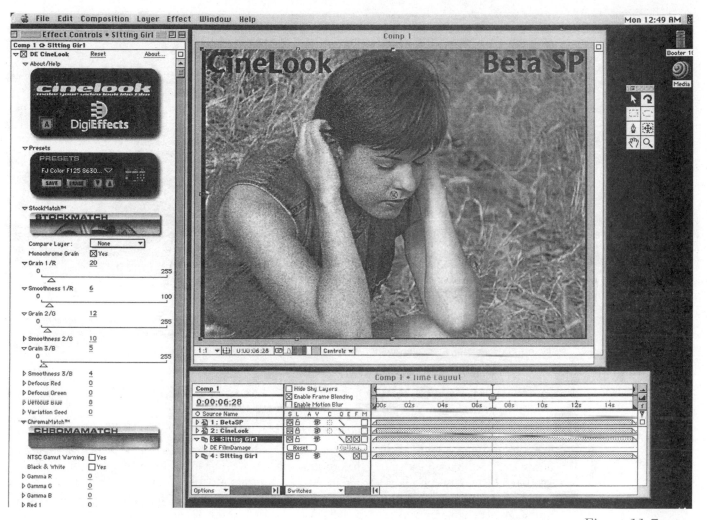

Figure 11.7

A screen from the Cinelook software that is used to make video footage look like film footage. (Photo courtesy of DigiEffects)

is at 100 percent so the audio will play back as it was recorded.

The slate identifies the program and usually contains such information as the program title, the director's name, the date the program was edited, and the program's length. Our Vanilla system has a built-in template for a slate, but if a system does not have this, it is fairly easy to create a slate using the graphics portion of the software. Someone playing back the tape uses this information to make sure the right program is, indeed, being shown.

The countdown gives the number of seconds before the program material will appear. Countdown numbers usually go from 10 to a single frame of 2, followed by black. Countdowns stop at the number 2 so that two seconds of black can play before the program's image appears. Again, Vanilla has a countdown, but a countdown could be created with graphics. The countdown

allows the person playing back the tape to place it on the air at the right time.

Once you have everything ready, you give your system the command to print. Depending on the software and how you have edited, the system may have to spend a good bit of time rendering before it can actually output the material. It is easy to exceed the capabilities of your computer when you try to output—a source of frustration that often leads editors to export their projects in segments rather than as a whole.

In addition to outputting your project, you should be sure to save your batch list to a floppy disk so that you have a copy of your edit decision list (see Figure 11.8). This is absolutely required if the nonlinear system is being used off-line and the final assembly will take place in an on-line editing suite. However, it is a handy thing to have regardless, just in case you want to redo something at some future time.[10]

EDIT DECISION LIST

Edit Number	Reel Number	Edit Mode	Tran- sition	Dura- tion	Play In	Play Out	Record In	Record Out
001	5	B	F	0:15	00:09:01:20	00:10:03:29	00:00:00:00	00:01:02:09
002	3	V	C	0:00	00:14:15:15	00:14:20:18	00:01:02:09	00:01:07:12
003	3	B	C	0:00	00:15:10:21	00:15:21:23	00:01:07:12	00:01:18:14
004	6	A	C	0:00	00:23:07:02	00:23:10:05	00:01:08:10	00:01:11:12
005	4	B	D	0:30	00:12:07:01	00:13:22:16	00:01:10:18	00:02:14:15
006	3	B	C	0:00	00:20:14:10	00:21:14:09	00:02:14:15	00:03:14:14
007	2	B	C	0:00	00:05:30:12	00:06:33:16	00:03:14:14	00:04:17:18

Figure 11.8

A typical edit decision list. Reading from left to right, the EDL shows the number of each edit, the tape that contains the shot, the edit mode (Video, Audio, or Both), the type of transition (Cut, Dissolve, Wipe, Key, Fade), the duration of the transition, and the time code address, in and out, for playback and recording.

A Nonlinear Example

In order to provide an overview of professional editing, we have included a current example of off-line editing using a nonlinear editing system. The flow chart (see Figure 11.9) shows the postproduction stages for an episodic television series—"Chicago Hope."[11] This is only one example, and in the rapidly changing field of postproduction there are, and will be, many others.

"Chicago Hope" is shot on 35mm film and the sound is recorded on a reel-to-reel Nagra audio tape recorder with SMPTE timecode. The show, however, is distributed on videotape for broadcast. Once the film has been transferred to video for editing, it is, in effect, treated like videotape throughout the rest of the editing process. As a result, much of this model is also applicable to television shows shot originally on tape.

Transferring Picture and Sound

After the original 35mm film negative has been shot and processed, it is transferred to video with a telecine.[12] At the time of the transfer, the audio is synced with the image. A video master is produced in the Digital Betacam format and set aside for future use. At this stage, the Digital Betacam master is not color corrected. Simultaneously, ¾-inch U-Matic SP cassettes are made with the telecine for use in an Avid nonlinear editing system.

Off-Line Editing

The off-line editor digitizes the ¾-inch cassettes into the nonlinear editing system and begins editing the picture and principal dialogue tracks. The lower image quality of the ¾-inch format is perfectly adequate for making off-line editing decisions. In addition, the lower resolution of the ¾-inch format conserves hard disk space and makes it easier (and faster) for the nonlinear system to render transitions.

When the editor has finally completed a cut of the picture and principal dialogue tracks, the show is turned over to the director for approval. If the show is on schedule (and things are not backed up), the director has four days to make changes. After the editor has incorporated the director's changes into the nonlinear editing system, the show is turned over to the producer for approval. If the show is still on schedule, the producer may have as long as two weeks to look at the cut and make new suggestions. Again, the editor makes any changes the producer wants back in the nonlinear editing system.

Lock Down and Final Cut Assembly

Once all of the editing changes have been made and approval secured, the picture is locked. The editing of the picture and principal dialogue tracks is finished and no further changes (except in unusual circumstances) will be made.

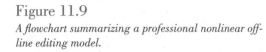

Figure 11.9
A flowchart summarizing a professional nonlinear off-line editing model.

Only at this point does the editor generate an edit decision list. A ¾-inch reference copy is printed out of the computer as a means of back-checking the EDL, but it is seldom used. The EDL is copied out to floppy disk.

With the EDL in hand, the entire show moves to an on-line editing suite. There a final cut is assembled using the raw original Digital Betacam master tapes that were produced with the telecine. There is almost no generation loss when making copies in a digital tape format. The copying process is virtually "transparent" for many, many generations. When the on-line cut is finally assembled, ¾-inch copies are struck from it and distributed to the various sound areas. Then while the sound tracks are being built, a color-corrected version of the final cut is produced from the final cut, again in the Digital Betacam format. Finally, that color-corrected version of the tape is used to produce another version of the tape with the titles added.[13]

Sound Building

While the color correction and titling for "Chicago Hope" are taking place, the sound editing begins. Sound is collected, recorded, rerecorded, and edited using a variety of equipment and audio formats. (See Chapter 13 for a complete discussion of the sound building process.) The ¾-inch copies of the locked picture are used as a visual reference as the various sound elements (dialogue, music, and sound effects) are being constructed.

After all the sound editing has taken place, all of the different sound elements are brought together for a **sound mix**. In the sound mixing facility the image is projected with a video projector, and the various sound tracks (music, effects, and so on) are routed into a sound mixing board. All the audio and video equipment is locked together with time code to maintain synchronization. The mixing session involves adjusting and equalizing the sound levels of all the individual sound elements in relation to the picture and to each other. The final result of the sound mix is three tracks of clean, balanced, equalized sound, one each for the dialogue, music, and sound effects.

Layback

The final step in our "Chicago Hope" example is the **layback,** the placing of the final mixed audio on the master videotape. At this point, you will remember, the video master has been color-corrected and titles have been added. The Digital Betacam tape format has four discrete audio tracks. Tracks 1 and 2 are used for a stereo mix containing all the program's sound elements. Tracks 3 and 4 are used primarily as a backup. Track 3 contains the dialogue only; Track 4, all the music and sound effects. Keeping the dialogue separate from the other sound elements makes it easier to fix the sound if some problem arises. And if the tape is used in a foreign country, a dubbed version of the dialogue can be recorded and then mixed with the music and sound effects on Track 4.

Once the picture and sound have been married, the completed master tape is ready for duplication and distribution. "Chicago Hope" is distributed on Digital Betacam tapes and a copy in the digital D-2 format is made for archival purposes.

It is important to remember that the flowchart in Figure 11.9 presents only one model of nonlinear, random access editing. There are many ways to execute postproduction. This model seems to have evolved from a film editing model: the film and principal dialogue tracks are cut first, and once they are locked, other postproduction activities can begin. In the digital age new possibilities abound. A telecine can transfer material directly to hard drives for immediate use in a nonlinear editing system. And once images and sound are converted into digital form, they can be stored in a central location and accessed from a network of digital editing systems. The step-by-step progression shown in the flowchart is likely to look far different in the future. For example, "Chicago Hope" is now experimenting with HDTV production. What impact this has on the flowchart remains to be seen.

Cuts-Only Linear Editing

Nonlinear editing is still fairly new. For several decades, the only way to edit tape was to lay down video, one element after another, in a linear fashion. Linear systems do exist, and although they are rarely used in conjunction with professionally produced movies, they still have a place in the world of student films. Some systems are cuts-only and some allow for effects, graphics, and various forms of image enhancement.[14]

A **cuts-only** linear editing system can butt one video image and its dialogue against another; it cannot be used to show two pictures at a time. In other words, a cuts-only system cannot execute a **dissolve** because doing so would involve overlapping two shots for a brief period of time. By the same token, it cannot be used for **wipes** and other special effects. A cuts-only system is the simplest, most basic editing system. The two primary methods of editing used with cuts-only systems are control track editing and time code editing.

Control Track Editing

Control track editing, as its name implies, involves using the video **control track.** This track, which has much the same function as **sprocket holes** in film, is present on all recorded videotapes. It helps to maintain picture steadiness, in part because it contains an electronic pulse for each frame. An **edit controller** that can count those pulses is connected between two VCRs. An operator uses the controller to mark the **inpoints** and **outpoints** on the tape. Then the controller backs up both machines an equal amount (usually five seconds) so that they can get up to speed, starts them forward with the frames running in sync, counts control pulses to the inpoints, and then starts the edit. This type of video editing involves rerecording each shot from the original tape onto another tape. In effect, the inpoint is simply a command to begin recording, and the outpoint is a command to stop recording.

The main drawback of control track editing is that the pulses are not numbered on the tape. There is no way to keep track of edit points so that they can be planned at one session and executed at another. And sometimes edits are not accurate because the tape stretches or edit

Figure 11.10
SMPTE time code displayed on a monitor. From left to right are hours, minutes, seconds, and frames. (Photo courtesy of Gray Engineering Laboratories)

points slip in the VCR after they have been marked on the tape counter.

Time Code Editing

The solution to these problems is SMPTE time code. Because it identifies each frame with a specific number that always stays with that frame (see Figure 11.10), it is similar to film **edge numbers.** The use of time code for linear editing requires a **time code generator** that writes the code on the tape, a **time code reader** that decodes it from the tape, and an edit controller that can read time code. This, of course, makes time code editing more expensive than control track editing, which uses pulses that are already part of any videotape recording.

One of the aspects of time code that is particularly important for linear editing involves where the time code is recorded. It can be on a **linear audio** track,[15] in which case it is referred to as **longitudinal time code.** Of course, if this track is used for time code, it cannot be used for audio. With formats that only have two audio tracks, this loss can be a major problem because it cuts down on the flexibility of incorporating audio during editing. Another disadvantage of longitudinal time code is that it cannot be read when the videotape recorder is in pause or is moving very slowly. This is because it is read by an audio head and not by the rotating video heads.

The time code can also be placed in the vertical interval. This is the retrace area where the

scanning stops at the bottom of the frame and returns to the top of the frame. If time code is placed here, it is referred to as **vertical interval time code,** or **VITC.** VITC can be read at slow speeds or in pause because it is riding with the video information and is read by the same rotating heads that enable the picture to stand still. The main disadvantage of VITC time code is that it must be placed on the tape at the same time that the picture is being recorded. Longitudinal time code can be recorded on the audio track as an audio dub after the picture has been taped. But because VITC rides along with the video, the only way to add it after the fact is to make a **dub** (another recording), which takes the material down a generation, a definite disadvantage in the analog world.

A number of formats place time code in a specifically dedicated area of the tape so that it is not necessary to use either an audio track or the retrace area. Many of today's camcorders have time code generators in them. In these circumstances, the time code can be placed on the tape during the original recording, a process that is preferable to making a dub.

Time code allows for editing that is **frame accurate** because it creates an address for each frame. If an edit is to be made at 00:02:34:12, it will occur precisely at that point, with no tape slippage. Editing equipment can store the time code numbers that indicate the inpoints and outpoints. Once these editing addresses are in the computer's memory, they can be recalled at any time in order to undertake the edit. This means that editing decisions can be made one day, and actual editing can occur a different day.[16]

Equipment

Cuts-only video editing involves two videotape recorders, one or two monitors, and an edit controller. (Figure 11.11 shows one simple editing system; another appears in Figure 10.8.) One videotape recorder, called the **source deck,** contains the original camera footage that is to be rerecorded. The other recorder, called the **edit deck** (or the **record deck**), is the machine onto which selected materials from the source

Figure 11.11

Sony's EVO-9700 Hi-8 editing machine with the source and editing decks in a single unit. This system uses a single monitor (not shown) for both the source and edit machines and includes a titling keyboard. (Photo courtesy of Sony Corporation)

Figure 11.12

An edit controller. (Photo courtesy of Panasonic Broadcast and Television Systems Company)

deck are edited. One monitor shows the output of the source deck; the other shows the output of the edit deck (with some editing systems, both the source and edit outputs appear on the same TV monitor). The edit controller is used to mark the editing points and cue the decks to execute the editing decisions.

The source machine has all the regular functions of most videocassette recorders, such as play, stop, fast forward, rewind, and pause. It does not necessarily need to have a record function because it is used only to play back. One control on the source machine that is particularly important for editing function is the **tracking** control. This positions the head for playback as it was when the

tape was recorded.[17] If the head is not positioned properly, the image quality will suffer. Tracking can be adjusted by turning the tracking knob and looking at the video meter. The best tracking position is where the needle peaks at its highest point. Obviously, the edit deck can record. In addition, it has special extra electronics that allow it to accept signals related to the editing procedure.

The edit controller, such as that shown in Figure 11.12, is usually a separate unit, but some edit decks can be programmed to mark editing points and do not need an external edit controller. Consumer editing systems sometimes include edit controller functions within the VCR's remote control. But most cuts-only controllers are separate units that are brand and/or format specific. In other words, a Sony controller probably will not work with Panasonic recorders, and a controller made for a VHS system will not work with a Hi-8 recorder.[18]

Controllers can usually undertake all the regular videotape recorder functions—play, fast forward, rewind, pause, stop—for both machines through remote control buttons. Look carefully at Figure 11.13 and refer to it frequently as you read this section. They also have a **search dial** that allows the operator to move the tape of either machine at varying speeds in order to find exact locations. The edit controller is used to set the inpoint on the source machine where you want the shot to begin and on the edit deck at the point where you want to start recording the edit. You can also use the controller to set the outpoint on the source machine, or you can end the edit manually after it is completed by pushing the **edit stop** button. On some systems the outpoint automatically becomes the next inpoint; with this type of system you can save a step if you mark the actual outpoint.

Once you have set the inpoints on both machines with the controller, you can preview the edit; that is, you can see exactly what it will look like without transferring any signal. In other words, you can see what the edit will look like on the monitor, but the edit deck will not actually record it. When you are satisfied that the edit will work properly, you press the edit button on the controller to execute the edit. Both

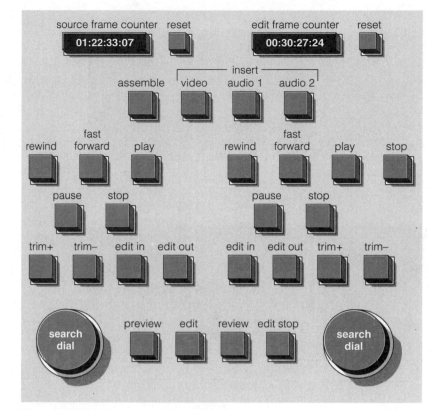

Figure 11.13
The controls on a typical edit controller.

the source deck and the edit deck **preroll** (backup) five seconds to get up to speed.[19] This is why you must have enough time on the source tape *prior* to your inpoint to execute the preroll. If not, most editing systems will abort the edit. If you do have enough material on the head of the shot to encompass the preroll, both the source deck and edit deck will back up and then go forward. When they reach the inpoints, the controller will place the edit deck in record so that the edit begins. You can review the edit by rewinding the tape or by pushing the review button on the edit controller.

A **frame counter** on the controller also helps to find locations. If a tape has time code, the frame counter will display the hour, minute, second, and frame address assigned to each frame. If the tape does not have time code, the frame counter will still display hours, minutes, seconds, and frames, and it will advance one frame each time the tape does. But the numbers will be more arbitrary; the operator can set the counter to zero at any point and count frames from that point. If the counter stops at any point and the tape continues to move forward, the tape does not have control track. Control track is essential for editing, so any lack of counter movement should be noted carefully. Edit controllers also have ways of marking beginning and ending points for edits without the operator having to enter all the points for both tapes. For example, if the operator marks one inpoint and two outpoints, the controller does the math to figure out the other inpoint. Also, as mentioned, some editors automatically use the last outpoint on the record tape as the inpoint for the next edit. Most controllers have a trim function so that frames can be added to or subtracted from the edit point without resetting the edit. In addition, they allow you to choose the elements you wish to edit—audio, video, or both audio and video—and also allow you to select the type of editing you desire, assemble or insert.

Insert and Assemble Modes

Assemble editing and **insert** editing are two different ways of laying down segments of material in linear editing (see Figure 11.14). The key

to understanding the difference between them is knowing what happens to the control track. For assemble editing, the control track information used to accomplish the edit is taken from the material on the source tape. As the edit is made, audio, video, *and* control track are transferred from the source machine to the record machine. At the point at which the edit stops, the picture will break up and the frame counter will stop because there is no more control track.

For insert editing, the control track information is already on the edit tape. When the edit is made, only the video and/or audio material from the source deck is transferred. This material is inserted onto the control track that exists on the tape in the edit deck.

Because a blank videotape does not automatically have control track on it, the control track must be laid down on the edit tape before the editing session is to begin. This is usually called **blacking** the tape. The tape is placed in a record machine that is connected to a video signal, and it is run through from beginning to end in the

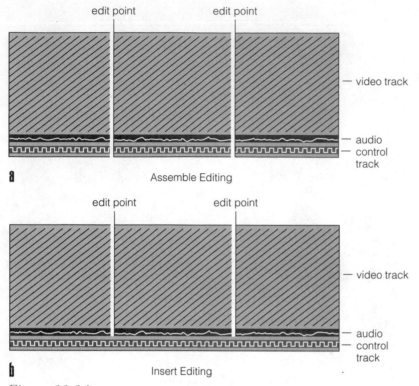

edit point edit point

— video track

— audio
— control
track

a Assemble Editing

edit point edit point

— video track

— audio
— control
track

b Insert Editing

Figure 11.14

The first panel (a) depicts assemble editing. A new control track is recorded along with the audio and video signals. In insert editing (panel b), the audio and video signals are inserted on an existing control track. Thus, the control track must be on the master tape before an editor can insert edit.

record mode. The video signal material that is recorded is black, usually obtained from a studio switcher. In other words, there is no picture. Theoretically, a picture could be recorded on the tape because it too would give the tape an unbroken control track, but black is usually preferred because it is less likely to show a disrupting image if an edit slips a few frames.

An analogy of a train and its track may help explain the difference between insert and assemble editing. For assemble editing, both the train (the video and audio) and the track (the control track) are brought from the source to the edit tape. For insert editing, the track is already on the edit tape, and only the train is brought over from the source tape.

A number of reasons exist for these two systems of editing. Assemble editing is quicker because it does not require time to black the tape. However, because the audio and video are tied to the same control track, they cannot be separated during the editing process. For example, if you have music laid down on the edit tape

and you wish to edit pictures to the music, you cannot do this in the assemble mode without erasing the music. Each time you lay down a picture from the source machine, you will also lay down the control track and audio from the source machine—even if the audio consists of silence. This new audio will erase the audio on the edit tape. Likewise, if you are using the dialogue from a shot of character A and want to insert a cutaway of character B, you cannot do so in the assemble mode.

Assemble editing is used primarily when you have a series of shots that you want to lay down (assemble) in succession without changing the audio or video. The insert mode is used when you want to lay down audio and video separately. Most edit controllers have buttons that allow you to select audio only, video only, or both audio and video when you are in the insert mode. In most instances, you have a choice of several audio tracks; you can choose to edit onto audio channel 1 or audio channel 2 or both. The insert mode can also be used to edit a series of shots without changing the audio or video. You can black a tape and then insert one shot in succession after another. Someone looking at the finished product usually cannot tell whether it was completed in the insert mode or in the assemble mode.

As its name implies, insert editing is also used to insert material after a basic tape has been built. For example, you might edit a scene with a man and a woman talking, cutting to both picture and dialogue of each person as he or she speaks. Later you would go back and insert the reaction shots of the man into the woman's dialogue and vice versa. You could not do this in the assemble mode, in part because the dialogue would be erased, and in part because you would lose the control track at the end of the edit. Because assemble editing brings a new control track with each edit, the picture breaks up at the end of the edit when the control track stops. This is not true of insert editing; the picture remains stable because it attaches to a control track that is continuing on the edit tape.

The breakup occurs during normal assemble editing, but it is not a problem because you are laying down one edit after another. When you

direction of tape movement →			
video	countdown	slate	color bars
audio			tone

Figure 11.15
The elements that should be placed on a typical video-tape leader and the order in which they should appear.

Figure 11.16
A Grass Valley 4000 Switcher. (Photo courtesy of Tektronix, Grass Valley Products)

put down the first piece of audio and video, you will have breakup after the end of the edit. But after you mark your second edit, the edit controller will back up both decks by five seconds from the edit point and will read the sync pulses on the source tape and the sync pulses that were laid down on the edit tape during the first edit. The controller will then make sure the two control tracks are matched when the second edit is made. In that way, the control track of the second edit will be a continuation of the control track of the first edit, and there will no longer be breakup after the end of the first edit. Of course, after the end of the second edit the picture will break up, but that can be rectified by the third edit.

Although a stable control track is built during the assemble process, this track is usually not as stable as the track that exists in insert editing, simply because the control track of the insert process never has any interruptions, even of a temporary nature. This stability is another advantage of insert editing over assemble editing.

One simple-sounding but thorny problem that occurs with cuts-only editing involves the creation of the leader (see Figure 11.15). With nonlinear editing, the leader can be built at the last moment, after you know the exact length of your movie and the other elements needed for the slate. With linear editing the leader should be built first so that it is on the tape before the actual program is edited. Sometimes it is not possible to get color bars and tone to a cuts-only system and sometimes you do not have the information you need for the slate until you have finished editing. One solution is to leave room at the beginning of the tape so that the leader can be built last. If you do this, you must time every element of the leader carefully, especially the countdown, so you do not accidentally erase part of your program. You must also be sure to add the leader elements in the insert mode so that you do not lose the control track right before your program begins.

More Advanced Linear Editing

As we have already mentioned, a simple cuts-only system can do no more than butt two images together. It cannot dissolve, fade, or wipe from one picture to another, hold an image still, or add graphics or lettering to the image. It also cannot correct minor color errors or losses of video information that become magnified during the editing process. Although nothing can eliminate this generation loss, inherent in analog linear editing, many "black boxes" have been designed to keep picture quality as high as possible. Because of all the limitations of a cuts-only system, people often use an expanded editing system that includes equipment for special effects, control and measurement of signal quality, and the addition of graphics.

Equipment for Effects

In order to **fade-in** or **fade-out,** you need some means of generating black and some means of making the transition from the image to black. The most common way to achieve this is to run the image of the source machine through a **switcher** (see Figure 11.16) to the edit machine. The source machine is punched up on one **bus** of the switcher, and black is on the other bus. A lever regulates the strength of the signal of each bus, gradually taking the image to black or vice versa.

In order to execute a dissolve (the temporary overlapping of one image over another), you must have two source machines so that the two images can be recorded on the edit tape at the same time. The same is true if you wish to wipe one picture into another or do any other special effects that require two inputs to appear on the screen at the same time. In the linear realm the film term A/B roll is used when two sources supply one edit machine.

Figure 11.17

A time-base corrector. (Photo courtesy of Nova Systems, Inc.)

a

b

Figure 11.18

(a) A waveform monitor display and (b) a vectorscope display. (Photos courtesy of Tektronix, Inc.)

The two sources cannot simply be fed into the edit machine, however. They too must be routed through a switcher or **special-effects generator** (**SEG**) so that an operator (or a computer) can manipulate a lever or knob to make one picture gradually replace the other.

In addition, these various effects require that the output of each source machine be routed through a **time-base corrector** (**TBC**) (see Figure 11.17) to synchronize the machines to each other and to the rest of the system. Using digital storage techniques, the TBCs place the pictures from the machines in temporary storage and read the pictures back out so that the timing of all machines is the same. Sometimes the TBC is built into the VCR.[20]

Equipment for Control and Measurement

Many pieces of equipment have been designed to maintain the quality of audio/video signals during the editing stage. Many of the functions of this equipment have been mentioned previously in connection with nonlinear editing, where they can be incorporated within computer software. Because basic linear editing systems are not digital, these functions require separate pieces of equipment for image control. For example, an **image enhancer** can be used to correct for the loss of sharpness and smearing of color that result when a picture is taken apart and recorded. A **dropout compensator** fills in gaps created when the head loses contact with the information on the tape.

The two pieces of equipment used most frequently during the editing process for measuring the video signal are the waveform monitor and the vectorscope (see Figure 11.18). As with the representations included in nonlinear software, the stand-alone waveform monitor measures the brightness of the video signal, and the vectorscope measures its color parameters.[21]

Equipment for Graphics

With linear editing, the **character generator** or **graphics generator** (see Figure 11.19) is a separate piece of equipment that has many of the same features as the graphics part of a nonlinear editing program. During the editing session, the graphics can be routed through a switcher. For example, if you are building an opening sequence that includes a video image of buildings and the opening credits, the switcher can be used to place the credits on top of the buildings.

However, one important caution is that, in the analog realm, you cannot add words to the picture after the fact without going down a generation. In other words, you cannot lay down the video of the buildings, finish the rest of your editing, and then come back and add the credits over the buildings. If you do an insert edit to add the credits, you will erase the buildings. Unlike nonlinear editing, there is only one channel of video on a tape, so two images cannot be recorded at the same time unless they are mixed through some sort of switching device. The only way to lay credits after the entire tape is built is to put the edited master in the source machine and run it through the switcher to the edit machine. As the buildings appear from the source machine, you can add the credits by routing them through the switcher. The finished tape with credits that is recorded on the edit machine will be a new generation and will have a certain degree of picture degeneration beyond what was on the source tape. For this reason, adding credits during the initial editing phase is the much preferred method.[22]

Obviously, using equipment for effects, measurement and control, and graphics adds to the cost of the editing process. Minimizing the amount of time that all this equipment needs to be used can significantly reduce the budget of any production, especially if an editing facility is being rented by the hour. One way to save time is to use the added equipment only for those segments of the movie that need it—those that involve effects, graphics, and multiple images. The rest can be done on a cheaper cuts-only system. Another way is to be thoroughly prepared before you enter the editing

Figure 11.19

A computer graphics generator that can be used to create, store, and retrieve graphics and titles. (Photo courtesy of Quantel Inc.)

room so that you do not waste time making rudimentary decisions or searching for some specific tape segment.

Notes

1. Of course, our wish list for our Vanilla could go on and on. Ideally, our hardware wish list would include networking our entire lab of nonlinear editing systems so that we can share drives on larger servers, a particularly effective way of handling our ever-expanding storage needs.
2. Refer back to Chapter 4 for a definition of field.
3. Daniel Greenberg, "PC Video Capture Cards," *Digital Video Magazine,* September 1995, pp. 71–82.
4. Motion-JPEG (M-JPEG) is the most common compression technology used in digital editing systems today. However, a new system, MPEG-4, is under development and may eventually take dominance over M-JPEG. The JPEG (Joint Photographic Experts Group) standard produces a stream of compressed individual frames that, for the moment at least, makes it easier to use for video editing than the MPEG 1 (Motion Picture Experts

Group) and MPEG 2 video compression standards. M-JPEG, which was developed for still image compression, is completely scalable. Compression rates are typically expressed as ratios: 1:1 is uncompressed; 5:1 might equal Betacam SP video quality; 10:1 Professional S-VHS video quality; 30:1 regular VHS video quality. JPEG compression does not visibly degrade the image at rates below 10:1. Most high-end capture cards today employ JPEG compression technology, and JPEG chips can also be used to accelerate video playback. See Ken Freed, "Support Builds for Powerful MPEG-4," *TV Technology*, 24 February 1999, p.1.

5. There are so many variables involved in compression. One is bit depth—the number of colors that are used. Another is frame size—the smaller the frame you are willing to work with, the more you can compress. One rough calculation of the approximate video quality and the number of minutes of video that can be stored per gigabyte is as follows: At a 2:1 compression ratio (roughly Digital Betacam quality), 1 minute 37 seconds of video could be stored per GB; at 5:1 (Betacam SP), 4 minutes of video per GB; at 10:1 (Pro S-VHS), 8 minutes of video per GB; at 30:1 (VHS), 24 minutes per GB; at 60:1 (low quality), 48 minutes per GB. See Stewart Sweetow, "Fast Electronic's DP/R: Can It Compete in the Marketplace?" *Video Pro*, August 1995, pp. 34–37; and Mark Magel, "Dressed to Compress," *AV Video Multimedia Producer*, January 1999, p. 33.

6. Another type of compression is temporal compression. It looks for things that don't change from frame to frame, such as the building behind a person who is talking. This uses keyframes—the ones for which all the data is recorded. The fewer keyframes, the smaller the data rate, but the picture quality suffers.

7. Scott Anderson, "Digital Video & Firewire Made Simple," *Videomaker*, May 1998, pp. 104–108.

8. One example of a 395-page manual is *Adobe Premiere 5.0* (San Jose, CA: Adobe Systems Incorporated, 1998). Articles that deal with nonlinear editing include: Jay Ankeney, "In Search of Edit Heaven," *TV Technology*, 10 February 1999, p. 48; Steve Mullen, "The Nuts and Bolts of Nonlinear," *AV Video*, January 1996, pp. 71–78; Tim Tully, "Nonlinear Desktop Video Editing Systems," *NewsMedia Tool Guide: A Special Edition*, 1995, pp. 31–45; and Bob Doyle, "Data Translation's Media 100," *New Media*, February 1996, pp. 59–60.

9. For more on graphics, see Michael Murie, "3-D Software for the PC," *NewMedia*, 29 January 1996, pp. 62–69; Jeff Burger, "Alpha Channels Unmasked," *NewMedia*, 29 January 1996, pp. 70–71; Frank McMahon, "Best Buys in 3-D Animation," *Digital Video Magazine*, March 1996, pp. 48–56; and Lynda Weinman, "2-D Animation's Not Just for Mickey Mouse," *NewMedia*, July 1995, pp. 41–46.

10. Jan Ozer, "Software Video Codecs: The Search for Quality," *NewMedia*, 29 January 1996, pp. 46–52.

11. Based on telephone interviews with "Chicago Hope" editor, Mark Baldwin, February 15, 1999.

12. Some dramatic, episodic television shows have begun moving from the 35mm film format to the Super 16mm film format as a cost-saving measure. Like 35mm, Super 16 preserves the 16-by-9 widescreen aspect ratio and will make it easier to convert the show to high-definition television.

13. Even at this next-to-last stage, dirt and dust removal, also known as "dust busting," might take place. This can be done at the same time as the titles are being added.

14. Several good books on linear editing are Arthur Schneider, *Electronic Post-Production and Videotape Editing* (Boston: Focal Press, 1989); Steven E. Browne, *Videotape Editing* (Boston: Focal Press, 1989); and Gary Anderson, *Video Editing and Post-Production: A Professional Guide* (White Plains, NY: Knowledge Industry Publications, 1986).

15. Some camcorders can lay time code on audio tracks other than the linear audio tracks. For example, machines that can record hi-fi audio can place time code on that track. This, like VITC, must be laid down during recording because the hi-fi track rides with the video. Recorders with PCM can place time code in that area, but the disadvantage of this is that the time code is then occupying the highest-quality, most flexible audio track.

16. Glenn Calderone, "Time Code," *Videomaker*, April 1995, pp. 88–93.

17. What the tracking control actually does is vary the delay between the control track and the head servo loop control so that the heads play back down the center of the recorded track.

18. For more on controllers, see "The Cutting Edge," *Video*, April 1990, pp. 63–65, and "Editing Controllers Tap Small Formats," *TV Technology*, February 1991, p. 1.

19. Some editing systems back up tape as little as three seconds, and others back it up as much as seven seconds. Others are adjustable, so you or an engineer can determine the number of seconds of preroll.

20. Matt Drabick, "The ABCs of TBCs," *AV Video,* September 1994, pp. 42–45.

21. Victoria Bushnell, "The New Heroes of Post," *Film and Video,* October 1991, pp. 58–68.

22. For more on graphics, see "Graphics Get High-Tech Look," *Broadcasting and Cable,* 1 February 1999, p. 46; and Bob Gillman, "Video in a Window: Picturing the Future," *AV Video,* May 1992, pp. 50–57.

chapter twelve
Editing Approaches

Some stories about editing have been told so often that they have become clichés: the actor whose great performance was left on the editing room floor, the producer or director who "saved" a film during the editing, the psychologist who blames the fast cuts of music videos for the three-second attention span of the American teenager. These are all exaggerations, of course, but they contain just enough insight into the power and purpose of editing to have a semblance of credibility. Editing is important. As much as any one area of moviemaking, editing can intensify the mood and place the audience within the action.

Examples of powerful and effective editing abound: the shift of rhythm in *Psycho* in the scene in which Norman cleans up after "Mother" has made a mess in Cabin 1, the scene in *The Wild Bunch* in which ninety-eight different shots are held together by the drumbeat of the steam engine as Angel separates the train cars to steal the weapons, the interrogation scene in *Bladerunner* that builds to the breaking point as the android grapples with the word *tortoise*.

In one way editing is relatively simple. The physical act of joining one shot to another is not difficult to accomplish in film or video. On the other hand, choosing which shot to use, where it goes, and how to cut it can be far more complicated. Fortunately, editing decisions are not irrevocable. Edits can be remade. Shots can be edited so that they are shorter or longer. The editor can try an entire group of shots in one position, move it to another, and then return it to its original position without permanently damaging the footage. The editing process is one of trial and error, of testing and retesting. Cuts are made, reviewed, then made again. Ultimately, someone—the director or the producer—must decide that a particular cut is the final cut. Otherwise, given the almost limitless number of editing patterns possible, the process might never end.

The editor is responsible for selecting and arranging shots according to the director's overall plan for the movie. Some directors totally control the editing process. Others convey their ideas to the editor and allow the editor to work in relative freedom, reviewing the work as it is completed. In theatrical filmmaking the script is the guide to the movie's basic structure, but the editor can play a major role in determining its rhythm, mood, and pace. Individual shots (and the principal dialogue track) are selected or rejected for a variety of reasons: the quality of the acting performance, the effectiveness of a particular camera angle or movement, the emphasis a shot gives to a scene, or the elimination of technical errors in the shot. Once these decisions have been made, the real job of editing can begin—establishing relationships between the individual shots in both time and space.

Conventional Hollywood Patterns

The classic style of Hollywood editing is so dominant worldwide that it is virtually the standard editing pattern for theatrical filmmaking, the norm against which other styles of editing are measured and evaluated. Even as a point of departure for less traditional editing, it is simply too pervasive to ignore.

Editing in the Service of the Story

In the hands of the early film pioneers, particularly D. W. Griffith in the United States, editing quickly became one of the most important tools for motion picture storytelling. This kind of narrative editing was honed to perfection in the Hollywood studios of the 1920s and 1930s. In the classic Hollywood editing system the editing is almost totally subservient to the dramatic needs of the story.

One of the key elements in this approach is **continuity editing,** the attempt to make the cut from one shot to the next flow as smoothly and unobtrusively as possible. This is most apparent within the **scene,** the basic building block in conventional motion pictures. The scene, as you will recall from our discussion in Chapter

1, can be defined as unified action, usually occurring in a single time and place. It may be composed of a single shot, but in most cases a scene is made up of a number of shots. In the typical Hollywood film the story unfolds scene by scene. In most cases the scenes are organized in chronological order, showing only those events that advance the story or provide some piece of information significant to the plot. The story may move from one time period to another or from location to location, but within each individual scene the editing usually creates the illusion of continuous time and place.

Take, for example, a group of scenes from Steven Spielberg's *Indiana Jones and the Last Crusade:*

Scene 6	Aboard a freighter during a violent storm, Indiana Jones and Fedora fight over the Cross of Coronada. Indy gets the cross and jumps ship.
Scene 7	Indy lectures to a class of admiring archeology students.
Scene 8	Indy gives Brody the Cross of Coronada.
Scene 9	Indy enters his office, wading through a horde of anxious students. He flees out his office window.
Scene 10	Indy meets Donovan, who convinces him to go after the Holy Grail. Indy learns his father is missing.
Scene 11	Indy and Brody find that someone has broken into the father's house. Indy recalls the package he received—his dad's Grail diary.
Scene 12	Donovan says goodbye to Indy and Brody.
Scene 13	Indy flies to Venice.
Scene 14	Indy and Brody arrive in Venice and meet Elsa.
Scene 15	Indy, Brody, and Elsa walk to the church that has been converted to a library.

These ten scenes illustrate some basic patterns of conventional Hollywood storytelling. The story moves forward in time, skipping extraneous events. We do not see how Indy gets from the ship to his classroom or how he moves from his meeting with Donovan to his father's house. Those periods of time are insignificant. In fact, it is impossible to determine exactly how much time passes from the moment Indy jumps ship until we see him in the classroom. It may have been a few days, a week, or a month. In the context of the film it does not matter. Similarly, the locations vary according to the needs of the plot. Within these ten scenes are seven locations (the ship, the classroom, Indy's office, Donovan's house, Indy's father's house, the plane flying to Venice, the Venetian library-church) and fragments from at least three different days. Obviously, the editing can organize the story events freely in time and space. But within each individual scene, such as Indy's lecture to the classroom of lovestruck coeds, a series of shots edited together presents a continuous piece of action in a single time and place.

In the single-camera shooting method a scene is shot from a variety of angles and perspectives. To ensure a continuous and clear flow between these different shots, Hollywood filmmakers developed an elaborate system that encompassed a number of editing techniques and procedures for shooting the scene. One basic goal of this system is to mask the cuts, to make them less apparent, an approach that is sometimes referred to as **hidden editing** or **invisible editing**.

What makes this system even more effective is that each successive shot is psychologically correct from the audience's point of view. Film theorist André Bazin has compared this to a stage play, where the viewer's attention shifts naturally from one character to another according to the logic of the drama, the dialogue, and the movements or gestures in the scene.[1] For example, a shot of a character who suddenly turns and looks off-screen is naturally followed by a shot of what the character is looking at. When two people are carrying on a conversation and one stops talking, we expect a cut to the other as he replies. This does not mean that the editor must always cut to the shot the viewer expects. In fact, cutting against the natural flow of the action and against the audience's expectations often heightens the drama. Nevertheless, in traditional filmmaking cutting

a

b

Figure 12.1

Cutting from shot (a) to (b) might maintain perfect continuity in terms of time and space, but the cut will appear to "jump" because the shots are so similar in size and angle.

to a shot that is totally unrelated to the basic action in the scene would be inappropriate.

At its core Hollywood-style continuity editing is self-effacing: it does not call attention to itself. It avoids disconcerting shifts in time or space and encourages anything that makes the shots in the scene flow together smoothly and unobtrusively. The editing is supposed to serve the story, organizing scenes and the different shots within individual scenes in a clear, logical, and convincing manner. From the point of view of the Hollywood editor, if the audience is unaware of the editing, its attention is focused where it should be—on the actors and the story.

The Continuity System

The continuity system creates the illusion of continuous action by carefully coordinating every element of the **mise-en-scène**, the cinematography, and the editing. The way a scene is staged for the

camera can also break continuity: the prop that appears in one shot and disappears in the next, the lighting that changes direction or color on the cut, the tie that changes patterns or the actor who abruptly reverses screen direction. The script supervisor helps to guard against continuity violations during production, and the editor tries to hide them in the editing. To discuss continuity editing without referring to how the scene is shot and staged for the camera is impossible.[2]

Technically, a single **shot,** no matter how complex, will always maintain continuity. Problems arise when we try to edit a group of shots together seamlessly, with no sense of break, jump, or discontinuity in the action. To make it easier for the editor to hold continuity among these different shots directors frequently use a technique called **overlapping action.** The director makes sure that action in one shot is repeated, at least in part, in the shot that may follow it. In other words, a character opening a door in one shot repeats that movement exactly when shot from a different angle. This provides the editor with a number of possible places at which to make a **match cut,** a cut in which the character's movement and position are perfectly aligned in time and space from one shot to the next. Failure to do this results in what is commonly called a **jump cut,** an obvious and jarring break in continuity from one shot to the next. A similarly abrupt jump occurs if part of the action is repeated in successive shots. This is sometimes called *double action.*

Hollywood filmmakers also recognized a related problem. Even when two shots match perfectly in time and space, a jump can appear to occur if the camera angles or the size of objects in the shots are *too similar.* Correcting for this requires emphasis of the difference between two shots by changing their angle and size. Judging how much the shots should vary is not always easy. If the change between the shots is too great, the edited footage can be disconcerting; if the change is too small, their similarity will make the cut seem to jump.[3] (Figure 12.1 illustrates shots that are too similar.)

The Master Shot Method

Hollywood filmmakers developed a method of shooting that provided the editor with shots that could be edited together seamlessly and

```
SCENE 11

EXT. MRS. OLIVER'S HOUSE - NIGHT

David and Scottie pass by Mrs. Oliver's house.  The
lights are off.  The dark old house looms in front of
them like an old haunted mansion.  An owl hoots from a
nearby tree.  A cat screeches in the distance.

                         SCOTTIE
     1           I wonder if the old witch is home
     2           tonight.

                         DAVID
     3           I bet she is.  She just doesn't
     4           want to give out any candy.
     5           (Pause)  Hey, look at this.

They bend down.  David draws a picture of an old witch
on the sidewalk with a chunk of chalk.

                         DAVID
     6           This is what Oliver looks like.

                         SCOTTIE
     7           Hey, that's great!  Put a wart on
     8           the end of her nose.

David adds the wart and then writes in big letters, OLD
MOTHER WITCH, and draws an arrow pointing toward Mrs.
Oliver's house.  The boys laugh.  Then Scottie gives
David a shove toward the house.

                         SCOTTIE
     9           Ring Oliver's bell!

They start scuffling and shoving each other.

                         DAVID
    10           Hey!  Not me!  Come on.  Let's go
    11           to the Bridwell's.
```

Figure 12.2

Scene from Old Mother Witch. *The numbers in color are added for reference.*

continuously. It involves analyzing and breaking the action in the scene down into its logical components. The first step in this method is to shoot a **master shot.** This is usually a wide shot or long shot that covers all the action and dialogue in the scene or portion of the scene. The master shot has the effect of locking continuity for all other shots. It establishes the lighting, the costumes, the props, the setting, and the spatial relationships of the actors. Once set, shooting additional shots from different angles and perspectives breaks the scene down further.

A brief scene from *Old Mother Witch*, shown in Figure 12.2, provides an example of how this

Figure 12.3

The traditional exposition pattern—moving closer and closer within the scene. A scene from the made-for-television movie Flight 90 *begins with (a) an establishing shot to set up the airport location, followed by (b) a long shot inside the terminal, cutting to (c) a medium shot in the ticket line, and to (d) a close-up of the ticket agent. (Photos courtesy of Finnegan-Pinchuk)*

might work. Note that the numbers next to the dialogue are for reference only.

Neither of the actors playing Scottie or David is enough of an artist to draw the witch on the sidewalk. A close-up of the real artist's hand reaching into the frame to do the drawing covers that action. Because the scene has this natural break, the master shot breaks into two different shots: one is a wide shot covering all the dialogue and action from line 1 to just beyond line 5, where the boys bend down to begin drawing the picture, and the other is a wide shot providing coverage of the dialogue

and action from line 6 to line 11 (the actor playing David *can* draw a wart on the nose and add the lettering and arrow).

The first master shot functions as an **establishing shot** for this scene, orienting the audience to the location and providing information vital to the action (Mrs. Oliver's house in the background). Establishing shots are the traditional way of beginning each new scene in narrative moviemaking. In fact, the traditional editing pattern of establishing shot–long shot–medium shot–close-up (see Figure 12.3) developed for much the same reason—to establish the location

Figure 12.4

Reversing the traditional pattern. Isolated close-ups of (a) the man, (b) the dog, and (c) the woman in a scene from Flight 90 *creates questions in the audience's mind about what the action is and where it is taking place. These questions are eventually answered by the last shot in sequence (d), which brings the three together in the same shot. (Photos courtesy of Finnegan-Pinchuk)*

before moving in to focus on important details within the scene. Sometimes a scene will have, in effect, two establishing shots. For example, we might see an exterior shot of an office building and then cut to the scene inside (a space that will also have to be established). Reversing this pattern—starting with a close-up of some detail within the scene—can build anticipation, making viewers wonder where they are (see Figure 12.4). These questions are answered as subsequent shots reveal and establish the space in which the scene is taking place.

The master scene shooting method mirrors the logic of the traditional establishing shot–long shot–medium shot–close-up pattern. Once the master scene shots are completed, the scene is broken down into increasingly greater detail.

For example, we might shoot close-ups of David and Scottie delivering their lines. This will enable the editor to establish the familiar **shot/reverse shot** pattern (see Figure 12.5) by cutting from a shot of David talking to a shot of Scottie talking. In framing, these shots will mirror each other. The shot/reverse shot pattern often uses **over-the-shoulder shots.**

The scene breakdown might include **reaction shots,** shots of David or Scottie reacting to something the other has said or to something else in the scene—the drawing on the sidewalk or Mrs. Oliver's foreboding house. The **shot/reaction shot** pattern (see Figure 12.6) gives the editor the option of focusing the audience's attention on the character responding to the dialogue or action, rather than

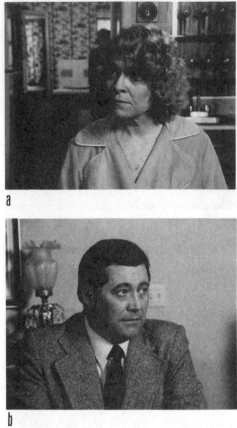

a

b

Figure 12.5

A shot and a reverse shot in Flight 90 *mirror each other in composition and subject size. (Photos courtesy of Finnegan-Pinchuk)*

a

b

c

Figure 12.6

The young boy's reaction shot (b) is cut between shots of his mother talking on the telephone (a and c) in a scene from Flight 90. *(Photos courtesy of Finnegan-Pinchuk)*

on the person speaking or the action itself. Alfred Hitchcock, a director who felt that the event was usually less interesting than a character's reaction to it, frequently exploited the power of the reaction shot.[4]

For shot/reverse shots and shot/reaction shots the editor will need to be highly conscious of **eyeline match** (see Figure 12.7). Because these shots may isolate David or Scottie in the frame, the directions in which they are looking off-screen (toward each other) and their angles of view must match precisely. If Scottie is taller, his eyes will need to angle slightly down to where David is supposed to be standing. In effect, the direction established by Scottie's eyes creates a target area that the editor must match in the shot that follows.

Finally, to complete our breakdown we will probably shoot close-ups of significant details within the scene, such as the chalk drawing of the witch (or even a small part of the drawing).

Figure 12.7

The eyeline established by the woman in shot (a) must be matched by the man's eyes in shot (b). (Photos courtesy of Finnegan-Pinchuk)

The editor will use some of these close-ups for **cut-ins** and some for **cutaways.** A cut-in focuses on some element that appeared in the previous shot (see Figure 12.8). A cutaway is a shot of something that did not appear in the previous shot (see Figure 12.9). For example, if the shot for lines 7 to 8 was a long shot that included Scottie, David, and the witch, a cut to the drawing of the wart would be a cut-in. If the shot for lines 7 and 8 was a close-up of Scottie's

Figure 12.8

In this series of pictures the close-up of the baby (b) is used as a cut-in between shots (a) and (c). If you look closely, you can see a continuity problem with the baby's arm and the man's hand. (Photos courtesy of Finnegan-Pinchuk)

Figure 12.9

In this sequence from Flight 90 *shot (b) functions as a cutaway between shots (a) and (c). Because neither pilot appears in the cutaway, continuity can be dropped momentarily and then be picked up again when we return to the pilots in shot (c). (Photos courtesy of Finnegan-Pinchuk)*

face, the cut to the wart would be a cutaway. Cut-ins must maintain continuity. If David's foot was on the witch's mouth in the long shot, it must be there on the cut-in. Cutaways do not need to maintain continuity; the position of David's foot is not crucial.

In reality, the director probably would not shoot such extensive coverage for a scene this simple. To do so would take too much time and be too costly. Some decisions about how the scene will be edited will be made *before* the shooting, allowing the director to shoot fewer shots. Nevertheless, even without such comprehensive coverage the editor will still have countless options for structuring the scene.

Ensuring a Consistent Screen Direction

Obviously, it is not easy for the editor to maintain continuity when the scene is broken down into different shots this way. It was for precisely this reason that the so-called **180-degree rule** evolved. This system of shooting, as you will recall from Chapter 5, is used to ensure a continuous and unconfusing space from one shot to the next. The placement of David and Scottie in the shot establishes an **axis of action,** or *line*. As long as all shots are taken on one side of that line (within the 180 degrees), the space presented in those shots will be consistent when they are edited together. Crossing the axis will make the characters' positions shift drastically. This principle is also helpful in preserving a constant screen direction when the shot contains movement. Once a character begins moving in one direction, the next shot must maintain that direction. Again, crossing the imaginary 180-degree line can cause confusion, making the character appear to reverse direction abruptly on the cut. When a character enters or leaves the frame, that too sets up anticipation of direction for the next shot. If David walks out of the frame by moving from left to right, we expect him to enter the next shot from the left side. A shot directly down the axis of a character coming toward or away from the camera is neutral, allowing the editor to establish a new screen direction in subsequent shots (see Figure 12.10).

By maintaining consistent direction and systematically covering the scene with the master scene shooting method, the director provides the editor with material that can be edited together to create the illusion of continuous action. The editor uses the individual shots to build the scene according to the logic of the drama, the dialogue, and the actor's movements or gestures. With such comprehensive coverage the editor can also develop a sense of off-screen space, building expectations that can be used to motivate and drive the film forward.

Finding the Cutting Point

By looking carefully at two shots in succession, the editor can select the appropriate cutting point at the end of the first shot and the beginning of the next. This is often a difficult task that involves looking for continuity details. Hands, arms, feet, and other elements must be in similar positions from shot to shot. This is much easier if the director has provided many cutting places by overlapping action during shooting. One technique for making two shots flow together more smoothly is **cutting-on-action**. Rather than letting the actor complete an action in one shot and cutting to the next, the action *begins* in the first shot and ends in the second. Continuing the same movement across two shots draws the viewer's eye naturally to the next shot, helping to mask the cut and make it less obvious.

Often the editor will find it necessary to drop continuity and then pick it up again. This is where cutaways and reaction shots are especially handy because they do not include elements present in the previous shot. They allow the editor to momentarily drop continuity, either for aesthetic reasons or to hide continuity problems that occurred during shooting.

Other Editing Concerns

The editor also is responsible for controlling the rhythm or tempo for each scene and for the movie as a whole. Each shot has its own pace or rhythm, determined by the speed of the dialogue or the movement of the camera or actor in the shot. But the editor can control or alter

a

b

c

Figure 12.10

Shooting right down the axis (b) allows the screen direction to be reversed from shot (a) to shot (c).

a

b

Figure 12.11

Compressing time by eliminating unimportant material is a common editing practice. Here a shot of an airplane that has just landed on the runway (a) is followed by a shot of the airplane as it docks at the terminal (b). Eliminating a portion of time in this manner is seldom confusing to the viewer. (Photos courtesy of Finnegan-Pinchuk)

that pace by varying the length and number of shots in the scene. The shorter each shot is, the faster the tempo becomes. Long, uninterrupted shots slow the tempo. Similarly, the time it takes for a scene to unfold can be expanded by inserting in the main action a series of extra shots, such as cutaways, reactions, and different angles. The editor can compress time by cutting shots shorter and by using cutaways or reverse shots that eliminate some part of the action while maintaining a semblance of continuity (see Figure 12.11). For example, the first shot of a person going to bed might be of the person starting up the stairs. The next shot is that person opening the door, taken from an angle within the bedroom. Time compression is commonplace in theatrical films. It enables the editor to control the tempo and eliminate extraneous material while moving the story forward.

A completely different kind of time-space manipulation occurs in **parallel editing** or **cross-cutting**. By alternating shots from one line of action to another, the editor can imply that the two actions are occurring simultaneously (see Figure 12.12). This would seem to be a complete violation of continuity, but in conventional filmmaking what holds the different actions together is their relationship in the story and the implication that they are occurring at the same time. We have all seen the old melodrama in which the black-caped villain is tying

the heroine to the railroad tracks. This traditionally is cross-cut with scenes of a steam engine roaring down the track and the hero riding furiously to the rescue on his white horse. When these scenes are intercut, usually at a faster and faster pace to build suspense, we all understand their conventional meaning—the hero is trying to reach the heroine before the train does. Although the individual scenes are unrelated in space and time, the cross-cutting unifies them in the context of the story. Cross-cutting need not be so melodramatic, however. It can be used to comment on, or compare, different lines of action, or it can be used to expand time in the scene.

An editor might also choose to **flash back** or **flash forward** to a scene or sequence that portrays events in the past or future. In traditional moviemaking a line of dialogue or some other device (pages flipping on the calendar or a dissolve from an old woman in a rocking chair to a young woman in the same chair) cues the viewer to a jump to the past or future. A **flash cut,** a shot just a few frames long, can present a brief image from the past or future that is almost subliminal—Magnum, P.I. flashing back to some moment in Vietnam or forward in anticipation of some event. A less traditional filmmaker, such as Alain Resnais in *Last Year in Marienbad,* uses this kind of time shifting to disorient the viewer.

Figure 12.12

Parallel editing. The film Flight 90 *relies heavily on parallel editing to develop the narrative. The preparation of the airplane (b, d) is intercut with scenes of many characters (a, c, e) as they prepare to board the ill-fated flight. (Photos courtesy of Finnegan-Pinchuk)*

The editing process can also enhance an actor's performance. By **overlap cutting** the sound track the editor can allow an actor's lines to be heard while we see something else. With a judicious use of cutaways and reaction shots, the editor may be able to strengthen an actor's performance. By eliminating bad takes and by taking parts of lines from other takes the editor can sometimes create a better reading. **Point-of-view shots** can add a subjective feeling that a scene needs, and intercutting just the right close-up or reaction shot can build a dramatic moment that did not actually exist in the original performance.

Other Transitions

Thus far we have been concerned only with **straight cuts,** a transition in which one shot instantaneously replaces the next. This is not the only kind of transition that the editor has at his or her disposal. Fades, dissolves, wipes, and a whole arsenal of digital effects provide other ways to join shots together.

A **fade-in** is a gradual transition from black to a full view of the image. A **fade-out** is the reverse, a transition from the image to black. The editor can also choose how quickly or slowly these transitions occur (a fast fade-in, a slow fade-out). Most movies and television shows begin with a fade-in and end with a fade-out. Using a fade-out to end a scene or sequence *within* the movie usually implies a stronger degree of closure, a more final conclusion to the scene than a straight cut. To use a punctuation analogy, a straight cut between two scenes is like a comma, whereas a fade-out is like a period. Furthermore, because a scene ending with a fade-out is usually followed by a fade-in to the next scene, the fades suggest a greater passage of time between the two scenes than does a regular cut. This sensation is heightened if the fades are executed more slowly.

A **dissolve** is a much softer transition than a fade or a cut. It entails the gentle fading of one shot *into* the next. Actually, as the first shot fades out, it overlaps with the second shot as it fades in. For a brief time in the middle of the dissolve the two shots are superimposed. This is much more visible in a long, slow dissolve than in a short, quick one. Like a fade, a dissolve suggests the passage of time, although possibly with less emphasis. Editors often use dissolves to hide problems (such as a reversal in screen direction) or as a transitional device when some part of an action is omitted. Because dissolves visibly (albeit briefly) combine shots, they suggest a relationship between them that can be exploited effectively. In a flashback, for example, the editor might select a dissolve to amplify the link between the present and the past. Similarly, dissolves can suggest a link between images because of their common shapes, colors, movements, or subject matter.

While a dissolve is a soft, unifying transition, a **wipe** is generally a hard, abrupt, and obvious one. In a wipe the second image pushes across or into the first image, replacing it on the screen. The two images are not superimposed as in a dissolve; rather, the cutting edge of the second image has a visible pattern or shape (vertical, diamond shaped, circular, rectangular) as it gradually replaces the first image. A wipe suggests the passage of time or a change of location in the same time. Its use as a transition is somewhat different in film than in video. In theatrical moviemaking a wipe is somewhat archaic, a familiar transition in the era of movie serials and melodramas. Sometimes wipes were used to add a touch of humor to the transition between two scenes. In comparison, wipes are a fairly common transition in video. They often appear in televised sports events, commercials, and TV magazine shows.

Digital video effects provide another type of transition. Once an electronic signal is converted into digital form, an editor can manipulate its shape, size, and movement to create almost any transition imaginable. Such effects (spins, twirls, flips, page turns) are obvious, of course, and not as useful in conventional Hollywood-style storytelling where the objective is usually to make transitions as invisible as possible.

These various transitions—fades, dissolves, wipes, and digital effects—imply the passage of time. In the appropriate place they can be just the transition the editor needs to punctuate a scene, to shift tempo, or to link a series of shots. Student moviemakers often overuse these transitions, however. Unless there is a good reason

in the context of the story for using a fade, dissolve, wipe, or digital effect, the cleanest and most efficient transition is still a straight cut. Using transitional effects too often lessens their impact when you really need them.

Alternatives in Time and Space

Every cut, as we have already seen, is a cut in both space and time. Although there are many time-space relationships, conventional Hollywood editing tends to limit itself to a handful of possibilities.[5] In a traditional Hollywood motion picture the editing typically organizes events in chronological order. The story moves forward, omitting unimportant segments of time. Time reversals of any kind are not the usual way of advancing the story. Movies use flashbacks occasionally, of course, but they are a relatively rare and unusual transition, often set apart in quotation marks by spinning clock hands or a dazed look in the character's eyes. Cuts forward in time are even more rare. Similarly, the classic style consciously avoids any time-space relationship that creates a jump in time or space.

Obviously, there are many alternatives to this conventional pattern. Imagine, for example, a music video that shows a dancer repeatedly performing the same dance step. Each shot, in effect, repeats the action of the previous shot. Yet the space (or background) in each shot might be totally different (at the seashore, in the snow, in a forest). This kind of editing would be totally unacceptable in conventional Hollywood filmmaking but is rather commonplace in music videos. Freed of the constraints of narrative editing, the editor can explore many more time-space relationships, cutting to the beat of a very different drummer.

While the goal of conventional narrative editing is to maintain continuity and make the edits as invisible as possible, a less traditional editor may want the cuts to be abrupt, discontinuous, and extremely obvious. The editor may select cutting points in order to create a particular rhythm or beat. The tempo of the music,

not the natural rhythm of the shot, might govern those decisions. An editor may match shots according to some shape, form, movement, or color in successive shots, a rationale that has nothing to do with consistent screen direction or smooth, continuous action.

Such cutting is relatively common in nonnarrative productions such as abstract films and videos, commercials, music videos, and some of the newer multimedia productions. But many directors, such as Robert Bresson, Michaelangelo Antonioni, Nicholas Roeg, Jean-Luc Godard, and Bob Fosse, have consciously broken or extended the rules of the classic continuity system in their own narrative films. Their work suggests that classic Hollywood-style editing is only one of many approaches. It is simply the *conventional* way of editing, not the only way.

Montage Editing

Perhaps the best-known alternative editing system is called **montage editing.** This term has been applied to so many different types of editing that it can be confusing. Montage is simply the French word for editing, but it implies a more comprehensive building up or assembly of the total film.

Several Russian filmmakers and theorists extended this concept in the 1920s.[6] V. I. Pudovkin, for example, developed a theory of montage based on what he called relational editing—a process that emphasized the different relationships that could be established among a series of shots by using contrast, similarity, symbolism, or repetition. Pudovkin felt that a scene could be constructed simply by adding significant detail to significant detail and that this kind of "linkage" could be done unobtrusively, masked by the logic of the editing and power of the drama. Film director Sergei Eisenstein, Pudovkin's contemporary and the author of numerous essays on editing, developed an opposing theory based on the violent "collision" of images.[7] Eisenstein believed that an entirely new meaning could be created by blatantly and obviously cutting from one shot to another; the meaning was not contained

in either shot alone but was produced exclusively by their juxtaposition.

Today, the one place where such concepts are most consistently applied is television commercials. Think about the typical cold drink or beer commercial. The sequence of shots might go something like this:

1. Shot of beautiful suntanned teenagers playing volleyball on the beach.
2. Close-up of a beautiful smiling blonde in a tiny bikini.
3. Medium shot of a grinning lifeguard with sunglasses. Drops of sweat are rolling down his handsome bronzed face.
4. Extreme slow-motion close-up of a hand reaching into an ice-filled container. The hand slowly pulls out a can of Brand X soft drink or beer—icy water runs down the side of the can in tiny rivulets.
5. Shot of a dog catching a Frisbee in the surf.
6. Shots of happy beautiful teenagers on beach blankets. The boys and girls are just beginning to talk in the hot sand.
7. Another dreamy close-up of a bottle of Brand X being extracted from the ice chest. (And so on . . .)

You have seen this pattern enough times to finish it in your own mind. Juxtaposing the shots of the happy beachgoers with the sweating bottle of Brand X creates a meaning that is not contained in the shots of the beachgoers or soft drink bottle alone. Of course, to make sure you don't miss the connection between Brand X and the active beautiful people (who are obviously successful with the opposite sex), most advertisers would probably insert shots of the teenagers and Brand X together as the commercial progresses.

It was precisely the power of editing to suggest new relationships that most interested Pudovkin and Eisenstein. From their perspective, editing need not always be focused on maintaining continuity. A shot of a spinning tire might be cut to a spinning roulette wheel because of the similar shape and movement in the two shots. An editor might make a cut for metaphoric purposes: a shot of a Cossack swinging his sword at a peasant cut against a shot of helpless animals being butchered in a slaughterhouse.

Ironically, Hollywood filmmakers also tried their hands at montage. Many films in the 1930s and 1940s contained a *montage sequence,* often credited to special montage editors such as Slavko Vorkapich and Jack Killifer. Hollywood montage, however, tended to adopt the Russian methods in a unique way—it created a discrete sequence designed either to establish a particular mood or to condense a long and complicated action in a brief on-screen time period. The bicycle ride (cut to the tune of "Raindrops Keep Falling on My Head") in *Butch Cassidy and the Sundance Kid* and the tribute to Beethoven cut to his Ninth Symphony in *Immortal Beloved* are typical of Hollywood mood montages.

Just as common are the time-compression montages. We have all seen the montage shorthand for "the election campaign": shots of speech making, baby kissing, spinning newspaper headlines, more speech making, pages of the calendar turning, more speech making. Together this series of shots equals The Long Election Campaign. Many series TV shows open with a montage that condenses the backstory. "The Nanny" starts with a series of cartoons cut to music that show how the main character moved from working in a bridal shop to selling cosmetics to being taken in as a nanny. The opening of "Fresh Prince of Bel-Air" condenses the story of how a ghetto kid came to live with rich relatives, all set to rap music.

Although this technique clearly uses many of the Russian montage principles, it is basically a special device that Hollywood editors use to abridge time without confusing the audience. In effect, conventional Hollywood filmmaking uses montage in exactly the same way that it uses every other editing technique—in the service of the story.

Notes

1. André Bazin, *What Is Cinema?* trans. by Hugh Gray (Berkeley: University of California Press, 1972), pp. 31–32.
2. Jay Ankeney, "Editing with an Eye for Style," *TV Technology,* September 1995, p. 73.
3. The so-called 30-degree rule (discussed in Chapter 5) evolved to respond to this problem.

4. See, for example, François Truffaut, *Hitchcock* (New York: Simon & Schuster, 1967); David Sterritt, *The Films of Alfred Hitchcock* (Cambridge: Cambridge University Press, 1992): and Alfred Hitchcock and Sidney Gottlieb, *Hitchcock on Hitchcock: Selected Writings and Interviews* (Berkeley, CA: University of California Press, 1997).

5. For a systematic classification of time-space relationships and an excellent discussion of traditional narrative editing and alternative approaches, see Noel Burch, *Theory of Film Practice,* trans. by Helen R. Lane (New York: Praeger, 1973), pp. 3–15.

6. See, for example, V. I. Pudovkin, *Film Technique and Film Acting* (New York: Grove, 1970), and *Kuleshov on Film: Writings of Leo Kuleshov,* trans. and ed. by Ronald Levaco (Berkeley: University of California Press, 1974). For a general discussion of the Russian montage experiments, see David Bordwell and Kristin Thompson, *Film Art: An Introduction* (New York: McGraw-Hill, 1993), Chapter 7, and Gerald Mast, *A Short History of the Movies* (New York: Macmillan, 1986), Chapter 8.

7. Eisenstein's combined essays are contained in two volumes: Sergei Eisenstein, *Film Form* (New York: Harcourt, Brace & World, 1949), and *Film Sense* (New York: Harcourt, Brace & World, 1947).

chapter thirteen
Structuring Sound

Structuring sound refers to creating, editing, and mixing different sounds—dialogue, music, and various forms of sound effects. All sounds are manipulated so that they are distinguishable and so that each contributes to the reality and emotion of the movie. Sometimes the process of working with postproduction sound is called sound **sweetening**.[1] Originally, *sweetening* referred to improving sound recorded during production by adding **reverb**, using **equalization**, or in some other way manipulating the sound. However, as time progressed, the meaning of sweetening broadened to include the myriad processes that have become available for sound postproduction. In fact, 85 to 90 percent of what you hear in a movie is added after the movie is shot.

In recent years sound postproduction processes have been changing rapidly, thanks mostly to digital technology. The various production facilities have been experimenting to try to find the most efficient and creative ways to utilize the new technologies. As a recent article in *Mix* magazine states, "Perhaps the most exciting change brought on by the technical revolution in sound-for-film is that there are no more established rules for putting together effects, music, and dialogue elements of a re-recording session."[2]

Variations in Structuring Sound

The number of variations for editing and mixing sound has become almost infinite. In recent years the innovations in this field have been as great as those for video editing, if not greater. Most sound is now structured on tape or within a computer.

However, movie sound, like its picture counterpart, draws heavily on its historical roots.

Magnetic Film Stock Systems

Because movies used to be edited using **flatbeds** (see Chapter 10), some elements of sound, especially dialogue, needed to be reproduced in a form that could be used on a flatbed. This process involved the use of **magnetic film stock.** As you may remember (see Chapter 8), film is almost always shot **double system**: the picture in the camera and the dialogue on an audiotape recorder such as a Nagra. When the picture was edited on a flatbed, the dialogue (and any other synchronous on-location sound) was transferred to magnetic film stock (often shortened to "mag stock"), a recording material that was the same gauge as the film (16mm or 35mm) and had **sprocket holes** down the side so that it could be edited in an exact frame-for-frame relationship with the picture (see Figure 13.1). The transfer from audiotape to mag stock was done with the aid of a **resolving unit** (see Figure 13.2). This piece of equipment locked on to the special sync signal recorded in the field, enabling the mag stock to be synched frame for frame with the picture.

The mag stock was then placed on the flatbed on platters that were right below the platters holding the picture (see Figure 10.4). The platters were **interlocked** so that picture and sound were in sync. In this way the film **workprint** and sound were edited together; if ten frames were taken out of the picture, the same length of material could be removed from the sound track.

In the past, other elements of sound (music, sound effects, narration) would also be recorded on mag stock and these too would be synched to the picture. Then all the reels of mag stock would be taken to a sound mixing facility and loaded on a bank of magnetic stock players (see Figure 13.3) that could be synched to each other and to a projector that displayed the picture. The outputs of these mag players would be sent to an **audio board** where one or more technicians, while watching the picture, would adjust the levels so that they best suited the

240

Figure 13.1
A roll of 35mm magnetic film stock. (Photo courtesy of GCI Group, Inc.)

Figure 13.3
A bank of mag players at a sound mixing facility. (Photo courtesy of Ryder Sound Services)

Figure 13.2
A sound transfer unit. The 1/4-inch tape goes on the top reels and the mag stock on the bottom reels.

movie. The output of the audio board was then recorded on another reel of magnetic film stock that was taken to the lab with the **conformed** negative of the picture. Picture and sound were then placed together on the **release print**.[3]

Magnetic Tape Systems

Sound is now often created, edited, and mixed using equipment that incorporates magnetic audiotape and/or videotape or some form of computer-assisted system. Chronologically, magnetic tape was available before computer systems, and the processes related to it have been highly developed. However, because sophisticated tape mixing systems are expensive, universities have traditionally been quite limited in terms of what they have been able to accomplish in the way of tape sound building. For some, the only postproduction "audio equipment" has been the controls that are part of the videotape recorders. The volume can be changed a bit by raising or lowering the record control on a machine during dubbing or linear editing, but little else can be accomplished. In other university settings, the linear editing equipment incorporates an audio board and some other equipment such as a CD player, making more options available. But videotapes have a limited number of audio tracks (usually only two to four), so complicated sound building is at best difficult.

More effective are audio editing facilities where sound can be edited and mixed on a **multitrack audiotape recorder** that is separate from the VCR and that, as its name implies, can hold many tracks on audio—8, 16, 24, or more. A VCR is still needed in such a configuration. It is used to display the picture so that the audio technicians can use the video as a reference while they make their decisions. These multitrack facilities vary in their sophistication, but at

Figure 13.4

A typical multitrack sound mixing setup. The picture is projected onto a large screen, and several people operate the audio board so that they can mix the various sources properly. (Photo courtesy of Digital Sound and Picture)

the very least they contain a professional audio board with multiple inputs and outputs, a number of pieces of **outboard equipment** (CD players, cart machines, DAT cassette players, music synthesizers), and the multitrack audiotape recorder (either **analog** or **digital**) that can record what comes out of the board. Various sounds (music, dialogue, sound effects) are placed on different tracks of the tape and can then be mixed onto yet another track of the tape. (See Figure 13.4.)

This configuration works best if the multitrack recorder, the VCR, and at least some of the outboard equipment can operate in sync. This is most easily accomplished if all the inputs and outputs are tied to **SMPTE time code** and if a special machine that reads the time code and keeps all the machines running together is part of the system. This machine serves as the "sprocket holes" of the system. Many of these facilities also have equipment that can improve or alter the sound by varying **frequency, timbre, duration,** and other audio characteris-

tics. And they often have special rooms for creating sound in a controlled environment.[4]

Computer Systems

The newest concept in audio postproduction involves digital computer-based sound software. Often what is used for structuring sound, especially at the university level, are the audio tracks of a **nonlinear** video editing system, such as the Avid. These are inexpensive because they are part of the overall editing software, and they allow for much greater flexibility than the limited tape configurations previously used. More and more professionals use these tracks also.

However, when a large number of sounds must be mixed together, professionals sometimes prefer stand-alone computerized audio systems, often referred to as **digital audio workstations (DAWs)** (see Figure 13.5). As with many other pieces of equipment, these vary in capacity, complexity—and price. Some can hold over a hundred channels of audio; others are de-

Figure 13.5

A digital audio workstation. (Photo courtesy of Digidesign)

signed for 24. Audio does not require as much computer storage space as video, but working with a separate DAW helps assure that complex audio can be manipulated easily. Sometimes audio is built in a rather tentative "scratch track" fashion using a nonlinear editing program and then polished on a DAW.[5]

With DAWs or nonlinear editing systems, all sounds are fed into some sort of a computer hard drive where they can be stored and manipulated in nonlinear **random-access** fashion. Unlike video, audio is usually not compressed when it is placed into a computer editing system. In part this is because audio does not occupy as much storage space as video and in part it is because compression degrades the quality of the sound.

What is manipulated to accommodate storage space is **sampling rate** and **bit depth.** An analog signal is a continuous representation of sound whereas a digital signal is a series of on and off (zero and one) pulses that sample the sound wave (see Figure 13.6). The amount of sampling can vary, but the more often a signal is sampled, the higher the quality of the sound and the more storage space it uses. The most common sampling rates are 22 kHz, 32 kHz, 44.1 kHz, and 48 kHz. Bit depth measures that number of tones per sample and is somewhat similar to color in video. Common bit depths are 8-bit, 12-bit, and 16-bit; the higher the bit depth, the better the quality and the more storage needed. As a reference point, CD-quality audio has a sampling rate of 44.1 kHz and a bit depth of 16. Sound placed in a computer at 22 kHz and 8 bits will be good enough to distinguish dialogue in order to edit it but would not be suitable for a final production. In most nonlinear editing systems, the parameters for audio must be set before you start editing—in other words, you must tell your computer what you intend for sampling rate and bit depth. Changing these parameters after you begin editing can cause long delays or computer crashes because

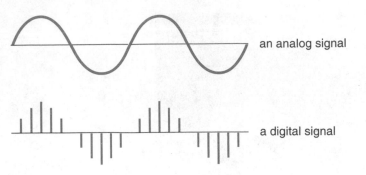

an analog signal

a digital signal

Figure 13.6
The analog signal is continuous. The digital signal samples the sound wave.

Figure 13.7
Waveforms of the audio tracks are visible on the computer screen and make it easier to edit the sound. (Photo courtesy of Editing Machines Corporation)

your computer is trying desperately to recalculate the parameters each time it deals with audio information.

Although sound is not usually compressed for computer editing, it must be digitized, just as the video footage must be digitized. If the sound is already in digital form (a CD, a DAT tape, the audio track of a digital videotape), it can go directly into the computer. If it is in analog form, it must be converted to digital through a digitizing board. Or you can simply dub the analog audio to a DAT tape and input from that.

Editing is where the flexibility of the computer really shines. The audio tracks can be dragged from a **bin** or a **library** or a project screen and placed on the **timeline**, right by the video tracks.

The same general principles apply for selecting and trimming audio clips as for manipulating video clips. You create inpoints and outpoints; you layer sounds on different tracks; you use "rubber bands" to fade music in and out; you cut, paste, trim, repeat, delete, and so on. You can separate the audio from the video in order to reposition it or you can lock it with the video so that the two are not accidentally taken out of sync. You hear the audio on sound monitors just as you see it on picture monitors, and you can preview and review your sound as often as you want. Everything is **nondestructive,** so if you need some sound you have eliminated, it is still there. "Undo" will get you out of a mess with audio, just as it will for video. One of the particularly helpful audio features of most nonlinear editing systems is the availability of **waveforms** that show a visual representation of the sound (see Figure 13.7). With waveforms you can see exactly where a sound begins, ends, increases in volume, and so on, so that you can make precise edits. Some nonlinear programs provide audio **filters** or other special effects—you can change a voice to sound like it is coming over a telephone; you can take one voice and make it sound like many; you can create an echo.

Once you have edited, refined, and mixed your audio, it is "printed" out of your computer along with the video to tape, video disk, CD-ROM, the Internet, or wherever its destination. Your audio editing decision, along with your video editing decisions, can be placed on a floppy disk and taken to an on-line system.

Digital technology is now used extensively in the creation, recording, and manipulation of sounds used in movies.[6] In the remainder of this chapter we will discuss the different types of sounds that might be present in any movie and tell how they might be handled using different types of equipment. We will then cover the mixing function, showing in detail how it is undertaken with the various forms of sound structuring.

Dialogue

Dialogue is edited with the picture using methods and techniques discussed in Chapters 10,

Figure 13.8
A Jaz drive. (Photo courtesy of Iomega® Corporation)

11, and 12. However, in many situations the dialogue is copied onto a tape or disk that is separate from the picture to make sound editing and mixing easier. Rerecording dialogue in this manner is referred to as **laydown.**

If tape is used, it is usually a ¾-inch, ½-inch, or 8mm videocassette tape that is used solely for audio. In other words, no picture is recorded on the tape; the whole tape is used for the audio and its accompanying time code. This, plus the fact that the audio is recorded digitally and diagonally using the **pulse code modulation (PCM)** method, makes for high-quality sound.

If a computer-based audio system is used, the dialogue is copied to a computer disk that stores it until it needs to be edited, mixed, or sweetened in some other way. Sometimes this sound is stored on the hard drive within the computer and sometimes it is stored on a removable hard drive such as a **Zip drive** or **Jaz drive** (see Figure 13.8). Storing it on a removable drive has the advantage that the sound from one movie can be removed from the computer and the sound for another movie can be loaded onto it. In this way several movies can use the same computer system, each being edited at different hours of the day.[7]

At some point all the dialogue that was recorded during production but is not being used for the final movie must be eliminated. When mag film stock was the primary sound postproduction medium, the extra dialogue was cut out, rolled up, and stored in boxes in case it was needed later. If a multitrack recorder is being used for the audio mix, all the audio takes that are going to be needed can be transferred from the ¾-inch (½-inch, 8mm) tape to one track of the multitrack tape, along with the appropriate time code. This will then be synced to the picture when the final mix takes place. The sound that was recorded during production but is not going to be used is simply left on the ¾-inch tape, where it can be retrieved if needed. With computer-based editing, the dialogue that is not being used can be deleted from the disc at any point, but unless the dialogue is taking up needed storage space, there is no compelling reason to do so.

Automatic Dialogue Replacement

If dialogue recorded during the filming or taping process is of such poor quality that it cannot be used, then it must be rerecorded. Today, this rerecording process is called **automatic dialogue replacement,** or **ADR,** sometimes referred to as **looping.**

On occasion, scenes are shot with the idea that ADR will be used. For example, a certain camera angle might make it impossible to place the microphone properly in the shot, or very fast movements by the actors might make them sound unnecessarily out of breath. In these instances, everyone knows the dialogue must be recorded later.

In other instances, ADR is needed because of mistakes that were not caught at the time of shooting—an airplane flying overhead during a Civil War movie or the university chimes ringing during the master shot but not during the close-ups that are to be intercut with it.

After the movie is shot, someone needs to **spot** for ADR. This involves looking at and listening to (on a high-quality speaker) all the footage, logging places where ADR will be needed. Of course, if the shots with bad audio are not going to be used in the final version of the movie, there is no reason to redo them. Also, sometimes the person who is spotting can find good audio of the same dialogue on a **take** that is not being used in the final movie but that can work with the scene that is going to be used.

ADR is an expensive, time-consuming process, so the less of it that needs to be done the better. It requires bringing the actors back for a session in a special soundproof room where

Figure 13.9

An automatic dialogue replacement session is anything but automatic. The woman by the podium is rerecording some dialogue. (Photo courtesy of Ryder Sound Services)

they watch short segments of themselves on a screen and listen through earphones to the audio that needs to be changed. They rehearse the lines until they feel they can deliver them in sync with their lips as seen on the screen. When they are ready, they record the lines into a microphone. Then they go on to the next few lines and rehearse and record. This goes on until all the necessary dialogue replacement is completed. (Figure 13.9 shows an ADR session.) If ADR needs are minimal and not tightly tied to a picture, an actor can repeat the words at a distant location and send them over a high-quality phone line to the postproduction facility.

The ADR used to be referred to as looping because individual loops of magnetic stock had to be cut for small segments of sound, usually a sentence. These loops would be played back, and the actors would rerecord one loop at a time. Then these loops had to be spliced back together in sync with the picture. As magnetic sound recorders improved and as audiotape recorders began to be used for rerecording dialogue, these individual loops were no longer needed, and longer segments could be dealt with at one time. At this point, the term *automatic* was devised to describe the dialogue re-

placement, although a great deal of tedious manual work still goes into ADR. In truth, there is nothing very automatic about automatic dialogue replacement. Some computer postproduction audio programs make it possible to create "loops" easily because the computer can be used to mark beginning and ending points of what needs to be replaced, can repeat the material over and over, and then can record and delete as often as needed. But still, the actor has to get it right.

Once ADR is complete, the new dialogue is substituted in the sound track for the poor dialogue. This can be done by recording the new dialogue over the old on the master, the workprint, the separate audiotape made during laydown, and/or the computer disk. However, the dialogue recorded by ADR often sounds different from the other dialogue because it was recorded in a soundproof studio and the other dialogue was recorded in the field. So somewhere during the mixing process, field sounds need to be mixed with the new dialogue. For that reason, ADR often is not actually laid over the original but is kept separate so that it can be manipulated later in the mixing process. Its position within the movie is carefully logged so that it is easy to find when it is needed.

Some actors are better at rerecording dialogue than others, but all actors should be brought back for these sessions as soon as possible after shooting is completed. Their memory of the production experience will still be fairly fresh, and they are less likely to be off somewhere shooting another movie.

The voices for dubs into foreign languages are usually done as though they were ADR. The people doing these must, of necessity, become adept at the process.

Students rarely have the luxury of replacing dialogue. Most colleges do not have facilities for ADR, so the solution is to record the sound properly in the first place.

Voice-Over

Voice-over (VO) also involves adding words after the fact, but because it does not involve lip

sync, it is a much simpler process than ADR—and one that students can usually accomplish fairly easily. Voice-over can be used for any number of reasons—someone's conscience talking, someone's thoughts. The most common use, however, is narration—commenting on what is occurring in the picture.

Once a movie is edited, VO can be recorded in the same facility as ADR, or it can use any soundproof room where the picture can be shown on a monitor. The performer watches the picture and reads the narration or other form of VO at a pace that matches what is on the screen. When what is being conveyed through words is the dominant element, the voice-over sometimes is recorded before editing, and the picture is then edited to the narration. In this case, the recording can be done just about anywhere because there is no need to play back a picture.

Narration can be recorded directly onto a master videotape simply by plugging a mic into one of the input channels of the VCR. This has certain disadvantages, however. If the talent stumbles over a word or makes some other mistake, the recording has to be stopped. The recording can be started over again from the beginning, or from a spot where an edit is executed. The former can be a time-consuming process, especially if the error is near the end of the recording. The latter is difficult to do smoothly because the pace of the narration is likely to change, or a word may sound cut off. Also, if music, dialogue, or other sound elements are to be mixed with the voice-over, the relative levels may be hard to control if the recording has been done on the master tape.

A better way to undertake voice-over is to record it on a separate audiotape that can be mixed and added later. If a multitrack recorder is going to be used, the voice-over can be recorded on one of the tracks. Likewise, a VO can be recorded directly to computer disk. One of the advantages of recording it on a computer is that if minor changes are needed when picture and narration are joined together, they are easy to accomplish. For example, if the narration runs a second longer than the picture, small portions of the silence between words can be deleted so that the narration becomes the right length.

For linear editing the narration can be recorded on a separate videotape. In this way, the narration can be on a source tape that is edited onto the master tape in the audio-only mode. If errors occurred and the narration was recorded in segments, these segments can be previewed before they are joined together. If need be, they can be trimmed so that the pacing is smooth on the final edited version.

Of course, in earlier times voice-over could also be recorded on magnetic film stock. Compared to ADR, voice-over is usually a fairly simple process, but as with all other aspects of sound, it must be carefully monitored so that it is completed properly. Mistakes should be corrected during the recording session, before the talent has left.

Sound Effects

Some **sound effects** are taped or filmed during production, and others are found and added after production. Both need to be handled during the postproduction stage. First, someone needs to verify the usability of the sound effects taped on location. Does the car's backfire actually sound like a backfire, or does it sound more like a cannon? Often, sound effects taped on location need to be replaced or at least improved. Those that are of good quality and that are intrinsic to the action can be left on the dialogue track and edited along with the picture and dialogue.

Once picture and dialogue (and limited sound effects) are edited, someone needs to look at the entire movie and spot all the places where additional sound effects are needed. This person makes up a **spotting sheet** that indicates at what point in the movie the effects should be placed (see Figure 13.10). Often, the person will make a note as to whether or not the sound needs to be synchronous. The sound effect of a dog barking off-screen is much easier to execute than a dog barking on-screen because the off-screen barks do not need to be in sync with the dog's mouth.

After all the sound effects are listed, they need to be found. Some of this hunting can start

Figure 13.10
*A spotting sheet used to
list various sound effects
that will be needed for a
movie sound track.*

SPOTTING SHEET

Project Title ___The Event_____ Page Number ___4____

Spotter ___Al Marcino_____ Date Prepared ___10/21___

Item	Sync/ Nonsync	In Time	Out Time	Description
1	NS	01:42:15:10	01:43:12:09	Airplanes taking off
2	NS	01:45:26:29	01:46:15:12	Muddled voices
3	S	01:49:52:12		Door slam
4	NS	01:49:52:12	01:53:05:05	Traffic noises
5	NS	01:54:03:27	01:56:22:17	Restaurant noises
6	S	01:56:13:25		Gunshot
7	NS	02:03:14:23	02:04:03:10	Phone ringing
8	NS	02:10:52:12	02:11:01:24	Glass breaking
9	NS	02:11:27:03	02:12:04:19	Dog barking
10	S	02:12:46:18		Glass breaking
11	NS	02:15:33:16		Thunder
12	NS	02:16:12:15	02:19:22:04	Rain, wind, and thunder
13	S	02:21:45:23		Car backfire
14	NS	02:21:50:20	02:23:47:04	Children playing
15	NS	02:23:47:04	02:26:33:12	Ocean waves
16	NS	02:24:55:23		Thunder
17	NS	02:26:10:10		Thunder
18	S	02:30:12:14		Hit glass
19	NS	02:33:05:06	02:34:55:07	Dogs barking
20	NS	02:35:12:14		Door slam
21	S	02:36:36:11		Door slam

as early as preproduction because the script will indicate many of the effects that are needed. The best source is sound-effects CDs. These are available in audio stores, but most production companies and many universities have libraries that include not only commercially available sound effects but also effects that have been specially taped for previous productions.

If some unusual effect cannot be found or if the effect on a CD just won't sync with some-

thing on-screen, a crew may need to go out and tape that particular effect. If these needs can be anticipated during production rather than left for the postproduction stage, the sounds can be taped while principal photography is being completed. This saves time and money.

Some facilities, especially those using computer-based audio, can create sound effects from digital samplers. These consist of recordings of various sounds that can be changed to sound like something else. By manipulating such characteristics as pitch, volume, and timbre, a door slam can become an explosion or raindrops can become machine-gun fire. A dog's bark could also be slowed down or speeded up to fit with the action of the scene.

Once the sounds are located, they must be recorded so that they can be used during the sound mix. Sometimes, especially for linear editing, a tape sound-effects reel is built, a process that is similar to that used in the past for magnetic film stock editing. The sound effects are placed on a separate audiotape in the order needed. Then they are dubbed onto one of the tracks of the master videotape, or they can be recorded on a source videotape so they are previewed and edited onto the master videotape (the process that was described for voice-overs).

For multitracking, the sound effects can be placed on one track of the tape, positioned in such a way that they will sync with the video. Time code is essential for this process. With computer-based audio, the sound effects can be recorded on the computer disk in any order. Then they can be brought in as needed—a gunshot to accompany the pulling of a trigger, a door slam as a person exits. The beauty of doing sound effects with computer programs is that the effects can be manipulated very easily. Because the computer screen displays waveforms, it shows exactly when each portion of an effect occurs. If the effect comes in a little too soon, it can be moved slightly with a few clicks of the mouse. Some computer audio programs include a sound-effects library. When some particular effect is needed, the random-access capability of the computer allows quick access to it. Sound effects are so easy to do on a computer that sometimes they are added to the **rough cut** of the dialogue and picture so that

the director (producer, client, and so on) can have an idea of how they will be incorporated in the final version of the movie.

If the picture calls for a large number of effects to occur simultaneously, several sound-effects reels will be made (or several tracks on a multitrack tape will be used). If the number of reels or tracks becomes excessive, a **premix** is needed to combine some of the effects before the final mix.

The person in charge of sound effects should keep close track of where they came from and how they are going to be used. This is essential information, especially if something doesn't work during the final mix.

Foley

Foley work involves a special type of sound-effects recording. The person spotting a movie for sound effects usually also spots for Foley. An unusual sound effect, such as a hyena laughing, that cannot be found on a CD can be created in a Foley room, but the word *Foley* is more often thought of in terms of background sounds such as footsteps, clothes rustling, and branches waving in the wind.

The Foley process is named after Jack Foley, the man who designed the room in which Foley activities take place. This room contains a large screen, several mics, a number of sound-effects devices, and many walking surfaces—gravel, sand, dirt, cement, carpet, hardwood floor (see Figure 13.11). A Foley room often contains a variety of cloth that can be rustled to simulate people walking past furniture, water to be poured from one container to another, twigs and branches to be snapped, dishes and utensils to be jiggled, and a variety of other articles.

People called **Foley walkers** watch the movie being projected onto the large screen and perform the acts needed to provide synchronous sound for the actors' movements, recording them all through properly positioned microphones. For example, if the movie shows an overweight man walking on dirt in tennis shoes, the Foley walker will put on tennis shoes, place the mic by his feet, and walk heavily in the dirt pit in step with the man on the screen.

Figure 13.11

A Foley room setup. The two Foley walkers are using the various pits and equipment to perform, in sync, the sounds that should emanate from the picture on the screen. (Photo courtesy of Ryder Sound Services)

In addition, Foley walkers clap their hands, scream in terror, slap faces, or fall for fight scenes. Most Foley walkers are very graceful; in fact, many of them are dancers or ex-dancers.

Someone (usually the person in charge of sound effects) prepares a Foley setup sheet for the Foley walkers. This lists all the actions they need to perform for the movie (see Figure 13.12). Foley walkers use it to determine whether they have all the supplies they need. For example, if the setup sheet calls for wind chimes, they might need to purchase or request some.

Foley walkers sometimes work in pairs—a man imitating men's movements and a woman imitating women's movements—but sometimes they work alone and do the actions of each character in the scene in turn. A technician usually sits in an adjoining room and records all the sounds on an audiotape that is synced with the picture. This later becomes the Foley reel used in the final mix. Or the sounds can be recorded on a computer disk.

Computer-based audio lends itself very well to Foley. The sound of one footstep can be placed in a computer, and the audio characteristics of that footstep can be manipulated so that it can take on just about any sound—an overweight man walking on dirt in tennis shoes, a woman in high heels on a pavement, a horse galloping through a field. What's more, the step can always be placed in perfect sync. Computerized Foley is usually created by someone hitting a key on a piano keyboard that is attached to the computer. The sound (for example, the click of a woman's high heel) is created and programmed to occur whenever someone pushes middle C on the keyboard. A person watches the movie and plays middle C each time the woman's shoe hits the pavement. The harder the key is hit, the heavier the sound will be. If the person misses and gets one or two of the steps out of sync, he or she can later correct this mistake by looking at the computer screen waveform and moving the step to the right position. A number of Foley effects can

FOLEY SET UP AND LOG

Program _The Top_ Date _11/4_

Foley Walkers _Susan O'Donnel Jack Washington_

Time Code	Track 1	Track 2	Track 3
00:20:03:40	Maribel walking (red shoes, concrete)	Jim walking (tennis shoes concrete)	
00:25:00:00	Maribel's dress rustles (silk)	glasses clink (white plastic glasses) / dishes move (fork and plate)	candle is lit (match)
00:30:00:00	waitress walks (brown shoes carpet)		customer knocks on door (screen door)
00:35:00:00		coffee is poured (water, pitcher, cup)	

Figure 13.12

A Foley setup sheet to indicate what sounds should be made at which points in the movie and to list the materials needed to make those sounds.

be created at once. A man's footstep on dirt could be programmed into A above middle C; the clink of a glass could be accessed from G-sharp. Someone "playing a keyboard" can cre-ate as many effects as hand-eye coordination will allow. In fact, sometimes creating effects is like playing the piano. Glass clinks that are low-pitched could be programmed into the

bottom of the keyboard and could become progressively higher pitched with each note that progresses toward the top end of the keyboard. The person creating effects plays the various keys depending on the size and shape of the glasses being clinked.

Traditionally, student productions have incorporated very little Foley work because of the complexity of the setup, but the little touches provided by Foley are often what differentiate, at a subconscious level, a professional motion picture from a nonprofessional one.

Ambient Sounds

Ambient sounds also differentiate professional movies from nonprofessional student ones. However, in this case, students can easily add ambient sounds if they take the time to record them in the field.

Room tone and/or **walla walla** are often mixed into the final audio so that there will be a consistent background sound for all shots from one location (see Chapter 9). A master scene may be shot in a building on a hot day when the air-conditioning is operating, and the close-ups may be shot on a cool day when the air-conditioning is off. When cuts are made from master shot to close-ups, the lack of the air-conditioner sound will be noticed. If room tone was recorded on the first day, the air-conditioning sound can be added to the close-ups. Likewise, walla walla of voices in a restaurant could be used to cover the sterile background sound that might occur from taping in that restaurant when it was closed. Room tone and walla walla are invaluable when dialogue is replaced. The background noise level of the soundproofed ADR room will be very different from the inherent sound of the location.

Ambient sounds can also add to the atmosphere of a particular location. A brook flowing near a field will probably not record very loudly on the dialogue track, but if it is recorded by itself, it can be mixed in at a louder level, giving a more bucolic feeling to a scene. In fact, even if there is no brook flowing near the field,

the illusion of one can be achieved by adding a brook sound taped somewhere else.

For tape-based sound mixing, ambient sounds are often recorded onto a continuous loop of tape so that they can be brought in at any time during the mix. If they are part of a computer audio system, they can also be repeated endlessly. They are never synchronous, so they do not need to be timed and placed as carefully as other sounds. They do need to be listened to carefully, however, to make sure they do not contain some recurring noise. A ten-second loop of outdoor sounds that contains several recognizable bird chirps can become humorously distracting if it is played over and over during a two-minute scene.

Sometimes these atmosphere sounds are found in sound-effects libraries, and sometimes they are specially recorded. Of course, someone must spot the film to determine where they are needed. Usually, one person can spot for sound effects, Foley, and ambient sounds.

Music

Music for theatrical movies, corporate videos, multimedia productions, or documentaries can be obtained a number of different ways. Professional moviemakers usually hire a composer to write music specially for the various scenes of the movie. However, music that has been recorded previously can also be used. Sometimes this is popular music that needs copyright clearance, sometimes it is music that is so old it is in public domain, and sometimes it is stock music that comes from special libraries of copyright-cleared compositions.

Original Music

When a composer is to write music for a picture, the first chore is spotting the movie to determine where music is needed. This spotting should not be done at the same time as spotting for sound effects, Foley, ADR, and/or ambient sounds. Spotting for music involves a very different process that generally has nothing to do

with the quality of the previously recorded sound.

The picture and dialogue almost always are totally edited before anyone begins to consider the music. There is little sense in planning music at the raw footage stage because the music must fit precisely with the action as it appears in the final edited version. One of the problems inherent in this process is that the composer is usually under intense time pressure. The movie has been edited, and people are almost ready to begin the sound mix, but this cannot be accomplished until the music is finished. The composer is the last person in the postproduction process.

Usually, music spotting is a joint project of the director and the composer. However, this is not always the case. The director or someone else can determine where music should be placed and then send that information to the composer, who determines the actual notes, rhythm, melody, and other musical elements.

Traditionally in film a composer was given a copy of the edited film workprint to use as a guide for composing. The spots where music was to start and stop were marked on the workprint with a diagonal pen line called a **streamer.** Obviously, videotape cannot be physically marked, but composers can use a computer program that ties a videotape workprint to computer graphics and places a computer-generated streamer at the beginning and end of each section of the movie in which music will be required. Many composers use their VCRs to watch the tape while composing at home.

Composers also used to use a **click book** as an aid to writing music for movies. This helped a composer figure out how many measures to compose for a certain length of movie according to the tempo of the music. In other words, if a section of the picture needing music was two minutes long, the click book told the composer how many measures to write if the music was in 3/4 time at a slow rate of 60 beats per minute or if it was at some other rate, such as 4/4 time, at 150 beats per minute. This book has now been superseded by computer programs that calculate and display this information easily.

Once the music is spotted, the composer can begin to create the music. Whether this spot-ting is completed by the composer or by someone else, the spotter usually prepares a **timing sheet** to aid in the composition process (see Figure 13.13). This sheet gives **time code numbers** for the places where music is to be heard, tells the length the music is to run, and gives a description of what is happening in the scene. The composer uses this as a guide for completing the job, making sure all music is the right length and conveys the mood of the visual material.

Sometimes, composers both write and record the music. This is especially true if the music can be played with a synthesizer, drum machine, and other electronic equipment. Since 1983 musicians have been using **musical instrument digital interface (MIDI)**, a technical standard that allows electronic instruments to interact with each other. For example, a musician playing a melody on an electronic keyboard can use MIDI to coordinate, select, start, and stop the rhythm that is coming from a drum machine. In the late 1980s MIDI met SMPTE time code, and now MIDI-based music can easily be incorporated in videos. The MIDI commands coordinate (*shake hands* in computer terminology) well with computer audio systems (see Figure 13.14).[8]

A fair number of computer programs exist to help composers create music.[9] (See Figure 13.15 and Color Plate 10.) For some of these the music is stored on the computer hard drive. For others only the commands that activate the electronic instruments are stored within the computer; these **triggers** store and convey information such as pitch, volume, and timbre. Other computer programs are designed to store triggers and samples of digitally recorded instruments or voices. The main difference is that some programs are made to be used with digital audio workstations that have very large storage capacity while others are designed as programs to run on personal computers with more limited capacity. For example, storing the triggers for a snare drum for a three-minute piece of music might take about 15 kilobytes whereas putting the snare drum itself on the hard drive would use up about 15 megabytes— a thousand times more space.[10]

Figure 13.13
An example of a timing sheet, which goes to a composer as an aid for writing the music. The actions taking place and their durations are specified so that the composer can work (at least some of the time) without actually watching the movie.

```
                        TIMING SHEET

TITLE: Up in Arms

DATE: November 4, 1990              START: 00:50:03:21

CODE            TIME                DESCRIPTION
                                    Max and Oliver enter the room and
                                    glare at Maggie.

00:50:03:21    :00:00:00           Music starts as Maggie moves toward
                                    the sofa.  The camera follows her
                                    as she sits and stares at the two
                                    men.

00:50:10:23     00:07:02           CUT to MS of Oliver.

00:50:12:21     00:09:00           Oliver: You don't seem to be
                                    showing no respect.

00:50:13:24     00:10:03           Cut to CU of Maggie.  Maggie: Why
                                    should I?

00:50:14:25     00:11:04           Cut to CU of Max glowering.

00:50:15:22     00:12:01           Max: That really ain't a smart way
                                    to talk to two nice gents like us.

00:50:17:02     00:13:40           Music swells as a LS reveals Oliver
                                    and Max moving in closer to Maggie,
                                    who is still sitting on the sofa.

00:50:27:00     00:23:38           CU of Maggie looking frightened.

00:50:29:04     00:25:42           MS of Max and Oliver.  Music stops
                                    abruptly.  Max and Oliver laugh an
                                    evil laugh.  Max: That's all for
                                    this time, babe, but next time you
                                    don't get off so easy.
```

The MIDI-SMPTE-computer liaison has simplified much of the movie music composition process. For some TV shows and movies the music is spotted in Hollywood by a person with musical training, and the timing sheet and a VCR copy of the entire movie (or just the parts that need music) are sent to a composer in another state. The composer writes and performs the music and sends it back to Hollywood on an audiotape or disk or over a high-quality phone line. This material then is used for the audio mix.

At other times a composer writes the music, and an orchestra or other musical group performs it. In these cases the composer must know how much is budgeted for the music so that he or she does not write for more musicians than the picture can afford. When the music is recorded, the musicians gather in a recording studio that has a large screen onto which the movie can be projected. A conductor (often the composer) leads the orchestra while watching the movie on the screen. This ensures that all the passages will be the right length. Techni-

cians in a control room record all the music. The miking and recording techniques used for recording are similar to those used for miking and recording live musicians during the production phase of moviemaking. Mics can be set up for **monaural, stereo,** or **surround sound.** The whole orchestra can be recorded at one time, but more often multitrack recording is used so that the instruments can be balanced later (see Chapter 9).

Overall, composing and recording music is a complicated job that involves many stages. However, audiences have come to expect music in movies, and it contributes to the overall effect of the picture.

Figure 13.14

A digital audio editing suite with a synthesizer and DAW. (Photo courtesy of Digital Sound and Picture)

Previously Composed Music

To lessen the hassle (and sometimes the cost) of having music specially composed and recorded for a movie, musical selections that have already been written and recorded can be used. These include popular songs of the day (or yesteryear). Sometimes these are needed because they help establish a particular time or place. A scene set in the 1960s might be enhanced by a Beatles song of that era. Jazz could help establish a New Orleans nightclub. More often, though, such music is used because it matches the mood of the movie.

Most previously composed music needs copyright clearance. This is often a time-consuming and expensive process. Music that is old enough to be in **public domain** does not need copyright clearance, but often special arrangements of it are not in public domain. In these cases, the arrangements need copyright clearance.

Because of the difficulties involved both in composing original music and using already composed popular music, a number of libraries offer copyright-cleared music for a nominal fee.[11] Many of these now deliver the music over the Internet. Anyone choosing to use this music can be assured that it does not need copyright clearance or payment; either it has been specially written and recorded for the library or it is in public domain. These libraries often also categorize the music—chase music, romance music, dinner music. The problem with many of these

Figure 13.15

A screen from the computer program Cakewalk, which can be used to assist people who are composing music. (Photo courtesy of Cakewalk Music Software)

music libraries is that much of their music is uninspired; it all sounds more or less the same. One of the difficulties with using any type of prerecorded music is fitting it into the allotted time. Because it was not specially composed to fit a certain set of actions, it will not necessarily end when the action ends. Sometimes it is more difficult to try to find music that fits a scene, both in terms of time and mood, than it would be to have it specially composed.

Students often find it easier to use prerecorded music because they do not have elaborate recording facilities at their disposal. However, with MIDI-based electronic equipment readily available and with music departments on most campuses, specially composed music is becoming more prevalent.

Mixing

After all the various elements—dialogue, voiceover, ADR, sound effects, Foley, ambient sounds, and music—are found and recorded, they must be mixed together. The process of doing this varies according to the type of postproduction equipment being used. Multitrack recording has more steps (and more flexibility) than VCR-to-VCR recording. The computer-based editing systems have great flexibility for little cost.

Limited Mixing

The least flexible of all sound editing involves transferring sound from the source VCR to the edit VCR, as is done in linear editing. About the only type of sound manipulation that can take place is varying the volume. Usually, this procedure does not really qualify as "mixing" because only one source of sound (usually dialogue) is transferred. Although this VCR-to-VCR process is common (and appropriate) for news and talk shows, it generally proves unsatisfying for narrative forms because there is little possibility for music and sound effects.

VCR-to-VCR flexibility can be improved slightly if the dialogue from the source VCR is sent to one channel of the edit VCR and the output from a cassette recorder is sent to another channel. In this manner, music and voice can be mixed together. However, determining the relative volume of the two sources can be quite difficult. It is all too easy to mix in such a way that the music totally overpowers the dialogue.

One step better is to route various audio sources through an audio board to the VCR. Dialogue from the source machine, music from a cassette, sound effects from a CD, ambient sound from a cartridge loop—each can be wired to a separate channel of an audio board. Then they can be raised to the proper volume level and mixed together as the master VCR tape is being edited. However, bringing in the right elements at the right time can be quite difficult. Sound effects of a door slamming must occur as the door closes. If the audio operator does not hit the play button on the CD at the precise moment, the effect will be out of sync. However, movie sound that is not overly complicated can be mixed successfully with a little practice.

To make the process a little less harrowing, sounds can be mixed onto a separate videotape instead of the master. This tape can then be used to edit the sounds onto the master in the linear audio-only edit mode. This allows for more control because edit-in and edit-out points can be set; a proper edit is not dependent on someone cuing up a CD or bringing in an audiotape at the right time.

One definite limiting factor of dealing with VCR audio tracks is that most videotape formats have only two or three tracks. Even Betacam has only four audio tracks. If something is to be mixed in stereo, track flexibility is very limited. Surround sound, which usually has at least six outputs, is, of course, impossible.[12]

Professional-Level Multitrack Tape Mixing

Movies, music videos, multimedia productions, corporate videos, and other professional-level productions use audio mixing facilities that allow for greater control and accuracy than those discussed previously.

They often use a number of audio players (one for music, one for sound effects, one for ambient sound, and so on), an audio board, and the master videotape. But all the tapes will contain time code, and all will be locked together by synchronizing machines that read the time code.[13] This is similar to the process long used for films—the one that involved many reels of magnetic film stock being mixed down to one. However, instead of being governed by sprocket

b

Figure 13.16

(a) A twenty-four-track analog multitrack recorder that uses 2-inch tape and (b) an Emmy-award winning digital cassette recorder (Photos courtesy of TASCAM, TEAC Professional Division)

a

holes, the tapes are governed by time code. When the master VCR advances five seconds, each audio player also advances five seconds.

Other times, all sound will have been recorded on one multitrack tape, with each sound occupying a different track and the all-important time code placed on a separate track. These sounds could have come from a wide variety of sources—Nagra for dialogue, DAT for music, CD for sound effects, audio cart for walla walla, DAW for Foley.

Originally these multitrack recorders were analog, but now many of them are digital—a definite advantage because the sound will not degrade as it is rerecorded. A wide variety of brands and types exist; some use 2-inch tape while others use ½-inch or 8-millimeter tape. Analog recorders traditionally had twenty-four tracks; digital recorders tend to have fewer tracks because the sounds can be combined a number of times without losing quality[14] (see Figure 13.16).

Usually the first step in this professional-level multisource mixing process, be it multi-track or separate sources, involves playing back the picture and sounds without regard to the relative volume of sounds. This allows someone to make sure that all the sound elements can be brought in at the right time and are the right length. This process is referred to as **interlock** or **lock-up.**

Before mixing occurs, someone prepares a **cue sheet.** This lists all the different sources of sound and indicates when each should be brought in and taken out of the sound mix (see Figure 13.17). This is really a compilation of all the spotting sheets that have been prepared.

One of the main purposes of the mix is to rerecord all the material so that each sound is at the right relative volume. In order to undertake this mix, each sound source is routed to a different input on an audio mixer. The mixed sound can be fed from the board to a master videotape or, more commonly, to a multitrack audiotape. Time code is laid down on the multitrack tape for synchronizing the various elements. Usually, time code is placed on the bottom track, and the track above it is left blank because time code has a tendency to bleed over into the tracks near it.

In multitrack recording, how the output tape is actually handled varies from situation to situation. Sometimes each sound is rerecorded on a separate track of the multitrack tape. (Figure 13.18 shows the various sounds that might appear on a twenty-four-track multitrack tape.) The only major difference between the input and the output is that the volume of each sound has been adjusted so that it meshes correctly with volumes of other sounds. At other times various sound elements are mixed together so that the multitrack tape contains only three or four tracks, perhaps

CUE SHEET

Production: _Away with Time_ Date: _9/17_ Editor: _Peterson_

Track No. 1 Dialogue	Track No. 3 Music A	Track No. 4 Music B	Track No. 6 Effects A	Track No. 7 Effects B
	2:15 <		2:15 fire, crackles in fireplace.	
2:31 Peter: Try				
				2:41 glass breaks in fireplace
2:47 (last word) think.				
2:49 Susan: No				
3:15 (last word) today				
	3:21 ⟶	3:21	3:21 wind	3:21 rain
	4:45 <	4:45	4:45	4:45
4:47 Peter: Someday				
5:06 (last word) gun	5:06		5:06 gun shot	

< = fade in > = fade out ⟷ = segue (dissolve)

Figure 13.17

A cue sheet used during the mixing session. It indicates when each sound should be taken in and out.

one for dialogue, one for music, and another for everything else.

Several technicians sit at the audio console working with the various sounds as indicated on the cue sheet. They work cooperatively so that the overall sound is balanced properly. If the music is overpowering the dialogue, they may lower the music, raise the dialogue, or do a little of each. Many sound technicians prefer that all sound be recorded originally at approximately the same volume level so that they know what to expect and can plan changes more easily. Modern boards have memory so that the levels of the different inputs can be stored and called up again. In this way, the people mixing sound can try one combination, store it, try another combination, store it, and then compare the two and select the one that sounds best.

Depending on the equipment available in the recording facility, sound mixers may also enhance the sound. For example, if scratchy sounds are evident in a sound effect, they can use an equalizer to help remove the frequencies where the scratches occur. If the dialogue sounds lifeless, they can use a reverb unit to give it some bounce. Some recording facilities include **room simulators**. These can be used to create room tone of various-sized rooms, which is helpful if proper room tone was not recorded originally.[15]

The whole mixing procedure depends on the complexity of the movie and to some extent on the philosophy of the director and those charged with obtaining proper sound. Some people like to split dialogue onto several tracks—perhaps one for master scenes and another for close-ups or one for the male lead and another for the fe-

male lead. They do this because they feel those types of sounds need different treatment in terms of such factors as equalization and reverb. Others keep all dialogue on one track in order to simplify the mixing process. Some like to have all the original dialogue available, not just the dialogue that was used in the edited version. That way, they can go back to the original if some of the processed sound is not to their liking.

Sometimes several sound effects tracks are needed because various effects are heard at the same time. Some people like to do a premix of sound effects so that they are already mixed at the proper relative levels for the mixdown. If **crossfades** from one music source to another occur, several music tracks will be needed, unless, of course, these crossfades have been premixed. In general, some people think that the more tracks there are, the easier it will be to mix, whereas others think just the opposite.

Multitrack mixes are usually done in stereo or surround sound rather than in monaural. In these cases, various tracks can be assigned different sounds that will eventually be heard on different speakers. Usually effects are recorded so they will appear to come from the left and/or right. Dialogue is made to sound as though it is coming from the center because people who are talking are generally center screen. Music can be right and left channel, according to how the music was recorded. For surround sound the ambient sounds are usually the ones recorded on tracks that will play back through the speakers positioned around the room.

In the mixing session short segments of the movie are rehearsed over and over until all the sound mixers agree that they have the proper levels and enhancements. Then that section is recorded, and another section is rehearsed. Eventually, all the sound is transferred from the various audio inputs to the single tape on which the mix appears.[16]

Computer-Based Mixing

When sound is manipulated on a computer, the line between editing and mixing blurs. Because all the sounds are on different tracks of the timeline, they can be mixed while they are being positioned.[17] If the music is to crossfade

Track	Sounds
1	Original production dialogue
2	Foley 1
3	Foley 2
4	Edited dialogue 1
5	Edited dialogue 2
6	ADR 1
7	ADR 2
8	Ambient sounds 1
9	Ambient sounds 2
10	Walla walla
11	Sound effects 1
12	Sound effects 2
13	Sound effects 3
14	Music 1
15	Music 2
16	Music 3
17	Dialogue mix—right channel
18	Dialogue mix—left channel
19	Music mix—right channel
20	Music mix—left channel
21	Effects mix—right channel
22	Effects mix—left channel
23	Blank
24	Time code

Figure 13.18
Sounds that might appear on a twenty-four-track tape.

from one piece to another, one piece of music can be placed on audio track 3 and another can be overlapped on track 4. By using "rubber bands" and "handles," the person operating the computer can bring in one sound and fade out the other.

Theoretically, the person who edits picture and dialogue could find, record, edit, and mix all the audio. Often, this is done for student films, but it is not common in the professional world. Part of this tradition—editors and sound mixers have different skills and are not particularly comfortable doing each other's jobs. Part of it is also time constraints. Movies are usually on a tight schedule, and if one person does everything, it will take that person longer than if the job is subdivided.

Still common, even with the existence of nonlinear systems, is for the editor (or editors) to complete the picture and dialogue editing and then for one (or more) sound editors to work with the sound effects, music, Foley, and other sounds that they have been preparing while the picture was being edited.

a

b

Figure 13.19

The board on the left (a) is a real audio mixer such as might be used in a multi-track mixing session. The "board" on the right (b) is actually a Macintosh computer screen that simulates a mixing board. (Photo a courtesy of Digital Sound and Picture; photo b courtesy of New England Digital)

They may have been preparing these sounds with a nonlinear editing program used on a personal computer or with a dedicated audio program on a digital audio workstation. One recent trend is to place all the video and audio material on a computer network; then different people can access what they need to do their particular job—mix in room tone, compose music, create Foley effects. As they complete their work, they can add it to the network so that others can hear and use it.[18]

The mixing functions on the programs of computer-based systems are quite powerful. In an attempt to be user-friendly, some programs employ a graphic of an audio board. The person doing the mixing can use a mouse to raise and lower fade bars for the various sounds coming into this "mixer" (see Figure 13.19). Other programs look more like a visualization of a multitrack tape. The waveform of the sound on each track is shown, and the operator can fade the sounds in and out as desired. The results can be previewed easily. Clicking the mouse on a particular area will play that particular sound back immediately. If the results are unaccept-

able, it is easy to make changes. For example, if a musical bridge comes in a little too soon, the mouse can be used to build a box around the waveform of the bridge and move the whole thing forward slightly.

The video image and its code allow for flawless accuracy. The time code of the frame at which the music is to start can be noted, and the music can be started at that exact frame. If a computer audio operator makes a mistake and brings in a dog bark rather than the music, the "undo" function comes to the rescue and eliminates the unwanted sound.

Sounds can be changed while they are being mixed. Reverb can be added, and frequencies can be filtered, provided those functions are included in the computer program. Sounds can be made to go faster without the accompanying change to a higher pitch that occurs when taped sounds are speeded up. If a fifteen-minute piece of music is two seconds too long for a particular sequence, the music can be slowed down very slightly throughout so that it covers two seconds less without any perceptible change in tempo. If an actor made a mistake and said "walks" instead of "walk," the ess sound on the end of walks can be eliminated by using the mouse control to trim the very end of the waveform.

Because computer-based technologies are digital, the sound quality does not degrade, and because they are nonlinear, sound for the end of the movie can be mixed before sound for the

beginning. Computer-based mixing has not replaced multitrack mixing, but frequently sounds that are created and manipulated to some degree in a computer environment are then taken to a multitrack mixing facility where they become inputs for the final mix. Computer audio technology has come a long way in a short time and promises to proceed even further.[19]

Laybacks and Dubs

Once all the sounds are mixed together, this final mix must be rerecorded on a master copy of the movie, a process known as **layback**. For a videotape master the multitrack audiotape or computer output is dubbed onto the master along with the picture. At the professional level this tape will most likely be in one of the digital formats, but the master tape could be in any of a variety of forms—Hi-8, Betacam SP. The master could also be a video disk or a CD-ROM.[20]

Time code is an important element of this layback process. At this point the final sound mix on the multitrack audiotape or computer has the same time code as the video on the workprint; therefore, as long as the machines are all set up properly, picture and sound should stay in sync. For most professional TV programs sounds are edited and mixed in stereo, so two tracks of the master videotape are used.

Student productions often do not have this luxury and are recorded in a monaural fashion. If such is the case, all sound should be on one track. In other words, the dialogue should not be on one track and the music on another. The best procedure is to place the entire movie audio on all available tracks. In that way, the sound will be heard regardless what tracks are played back.

After the master tape is made, copies can be dubbed from it. At the professional level this is done so that the product can be distributed. At the student level it is often done so that all the students involved in the project can have a copy. Audio should be carefully monitored during the dubbing process. Sometimes people forget to check the levels on both the master copy and the **dub** and wind up with dubs that have unsatisfactory sound.

For movies that are going to be dubbed into a foreign language, the dialogue track must at some point be kept separate from all other tracks, usually at the final mix stage. Then new dialogue in a foreign language can be recorded and mixed with all the other premixed sounds, saving time and money. Even sound effects such as doors slamming should be on some track other than the dialogue track. Because these synchronous sounds are often recorded with the dialogue, the sound effects and Foley people often have extra work to do for a foreign dub. They must go through the movie noting the effects that are recorded with the dialogue and then recreate them so they can be recorded on the effects track.

The layback process for a movie that is going to be shown theatrically is more complicated. Theaters often have digital surround sound, so the final mix consists of six or so tracks that can be sent to separate speakers throughout the theater. For example, in the drawing of Figure 13.20, one set of sounds would go to the left speaker, one to the subwoofer, one to the center speaker, one to the right speaker, one to all the right surround speakers, and one to all the left surround speakers. These six channels of sound, recorded on a multitrack tape or computer, would be sent to the film laboratory where they would be joined with the picture on the film itself. In recent years, there have been many different, incompatible systems developed for surround sound projection. One uses a compact disc that is synched to the picture, one uses space between the sprocket holes, one uses the edge of the film next to the picture. A single motion picture usually provides for all these forms of sound so that it can be shown in all theaters, regardless of the type of equipment they have opted for. Of course, the sound must also be recorded in the old-fashioned, analog, stereo format for theaters that have not converted to digital. That audio is on an **optical sound track** that rides next to the picture, where it has been since the early days of sound[21] (see Figure 13.21).

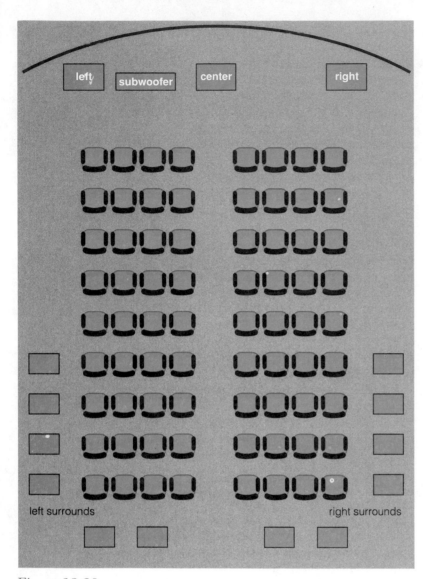

Figure 13.20

Speaker placement in a surround sound theater.

Figure 13.21

This frame shows optical sound and one form of digital sound.

ProTools is an example of specialized audio software.

Notes

1. "Terms of End-EAR-ment," *AV Video*, April 1991, p. 57.
2. Tom Kenny, "Assembling the Soundtrack for Martin Scorsese's *Casino,*" *Mix*, January 1996, pp. 82–83.
3. For more on magnetic film stock, see Eastman Kodak, *The Moving Image* (Rochester, NY: Eastman Kodak, 1990), pp. 19 and 23; and Norman Hollyn, *The Film Editing Room Handbook* (Los Angeles: Lone Eagle Press, 1990).
4. Don Rushkin, "Five Decades of Magnetic Tape in Broadcasting," *College Broadcasting*, April-May 1990, pp. 30–31.
5. Adobe Premiere and Speed Razor are examples of video and audio nonlinear editing programs.
6. Mike Sokol, "Digital Audio Options Expand," *TV Technology*, 24 May 1996, p. 72.
7. Sometimes dailies are shown electronically using a nonlinear editor. At the telecine, the picture will be digitized onto one removable storage drive and the sound will be digitized onto another. Both drives are then inserted into an editing system such as the Avid, picture and sound are synched, and the day's work is viewed by the director and others. See Mel Lambert, "Audiotracks' Digital Dailies," *Mix*, January 1996, pp. 165–174.
8. David Miles Huber, *The MIDI Manual* (Woburn, MA: Focal Press, 1998).
9. One of the most popular is "Cakewalk," from Twelve Tone Systems, Inc., P. O. Box 760, Watertown, MA 02272.
10. Mike Sokol, "DAWs Stay on the Right Track," *TV Technology*, NAB Extra 1995, p. 98.
11. Some of the music libraries are Associated Production Music (800-543-4729), De Wolfe Music Library (800-221-6713), FirstCom/Music House/Chappell (800-858-8880), Killer Tracks (800-454-5537), Metro Music (800-697-7392), The Music Bakery (800-229-0318), and Sound Ideas (800-387-3030). For further detail, see "Whistling Down the Wire," *AV Multimedia Producer*, November 1998, pp. 111–116.
12. Mike Sokol, "Keeping Track of Your Audio Decks," *TV Technology*, October 1995, p. 27.
13. Two brand names for these synchronizing machines are Lynx and Adams-Smith.
14. Two of the most popular digital multitrack recorders are the Alesis ADAT and the Tascam DA88. See Michael Groticelli, "Affordable Digital Multitrack Update," *Videography*, September 1995, pp. 88–89.
15. Two videotapes available on this subject are "Shaping Your Sound with Equalizers, Compressors and Gates," and "Shaping Your Sound with Reverb and Delay." Both are available from Alan Gordon

Enterprises, 1430 Cahuenga Blvd., Hollywood, CA 90028. See also Barry Rudolph, "Understanding Compressors," *Mix,* January 1999, pp. 50–52.

16. Ken Hahn, "Multitrack's Mighty Role," *TV Technology,* January 1992, p. 13; and Joe Fedele, "5.1 Audio Channels: The Final Frontier," *TV Technology,* 20 April 1998, p. 8.

17. Peter Bergren, "Blurring the Lines Between the Edit and the Mix," *Mix,* March 1997, pp. 84–90.

18. Tom Kenny, "Digital Sound and Picture," *Mix,* January 1996, pp. 165–170.

19. "Sound for Picture," *Mix,* April 1996, pp. 4–15; and Mel Lambert "Fairlight MFX3," *Mix,* November 1995, p. 132.

20. Rock Stamberg, "To DVD or Not to DVD?" *AV Video Multimedia Producer,* December 1998, pp. 39–42.

21. "Theater Folk Struggle with 3-System Dilemma," *Daily Variety,* 22 May 1996, p. 18.

chapter fourteen
Approaches to Structuring Sound

The French theoretician Christian Metz describes five channels of information in motion pictures: the image, written language and other graphics on the screen, speech (dialogue and narration), music, and noise (sound effects and ambient sounds).[1] In this analysis there are more possibilities for communicating information through sound than through picture. Metz makes an even stronger point when he discusses how we look at an image versus how we hear sound. We must redirect our attention in order to read words on the screen or look at the picture, whereas sound washes over us.

Many writers stress the image when discussing film and television. They consider the two to be visual media. But as Metz's analysis (and common observation) demonstrates, film and TV are really audiovisual media. The sound we hear influences the way we look at the picture. The same series of pictures projected with different sound tracks can have radically different meanings.

The Evolution of Sound

The early filmmakers recognized the importance of sound almost from the beginning. In fact, Thomas Edison and William Dickson, who have been credited with inventing the motion picture in America, were really trying to create pictures to accompany Edison's phonograph.

Even though early movies were silent, they were usually accompanied by music when shown in a theater. At first piano players improvised as they watched the film—fast music for chase scenes, minor chords for grief. Eventually, magnificent organs and even full orchestras accompanied the showing of films. Much of the power of the silent era, which is usually considered to have lasted until the 1927 showing of *The Jazz Singer,* was the overwhelmingly powerful live music that accompanied the moving image.

When sound on film arrived, many moviemakers felt it would destroy the art of the image. Cameras had to be locked down in soundproof booths so that the microphone would not pick up their whirring. Actors could barely move because they had to stay within pickup distance of the mic, which was usually hidden in a flowerpot.

But the audience loved sound, so the moviemakers could not dismiss it. In 1926 only a few movies had any type of recorded sound, and most of that was bits and pieces of music. By 1929 almost all movies were shot with synchronous sound.

The Hollywood community eventually learned to manipulate the sound equipment so that sound did not hinder the picture. Someone thought of placing the mic on the end of a pole (**boom**) so that it could be moved around, and housings were built to silence cameras so that they too could move. Perhaps most important was the development of postproduction sound techniques that meant sound could be built into the movie after it was shot. Car chases, for example, could be shot silently and all the crash noises, screeches, and chase music could be added later. All of this made sound an important aspect of the movie business; today some films often have dozens of sounds playing at one time.[2]

Television, of course, was never silent. But in the early days of TV, audio received little emphasis, mainly because engineers were struggling to produce a viewable image. Today sound on videotape is approaching the same importance and sophistication that sound in film has acquired. In both media, postproduction of sound greatly enhances the movie's impact on the audience.[3]

The Relationship of Sound to Image

Despite its importance, the sound in motion pictures does not stand alone like the music on compact disk. Movies by definition involve the juxtaposition of sound and image. In fact, one of the editor's primary concerns in postproduc-

tion is establishing or creating effective relationships between the picture and the various elements of the sound track—the dialogue, sound effects, and music.

The spoken words and ambient sounds recorded with the image during production are usually referred to as **synchronous sound.** In **double system** film production the editor must actually sync up the picture and sound, but regardless of how this relationship is created, it is essentially a relationship in time. In other words, we consider the sound and picture to jibe in sync if the sound we hear is perfectly matched in time to the person or object creating that sound on the screen. Conversely, sound is out of sync if a person talking or a hand knocking on a door is not timed precisely with the sound of the words or door knock.

In the first stages of editing the editor usually places the picture and synchronous dialogue track together. But as the editing proceeds, the editor can begin to establish entirely different relationships between the picture and its matching sound. By using cutaways, reaction shots, or close-ups of isolated details within the scene, the editor may juxtapose the synchronous sound from one shot with images that are entirely different. Furthermore, the editor can make the sound from one scene overlap the following or preceding scene, foreshadowing the scene we are about to see or recalling the scene that has just ended.

Because the editor can position the sound track at any point, it is possible to establish a variety of relationships with the image. The editor can use sound to create a **sound flashback** or **sound flashforward.** We might, for example, hear sounds from a character's past while seeing an image of the character in the present. This kind of sound-image juxtaposition is also possible with sound effects and music.

In their book *Film Art: An Introduction,* David Bordwell and Kristin Thompson examine a variety of sound-image relationships.[4] They differentiate between sound that is **diegetic** (from within the story space) and sound that is **nondiegetic** (outside the story space). When we see the image of characters talking and also hear their words, the sound is diegetic. The same would be true of sound effects or music that emanate from sources on the screen, such as a door

slam or jukebox. All these sounds might occur on-screen, but they would still be diegetic sounds if they took place off-screen—provided that they came from the story space.

Nondiegetic sound comes from outside the story space. The most common kind of nondiegetic sound is the musical score that typically accompanies a motion picture. Unless the director is making some kind of joke, we do not expect to see a shot of John Williams and the British Philharmonic Orchestra as the film reaches a dramatic climax; the musical score by convention is not part of the story space.

Similarly, an omniscient narrator might provide a voice-over introduction to a motion picture, setting the stage for the action to follow. This kind of narration would be nondiegetic, but if it were provided by a character in the story it would be considered diegetic sound.

Whether it is diegetic or nondiegetic, narration can provide information about the past, present, or future that may not be contained in the image. Many directors have made extensive use of interior monologues, in which we hear what characters are thinking but do not see them moving their lips in the image on-screen. This kind of subjective narration is diegetic. A narrator who comments on the action from outside the story space would convey a completely different kind of information and set a different tone.

Such distinctions are helpful in demonstrating at least a few of the complex relationships the editor can develop while constructing the sound tracks. No sound is irreversibly locked to its matching image. The editor is free to build any number of sound-image relationships in space or time. Sounds may originate from within the story space or from outside it. Sounds may be on-screen or off-screen. They may present information about the past, present, or future. In the hands of a skillful and creative editor, sound-image relationships can make a significant contribution to the completed motion picture.

The Functions of Sound

The editors who spot for music and sound effects and who edit dialogue must be aware of

the various purposes that sound can fulfill. They do not wantonly place cricket chirps, tire squeals, factory noises, soft romantic music, and lines of dialogue in the sound track. They go through a definite thought process, either consciously or subconsciously, to determine which sounds are needed and where they should go. Usually, the picture and dialogue cue the music and sound effects. That is why **spotting** is not done until *after* the picture and principal dialogue track have been edited. The people working with sound must consider the various possibilities for sound and incorporate them when and where they are appropriate. There is no set list of purposes for sound, but most sound can be thought of in terms of supplying information, enhancing reality or fantasy, establishing time, place, and character, creating mood and emotion, giving a sense of rhythm, and directing attention.

Supplying Information

In many instances sound, primarily the **dialogue,** conveys most of the information in a movie. Talking heads do not give much visual information beyond the emotion that actors can convey through their expressions. The essence of the information is in the words that they speak. For this reason, great care should be taken to ensure that the dialogue is understandable.

If you are spotting for **automatic dialogue replacement (ADR)**, the need to supply information must be uppermost in your mind. Any dialogue that is so muddled that it cannot be understood should be rerecorded. If you are editing, you should consider the clarity of the dialogue in selecting the takes to include in the master. The original dialogue should also undergo as little generation loss as possible so that it does not lose its information-giving ability.

Voice-over narration can also convey a great deal of information, but it must be planned and recorded properly so that its message is understood. In productions designed primarily to inform, voice-over is often the main source of information. In these cases, the director must decide whether the picture should be edited to the voice-over or the voice-over should be

recorded to suit the needs of the image. Also, the picture and voice-over must be coordinated so that there are no duplications. If the words simply describe what is happening in the picture, they are superfluous and often give the impression that the narrator is talking down to the viewer. Another problem arises when a narrator reads words that appear on the screen. Most members of the audience will be able to read the words faster than the narrator can speak them, so the visual and aural information will interfere with each other. The best way to convey information through narration is to have the voice-over convey facts that relate to but also add to the picture.

When voice-overs are used in movies, they often appear at the beginning of a film to give information about what has preceded the action or to provide information about what is going to happen. An excellent example of this is the opening narration from *Bull Durham* by writer-director Ron Shelton (see Figure 14.1).[5] This voice-over, delivered by Annie Savoy (played by Susan Sarandon), succinctly covers much of the backstory. It also prepares the viewer for the story line of the movie.

Someone had to select the pictures to use with the voice-over. The picture could have shown Sarandon delivering the lines to the camera, but then the image would not have given much more information than the audio. The pictures could have illustrated the various "religions," but that would have repeated what the words were saying. What was selected—a few baseball photos and shots of Sarandon primping before the mirror and walking to the baseball stadium—conveyed additional information and moved the story toward the next scene.

Occasionally, voice-overs state what people are thinking or reiterate dialogue from earlier in the movie. This technique uses the dialogue and voice-over to link several parts of the film, doubling the impact of the information contained in the words.

Sound effects and **ambient sounds** can also convey information, albeit in a less straightforward manner than dialogue or narration. Dogs barking can mean someone is coming; the volume of an ambulance's siren is an indication of

ANNIE SAVOY'S SOLILOQUY FROM <u>BULL DURHAM</u>
by Ron Shelton

I believe in the Church of Baseball.

I've tried all the major religions and most of the
minor ones--I've worshipped Buddha, Allah, Brahma,
Vishnu, Siva, trees, mushrooms, and Isadora Duncan.

I know things. For instance--

There are 108 beads in a Catholic rosary. And--

There are 108 stitches in a baseball.

When I learned that, I gave Jesus a chance.

But it just didn't work out between us...The Lord laid
too much guilt on me. I prefer metaphysics to
theology.

You see, there's no guilt in baseball...and it's never
boring.

Which makes it like sex.

There's never been a ballplayer slept with me who
didn't have the best year of his career.

Making love is like hitting a baseball--you just got to
relax and concentrate.

Besides, I'd never sleep with a player hitting under
.250 unless he had a lot of R.B.I.'s or was a great
glove man up the middle.

A woman's got to have standards.

The young players start off full of enthusiasm and
energy, but they don't realize that come July and
August when the weather is hot it's hard to perform at
your peak level.

Figure 14.1
This opening soliloquy sets the stage for the movie. (© 1988 Orion Pictures Corporation. All rights reserved.)

(Continued)

how soon help will arrive. Off-screen sound effects can tell us that the teenage son has crashed the car into the garage even though we never see the crash and no one in the cast refers directly to it.

Supplying facts is not the primary power of music, but on occasion music can be informative. When lyrics comment on what is being presented, they add another layer of meaning. In fact, in musicals the lyrics often drive the

Figure 14.1
(Continued)

The veterans pace themselves better. They finish
stronger. They're great in September.

While I don't belive a woman needs a man to be
fulfilled, I do confess an interest in finding the
ultimate guy--he'd have that youthful exuberance but
the veteran's sense of timing...

Y'see there's a certain amount of "life-wisdom" I give
these boys.

I can expand their minds. Sometimes when I've got a
ballplayer alone I'll just read Emily Dickenson or Walt
Whitman to him. The guys are sweet--they always stay
and listen.

Of course a guy will listen to anything if he thinks
it's foreplay.

I make them feel confident. They make me feel safe.
And pretty.

'Course what I give them lasts a lifetime. What they
give me lasts 142 games. Sometimes it seems like a bad
trade--

--but bad trades are part of baseball--who can forget
Frank Robinson for Milt Pappas, for Godsakes!

It's a long season and you got to trust it.

I've tried 'em all...I really have...

...and the only church that truly feeds the soul--day
in, day out--is the Church of Baseball.

story forward. For example, in *Singin' in the Rain,* the song "You Were Meant for Me" establishes the love interest between Gene Kelly and Debbie Reynolds that Kelly is supposedly unable to articulate (Figure 14.2 shows Gene Kelly singing "You Were Meant for Me").

Music can also foreshadow, giving information before the picture or dialogue do. For example, the music can become ominous before tragedy occurs. Music can also heighten the impact of information given by dialogue or narration. It can punctuate the words to give them added

importance. In a few films music has been a source of information. The spaceship's musical refrain in *Close Encounters of the Third Kind* was part of a language that the people on Earth had to decode.

Sound can also *withhold* information. In *North by Northwest* Alfred Hitchcock uses the noise of an airplane to drown out part of a conversation between Cary Grant and a CIA agent.

Sometimes sound conveys information that is totally *opposite* to the picture. This can be used for comic effect. In *Singin' in the Rain* Gene Kelly's voice tells of his glorious rise in show business while the pictures are showing that he was really a flop. It can also be used for shock effect. Light, happy music accompanies the opening scene of *Natural Born Killers* that shows numerous people being murdered.

Supplying information is a primary power of sound, especially within the structure of corporate videos and conventional Hollywood narrative films. Most films are not intended to be abstract or ethereal. If they are to be successful, the audience must understand what is happening. If you are spotting a movie, you must make sure that some sound source will give the audience all the information you want them to have that is not conveyed in the picture.

Figure 14.2

In this scene from Singin' in the Rain *the lyrics advance the story. (© 1952 Loew's Inc. Ren. 1979 Metro-Goldwyn-Mayer, Inc.)*

Enhancing Reality and Fantasy

Adding reality cues is a major function of **Foley**, ambient sounds, and sound effects. These are the elements that make the viewer believe the mise-en-scène. An airport without airplane noises, a crowded waiting room without coughs and muffled voices, or silent footsteps on gravel would not be believable. For dialogue the main reality cue is **perspective**; a booming voice coming from someone who is far away does not sound real. Sound effects can employ perspective, too. In *Jurassic Park* the sound of the dinosaurs approaching from the rear of the theater gives an exceptionally realistic scariness to the movie. The asteroids in *Armageddon* have a whiz-by sound.[6] In general, dialogue and voice-overs can set up reality, but the little noises that are always present in life are what give that reality substance.

John Edwards-Younger, who is in charge of effects for "NYPD Blue" has a definite thought process he goes through in order to make the series realistic. He places **walla walla** in each scene of each episode because there is always noise in bustling New York. The show has a group of actors that have been named the SuperLoopers, who do all the different types of walla walla from very general cafe noises to cops in the background yelling out codes. Edwards-Younger also includes traffic noises in all scenes, be they indoor or outdoor, again because one can always hear traffic in New York, even in a quiet apartment. He then considers general off-screen elements—perhaps jackhammers or fire sirens if the scene is a busy street. Often these noises are used to fill holes where there is no dialogue, so Edwards-Younger will go through a scene and

"paint" in sounds to enhance the aural canvas. He also considers off-screen needs of the story; if a helicopter is coming, it must be heard well before it is seen. Finally, he looks for on-screen needs. Often this requires knowledge of the story line. For example, if a woman officer answers the phone, he must know if she is waiting for the call and answers it quickly or if she is engaged in something more important and lets the phone ring several times before answering. Easier are on-screen **hard effects** such as door slams that give a very concrete sense of reality.[7]

Creating fantasy is another matter. Music is excellent for creating fantasy because most of us do not hear violins as you walk down the street. Sound effects are also excellent for creating fantasy. The sound that is made when one of the Three Stooges "gouges" someone's eyes does not approximate the actual sound that act would make. The sound lets you know that this action is not real. In fact, if the sound were authentic, the Three Stooges' movies might be truly offensive. Sounds that do not exist on earth give such films as *Star Wars* a futuristic effect. Dialogue and voice-overs can also add to fantasy. Donald Duck's voice would never be mistaken for real, although it is diegetic.

Spotting for these elements is difficult. You must look at the entire scene carefully and determine what sounds would be appropriate. Would there be traffic noises coming in the open window? Will the clinging evening gown rustle as the woman moves? To what extent should the clinking glasses in the long shot of the bar carry over to the close-up of the two gangsters talking? Is the guitar playing in the background acoustic or electronic? What kind of noise might a laser gun make? Is the sound of an extra snapping his fingers in the back of the scene worth including? These are the types of details that spotters must consider.

Acquiring and recording the sounds is not easy either. Sound effects from CD libraries are often not quite right (and they are unlikely to contain futuristic sounds). Going to the actual source sometimes does not work. A real crackling fire doesn't sound very much like one when it is recorded. Wrinkling paper might create a more "realistic" crackle. **Digital samplers** and computers can help create unusual or specific sounds, but

consulting an experienced sound editor is often the best way to find just the right effect.

Establishing Time, Place, and Character

Theoretically, the dialogue could establish everything the audience needs to know about when and where the scene is taking place and the type of people involved. However, using only dialogue to do so usually becomes tedious and stilted. ("I'm glad we're coming to visit Uncle Herman this bright May morning even though I know he is your father's grouchy bachelor uncle who lives on a rundown farm with his cows and pigs and never answers his telephone.")

For this reason, sound editors often use other elements to help identify time, place, and character. Voice-overs can do this even more blatantly than dialogue without seeming forced. For example, the narrator in Orson Welles's *The Magnificent Ambersons* opens the film by describing all the characters. People accept narration as expository and so do not find being bombarded with facts unnatural.

Music is excellent for establishing time, place, and character. A Gregorian chant bespeaks medieval times; oriental music sets a movie in China; jazz puts the audience in New Orleans; and "Here Comes the Bride" establishes a wedding. In *Forrest Gump* music from the various decades accompanies Forrest's life story. Character is a little more difficult to establish with music, but some films contain a **motif**, a particular group of notes that is played to herald the arrival of a particular character. For instance, in *Jaws* the same music always signals the appearance of the hungry shark. Music can also indicate character qualities. In old melodramas cellos playing in a minor key often denoted a villain, a sturdy brass march accompanied the hero, and soft violin passages signified the heroine.

Sometimes music is purposely composed to contrast with the picture. This can create a comedic effect—for example, serious overblown music accompanying the antics of Jim Carrey.

Sound editors also use sound effects and other noises to indicate time, place, and charac-

ter. The cock crowing, the alarm ringing, and the clock striking midnight all indicate time. Putting traffic noises in the background during a close-up of a woman tells us that she is in the city and can eliminate the need for an establishing shot. Similarly, cannon noise can save the cost of a mammoth battle scene and allow you to concentrate on several actors involved in battle. Sound effects can also signal a character's arrival. A particular snort or the sound of creaky shoes can announce that some well-established character is near. Surround sound can provide an unusual type of location cue. An editor can convey sense of space in a particular scene by delaying sound between the speakers in the back and those in the front.

One of the main considerations when spotting, editing, and mixing sounds that establish time, place, and character is not overdoing them. If the time is evident from the picture or the dialogue, there may be no need to add the crowing cock, which has become a cliché. Like sounds that supply information, sounds that establish time, place, and character should clarify what is happening.

Creating Mood and Emotion

Music is important for creating mood and emotion. Music can express just about any emotion—love, hate, fear, tension, serenity, anger, friendship. Music has its own cultural language in this regard. Soft, slow music is considered romantic, and music in the minor key denotes sadness. However, music is highly subjective. For this reason the director and the composer should be of the same mind about what the music is conveying or the postproduction process will grind to a halt as they argue over the appropriateness of a particular score.[8]

Theme music can provide a comfortable familiar mood, especially if it is associated with a popular production. Series TV makes great use of theme music over opening and closing credits. Just about anyone can hum the theme music from a favorite series—"The X-Files," "Star Trek," or "Friends." Movies with sequels, such as the James Bond series, also use music to capitalize on past successes and familiarity. Theme music can be reassuring even within a

Figure 14.3

For many people any scene from Dr. Zhivago *will automatically conjure up the theme music. (© 1965 Metro-Goldwyn-Mayer, Inc.)*

movie. For example, the theme for *Dr. Zhivago* (see Figure 14.3) repeats often throughout to reemphasize emotion.

A movie's opening music can set the mood for the entire motion picture. Specifically, it clues the audience to whether the movie is for laughing or for crying. Music within a movie can also create humor by punctuating a humorous event with an unusual musical sound. Or the music itself can be funny, as in the toy store piano-playing scene in *Big*. Tom Hanks using his feet to play "Chopsticks," a ditty just about everyone has heard or played, added to the humor of the scene.

Most film music is composed after the movie is completed so that it can fit the emotion and timing of the scene. Sometimes, however, the music comes first. *While You Were Sleeping* used familiar popular music from the past to heighten its emotion. Documentarian Ken Burns ("The

Civil War," "Baseball") usually starts with music. As he puts it, "We do not 'score' a picture, which is the mathematical application of timed music once a film is done. When music is added to a film in this way, it can only be 'canned.' What we do instead is record the music of the period before we begin editing, giving ourselves a wide variety of music, which, more often than not, dictates the rhythm and the emotion of every scene before we begin to edit it. So in the case of the Civil War, we will hear the sounds of the music that the soldiers sang and played among themselves, and we will hear it on the authentic instruments that they themselves played. In addition, we isolate certain theme music which we feel can become a bridge to our twentieth-century audience, reminding them of music's incredible power to convey the most complicated emotional information."[9]

Although music is written or selected to enhance the script and visual aspects of the movie, it often takes on a life of its own. Many movie scores have become popular in their own right and have hit the top of the record charts, as did the scores from *Saturday Night Fever, Titanic, Against All Odds,* and *Waiting to Exhale.*

Sound effects can also create mood and emotion. Waves lapping against the shore or birds chirping connote serenity. Squealing tires create tension. An ominous off-screen thud can raise anticipation. A siren signals danger. A coyote call denotes isolation. Sound effects are also excellent for creating humor. Many of Jim Carrey's antics in *The Mask* are made funnier by the sound effects that accompany them.

Voice elements in dialogue and voice-overs can also create emotion. The muffled voices of an argument add to tension. The tone and content of the voice-over at the beginning of *Bull Durham* say that this movie is not going to take itself too seriously.

One of the best devices for creating emotion is the absence of sound—silence. Because sound permeates most movies, a period of silence creates great tension. The first sound that follows silence greatly intensifies its impact. For example, in *Platoon* a long period of silence ensues while the soldiers are watching for the enemy. Suddenly a twig snaps. The audience does not see danger but certainly feels it because of the sound.

Spotting for mood and emotion is probably the most difficult of all spotting because context clues are not obvious in the picture. There is no dress that needs to rustle or lightning that needs thunder. The person doing the spotting must feel the emotional needs and think of ways to fill them.

Giving a Sense of Rhythm

As much as picture editing, music can establish pace—long phrases and a limited number of notes per measure (perhaps a minuet) for slow-paced material and short phrases and a multitude of notes (perhaps heavy metal) for fast-paced material. The music's level of rhythmic energy greatly affects the energy level of a movie scene.

Music can also magnify the movie's climaxes—cymbals clashing just as the prizefighter floors his opponent. Making climaxes of music and picture coincide is fairly easy if the music is composed specifically for the movie. But if the music is acquired from a library or other source, creating this effect usually requires an editing technique known as **backtiming.** For linear editing the editor lines up the climax of the music, which is on audiotape or on the source videotape, with the prizefighter's punch on the master videotape. Then using the edit controller, the editor backs up both machines an equal number of frames to the point at which the music begins. For example, the music climax might come at 00:05:30:00 on that tape, and the punch might be at 00:20:30:30 on the master videotape. If the music, from the beginning to the climax, lasts 1 minute and 30 seconds, the editor needs to rewind both machines by 1:30 to 00:04:00:00 and 00:19:00:30, respectively. Those two points become the edit-in points for the edit. The edit-out point would be at the end of the music, perhaps 30 seconds and 10 frames past the climax. The editor would set the edit-in points on the controller, the source and record machines would back up, and the music would be recorded on the master tape, starting at 00:19:00:30, climaxing at 00:20:30:30, and ending at 00:21:00:40 (see Figure 14.4). Backtiming can be undertaken with control track as well as time code and is frequently used for montages.

Handling this type of picture-music interrelationship is easier with nonlinear computer

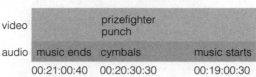

Figure 14.4

By backtiming the music the sound editor can make the punch of the prizefighter and the clash of the cymbals occur at the same time.

Directing Attention

Sound also has the ability to direct the audience's attention. Ordinarily, the audience focuses its attention on the person who is talking, and that person is usually in the center of the screen. But if a door opens to the right, the audience will expect someone to enter from the right and will probably look in that direction. In this way sound expands the frame, defining off-screen space in such a way that it becomes almost as much a part of the story as the on-screen space. Directing attention with sound can also frighten the audience (à la Hitchcock). If the audience is looking to the right side of the frame because the main sound and action are occurring there, the director can bring in something unexpected from the left. The audience members may be caught unaware, and their fear will be heightened.

Sound can direct attention to particular elements of the frame that might not be noticed otherwise. A car that is backfiring often is just part of a traffic scene, in which case the backfire might not even be heard on the sound track. But if that car's presence in the scene in which the hero gives secret documents to a spy is important to the story, the editor can accentuate the backfiring noise in such a way that the audience becomes aware of it. Then when they again hear the car at the scene of the murder, the audience members who were aware of the backfire become privy to a special clue.

Even more extreme would be including the sound of a bomb ticking, which might not actually be audible in a particular circumstance, to focus the audience's attention on the possibility of an explosion. Sometimes the sound track even includes something totally inaudible, such as a beating heart.

Sound at the end of one scene can foreshadow the next to intensify the audience's reaction to the second scene. A siren wailing at

editing. For example, Martin Scorsese's *Casino* used only 1970s and 1980s music that already existed. Before editing the picture, Scorsese laid most of the music tracks. He gave the editors directions about actions he wanted to occur at particular lyrics within the songs or at particular musical points. The editors then tried to cut the picture so that it matched the music and still made sense from a visual point of view. Sometimes this did not work out perfectly and the picture could not be made to hit the music cues exactly. However, because the music was on a digital audio workstation, the editors were able to expand or contract segments slightly so that it fit with the picture.[10]

For some types of editing, music dictates the pace and the picture supplements it. This is almost always true for music videos because the music exists before the pictures. The picture-editing decisions are based on the content, the rhythm, and the feel of the music. Usually with this type of editing, you want to make the video cuts on the music beat, although doing so throughout an entire selection can become boring. Music sets the rhythmic agenda for many commercials. Within narrative motion pictures music can be the driving force of montages. For example, at the beginning of *Wayne's World* a montage sequence is cut to the beat of Queen's "Bohemian Rhapsody."

Sound effects too can add to the rhythmic effect of the movie. Cartoons often use a barrage of effects, mixed with music, to punctuate chases, tumbles, and other antics that make up most of these high-energy minimovies.

Dialogue and voice-overs can set pace. Clipped speech delivered in a sarcastic tone is usually fast paced, and raised voices of an argument often build to a climax.

Generally, all the sound elements work together and with the picture to reinforce certain rhythmic elements. But sometimes the sounds are in opposition to the picture, just as they are when they provide incorrect information.

The rhythmic function of sound is subtle. Sound editors and composers must be in accord with the director on the pace, energy, and climaxes of the movie and individual scenes. A high-energy picture with slow sound will lose energy.

Figure 14.5

A sound mixing session. Note the cue sheet propped up on the console. (Photo courtesy of Ryder Sound Services)

the end of a bucolic scene can draw the audience into the next scene, where a frantic rescue attempt is under way. When the fireplace shoots flames into the living room in *On Golden Pond,* we hear Katharine Hepburn's screams about the fire for several seconds (over a shot of Henry Fonda and the boy) before the cut shows Hepburn and the fire.

Using sound to direct the viewer's attention where the director wants it focused is a rather subtle art. Sound is not often used for this purpose and probably should not be. Using sound to direct attention should be reserved for especially appropriate circumstances. People who spot for music, sound effects, ambient sounds, Foley, and ADR usually do not consciously consider the various purposes of sound; indeed,

these purposes could be identified in many different ways.[11] What is important is that sound is used to enhance the movie.

Layering Sound

Usually by the time the director and the editor are ready for the final sound mix, much of the decision making is over. The postproduction team has spotted, gathered, and edited into place the various sound tracks in relation to the cut images. All that remains is the mix—the last creative task in the moviemaking process.[12]

The mixing cue sheet that the sound editor brings to the mixing session is a graphic illustration of the remaining creative decisions (see Figure 14.5). It is a map showing which sound elements the editor has made available and where they begin and end in relation to the picture. Still, even with this guide the sound mixer(s) must make a number of aesthetic judgments during the mixing session. Working by ear and with suggestions from the director or editor, the mixers must blend the various sound elements together to create the final sound track.

This is what sound **layering** is all about. Although motion pictures make occasional use of multiple images or superimpositions, we cannot really read a group of images if they appear simultaneously on the screen. In comparison, we are accustomed to hearing many sounds together and selecting what is most important to listen to. Therefore, it is appropriate to think of sound track building as a layering process, the construction of not just one sound element (such as dialogue) but of a variety of sounds (sound effects, ambient noise, and music) that may all be heard at the same time.

Our ears (and minds) hear sound selectively—we subconsciously shut out unimportant background sounds (the television, air conditioner, and refrigerator hum) to hear what we want to hear, such as someone talking to us. This does not automatically occur in a motion picture sound track, however. Even a relatively simple scene can easily contain five or six different sound elements (dialogue, background music, and three or four sound effects), all playing simultaneously. Unless certain sounds are given special emphasis during the mixing ses-

sion, the finished sound track will be an unintelligible muddle of competing sounds.

Many of these decisions are fairly subjective. A mixing session proceeds by trial and error, providing an opportunity to test different choices. Essentially, the sound mix manipulates the various sound elements in three basic ways. The first involves volume levels. Generally, the louder the sound, the more emphasis it has. By raising the sound level for a particular sound effect, line of dialogue, or piece of music, the mixer(s) can separate it from the other sounds and give it special significance. In an exchange of dialogue one performer's lines may need to be punched up to a higher volume. At other times it may be more appropriate to drop a performer's lines into the background. The volume of music will vary according to whether dialogue must be heard over it or whether the music is the primary sound element. In a typical shoot-'em-up scene the music is often the most important (and loudest) sound, with the sound effects and throwaway dialogue playing a distinctly supporting role.

The second area of control concerns when and how to establish a sound in relation to the image. Music, for example, often fades in slowly and unobtrusively at some point in the scene, pushes to a higher level as the intensity of the drama increases, and gently fades out after the climax. In contrast, an explosion or door slam should be abrupt. Such sounds must begin immediately at full volume. A gentle fade-in would destroy the effect.

Finally, because most sound elements are recorded flat (without equalization) they sometimes need equalization during the mix. This is often true for dialogue because the quality of location sound recordings tends to vary wildly. The high or low frequencies in a particular sound may need boosting or lowering. The mixers might have to use special effects (reverberation or filters) to simulate a telephone conversation or echo-filled cave.

Admittedly, the director, editor, sound editors, and composer will have discussed and made many of these sound decisions before the mix. If the proper sound elements are not available in the appropriate places on the sound tracks or in the computer, they will not magically appear during the mixing session. Nevertheless, the best

planning and intentions mean nothing until they are brought to life in the final sound track. The mixing session is the final chance to make adjustments, to see and hear how the various sound and picture elements work together.

Notes

1. Christian Metz, *Film Language: A Semiotics of the Cinema,* trans. by Michael Taylor (New York: Oxford University Press, 1974), pp. 39–91.

2. For more on the history of sound, see Douglas Gomery, *Movie History* (Belmont, CA: Wadsworth, 1990), pp. 163–168; Kristin Thompson and David Bordwell, *Film History: An Introduction* (New York: McGraw-Hill, 1994), pp. 213–220; and David A. Cook, *A History of Narrative Film* (New York: W. W. Norton, 1990), pp. 253–266.

3. Frank Beacham, "Every Sound Tells a Story," *TV Technology,* November 1991, p. 16.

4. David Bordwell and Kristin Thompson, *Film Art: An Introduction,* 4th ed. (New York: McGraw-Hill, 1993), pp. 244–273.

5. *Bull Durham* (1988) is an Orion Pictures Release from A Mount Company Production. It stars Kevin Costner, Susan Sarandon, and Tim Robbins. The executive producer is David V. Lester, the producers are Thom Mount and Mark Burg, and the writer and director is Ron Shelton.

6. Tom Kenny, "Sound Design for Steven Speilberg's Dinosaur Epic," *Mix,* July 1993, pp. 128–134; and "Armageddon's Asteroids," *Mix,* July 1998, pp. 58–64.

7. Maureen Droney, "A Sonic Week in the Life of *NYPD Blue,*" *Mix,* May 1995, pp. 148–155.

8. Mitch Coodley, "Secrets to Successful Collaboration with a Composer," *AV Video,* July 1992, pp. 52–57.

9. Ken Burns, *Making Film History* (Detroit: General Motors, n.d.), p. 5.

10. Tom Kenny, "Assembling the Soundtrack for Martin Scorsese's *Casino,*" *Mix,* January 1996, pp. 82–91.

11. For other approaches to this subject, see Lee R. Bobker, *Elements of Film* (New York: Harcourt Brace Jovanovich, 1974), pp. 82–107; and Herbert Zettl, *Sight-Sound-Motion: Applied Media Aesthetics,* 2nd ed. (Belmont, CA: Wadsworth, 1990), pp. 333–385.

12. Ken Hahn, "The Effects of an M&E Track," *TV Technology,* June 1995, p. 28; and "The Basics of Mixing," *Mix,* August 1998, pp. 190–199.

Glossary

A-B roll A process that enables two pictures to overlap, either by printing two rolls of film, by taking two video signals through a switcher and time-base corrector, or by overlapping two shots on a nonlinear timeline.

above-the-line Refers to expenses for the many administrative, conceptual, and creative aspects of a specific motion picture, such as writing, producing, acting, and directing.

AC Alternating current; usually used to refer to the power found in homes and offices.

Academy ratio The standard of three vertical units to four horizontal units adopted by the Academy of Motion Picture Arts and Sciences as the aspect ratio for movies; also a standard television aspect ratio.

ADR See *automatic dialogue replacement*.

AFM See *audio frequency modulation*.

AGC See *automatic gain control*.

alligator clamp A spring-loaded clamp that opens in such a way that it can secure a light almost anywhere; also called **gaffer grip**.

alpha matte A black or white background used to create a hole in the source material so that an image, such as a title, can show through.

ambient sounds Background noise recorded asynchronously, either during production or at a different time for use during editing.

amp A unit of electrical current or rate of flow of electrons.

amplification The boosting of a signal by an apparatus that draws power from a source other than the input signal and then increases the essential features of the input.

amplitude The height of a sound wave.

analog A recording, circuit, or piece of equipment that produces an output that varies as a continuous function of the input. Analog recordings tend to degrade as material is transferred from one source to another.

anamorphic lens A lens that optically squeezes an image during filming and then unsqueezes it during projection to produce a widescreen aspect ratio.

answer print The first film print obtained from timed A-B rolls and magnetic stock; also known as a trial print.

aperture The variable opening in a lens that controls the amount of light passing through it.

arc Moving of a camera and its supporting device in a circular manner around an object.

art director A person who deals with the look of sets and other visual aspects of a movie.

ASA A rating system developed by the American Standards Association that refers to the sensitivity to light of different film stocks. See also *exposure index*.

aspect ratio The relationship of the height to the width of a picture; for example, most TV screens are three units long for each four units wide, creating a 1:1.33 aspect ratio.

assemble An edit mode that transfers the control track of the source tape to the edit tape along with the image and sound during editing.

assistant director In film production, the person who does work delegated by the director, such as conducting rehearsals or directing a second unit. See also *associate director*.

assistant editor A person who helps an editor by digitizing tapes, preparing edit decision lists, and handling other duties.

associate director The TV production term for the person who assists the director. See also *assistant director*.

atmosphere sound General background noise recorded to add a certain feeling or sense of location to a scene.

ATR See *audiotape recorder*.

attack The amount of time it takes a sound to get from silence to full volume.

audio board A mixer used to combine various audio sources and then send them to other equipment.

audio frequency modulation An audio signal recorded diagonally on videotape along with the video signal so that it cannot be separated from the video; abbreviated **AFM**.

audio mixer A board used to combine various audio inputs and then send them to other equipment; a person who combines sounds by using an audio board.

audio technician A video term for the person who records, edits, adjusts, and mixes sound; also called an **audio mixer**.

audio tone See *tone*.

audiotape recorder A device that can be used to record, store, and play back sound; abbreviated **ATR**.

automatic dialogue replacement Rerecording dialogue that for one reason or another was not recorded properly during production; abbreviated **ADR**.

automatic focus A device that continuously alters the focus control of a lens to keep the picture sharp and clear.

automatic gain control A device that continuously alters the strength of a video or audio signal to produce the best possible picture or sound; abbreviated **AGC**.

automatic iris A device that continuously alters the diaphragm of a lens to create the best exposure possible.

AV-certified Computer drives capable of moving large amounts of video and audio information.

axis of action The principle that places an imaginary line between two people talking or the screen direction established by a walking character or moving object. If the camera is placed on one side of this imaginary line anywhere within a 180-degree arc, spatial continuity will be maintained; if the camera is placed beyond 180 degrees, screen direction will change on the cut.

back light A spotlight placed above and behind a person or object to make it stand out from the background.

background light A light that illuminates the scenery, giving depth to the scene; also called **scenery light**.

backstory Background material that the audience needs to know to understand the plot.

backtiming Making the picture and sound end at the same point by timing a sound element (music or effects) so that it can be started at the right point to make a perfectly timed edit.

balance The relative volume of different sounds or the relative weight of different portions of a picture.

balanced Refers to cable that has three wires, one for positive, one for negative, and one for ground; also refers to a composition that has the same relative weight on both sides of the frame.

barndoor Black metal flaps placed on a lamp or lamp housings to block part of the light beam.

barney A soft, foamy case that dampens the noise of film cameras.

base The part of film that serves as a support for the emulsion.

base plate A light fixture that attaches to a flat surface to hold a light.

baselight level The minimum amount of light needed to ensure proper exposure by a particular imaging system.

batch list The in and out points of the time code for a number of edits; they can be stored on a floppy disk.

below-the-line Refers to expenses, usually in the crafts areas, that could be associated with any movie, such as costumes, camera rental, set designers, camera operators, and transportation.

Betacam Sony's ½-inch, professional-level video format.

Betacam SP An improved, hence Superior Performance, version of the ½-inch, professional-level Betacam video format.

Betamax The first ½-inch, consumer-grade video format, introduced by Sony.

bidirectional A microphone that picks up sound from two directions.

bin In film, a large container in which shots are hung; in nonlinear editing, the part of the software program that stores video and audio information.

bit depth In digital audio, the number of tones per sample, usually 8, 12, or 16.

bit players Actors with five lines of dialogue or fewer in a movie.

black reference Something in a scene that is at the lowest level of the brightness range the camera can reproduce.

blacking Placing a control track on a videotape by feeding it a black signal from some source, such as a switcher or camera.

blimp A hard camera cover that softens the noise of film cameras.

blocking Placing actors and determining their movement within a particular shot.

blue-screen photography A photographic process for creating different layers in a special effects shot. An actor or object is filmed against a blue (or green) backdrop, and after lab work, cut out of the shot. After additional lab work, the actor (or object) is inserted into a separately photographed background, producing a seamless marriage of the two image layers.

BNC connector A bayonet-type video connector that uses a twist lock.

body brace A device that attaches to a camera and a person's body, enabling the person to hold the camera steady.

boom A long, counterweighted pole that holds a microphone; moving a camera and what it is mounted on up and down.

boom arm A device for mounting a light-weight light.

boom operator The person who positions the boom microphone before and during production.

bounce light Light reflected into a scene from a ceiling, wall, or reflector.

bracket To shoot a scene at several different f-stops above and below what you think the actual f-stop should be.

brightness How light or dark a particular color appears on a black-and-white television set or how much light a color reflects on a color television set.

broad A rectangular floodlight that has an open-faced housing.

bus One row of buttons on a switcher.

butterfly scrim A large piece of translucent black fabric or stainless steel mesh suspended from a frame to reduce the intensity of sunlight.

call sheet A list posted during production to let people know when and where they should report each day.

camcorder A single unit that contains both a camera and a videocassette recorder.

camera assistant The person assigned to help the director of photography.

camera light A small battery-powered light mounted directly on the camera.

camera mics Microphones built into or mounted on video cameras.

camera operator The person who actually sets up and handles the film or video camera during production, doing such things as framing shots and focusing.

canted shot Picture composition in which the framing is not level with the horizon.

capacitor The element in a condenser mic that responds to sound.

cardioid A microphone that picks up sound in a heart-shaped pattern.

casting Deciding who will act the various roles in a movie.

CCD See *charge-coupled device.*

C-clamp A clamp with a screw that locks against a pipe or other support in order to hold a light.

cement splicer A piece of equipment that glues together two pieces of film.

center-weighted metering A light-metering system that measures light for the entire frame but is biased toward a rather small area in the middle of the frame.

CGI See *computer-generated imagery.*

character generator A piece of equipment an operator uses to type letters onto a screen electronically and then store them so they can be added to video material whenever they are needed.

charge-coupled device A solid-state imaging device (also called a **chip**) that translates an image into an electronic signal in a video camera; abbreviated **CCD**.

chrominance The color characteristics of a video signal.

cinematographer The person who has the overall responsibility of making sure all shots are properly lit and composed; also called the **director of photography** or **DP**.

clean room A spotless room with filtered air used to cut the original negative of a film.

click book A list or computer program that indicates to a composer how many measures of music to compose for a certain length of film and at what tempo.

close-up A shot that isolates a subject in relation to the surroundings; abbreviated **CU**.

color balanced Refers to the way a film stock is manufactured to produce the correct colors in different lighting conditions (such as daylight or tungsten light).

color bars The colors red, green, blue, yellow, magenta, cyan, white, and black as shown on a monitor for test and setup purposes.

color circle A graphic representation of which colors complement each other.

color conversion filter A filter that converts daylight-balanced light for use with a tungsten-balanced film or electronic imaging system, or that converts tungsten-balanced light for use as daylight.

color corrector A piece of equipment used to make subtle color changes in a video picture; sometimes called a **timer**.

color temperature A measurement, expressed in degrees Kelvin (K), that provides color information about light. The lowest numbers are reddish, and the highest numbers are bluish.

color-compensating filter A filter that compensates for subtle shifts in the color temperature of light.

completion guarantee A type of insurance that covers expenses so a movie can be finished if its original funding is inadequate.

component A video system that records luminance and chrominance information separately.

composite A single video signal containing the picture information (chrominance and luminance) and sync information; a video recording system in which the luminance and chrominance are recorded together.

composite release print A single strip of film holding picture and sound.

compression A technique for placing more video information in less space, for example, by including only elements that change from one frame to another.

computer-generated imagery Images created in the computer that can be combined with other film, video, or digitally produced images; abbreviated **CGI.**

computer graphics generator Equipment used to manipulate lines and forms to draw graphs, alter photographs, create credits, and undertake a variety of other, art-related tasks.

concept A brief written account of the basic idea for a story.

condenser mic A microphone construction that is based on changes in which movement of a diaphragm results in changes in capacitance.

conform To match the camera original of a movie to the workprint.

contact printer A piece of equipment that prints film by running the negative and the unexposed print stock next to each other and past a light source so that the light passes through the negative and exposes the emulsion on the print stock.

continuity Consistent and unobtrusive progression from shot to shot in terms of screen direction, lighting, props, and other production details.

continuity editing A cutting method designed to maintain a smooth and continuous flow of time and space from one shot to the next.

contrast The varying levels of brightness and darkness within a particular scene.

contrast range The range of the brightest area in the scene to the darkest area in a scene.

contrast ratio A ratio (for example, 8:1) of how bright the brightest part of a scene is in relation to how dark the darkest part is.

control track Part of a videotape that contains the electronic timing impulses to keep the picture information stable.

copyright The exclusive right to a publication or production.

costume designer A person who plans and creates what people will wear in a movie.

countdown Numbers (usually 10 to 2) on a tape or film just before the program material that are used for cueing.

crane A large piece of equipment that holds the camera and its operator and moves in many directions, including up and down; moving the camera and its supporting device up or down.

cross-cutting Editing back and forth from one location to another or one story line to another in order to imply that the two actions are taking place simultaneously; also called **parallel editing** or **intercutting.**

cross-fade To gradually bring in one sound while another is gradually fading out.

crystal The crystal-controlled timing element in film cameras and audiotape recorders that allows both to run at the same speed without a connecting cable.

CU See *close-up.*

cue sheets Vertical lists that indicate when each sound of a movie should be brought in and taken out during the mix.

cutaway A shot of someone or something not directly visible in the previous shot. It is frequently used to show some related detail or reaction to the main action.

cut-in A cut to a shot that isolates some element in the previous shot.

cuts-only A form of editing that only places one piece of material after another. It cannot involve dissolves or other transitions.

cutting-on-action Refers to shots edited so that action begins in the first shot and is completed in the second.

D1 A composite digital format introduced by Sony in 1986.

D2 A composite digital format introduced by Ampex in 1988.

D3 A composite digital format introduced by Panasonic in 1990.

dailies The unedited workprint of a film that comes from the lab each day, allowing the director and others to view their work before the next day's shooting.

daily production report A report, usually on a standardized form, that tells what was accomplished during each day of production.

DAT See *digital audiotape.*

DAW See *digital audio workstation.*

day-for-night Shooting during the day but making it look as though the footage were shot at night.

dB Abbreviation for **decibel.**

DC Direct current; usually used to refer to battery power.

DCC See *digital compact cassette.*

DCT The first compressed digital format introduced by Ampex in 1992.

decay The time it takes a sound to go from full volume to silence.

decibel A measurement of noise or loudness; abbreviated **dB.**

degausser Electromagnetic equipment that erases tape by lining up all the iron particles.

depth of field The area in which objects located at different distances from the camera remain in focus.

desktop The screen on the computer that has various icons and/or windows on it.

dialogue Words spoken by characters in the movie.

diaphragm The adjustable ring of a lens that opens and closes to allow more or less light to pass; an element in a microphone that

vibrates to create electronic impulses in the form of sound.

dichroic filters Blue filters that convert tungsten-balanced lamps to daylight balance.

dichroic mirror A filterlike mirror that reflects certain colors and allows others to pass through; used in some cameras to separate the incoming light into its red, blue, and green components.

diegetic sound Sound that comes from within the story space.

diffusion filter A filter that scatters light, making for a softer, less detailed picture.

digital Refers to a recording, circuit, or piece of equipment in which the output varies in discrete on-off steps so that it can be reproduced without generation loss.

digital audio workstation Computer equipment that can be used to record, create, store, edit, and mix sounds, all in digital form; abbreviated **DAW.**

digital audiotape A high-quality audiocassette format that records diagonally; abbreviated **DAT.**

Digital Betacam/SX A compressed format introduced by Sony in 1993.

digital composite An image composed of different layers or elements that are combined together in the digital domain.

digital sampler Equipment that manipulates sounds by varying such characteristics as speed and volume so that one sound can be made to sound like something else.

digital versatile disc A video disc with a large capacity for storage; abbreviated **DVD.**

digitize The process of converting a film or video image and sound into digital form.

digitizing board A computer board used to convert an analog video signal into digital information that can be stored in the computer.

dimmer board A device that reduces the intensity of light by varying the voltage supplied to the lighting instruments.

direct sound Sound that does not bounce and therefore sounds dead.

directionality A microphone's ability to pick up sound from a variety of locations.

director The person responsible for the overall creative aspects of a motion picture.

director of photography The person responsible for making sure all shots of a movie are properly lit and composed; abbreviated **DP;** also called **cinematographer.**

director's cut The edited version of a movie that includes the suggestions made by the director.

dissolve The gradual fading in of one picture while another is gradually fading out.

distortion Muddy audio caused by recording a sound at a higher volume than the equipment can handle.

dolly A wheeled cart used to move a camera during shooting; moving a camera and its supporting device forward or backward.

dot A round piece of metal or cloth that can be placed between a light and a subject to create shadows or keep light from reaching certain surfaces.

double system A method of recording the sound on one piece of equipment and the picture on another.

double-fog filter A filter that scatters light from bright areas to shadow areas without reducing the sharpness of the picture.

DP See *director of photography.*

drop-frame time code A time code that is adjusted so that the frame rate of 29.97 per second reads out at 30 frames per second.

dropout compensator A piece of equipment used to fill in bits of video signal where imperfections in the oxide leave small unrecorded portions on the audiotape or videotape.

dropouts Areas where imperfections in the oxide leave small unrecorded portions on the audiotape or videotape.

dub A copy of a videotape or audiotape; also the process used to make a copy of a tape.

duration The length of time a particular sound lasts.

dusk-for-night Shooting at twilight in order to create the effect of shooting at night.

DVCAM Sony's ¼-inch compressed digital tape format.

DVD See *digital versatile disc*

DVPRO Panasonic's compressed digital tape format.

dynamic mic A microphone that creates an electrical current based on the motion of a diaphragm attached to a movable coil suspended in a magnetic field.

dynamic range The degree of loudness and softness that a piece of equipment can accommodate.

echo Sound that has bounced off a surface once.

edge numbers Numbers along the side of film used to synchronize and to conform the workprint, camera original, and/or sound.

edit controller The piece of equipment used to mark the editing points and cue the recorders used to execute the editing decisions in a linear system.

edit decision list A step-by-step list of each video edit (usually based on SMPTE time code) to be made, along with a description of the material, including the reel numbers involved, whether the edit is to be a cut or a dissolve, and the duration of the edit; abbreviated **EDL.**

edit deck The VCR onto which material is recorded.

edit stop A button on the edit controller that terminates an edit.

editor The person who cuts together the picture and principal dialogue of a movie.

editor's script A script prepared by the script supervisor for the editor that includes information about each shot as well as the changes made in the script during production.

EDL See *edit decision list.*

EI See *exposure index.*

electret condenser mic A type of condenser mic with a permanently charged backplate.

electromagnetic spectrum The continuous frequency range of wavelengths that includes radio waves and light waves.

electron gun The part of the TV tube that shoots electrons to the target, where they scan the information that becomes the video signal.

emulsion The film layer containing the light-sensitive materials that record the image.

encoder Part of a video system that recombines the red, green, and blue chrominance signals with the luminance signal.

equalization Emphasizing, lessening, or eliminating certain audio frequencies.

establishing shot A shot that orients the audience to a change in location or time.

executive producer The person who oversees a number of different movie projects.

exposure index A measure of the speed or light sensitivity of a film; abbreviated **EI.**

extendable lighting pole A device for mounting a lightweight light.

extras People who are part of the atmosphere of a movie but do not have any distinguishable lines.

eyelight A small focusable light placed near the camera to add sparkle to a person's eyes.

eyeline match Matching two shots so that a person appears to be looking at the right person or in the right direction.

fade To go gradually from a picture to black or from black to a picture; also, to go gradually from silence to sound or sound to silence.

fade-in To go gradually from black to a picture; to go gradually from silence to sound.

fade-out To go gradually from a picture to black; to go gradually from sound to silence.

fast film stock Film that is very sensitive to light but does not record a particularly rich range of grays.

fast lens A lens that can transmit a large amount of light. A fast lens requires less light than a slow lens.

field Half of a frame that contains a scan of the odd-numbered lines or the even-numbered lines of the 525 lines of a TV image.

fill light Light that reduces the shadows and high-contrast range created by the key light; a lighting instrument, typically open-faced, used for fill lighting.

film bin A big container in which film shots are hung during editing.

film splicer A piece of equipment used to cut and join together pieces of film.

film-style lighting Setting up a new lighting scheme for just about every shot.

filter A glass or gelatin that alters light; something that changes audio sound by cutting out or letting through certain frequencies.

filter factor The degree of light exposure compensation needed for a particular type of filter.

filter wheel The part of a video camera that allows the operator to select the correct filter for different lighting conditions.

final cut The last edited version of a film or videotape.

finger A long, thin piece of metal or opaque material that can be placed between a light and a subject to create shadows or to keep the light from reaching certain surfaces.

firewire A connection that enables digital signals to be sent from one piece of equipment to another.

fishpole A type of mic boom that consists of a simple pole held by an operator.

fixed lens A lens of a single focal length, as opposed to a lens (such as a zoom lens) with a variable focal length; also called a **prime lens.**

flag A rectangular piece of metal or opaque material placed between a light and a subject to create shadows or to keep the light from reaching certain surfaces.

flashback Portrayal of events that happened before events already shown.

flash cut A shot of just a few frames, the effect of which is almost subliminal, that can be used to present a brief image from the past or the future.

flashforward A cut forward to portray events in the future before returning to the point in the movie at which the time shift began.

flashing A film process for reducing contrast that involves exposing the film to a low light level before it has been exposed in the camera or before it is processed.

flat In audio, a term describing frequencies picked up equally well; in lighting, a term describing placement of lights so that there are very few shadows.

flatbed An electrically powered film editing machine that is in a horizontal configuration.

flood To adjust a variable-focus lighting instrument to the position that allows it to cover a broad area.

floodlight A diffused light that covers a wide area.

floor stand A pole device that rests on the floor and is used to hold a microphone.

fluid head A mounting device on which a camera is placed that allows for smooth operation because it uses hydraulic resistance.

flying spot scanner A machine that produces a high-quality transfer of the film image to videotape and does not pull on the film.

focal length The distance from the optical center of the lens to the point in the camera where the image is in focus.

focus To make an image look sharp and clear.

fog filter A filter that scatters light from bright areas to areas with shadow, thereby lowering contrast and sharpness.

folder In nonlinear editing, the part of the software that stores video and audio information.

Foley The recording of sounds such as rustling dresses and footsteps in sync with the picture; the room where this activity takes place.

Foley walkers People who create the sounds in a Foley room.

font A particular letter style for graphics.

footcandle The amount of light that is present 1 foot from a source of 1 candlepower.

forced development Increasing the developing time when film is processed so that underexposed film receives more exposure. The effect of forced development is to increase film speed; it is also called *pushed processing*.

formats The specific size and/or characteristics of particular film or video systems (for example, 35mm, Super 8, VHS, DVCPRO, Hi-8).

frame In film, a single picture within a motion picture; in TV, one complete scan, from top to bottom, of the lines (composed of two fields) of video information.

frame accurate Refers to video editing systems that consistently execute an edit to the exact frame desired.

frame counter Part of an editing controller, VCR, or other piece of equipment that displays the time code or control track numbers.

freeze-frame To stop (that is, freeze) the action on one frame of film or video. In video, this can be accomplished in a variety of ways, using digital video effects equipment or still-frame storage units. In film, a freeze-frame is created in the lab during printing.

frequency A measurement of wave movement expressed in cycles per second (hertz).

frequency curve A line indicating how well a particular piece of equipment picks up different sound frequencies.

frequency response The range of sound frequencies that a particular piece of electronic equipment is capable of reproducing.

Fresnel spotlight A light with a well-defined lens. The beam width is varied as the bulb is moved toward and away from the lens.

friction head A tripod head, the movement of which is controlled by a spring or sliding mechanism.

front focus Focusing the elements of a zoom lens so that the image will stay in focus throughout the zoom range.

f-stops Numbers that indicate the setting of the lens aperture.

fundamental Refers to the main frequency of a particular sound.

gaffer A person who directs others on how to position and plug in lights on a set.

gaffer grip A spring-loaded clamp that can secure a light almost anywhere; also called an **alligator clamp.**

gaffer tape Strong adhesive tape used primarily for securing lighting equipment.

gain The amount of amplification an audio or video signal receives.

gangs Multiple tracks on a synchronizer that hold two to six rolls of film and/or magnetic stock in a constant relationship.

gelatin filter A filter made of a soft substance from animal skins that is placed over lenses, lights, or windows or in filter holders placed between the lens and the imaging device.

generation loss A deterioration of picture or sound caused by dubbing material from one tape to another.

glass filter A filter that has gel cemented between two pieces of glass, or dye laminated between two pieces of glass, or dyes added to the glass during manufacture.

graduated neutral density filter A filter that darkens only part of a frame, usually the top.

graphics generator See *computer graphics generator.*

grips People who do physical labor on a shoot, such as carrying set pieces, pushing dollies, and handling cables.

handle On a nonlinear timeline, a node used to start or end a fade.

hard effects Sound effects that are synchronous with the picture.

hard light Light that has a narrow angle of illumination and produces sharp, clearly defined shadows.

harmonics Pitches that are part of an overall sound and are exact multiples of the fundamental frequency of that sound.

haze filter A filter that eliminates the bluish cast on overcast days.

HDTV See *high-definition television.*

head A device placed between a tripod and a camera that allows the camera to pivot smoothly; magnetic elements that can erase, record, or play information on or from a videotape or audiotape.

headroom The amount of space above a character's head in a particular framing configuration.

hertz A frequency measurement of 1 cycle per second; abbreviated **Hz.**

hidden editing See *invisible editing.*

hidden mics Microphones placed in the set so they cannot be seen.

Hi-8 An improvement on the Sony Video-8 format that uses metal particle tape and a wider luminance band.

hi-fi A frequency modulated audio signal that is recorded diagonally on videotape along with the video signal in such a way that it cannot be separated from the video signal in editing.

high hat A camera mounting device that is close to the ground because it consists of a board on top of very short legs.

high-angle shot A shot taken from above, looking down on a scene.

high-definition television TV that scans more than 1,000 lines per frame and has an aspect ratio of 16:9; abbreviated **HDTV.**

high-key lighting Lighting that is generally bright and even, with a low key-to-fill ratio.

high-speed fluorescent A type of light that outputs reds, greens, and blues in a consistent manner to produce 3,200 Kelvin light that oscillates between 25,000 and 40,000 cycles per second; abbreviated **HSF.**

hiss A distracting high-frequency noise often inherent in low-quality audiotape.

HMI light Hydrogen medium-arc-length iodide lamp that is daylight balanced and therefore used to supplement the sun as a light source.

horizontal resolution The common way of describing a video camera's ability to distinguish fine detail in a picture; the number of vertical lines per millimeter that can be distinguished by a camera imaging device or a TV receiver.

hot splicer A piece of equipment with a heating element that uses glue to join together two pieces of film. The heating element speeds drying.

HSF See *high speed fluorescent.*

hue The specific tint of a color, such as red or purple.

hypercardioid Refers to a microphone that picks up in an extreme heart-shaped pattern.

Hz The abbreviation for **hertz.**

image enhancer A piece of equipment that corrects for the loss of sharpness and the

smearing of color that result from a video image being taken apart and recorded.

image stabilization A camera feature that makes for steadier shots by digitally magnifying part of an image and tracking it as the camera moves.

imaging device The part of a camera on which the image gathered by the lens is focused.

impedance A characteristic that refers to the opposition a sound signal encounters as it goes through a system.

incandescent light A lamp that contains a tungsten filament sealed in a vacuum tube that heats up and produces light when an electric current is passed through it.

incident light meter An instrument that measures the amount of light falling on the meter.

inpoint The precise location where an edit is to begin.

insert A method of linear video editing in which the control track is laid down on the edit tape first and then audio and video information only (not control track) are laid down from the source deck; audio and video can be split during the editing process.

interactive media Presentations in which the content can be controlled to some extent by the person using them; usually, the person can use a keyboard, mouse, or remote control to select the options.

intercutting Editing back and forth from one location to another or one story line to another in order to imply that the two actions are taking place simultaneously; also called **cross-cutting** or **parallel editing.**

interlaced scanning Combining two video fields in one frame by scanning all the even lines and then all the odd lines.

interlock The projection of a film or video workprint in sync with all its sound tracks so that all the sound elements can be checked to make sure they occur at the right points; also referred to as **lock-up.**

internal reflector spotlight A bulb with a reflector unit and focusing lens built into it.

inverse square rule The principle that light intensity decreases by the square of the distance from the subject.

invisible editing A process that attempts to mask edits and make them unobtrusive; also called **hidden editing.**

I/O (input/output) Putting information into a computer and accepting information that comes out of a computer; a device that can do so.

iris The adjustable metal diaphragm of a lens that can be opened and closed to allow more or less light to pass through.

Jaz drive A removable drive that can store digital information such as sound and video used for nonlinear editing.

jib-arm A cranelike, counterweighted mounting device for raising or lowering a camera.

jump cut A distracting break in continuity caused by a mismatch in object position, screen direction, action, setting, or other production details.

Kelvin The scale in degrees for measuring color temperature.

key A special effect whereby video signals from two or more sources are combined in such a way that one image looks like it has been cut out and placed on top of the other image.

key light The main source of light in a typical lighting setup, usually a spotlight set above the subject and to the front and side.

keyframe A representative point in nonlinear editing used to define movement; for example, to plot out the movement of a title or graphic in and out of the frame.

Keykode Eastman Kodak's system for marking film so that the negative can be cut accurately; it identifies frames with a bar code that can be related to a time code for electronic editing purposes.

kicker light A light placed low and behind a subject in order to provide more separation of the subject from the background.

latitude The difference, expressed as an amount, between the brightest and darkest areas that can be faithfully reproduced by a particular film stock or video imaging system.

lavaliere A small microphone, usually attached to a person's clothing.

layback To place the final mixed audio on the master videotape.

laydown To record production dialogue digitally so that it can be conformed to the picture later.

layering Blending various sounds so that each is given its proper emphasis or deemphasis.

leader Material that appears on a videotape before the program material; usually consists of color bars, tone, a slate, and a countdown.

leadroom The space to the side of the frame that is in front of someone or something that is moving.

lens The part of the camera that gathers light and focuses the image.

lens hood A cover built into or attached to a lens to keep stray light out.

library In nonlinear editing, the part of the software program that holds video and audio information, often including stock footage, sound effects, and copyright-cleared music.

light meter An instrument used to measure the amount of light falling on or reflected from a subject.

light stand A device that holds lights. It consists of a tripod base and a pole that can be telescoped.

light-balancing filter A filter that makes a slight shift in the color temperature of light.

lighting crew The people who set up and position lights in a TV studio or at a remote location.

lighting director In TV, the person in charge of setting up the lights in a studio or at a remote location.

lighting plot A diagram showing the camera position, the set, and the location, size, type, and direction of the lighting instruments.

lighting ratio The ratio of key light plus fill to fill light alone.

line inputs Jacks built into equipment for connecting tape recorders, CD players, and other pieces of equipment (but not microphones).

line producer The person who represents the producer on the set and makes sure all is being accomplished on time and on budget.

linear Refers to video material edited together in sequence from beginning to end.

linear audio The track along the edge of the videotape on which sound can be recorded. Time code also can be recorded in this area.

linear CCD array A film transfer device using two different sets of CCDs (one following another) to scan the image. The first device (with four separate sensors) scans only the luminance information; the second device contains three CCDs, one each for the red, green, and blue information. Together they produce a very high-resolution image with an excellent signal-to-noise ratio.

linear track The audio track on a videotape that runs horizontally near the bottom or top of the tape.

lock-up See *interlock.*

log A list of all the shots, in the order they are taken, and a description of each shot; also, to make a list of shots.

long lens A lens with a long focal length that magnifies a subject and foreshortens distances.

long shot A shot that emphasizes the surroundings and the subject's placement in them; abbreviated **LS.**

longitudinal time code Time code laid down on an audio channel.

look space See *noseroom.*

looping An old term for **automatic dialogue replacement.**

lossless A compression system that preserves all information so the clip can be restored to its original form when it is decompressed.

lossy A compression system that does not preserve all information and, therefore, cannot restore a clip to its original quality when it is decompressed.

low-angle shot A shot for which the camera is positioned low and angled up at the subject.

low-contrast filter A filter that scatters light in a scene so that it brightens shadows but does not reduce sharpness.

low-key lighting Lighting that is dark and shadowy with a high key-to-fill ratio.

low-light sensitivity The ability of a camera to produce an acceptable image with minimal illumination.

LS See *long shot.*

luminance Pertaining to the brightness characteristics of a video signal.

lux The amount of light 1 meter from a source of 1 candlepower; 1 lux is roughly one-tenth of 1 footcandle.

macro A setting on a lens that allows it to focus on objects very close to the front element of the lens.

magazine A lightproof device containing film that is placed on the camera.

magnetic film stock A sprocketed audiotape used in film editing that has the same dimensions as the film and moves at the same speed.

master scene script The final script for a movie, set up much as the script for a stage play, describing all the dialogue and action but without individual shot designations (as in a shooting script).

master shot A shot that covers an entire scene from an angle wide enough to establish all the major elements.

match cut A cut that provides a continuous sense of time and space between two shots.

matching action Cutting two shots together so that the movement seems to flow from one shot to the next.

matte box An adjustable bellows that attaches to the front of the camera and extends beyond the lens to hold filters or mattes that cut off part of the image; also called a **filter box**.

medium shot A shot that gives a sense of the subject and the subject's surroundings; abbreviated **MS**.

M-format The professional-level ½-inch video format of JVC and other companies.

MIDI See *musical instrument digital interface.*

M-II An improvement on the ½-inch professional-level M-format video format.

midside miking A stereo pickup method that combines bidirectional and supercardioid microphones. Also called **M-S miking**.

mic inputs Jacks built into equipment for connecting microphones. See also *line inputs.*

Mini Disc A recordable audio compact disk developed by Sony.

Mini-DV A digital tape format intended for consumer use.

minicassettes Small videocassettes used for field recording in some formats.

miniphone plug A small audio connector most commonly found in consumer-level equipment.

mise-en-scène A theatrical term that describes the placement of scenery and actors. In film and TV it refers to the director's control of such elements as lighting, sets, locations, props, makeup, costumes, and blocking and direction of actors; in other words, it refers to everything that can be controlled before the camera comes into play.

mix See *sound mix.*

mixed lighting Lighting that contains daylight and artificial light.

mixer An audio board that combines audio from various sources and then sends it to other equipment; a person who combines sounds.

modulate To vary the amplitude, frequency, or phase of a wavelength by impressing it on another wavelength that has constant properties.

monaural Single-channel audio.

monitor A TV set that does not receive off-air signals but can receive line level signals straight from a camera or a VCR.

mono See *monaural.*

montage editing Editing built on the relationships of the material being edited, such as size, theme, or symbolism, rather than its continuity.

morphing Gradually changing one video or film form into another, such as a man into a beast.

motif A particular musical refrain that follows a character or event throughout a movie.

MS See *medium shot.*

M-S miking See *midside miking.*

multimedia Information combining at least two formats, such as still graphics and video, and requiring the use of a computer.

multipin connector A connector that carries a number of signals between a camera and a VCR or between a monitor and a VCR.

multitrack audiotape recorder An audiotape recorder that can record and play back a large number (usually 4, 8, 16, or 24) of signals on separate channels.

musical instrument digital interface A communication system that allows musical instruments and other electronic gear, such as

digital audio workstations, to interact; abbreviated **MIDI**.

negative A photographic image that reverses the light values; in color, every color is reproduced as its complement; in black and white, dark areas are recorded as light and light areas are recorded as dark.

neutral density filter A filter that reduces the amount of light reaching the imaging device without affecting the color in any way.

neutral density gelatins Large pieces of gelatin, usually hung over windows to reduce the strength of the light.

night-for-night Shooting at night in order to create the look of night.

noise Any type of unwanted audio or video interference.

nondestructive editing Digital picture or sound editing that does not physically alter or damage the original recording.

nondiegetic sound Sound that is from outside the story space, such as the musical score.

non-drop-frame time code Time code that reads thirty frames as thirty frames, without any counting adjustments.

nonlinear Refers to video material that can be edited without having to lay one shot after another: the end can be edited before the beginning.

normal lens A lens with a focal length that shows objects approximately as they appear to the eye.

noseroom The space to the side of a frame at which a person is looking, sometimes called **look space**.

off-line Video editing that uses workprints rather than original footage.

off-screen space Areas beyond the edge of the screen and to the front and rear of the frame that can be used to imply that an action or a sound is coming from somewhere just beyond the visible picture area.

ohms A measurement of impedance.

omnidirectional A microphone that picks up from all sides.

180-degree rule The principle that places an imaginary line between two people talking, or the screen direction established by a walking character or moving object. If the camera is placed to one side of this imaginary line and anywhere within a 180-degree arc, spatial continuity will be maintained; if the camera is placed beyond 180 degrees, screen direction will change.

on-line Refers to editing that uses original material and actually puts all edits onto a finished master tape.

opacity The degree to which something does not transmit light.

open casting General auditions that anyone can come to in order to try to obtain a part in a movie.

optical center The part of a lens where the image is turned upside down so that it can be sent to the imaging device.

optical printer A piece of equipment that prints film by projecting the camera original onto unexposed film stock.

optical sound track A visual representation of film sound that runs along the side of the film and depends on the modulation of a beam of light.

OS See *over-the-shoulder shot.*

outboard equipment Equipment such as CD players and tape recorders that feeds into an audio board.

outpoint The precise location where an edit is to end.

outtakes Material shot but not used in the final movie.

overlap cutting Editing sound and dialogue so that the actor's lines are heard while something else appears on the screen.

overlapping action A method of shooting film or tape in which some of the action in one shot is repeated when the next shot is recorded. The technique is used to provide the editor with options.

overmodulation A signal recorded at a level higher than the system can handle, resulting in distorted sound.

over-the-shoulder shot A shot that looks from behind the shoulder of one character toward another character or object; abbreviated **OS.**

overtones Pitches that are part of an overall sound that may or may not be exact multiples of the fundamental frequency of that sound.

pan Moving the camera left or right on a tripod or by hand.

paper cut Information, such as edit inpoints and outpoints, that you write down on paper before you start using editing equipment.

PAR lights Parabolic aluminized reflectors, which have a reflector unit and focusing lens built into the bulb.

parabolic reflector A lamp housing that produces a concentrated beam of hard light.

parallel editing Cutting back and forth from one location to another or one story line to another, usually to show that two actions are occurring simultaneously but sometimes to compare or contrast two actions; also called **cross-cutting** and **intercutting.**

PCM Pulse code modulation; a digital audio signal that is recorded diagonally on videotape and is separate from the video.

peaking in the red Recording sound at such a high volume that the needle of the volume unit meter is almost always in the red area.

pedestal The control on a time-base corrector or other piece of video gear that sets the darkest level. Normally, this level is set to 7.5 percent on a waveform monitor.

perspective The spatial relationships established in regard to some source (audio or visual) within the picture.

phase The relationship of one sound wave to another, expressed in time; waves are *in phase* if they are at the same point in their cycles at the same time; they are *out of phase* if they are at different points.

phone plug A long slender audio connector often used for microphones and headphones.

phono plug A connector with a short prong and outer covering; also called an **RCA plug** or **RCA connector.**

photoflood An inexpensive artificial light that uses bulbs that look somewhat like normal household bulbs.

pickup pattern The particular directions from which a microphone gathers sound.

picon (picture icon) A selectable frame used to identify a shot in a nonlinear editing system. The frame is displayed as a picture icon and, depending on the editing system, can be dragged to a timeline and/or brought onto the screen.

ping-ponging Sound recorded from one track of a videotape to another.

pitch How high or low a particular sound is in terms of frequency.

pixels Light-sensitive picture elements.

point-of-view shot A shot that shows a scene as a particular character in the movie would see it; abbreviated **POV.**

polarizing filter A filter used to minimize reflections by influencing the angle of the light between the lens and a shiny surface.

positive Film that produces an image with lights and shades corresponding to those of the subject.

postproduction The stage of moviemaking that occurs after the shooting and that includes the editing and sound building.

postproduction supervisor The person who makes sure all of the phases of editing for series TV are completed properly and on time.

POV See *point-of-view shot.*

practical light A light, such as a table lamp or lighting fixture, that is visible in a scene.

premix Certain sounds, such as multiple sound effects, mixed together before the final sound mix is undertaken.

preproduction The stage of moviemaking that involves making the decisions, plans, and budget for production and postproduction.

preroll The time during which VCRs get up to a stable speed during the editing process.

presence The authenticity of a sound in terms of perceived distance and fidelity.

prime lens A single-focal-length lens; also called a **fixed lens.**

principal actors The people who have the main speaking parts in a movie, usually the leads and the supporting cast.

print-through When an audio signal on one layer of tape seeps through to the layer of tape above or below it.

print to tape Outputting video and audio material from a nonlinear editing system directly to videotape.

prism block A device in a camera that breaks incoming light down into the primary reds, blues, and greens present in a particular video image.

producer The person who is in overall charge of a particular movie, especially the schedule and money.

producer's cut The edited version of a film that includes the suggestions made by the producer.

production The stage of moviemaking during which all picture and principal sound are shot.

production assistant A person who performs a variety of general tasks during the production phase of moviemaking.

production designer The person whose job it is to make sure the overall look of the film is consistent.

production manager See *unit production manager.*

production schedule A detailing of the lengths of time allocated for preproduction, production, and postproduction and what should occur during each phase.

progressive scanning Laying down video information from top to bottom to create a frame, as opposed to laying down two fields, which is done in interlaced scanning.

props Items that are necessary to the plot of a movie.

proximity effect A phenomenon produced by certain microphones wherein low frequencies are boosted when someone speaks close to the mic.

public domain The legal condition covering copyright that states that when material is a certain age, it can be used without having to obtain permission.

pulling focus Manually changing the focus of a lens as a shot is in progress.

pulse code modulation See *PCM.*

pushed processing See *forced development.*

quadraphonic Sound that is picked up and reproduced through four separate channels.

quartz lamp See *tungsten-halogen lamp.*

quartz-halogen lamp See *tungsten-halogen lamp.*

rack focus To change focus from one object or area in a frame to another during the course of a shot.

radio frequency The carrier wavelength on which audio and video signals are superimposed; abbreviated **RF.**

RAID See *redundant array of independent disks.*

RAM See *random-access memory.*

random access The ability to bring up audio or video material instantly, in any order, such as from a disk, without having to wait for tapes to rewind.

random-access memory Resident memory in a computer that can emulate a very fast temporary disk drive; commonly referred to as **RAM.**

RCA connector See *phono plug.*

RCA plug See *phono plug.*

reaction shot A shot that shows someone responding or reacting to what someone else is saying or doing.

record deck The VCR onto which material is edited after receiving the signal from the source deck.

redundant array of independent disks A technique for linking two or more hard drives together to increase data storage capacity, reliability, and performance at the level required for multimedia applications and nonlinear editing; abbreviated **RAID.**

reel-to-reel An audiotape recorder that requires the tape be threaded from one side of the head to the other from open reels.

reflected light meter An instrument that measures the amount of light bounced off a subject.

reflector A light-colored surface used for bouncing light back into a scene; often used for fill lighting outdoors.

reframing Slightly adjusting the composition of a shot as characters change position.

release print The final print of a film, the one that is shown in movie theaters.

render The often slow, CPU-intensive process of creating multilayered graphics, animations, transitions, or effects in the computer.

resolution The degree to which fine detail in the image can be distinguished.

resolving unit A piece of equipment that uses the sync pulses recorded on ¼-inch audiotape to transfer the sound to magnetic stock so that it can be edited in sync with the filmed picture.

reverb See *reverberation.*

reverberation Sound that has bounced a number of times or has been processed so that it sounds like it has bounced.

reversal Camera film that produces a positive print when it is developed.

rewinds Two arms that hold the feed and take-up reels of film while they are on the editing bench.

RF See *radio frequency.*

RF connector A connector used to play back both picture and sound through an ordinary TV set.

Richter Shaky camera movement done on purpose.

riding in the mud Recording sound at too low a level, one in which the needle of the volume unit meter is usually below 20 percent.

ripple In nonlinear editing, the effect produced by one change in an edit, which automatically changes all the footage positions that follow.

rock 'n' roll Starting a scene with a series of long shots that move about a great deal as though someone was moving his or her head to see the whole area.

room simulators Pieces of equipment that can imitate the room tone of rooms of various sizes.

room tone The noise or the general ambience where a movie is being shot, recorded during production to be used as background during editing.

rough cut A loose assemblage of the pictures and dialogue of what will eventually become the edited master of a movie.

rubber band On a nonlinear timeline, a line that extends up or down to indicate a fade.

rubber lock Making the decision regarding the final picture and dialogue editing somewhat permanent but still subject to change.

rule of thirds The principle that, to make composition more dynamic, it is better to try to break a frame into thirds rather than halves.

sampling rate In digital technology, the number of times a particular signal is converted to zeros and ones.

saturation The intensity or purity of a color.

scanning The process by which the TV image is picked up and reproduced. It involves sending a signal very rapidly left to right and up and down on the TV screen.

scene A shot or series of shots, usually presenting a unified action and occurring in a single place and time.

scene number The number of a particular scene as shown on the master scene script; scene numbers often are followed by letters (A, B, C) labeling particular shots within a scene.

scene outline A list in numerical order of all the scenes in a screenplay, with a barebones description of what occurs in each scene.

scenery light See *background light.*

S-connector A video connector used to input and output luminance and chrominance information separately.

scoop A floodlight that contains a single bulb in a bowl-shaped metal reflector.

screen direction The spatial relationship established by composition or movement within the frame.

screenplay The final script for a movie that includes all the dialogue and action.

screen test The filming or taping of actors to see how they will come across in general or in particular roles.

scrim A translucent black fabric or a stainless steel mesh used to reduce light intensity.

script breakdown A list of all essential elements of each scene, such as whether it is interior or exterior, the time of day it is supposed to take place, and the actors and props needed.

script breakdown sheets The forms on which script breakdowns are written.

script clerk See *script supervisor.*

script supervisor The person in charge of seeing that all parts of the script are actually shot and that continuity is maintained; sometimes called a **script clerk.**

scrub A feature available in many nonlinear editing programs that allows the user to hear or see an audio or video file as the mouse drags through it.

SCSI-2 See *small computer system interface.*

search dial The dial on an editing controller that allows the operator to find particular points on a tape by shuttling at various speeds.

second unit A group of production people who shoot scenes that do not involve the principal actors while those actors are involved in the main production.

SEG See *special effects generator.*

separation light A light that enhances the modeling and three-dimensional effect of the three-point lighting system.

sequence A group of scenes linked together or unified by some common theme, idea, or action.

set decorations Items that give an overall feel to a scene but are not essential to the plot.

set designer The person who plans and makes drawings that define the look and needs of any location areas built specially for a movie.

shock mount A device that keeps a mic stable, even if the pole it is on is moved.

shooting schedule A list of what is to be accomplished during each day of production.

shooting script The director's breakdown of a master scene script into individual shots with particular camera angles, movements, or positions.

short lens A lens with a short focal length that makes objects appear smaller and farther apart than they appear to the naked eye; also called a **wide-angle lens.**

shot An element of a movie that begins when the camera starts running during production and ends when it stops running.

shotgun mic A microphone with a long, narrow pickup pattern that is used to gather sound from a great distance.

shot/reaction shot An editing pattern that cuts from some action or event to a character's response to it.

shot/reverse shot An editing pattern in which shots in succession mirror the framing of each other.

shoulder mount A device attached to the camera so that it rides comfortably on a person's shoulder.

shutter speed The amount of time per frame during which light is allowed to reach the imaging device.

signal-to-noise ratio The amount of desired audio or video a piece of equipment picks up in relation to the amount of unwanted electronic disturbance it picks up; abbreviated S/N.

single system A method of recording sound and picture on the same medium.

sky filter A filter that blocks out haze for black-and-white photography.

slate A tablet that provides pertinent information about a shot. It is held in front of a camera and recorded just before a shot is started. Also, an identification on a tape that precedes program material, listing such information as the length of the program and the director's name.

slate clap The sound of a wooden flag hitting the top of the slate. It is recorded on the audio during filming and later is used to synchronize picture and sound.

slow film stock Film that is not very sensitive to light but reproduces a rich range of grays and a sharp image.

slow lens A lens that cannot transmit a large amount of light. A slow lens requires more light than a fast lens.

small computer system interface One of several types of standard connections that allow computers to communicate with peripheral storage devices such as CDs and videotape recorders; abbreviated SCSI.

SMPTE time code Numbers recorded on tape that can be shown on a screen or displayed on the editor to indicate the particular address of the audio and the video in terms of hours, minutes, seconds, and frames.

S/N See *signal-to-noise ratio*.

snoot A metal funnel that restricts a light beam to a circular pattern.

soft light Gentle, diffused, shadowless lighting.

soft-contrast filter A filter that reduces contrast but preserves fairly dark shadows.

softlight reflector A lamp housing (reflector) that blocks the light coming directly from the lamp and bounces it back into and off the reflector's surface.

softlights Lighting instruments that produce diffused light.

sound editor A person who spots, acquires, and edits such sounds as sound effects and Foley.

sound effects Noises that accompany what is happening on the screen, either synchronously or asynchronously.

sound flashback The use of particular dialogue, music, or other sound to indicate within a movie something that happened in the past.

sound flashforward Particular dialogue, music, or other sound used to indicate within a movie something that happens in the future.

sound mix The final joining together in a single recording of all the sound elements of a movie so that they relate properly and are at the correct volume.

sound mixer The person who records sounds, blending them together as appropriate.

source deck The VCR that supplies the video image and/or sound to the record deck during linear video editing.

source lighting Lighting that mimics the direction and source of the light that might actually be in the scene, such as sunlight that might be coming through a window, or a street light in a dark alley.

spatial compression A method of compressing video that saves space by not repeating digital information common to a number of frames.

special-effects generator A piece of digital equipment that generates such special effects as wipes and starbursts; abbreviated SEG.

speech bump The phenomenon that allows a microphone to pick up speech frequencies better than other frequencies.

split-page A type of script often used for nonnarrative movies that lists video elements in a column opposite another column of audio elements.

spot To determine where sound effects, ambient sounds, automatic dialogue replacement, Foley, or music should occur within a movie; focusing the rays of a lighting instrument to a narrower, more concentrated pattern.

spot meter A special type of reflected light meter that measures the light coming from a very narrow angle of view.

spotlight A concentrated light that covers a narrow area. It usually provides some means for varying the angle of the illumination by moving the bulb within the housing.

spotting The process of deciding where music, sound effects, and other sounds should go in the movie.

spotting sheet A paper compiled by a sound editor that indicates at what point in a movie sound effects, ambient sounds, automatic dialogue replacement, Foley, or music should occur.

sprocket holes Holes at the edge of film used to keep the film moving evenly through a camera or projector.

standby A switch on a camera that allows the camera's circuitry to preheat without using full power.

stand-ins People who replace principal actors in a scene when equipment needs to be set up or changed.

star filter A special type of diffusion filter that turns a bright point of light in a scene into a bright star pattern.

Steadicam A counterweighted camera mounting device that allows extremely smooth handheld camera operation.

stereo Sound that is picked up and reproduced through two separate channels to simulate the way the ears hear.

storyboard Drawings that show the main actions of a movie; in nonlinear video editing, the pictures on the computer edit screen that show a frame grabbed from each shot being used.

straight cut A transition in which one shot is instantaneously replaced by the next.

streamer A marking that shows where on film or videotape music is to begin and end.

strike To tear down and clean up after shooting.

string-out A loosely edited assembly of all the film and sound to be used in a particular scene or sequence.

stripboard A large board that summarizes the scenes, locations, and actors needed for each day of movie production, or a computer-generated simulation of one.

supercardioid A microphone that picks up in an extreme heart-shaped pattern.

superimpose To layer one image atop another in such a way that the images are seen through each other.

Super-VHS A ½-inch video format that was enough of an improvement on VHS that it could be used by professionals as well as by consumers. Also referred to as S-VHS.

surround sound A sound recording or processing technique that emphasizes spatial relationships, giving the audience a sense of the sound moving around them.

sustain The amount of time a sound is at full volume.

S-VHS See *Super-VHS*.

sweetening Improving or in other ways working with sound during postproduction.

switcher A piece of equipment used to select and/or mix video inputs and send them to an output device such as a VCR.

sync To coordinate two elements, such as audio and video, with each other; in video, the electronic timing pulses that coordinate the scanning process.

sync block A piece of equipment that locks film and magnetic stock together in a consistent relationship during editing.

synchronous sound Sounds recorded during production that need to be in sync with the picture, such as dialogue and some sound effects.

table stand A device that rests on a table and holds a microphone.

take An indication of the number of times a certain shot is recorded; the first recording would be take 1, the second would be take 2.

tape splicer A piece of equipment that uses clear mylar tape to join together two pieces of film.

TBC See *time-base corrector.*

technical rehearsal A run-through of a shot or scene that is held mainly for the benefit of the technical crew rather than the actors.

telecine A device for transferring film to tape.

telecine operator The person who operates the equipment that transfers film to tape.

telephoto lens A long focal length lens that magnifies and foreshortens a subject.

30-degree rule The convention of changing the camera angle at least 30 degrees between two shots to minimize the apparent jump in size or volume when those shots are edited together.

three-point lighting A traditional approach to lighting that employs a key light, fill light, and back light.

three-to-one rule The principle that states that no two mics should be placed closer than three times the distance between them and the subject so that multiple mic interference will not occur.

three-two pulldown A process used when film is transferred to video to account for the fact that film runs at 24 frames per second and video scans at 30 frames per second; the odd film frames are transferred to two fields of video, and the even film frames are transferred to three fields of video.

threshold of pain The point at which sound hurts the ears, usually about 120 dB.

tilt Moving the camera up or down on a tripod or when hand held.

tilted shot See *canted shot.*

timbre The particular sound that each musical instrument or voice has, involving such characteristics as mellowness, sharpness, and resonance.

time code See *SMPTE time code* or *vertical interval time code* or *longitudinal time code.*

time code generator A device that produces numbers indicating hours, minutes, seconds, and frames of video.

time code numbers Hours, minutes, seconds, and frame numbers embedded in videotape or audiotape or on a computer drive that are used primarily to provide an accurate address for each frame to facilitate editing.

time code reader A device that displays on a monitor or other device the hour, minute, second, and frame numbers embedded in a tape or disc.

time-base corrector A device that places a VCR video frame (or part of it) in temporary digital storage so that its scanning timing can match that of video coming from other VCRs; abbreviated **TBC.**

timeline A graphical editing interface common in nonlinear editing software in which thumbnail representations of video and audio clips are arranged along a display of the different tracks.

timer A person who evaluates each scene of a film or tape and then corrects for exposure and color balance as needed; a piece of video equipment that can be used to make subtle color changes in the picture.

timing Making minor color corrections to a film or video image.

timing sheet A list that aids the music composer by providing the edge numbers or time code numbers for the places where music is to be heard, the length the music is to run, and a description of the scenes.

tonality The range of colors or black and white that a particular film stock reproduces well.

tone A high-pitched hum, usually coming from an audio board, that can be set at 100 percent in order to calibrate audio equipment; a control that can emphasize bass or treble frequencies.

tone generator The part of a tape recorder or audio board that sends out a constant 1 kilohertz sound that is used to set consistent volume levels on various pieces of equipment.

track Moving a camera and its supporting device left or right, parallel to the subject; a portion of tape on which audio or video reside.

tracking A control on a VCR that can be adjusted to make sure that the tape head position for playback is similar to the position used for recording.

transitions Methods, such as dissolves and fades, used to get from one shot to the next.

traveling matte A laboratory process for printing a moving object in one shot into a background that was shot separately. See also *blue-screen photography.*

treatment Written prose that gives the story line for a proposed screenplay.

trigger Part of a computer program that stores information about such sound elements as pitch, duration, and volume and then recreates those, through MIDI, to activate electronic musical instruments.

trim A button on a video edit controller or a setting on a nonlinear editing program that allows the operator to change an edit point slightly without marking entirely new edit points.

tripod A three-legged device for supporting a camera.

truck Moving a camera and its supporting device left or right, parallel to the subject.

t-stop Lens stop, similar to the f-stop, based on the actual amount of light transmitted through a particular lens.

tungsten-halogen lamp A light that has a tungsten filament and quartz envelope (bulb) filled with halogen. It maintains color temperature and brightness longer than regular incandescent lamps.

TV receiver A TV set that is designed to display broadcast signals.

ultracardioid A microphone that picks up in an extreme heart-shaped pattern.

ultraviolet filter A filter that eliminates haze by blocking out ultraviolet rays; also called a **UV filter.**

U-Matic The standard ¾-inch videotape format.

U-Matic SP An improvement (superior performance) on the ¾-inch U-Matic video format.

umbrella reflector Shiny material in umbrella shape that is attached to a light stand so that the lighting instrument can be turned into it and the light can be bounced off it, creating a diffused effect.

unbalanced Refers to cable that has two wires, one for positive and one for negative and ground; also refers to a composition with more relative weight on one side of the frame than the other.

undo Part of nonlinear editing software that enables you to go back to an earlier point in your editing.

unit manager See *unit production manager.*

unit production manager The person who breaks down a script and handles much of the scheduling and detail work of preproduction and production; also called the **unit manager** or **production manager.**

universal clamp A small metal clamp that attaches to a porcelain socket for holding photofloods.

upright An electrically powered film editing machine in a vertical configuration.

utility person A person who performs a variety of general tasks during the production phase of moviemaking.

UV filter See *ultraviolet filter.*

variable focal length lens A lens that can capture wide and narrow shots and everything in between; commonly referred to as a **zoom lens.**

variable shutter On a film camera, the thin metal disk near the iris that can be adjusted to allow more or less light to hit the film; on a video camera, an electronic device that makes it possible to record extremely fast action without blurring.

VCR operator The person who operates a videotape or videocassette recorder.

vectorscope A piece of equipment that displays the color characteristics of the video signal.

velocity The speed of sound.

vertical blanking interval The period of time during which the signal of a camera or receiver tube is turned off so that it can move from the bottom to the top of the picture in order to begin scanning another field.

vertical interval time code Time code that is recorded in the space created during the scanning process when the beam is retracking from the bottom to the top of the picture; also referred to as **VITC.**

VHS A ½-inch consumer-grade video format introduced by JVC that became very popular.

video assist Using a videotape in conjunction with a film camera to provide immediate feedback about how a particular shot looks.

video capture card A computer board used to convert an analog video signal into digital information that can be stored in the computer.

Video-8 A consumer-grade video format introduced by Sony, which uses tape that is 8mm wide.

videographer The person in video production who has overall responsibility for making sure all shots are properly lit and composed.

viewer A piece of equipment used by an editor to look at the footage during film editing.

viewfinder The part of the camera that shows the picture that is being framed.

VITC vertical interval time code; time code laid down in the vertical interval of a video signal.

VO See *voice-over.*

voice-over Words spoken by an off-screen narrator or character; abbreviated **VO.**

volt A unit of measure of electromotive force that equals the force required to produce a current of 1 amp through a resistance of 1 ohm.

volume The relative intensity of a sound.

volume unit meter A device, either with a meter and needle or a digital readout of lights, that shows how loud a sound is recorded or played back; also referred to as a **VU meter.**

VU meter See *volume unit meter.*

wall plate A light fixture with a flat surface that attaches to a wall in order to hold a light.

walla walla A background sound that involves the recording of people's voices so that the actual words they are saying cannot be understood.

watt A unit of electrical power that equals the power expended when 1 amp of current flows through 1 ohm of resistance.

waveform A visual representation of an audio or video signal.

waveform monitor A piece of equipment that displays luminance information about a video signal.

wavelength The distance between points of corresponding phases in electromagnetic waves.

white balance To adjust the imaging system of a video camera so that it reproduces white (and therefore all other colors) correctly for a particular lighting situation.

white reference Something in a scene that is at the highest level of the brightness range the camera can reproduce.

wide-angle lens A lens with a broad angle of view that makes objects appear smaller and farther apart than they appear to the naked eye; also called a **short lens.**

widescreen An aspect ratio wider than 1.33:1, such as 1.85:1, 2.21:1, 2.35:1.

wild sounds Asynchronous noise recorded separately from the picture and generally supplied during editing for background.

window dub A copy of recorded material that shows time code numbers burned into a rectangular area somewhere in the picture area.

windscreen A metal or foam cover for a microphone that cuts down on small disruptive noises.

wipe Gradual replacement of one picture with another by having one picture push the other off-screen.

wireless mic A microphone that operates on FM frequencies and has an antenna that transmits to a receiver. It does not require an audio cable.

workprint A copy of the original film or tape footage used for editing so that the original does not become damaged.

writer The person who creates the script for a movie.

XLR connector A connector that has three prongs and an outer covering; also called a **Cannon connector.**

X-Y miking A stereo pickup method that uses two cardioid mics placed next to each other.

Zip drive A removable drive that can store digital information such as sound and video used for nonlinear editing.

zoom To adjust the focal length of the shot on a variable focal length lens while the shot is being executed.

zoom lens A complex lens with variable focal lengths, adjustable in a range from wide to telephoto.

zoom mic A microphone, the pickup pattern of which can be changed gradually from cardioid to supercardioid so that it can pick up sounds at different distances.

Suggested Readings and Web Sites

Books

Alten, Stanley R. *Audio in Media,* 5th ed. Belmont, CA: Wadsworth, 1998.

Anderson, Gary H. *Video Editing and Post Production: A Professional Guide.* Woburn, MA: Focal Press, 1998.

Armer, Alan A. *Writing the Screenplay: TV and Film,* 2nd ed. Belmont, CA: Wadsworth, 1993.

Barr, Tony, Eric Stephen Kline, and Edward Asner. *Acting for the Camera.* New York: HarperCollins, 1997.

Bordwell, David, and Kristin Thompson. *Film Art: An Introduction,* 4th ed. New York: McGraw-Hill, 1993.

Brown, Blain. *Motion Picture and Video Lighting.* Woburn, MA: Focal Press, 1996.

Browne, Steven E. *Nonlinear Editing Basics.* Woburn, MA: Focal Press, 1998.

Burrows, Thomas D., Lynne S. Gross, and Donald N. Wood. *Television Production: Disciplines and Techniques,* 7th ed. New York: McGraw-Hill, 1998.

Carlin, Dan, Sr. *Music in Film and Video Productions.* Newton, MA: Focal Press, 1991.

Cartwright, Steve R. *Pre-Production Planning for Video, Film, and Multimedia.* Boston: Focal Press, 1996.

Cheshire, David. *The Book of Movie Photography.* New York: Alfred A. Knopf, 1984.

Crisp, Mike. *Directing Single Camera Drama.* Woburn, MA: Focal Press, 1998.

Cury, Ivan. *Directing and Producing for Television.* Woburn, MA: Focal Press, 1998.

Delamar, Penny. *The Complete Make-Up Artist: Working in Film, Television, and Theatre.* Evanston, IL: Northwestern University Press, 1995.

Di Zazzo, Ray. *Corporate Scriptwriting.* Newton, MA: Focal Press, 1992.

Eargle, John M. *Music, Sound, and Technology.* New York: Van Nostrand Reinhold, 1995.

Field, Syd. *Screenplay: The Foundations of Screenwriting,* expanded ed., New York: Dell, 1982.

Fitt, Brian, and Joe Thornley. *Lighting Technology.* Woburn, MA: Focal Press, 1997.

Gates, Richard. *Production Management for Film and Video.* Newton, MA: Focal Press, 1995.

Gomery, Douglas. *Movie History.* Belmont, CA: Wadsworth, 1990.

Harmon, Renee. *Film Directing.* New York: Lone Eagle Press, 1997.

Honthaner, Eve Light. *The Complete Film Production Handbook.* Los Angeles: Lone Eagle, 1992.

Huber, David Miles. *The MIDI Manual.* Woburn, MA: Focal Press, 1998.

Kehoe, Virginia. *The Techniques of the Professional Make-Up Artist.* Newton, MA: Focal Press, 1995.

Kindrew, Gorham, and Robert B. Musburger. *Introduction to Media Production: From Analog to Digital.* Woburn, MA: Focal Press, 1997.

LeTourneau, Tom. *Placing Shadows: The Art of Video Lighting.* Woburn, MA: Focal Press, 1998.

Lowell, Ross. *Matters of Light and Depth.* Philadelphia: Broad Street Books, 1992.

Madsen, Roy Paul. *Working Cinema: Learning from the Masters.* Belmont, CA: Wadsworth, 1990.

Maier, Robert G. *Location Scouting and Management Handbook.* Newton, MA: Focal Press, 1994.

Manner, Bruce. *Film Production Technique.* Belmont, CA: Wadsworth, 1996.

Miller, William. *Screenwriting for Film and Television.* Boston: Allyn and Bacon, 1998.

Millerson, Gerald. *Technique of Lighting for Television and Film,* 3rd ed. Newton, MA: Focal Press, 1991.

Monaco, James. *How to Read a Film,* rev. ed. New York: Oxford University Press, 1981.

Morgan, Bradley J., and Joseph M. Palmisano, *Film and Video Career Directory.* Detroit: Visible Ink, 1994.

O'Donnell, Lewis B., Philip Benoit, and Carl Hausman. *Modern Radio Production,* 2nd ed. Belmont, CA: Wadsworth, 1990.

Ohanian, Thomas A., and Michael E. Phillips. *Digital Filmmaking: The Changing Art and Craft of Making Motion Pictures.* Woburn, MA: Focal Press, 1996.

Olson, Robert. *Art Direction for Film and Video.* Newton, MA: Focal Press, 1993.

Pohlman, Ken C. *Principles of Digital Audio.* New York: McGraw-Hill, 1995.

Reese, David E., and Lynne S. Gross. *Radio Production Worktext: Studio and Equipment,* 3rd ed. Woburn, MA: Focal Press, 1998.

Rosenthal, Alan. *Writing Docudrama.* Newton, MA: Focal Press, 1994.

Rumsey, Francis, and Tim McCormick. *Sound the Recording.* Woburn, MA: Focal Press, 1997.

Schneider, Arthur. *Electronic Post-Production and Videotape Editing.* Newton, MA: Focal Press, 1989.

Seeger, Linda, and Edward Jay Whetmore. *From Script to Screen.* Stoneham, MA: Focal Press, 1994.

Sterritt, David. *The Films of Alfred Hitchcock.* Cambridge: Cambridge University Press, 1993.

Tucker, Patrick. *How to Act for the Camera.* New York: Routledge Press, 1993.

Viera, Dave. *Lighting for Film and Electronic Cinematography.* Belmont, CA: Wadsworth, 1993.

Von Samson, Renate. *388 Great Hairstyles.* New York: Sterling Publishing, 1998.

Watkinson, John. *The Art of Sound Reproduction.* Woburn, MA: Focal Press, 1998.

Wilson, Anton. *Cinema Workshop,* 3rd ed. Hollywood: ASC Holding Corp., 1983.

Zettl, Herbert. *Sight-Sound-Motion: Applied Media Aesthetics,* 3rd ed. Belmont, CA: Wadsworth, 1999.

Web Sites

www.actor.org
www.audiotechnica.com
www.broadcastingcable.com
www.dga.org
www.electrovoice.com
www.emonline.com
www.hollywoodnetwork.com
www.hollywoodreporter.com
www.kodak.com
www.loc.gov
www.panasonic.com
www.powerproduction.com
www.sennheiser.com
www.shure.com
www.smpte.org
www.sony.com
www.ufva.org
www.variety.com
www.wga.org
www.writerscomputerstore.com

Index